The Ansel Adams Guide

Basic Techniques of Photography

BOOK 2

D1127024

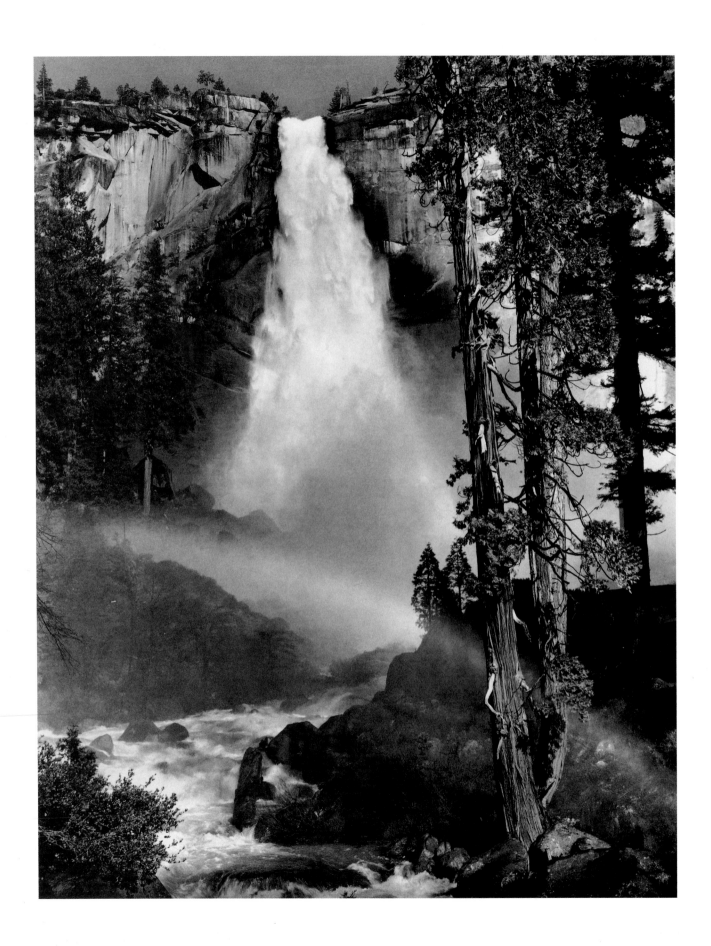

TR
146
.S374
1991
Bk.2

The Ansel Adams Guide

Basic Techniques of Photography

BOOK 2

JOHN P. SCHAEFER

Little, Brown and Company

Boston • New York • Toronto • London

GOSHEN COLLEGE LIBRARY
GOSHEN, INDIANA

To Helen, my enduring focal point

In 1976, Ansel Adams selected Little, Brown and Company as the sole authorized publisher of his books, calendars, and posters. At the same time, he established The Ansel Adams Publishing Rights Trust in order to ensure the continuity and quality of his legacy — both artistic and environmental.

As Ansel Adams himself wrote, "Perhaps the most important characteristic of my work is what may be called print quality. It is very important that the reproductions be as good as you can possibly get them." The authorized books, calendars, and posters published by Little, Brown have been rigorously supervised by the Trust to make certain that Adams' exacting standards of quality are maintained.

Only such works published by Little, Brown and Company can be considered authentic representations of the genius of Ansel Adams.

Copyright © 1998 by the
Trustees of The Ansel Adams Publishing Rights Trust

All rights reserved. No part of this book may be reproduced in any form or by any electronic or mechanical means, including information storage and retrieval systems, without permission in writing from the publisher, except by a reviewer who may quote brief passages in a review.

Acknowledgments of permission to reproduce from copyrighted materials appear on page 380.

First Edition

Published simultaneously in Canada by Little, Brown & Company (Canada) Limited

Frontispiece: Ansel Adams, *Nevada Fall, Rainbow, Yosemite Valley, c. 1947.*

Library of Congress Cataloging-in-Publication Data

Schaefer, John Paul, 1934–
 The Ansel Adams Guide: basic techniques of photography, book two/by John P. Schaefer. — 1st ed.
 p. cm.
 Includes index.
 ISBN 0-8212-2095-0 (hc)
 ISBN 0-8212-1956-1 (pb)
 1.Photography I.Title
TR146.S374 1991 90-27208
771 — dc20

Printed by Hull Printing
Bound by Acme Bookbinding
Designed by Douglass Scott and Cathleen Damplo/WGBH Design
Typeset in Adobe Garamond

PRINTED IN THE UNITED STATES OF AMERICA

Contents

Preface

The astounding versatility of photography is evident in the spectrum of its applications. Since its invention it has been used to create daguerreotypes, tin types, portraits on fine paper, gelatin silver prints, albumen prints, cyanotypes, platinum prints, gum prints, Polaroid pictures, magazine and book illustrations, chest X rays, video images, motion pictures, infrared images of galaxies, X-ray crystallography . . . and simple snapshots for a photo album. The incentive to take photographs comes from a desire to apply photography to our own interests, and most people begin by pursuing specific applications. While this approach can lead to a certain level of mastery, it is generally limiting.

In photography, as in other arts and sciences, a set of basic principles is the foundation of the discipline, and all of the applications are controlled by these fundamental rules. For example, the basic rules for exposure and development apply equally to daguerreotypes, Polaroid pictures, chest X rays, and platinum prints. After learning the basic rules of a discipline, it is a simple matter to move from one application to another.

The presentation of the fundamental principles of photography elaborated by clearly presented illustrations, detailed and interesting examples, and the shared experience of experts is the goal of the Ansel Adams Guides. This volume is intended as a continuation of *Basic Techniques of Photography, Book 1* (Little, Brown, 1992) and begins with a survey of various ways that outstanding artists have used photography over the past century and a half. A detailed review of the Zone System, developed and used so successfully by Ansel Adams, follows, with explanations of how to apply it to the exposure, development, and evaluation of any film.

Though the gelatin silver print and the C-print are currently the dominant ways photographs are printed, a growing number of photographers are using and exploring traditional and new printing techniques to create distinctive and exquisite photographic images. The literature pertaining to these alternative printing processes is often needlessly complex or filled with error. While there are many variants of the processes described in this text, the procedures that I have outlined produce predictable and consistent results and should form a solid foundation for any photographer who wishes to explore these printing techniques.

The alternative printing processes described do not require a traditional darkroom once a developed negative is in hand. With the exception of platinum printing, the processes are inexpensive, require minimal equipment, and are a delightful and satisfying way to create distinctive photographs. There is a special magic in hand coating a fine sheet of paper with simple chemicals, exposing it to the sun, and watching an image emerge. Mastering these

processes takes time and effort, but you will be rewarded with a new set of photographic skills that will enhance your appreciation and use of the camera.

With the advent of the computer and its link to photography, the medium has entered a new era, full of exciting possibilities. How the computer will add to the visual language that photography has given to us will be determined by the uses to which the emerging electronic tools are applied. The text provides an introduction to the use of the computer in photography along with examples of an art form that has just begun to be explored. Electronic imaging is a field whose aesthetic is yet to be defined and is an inviting field for creative photographers as well as for those who simply choose to use it as a tool to produce traditional images.

Throughout this book I have emphasized that photography is a visual language through which we can communicate. The aim of this volume is to encourage you both to examine and understand the basic principles of the medium and to explore processes and techniques that will emphasize the distinctive aspects of your own photographic voice.

Acknowledgments

A successful technical book is the result of a team effort. Early discussions with Martha Strawn, Todd Walker, Norman Locks, and Alan Ross helped to shape the form and contents of this volume. Comments and editing by Jane Tufts, who first read the manuscript, were invaluable and helped to clarify my prose. Contributing essayists David Scopick, Todd Walker, Michael Gray, Zoe Zimmerman, Alan Ross, Dick Arentz, Charles Palmer, M. Halberstadt, Barry Haynes, and Judy Miller have enriched the text with examples of their own creative work.

Bulfinch Press editors Janet Swan Bush and Karen Dane, copyeditor Pamela Marshall and production associate Ken Wong at Little, Brown, and designers Douglass Scott and Cathleen Damplo all played key roles in the production of this book, and I am grateful for their unique talents and dedication to this project.

Special thanks are due Alan Ross, who, throughout the evolution of this text, generously shared the insights and experiences gleaned during years of working alongside Ansel Adams, both in the field and darkroom. Most of the technical illustrations in the text were done by Alan.

Lastly, and most important, without Ansel Adams' commitment to teaching and writing about photography and the incomparable body of art he created, this book would not have been possible. It is to him and the inspiration that he has provided to generations of photographers that my greatest debt is owed.

The Ansel Adams Guide

Basic Techniques
of Photography

BOOK 2

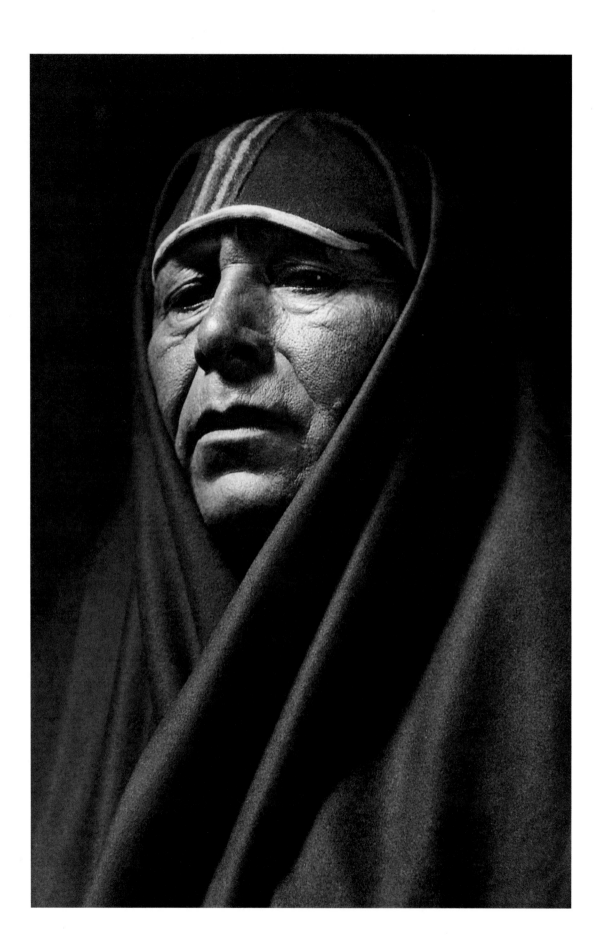

Chapter One

The Expressive Photographic Print

Photography is the most potent . . . the most stimulating medium of human expression in this day. Call it Art, term it Craft, place it with journalism, science, physics, or self-expression — it is not to be denied. It is a banal giant in the hands of superficial amateurs, an instrument of incredible penetration in the laboratory, a miraculous palette manipulated by the creative artist, a mirror of these fateful and ridiculous times when complementing the reporter's notebook. Never in all history has such an instrument of kaleidoscopic powers been placed in the hands of men for the dissemination of thought, fact, and emotion. Revelation, persuasion, stimulation — all are possible with the little black box and the mathematically figured piece of glass.
—ANSEL ADAMS

Recorded history begins not with words, but with images. Painted on the walls of secluded caves, etched into the surface of stones, these visual symbols from the past are messages about life and experiences. In time, images became another form of language, supplementing our primary mode of communication, the spoken word.

Writing, the translation of sound into symbol, overcame the most serious limitation of speech, namely the need for the speaker and listener to share each other's presence. Writing carries speech beyond the boundaries of time and space. Reading, conversation, looking at a picture are all processes through which symbols are transformed into ideas, emotions, or any of a myriad of actions.

Although speech, writing, and more complex forms of imagery operate through the creation and interpretation of symbols, the impact of a message is shaped and altered by the medium through which it is transmitted. A novelist, a poet, a musician, a painter, and a photographer can all communicate "dawn," but each portrayal reflects the virtues or limitations of the medium through which the artist responds.

The richness of a language depends upon the subtleties of vocabulary and how the meaning of words is expanded by altering their context. When Romeo says, "Juliet is the sun," we know that Juliet is not really the sun, but our romantic sensibility understands that Juliet is Romeo's poetic source of light, of warmth — his center — and the metaphor works. Study of the syn-

Figure 1.1: Ansel Adams, *A Man of Taos, c. 1930.*

Figure 1.3: Ansel Adams, *Dawn, Autumn, Great Smoky Mountains National Park, Tennessee, 1948.* The subdued lighting in this forest scene generates a visual and emotional experience completely different from that created by figure 1.2. The quality of light is an integral and defining element of the vocabulary of a photograph, just as the selection and order of words distinguish poetry and prose.

Figure 1.2: Ansel Adams, *Winter Sunrise, the Sierra Nevada, from Lone Pine, California, 1944.* Majesty, brilliance, and solitude are but a few of the qualities that this poetic image of a wintry dawn conveys.

tax of a language reveals how the assembly of words forms phrases, sentences, and, ultimately, ideas.

The mechanical and technological limitations of any medium create boundaries for an art form that control its syntax and what can be communicated. The inability of early photographic processes to reproduce color, for example, was a clear limitation of the method. The first attempts to overcome this shortcoming borrowed from older forms of printmaking, namely hand coloring the black-and-white image. Daguerreotypes were brushed with rouge to add color and depth to facial features to make them appear more lifelike. Decades passed before processes for producing true color images directly from the camera were developed. As photography's vocabulary expanded, so did its ability to translate facts, ideas, and emotions.

What is photography? I can't tell you exactly, but I believe I know what it could be. . . . Photography is but one phase of the potential of human expression: all art is the expression of one and the same thing — the relation of the spirit of man to the spirit of other men and to the world. . . . In photography we have one of the most powerful tools of human expression ever devised or imagined.

* Unless otherwise specified, italicized passages are excerpts from the writings of Ansel Adams. See pages 378–379 for a complete list of the sources for these quotations.

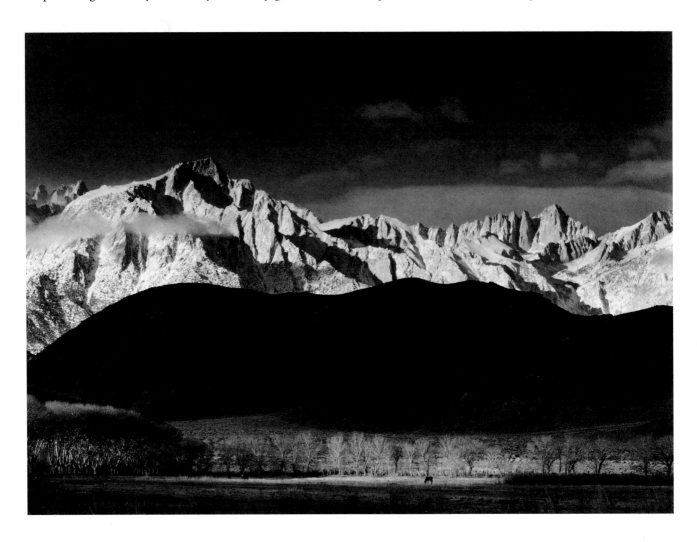

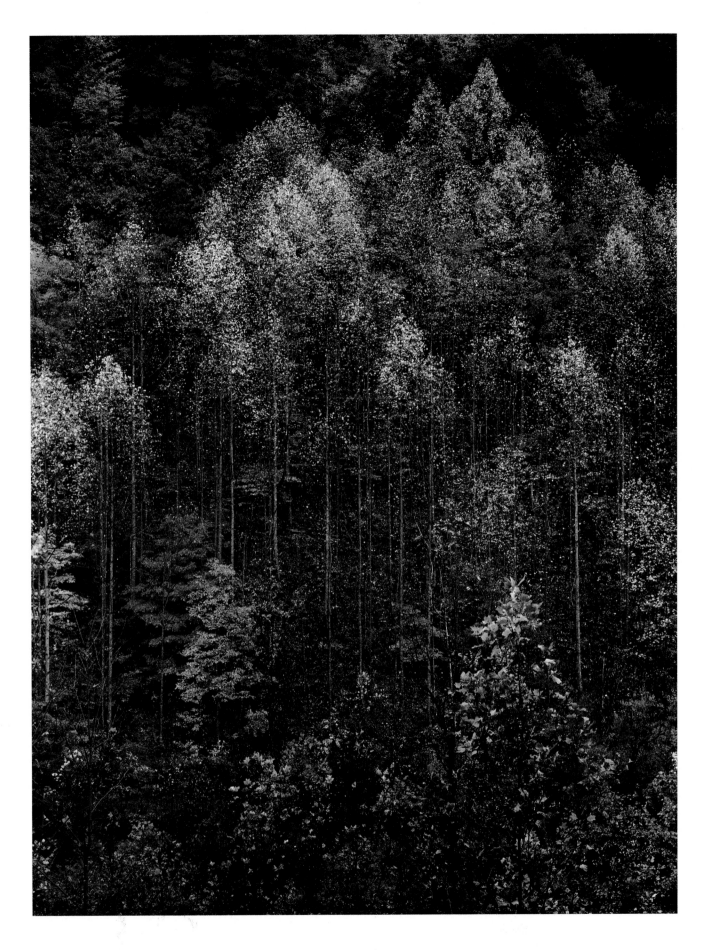

The technological evolution that has touched all aspects of photography over the past century continues to alter the nature of the photograph and what it is able to convey. If you intend to explore the use of the photograph as a way of creating images, it is important to understand how dramatically its ability to communicate is influenced not only by the obvious selection of lenses, perspective, and composition, or by the creation of tonal gradation, color, and tonality, but also by the photographic emulsion, paper surface characteristics, "chemistry" employed, and print size.

> *"Enlargement" in most people's minds is limited only by the clarity and quality of the negative image. Composition, texture, size and form of subject, and distance of viewing the enlargement are all factors that are of supreme importance. Stieglitz has a marvelous photograph of a cobweb and grass with dew, the print of which is about 2½ x 3½ inches in size. . . . The actual size of the print, small as it is, conveys the delicacy and mood of the subject as a larger print from the same negative could not accomplish. Photographers as a group are "salon minded," making prints too large and too consistently of the same size regardless of the more subtle inherent qualities of the subject and its treatment.*

Some of Ansel Adams' landscapes taken in the 1920s and printed at the time on hand-coated matte-surface paper are visual jewels. The matte surface reduces the overall brilliance of the prints, but the tonality of the blacks is rich and brooding, lending intriguing drama to the images. The small dimensions of the prints force you to draw close to examine fine details, which results in a viewing experience that differs from seeing a print in the distance on a wall. These same photographs enlarged and printed on glossy-surface modern papers lose their visual power and do not succeed. Both enlargement and printing the image on a glossy-surface paper sacrifice the subtleties that are an essential part of the image. (*Note:* It is not possible to provide an absolutely faithful visual comparison between the various kinds of photographic prints in a book unless different reproduction processes are used for matte, glossy, silver, platinum, or gum prints. A glossy reproduction masks most of the differences in the original prints.)

While the enlarged, glossy print toned to a cold blue-gray hue eventually became the stylistic signature Ansel favored for his later photographs, countless other possibilities exist. Each continues to have enormous potential as a photographic method and remains worthy of consideration as an alternative photographic voice.

Photography as an Art Form

A good photographer is like a good cook. Cooking is judged chiefly by the way the food tastes, not by the way it is prepared. After all, a photograph is something to look at; it is supposed to convey something to the mind, to the heart, or to both at the same time. If it is a good photograph it will convey its message; if it is a bad photograph it will not. A bad photograph can convey a bald fact; a good photograph will give the fact another dimension — conviction. A supremely fine photograph will give the fact still another dimension — universality.

Figure 1.4: This daguerreotype of a now-anonymous sitter by an unknown English photographer was hand colored in the studio to produce rouged lips and cheeks. Blue sky and wisps of clouds fill the background of the scene. Daguerreotypes were colored by fogging the plate with moisture from the breath and then applying fine pigments to the surface with an extremely fine, soft-bristled brush. (Daguerreotype from the author's collection.)

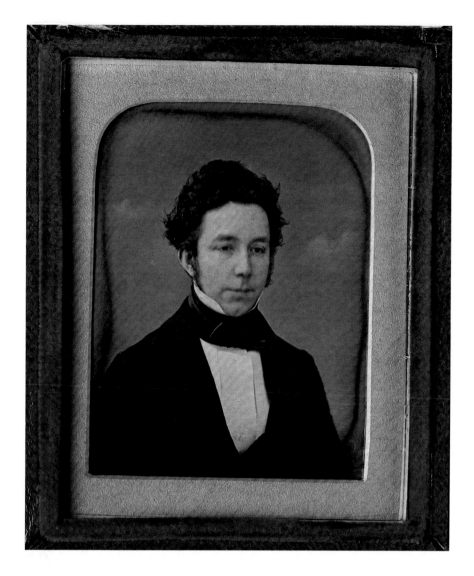

In art — as in virtually any creative endeavor — there are events that mark a new beginning, a new opportunity to explore issues of enduring concern. The invention of photography provided the world with a fundamentally new way of creating images. For many purposes (for example, the accurate rendering of intricate details), the power of the photograph easily exceeded the reach of an artist's brush and paints. And as photographers delved more deeply into the evolving toolboxes of chemists and physicists, new processes for making photographs were discovered. To the daguerreotype and salt print (calotype) were added cyanotypes, albumen prints, gum prints, platinum and palladium prints, tintypes, a host of color processes, the gelatin silver image, and many others. Each method was explored and favored or discarded by individual workers searching for the most effective way of expressing a personal vision.

The first truly great photographer was David Octavius Hill, who produced in the middle 1840s an amazing series of Calotypes. His work, unlike that of Daguerre, was basically similar to the photography of today insofar as he used negatives (sensitized papers) from which he made paper prints. Crude as his apparatus and materials were, his work is unsurpassed even in this

day. . . . It is the quality of honest functionalism that makes the Hill prints so remarkable and powerful. And Hill, as a painter, possessed a rare taste and selective intellect.

But Is It Art?

The wave of enthusiasm that greeted the invention of photography spurred a phenomenal and immediate output of images by amateurs, professionals, and artists. Toward the end of the nineteenth century the literature of the field began to voice what we today would call an identity crisis. Should or could photography be considered an art form, since a photograph's origin resides in the camera, which in reality is little more than a complex machine? Furthermore, *art* — as distinct from *craft* — is "the conscious use of skill and creative imagination esp. in the production of aesthetic objects" *(Merriam-Webster's Collegiate Dictionary).* In the minds of most latter nineteenth-century photographer-artists, *skill* implied the use of hands in the way a painter uses a brush. Ansel never harbored that illusion.

Figure 1.5: Linda Connor, *Petroglyphs, Hawaii, 1978.* Petroglyphs can be found all over the world, and Linda Connor has pursued them as a continuing photographic theme. She contact prints her 8 x 10-inch negatives on printing-out paper (POP) and gold tones the image to achieve both a desirable visual effect and archival permanence. Some petroglyphs are relatively easy to interpret, but the meaning of most remains obscure.

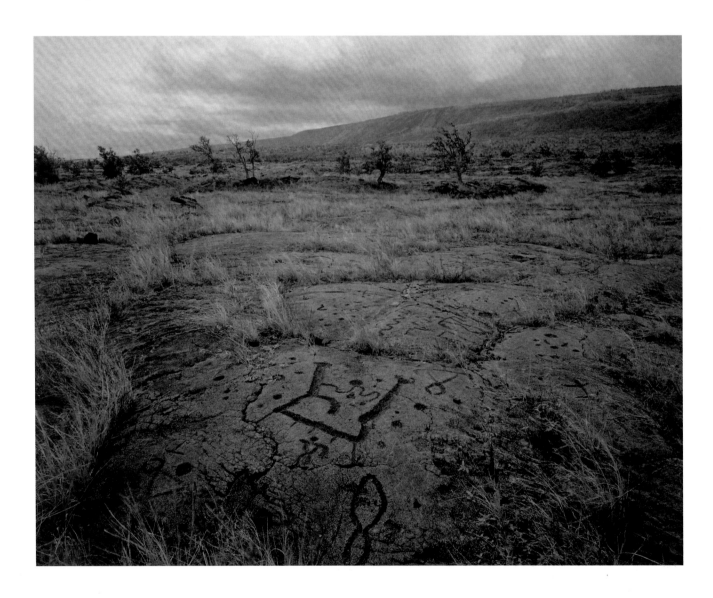

Figure 1.6: Ansel Adams, *On the Heights, 1927.* Parmelian print. This exquisite photograph was part of a portfolio of prints made by Ansel Adams in 1927 on a specially produced matte-surface paper. Although the stylistic elements of his later work can be found in this image, the presentation is completely different — and very successful.

The camera, properly used, is no more a mechanical "tool" than the painter's brush or the etcher's knife, and the emotional-aesthetic elements are derived from the imagination, taste, and technique of the artist no matter what form of expression is involved. We do not speak or write in two languages at the same time, nor do we paint with oil and water-colors on the same canvas. What justification have we then for superimposing the technique and expressive values of painting or etching on a photographic image? The photographic expression and technique achieves its most profound impact when it is simple, direct, and entirely true to itself.

Much of the uncertainty about the nature of photography stems from a failure to understand a fundamental difference between photography and painting. Historically, and in general, *photography is subject oriented:* whatever the photographer focuses the camera's lens on is the essence of the photograph. Creativity resides in recognition and selection of the subject and the point of view and in use of any of the tools and techniques that make up a photographer's arsenal.

In contrast, *painting is object oriented.* It is the painting as a complete object that motivates the artist: the subject being drawn or painted is often secondary or even irrelevant. The medium chosen (watercolors, oils, pastels, and so forth), the surface texture, colors, the artist's style, interpretation, and emphasis all contribute to the creation of the conceptualized object.

The essential element of creative vision — a complex of time, space, and love — is absolute. We expect it in the fine arts, in great music and literature. We are sometimes perplexed when confronted with it in photography. We ask, "How can something be both real and magical?" Magical a photograph may not often be. But one thing we know; it can never be truly real. I am reminded of the patron who at a Picasso exhibit said to the Master,

"Mr. Picasso, I do not understand this painting entitled FISH; *it certainly does not look like a fish to me!" Picasso replied — "Madam, why should it look like a fish — it is a painting!" A photograph can be nothing else but a photograph. We cannot define it as a counterfeit of reality — or even a reflection of reality. It remains, simply and inevitably, a photograph. Reality is just one element in the process of taking a photograph.*

The *pictorialist movement* was born during the latter part of the nineteenth century out of the belief that a photograph could be transformed into "art" only through the intervention of the human hand. While the images that were created were rooted in photography, the pictorialist's objective was to create a print that resembled an etching, a charcoal drawing, a pen-and-ink sketch — something close to one of the traditional art forms, but virtually anything other than a photograph! Pictorialists moved away from subject-oriented photography toward the concept of transforming the photograph into an object that could be considered "art."

The Pictorial Period, coincident with the romantic painting of the 1880s, 1890s, and early 1900s, produced an enormous amount of work but not much of basic photographic importance. The Pictorialists were interested chiefly in duplicating or imitating the qualities of the graphic arts (it was not always a conscious imitation, however). They objected to the frank literal qualities of photography as "unbeautiful," and turned to effects of diffusion, sentimentalism, and other contradictions of the medium of the camera, striving to attain effects which the artists and draughtsmen of the period were achieving. However, in the late 1890s a figure emerged who was destined to exert a profound effect on photography, bringing it to fulfillment as a great medium of art. . . . Stieglitz is the very effective link between the honesty and directness of the "Factual" period and the achievements of the photographic "Renaissance" in effect today.

Figure 1.7: Frank Meadow Sutcliffe, *They Also Serve, 1896.* This pastoral scene successfully evokes the mood of a romantic painting of the English countryside at haying time. Sutcliffe, who was referred to as the "pictorial Boswell of Whitby," described his method of working: "When photographing rustic figures out of doors, I think the best plan is to quietly watch your subjects as they are working or playing, or whatever they are doing, and when you see a nice arrangement to say, 'Keep still just as you are a quarter of a minute,' and expose, instead of placing an arm here and a foot there, which is sure to make your subject constrained, and consequently stiff." (Lee D. Witkin and Barbara London, *The Photograph Collector's Guide* [Boston: New York Graphic Society Books, 1979], p. 248.)

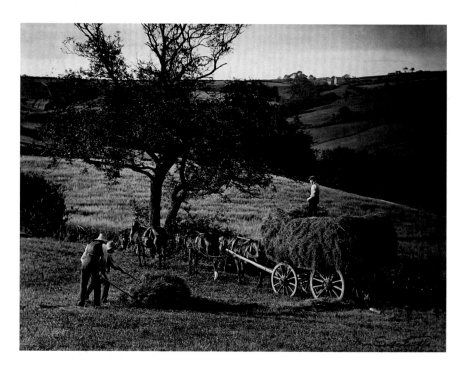

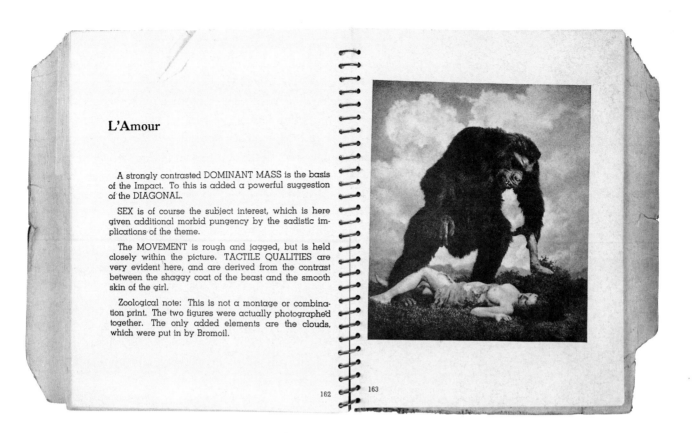

L'Amour

A strongly contrasted DOMINANT MASS is the basis of the Impact. To this is added a powerful suggestion of the DIAGONAL.

SEX is of course the subject interest, which is here given additional morbid pungency by the sadistic implications of the theme.

The MOVEMENT is rough and jagged, but is held closely within the picture. TACTILE QUALITIES are very evident here, and are derived from the contrast between the shaggy coat of the beast and the smooth skin of the girl.

Zoological note: This is not a montage or combination print. The two figures were actually photographed together. The only added elements are the clouds, which were put in by Bromoil.

162 163

Figure 1.8: William Mortensen, *L'Amour*, c. 1936. Mortensen's impressive technical prowess is evident in his photographs, but his images are almost a caricature of pictorialism, and his aesthetic sensibility placed him outside the mainstream of twentieth-century photography. The text that accompanies *L'Amour* is his.

Pictorialist images at their best were a tour de force of printmaking techniques and required extraordinary skill and patience. Scenes were carefully constructed to conform to rigid rules of composition, negatives were freely retouched, unwanted objects removed, and painterly touches such as brush strokes or scratches from an etching pen were added, all in an effort to escape the accusation that photography was nothing more than a product of the industrial revolution. With the passage of time pictorialist images passed from the occasional sublime to the ridiculous, wallowing in sentimentality and mirroring the trite.

The Eclipse of Pictorialism

Although he was once an active participant in the pictorialist movement, Alfred Stieglitz ultimately recognized that photography had to deal with its identity crisis by exploiting the unique virtues of the camera and lens rather than submitting to a role of imitating other art forms. His subsequent work, and that of kindred souls such as Paul Strand, Edward Weston, and Ansel Adams, forever established that *art is what an artist creates;* cameras, lenses, paintbrushes, and chisels are merely tools that artists use for their conscious modes of expression.

A pivotal moment in the history of modern photography was the San Francisco exhibition of the Group f/64 in 1932. The participants, notably Ansel Adams, Edward Weston, Imogen Cunningham, Willard Van Dyke, and Sonja Noskowiak, saw photography as an artistic medium whose virtues included an unparalleled ability to capture fine detail, to "freeze" time, and to express what had been captured on the negative in tonalities that varied from

Figure 1.9: Ansel Adams, *Dunes, Hazy Sun, White Sands National Monument, New Mexico, 1941.* **This sharply focused image is typical of the work of Group f/64 in style and subject matter.**

brilliant to subtle, whatever was appropriate for the image. In short, the exhibition marked a return of photography to *subject orientation* and celebrated its intrinsic virtues. The crystalline detail that could easily be coaxed from a gelatin silver print became the artist's voice in modern photography.

With the evolution of photojournalism and the advent of picture magazines such as *Life,* the ease of making enlargements and the ability to produce a gelatin silver print quickly for publication further boosted the popularity of the glossy print. In a surprisingly short period of time, virtually all of the traditional printing processes used by photographers were abandoned: the gelatin silver print reigned supreme.

In a gelatin silver print the image is suspended above the surface of a textureless white paper or plastic sheet, whose degree of whiteness defines how brilliant the photograph's lightest tonal values can be. Visually, it makes no difference if the base sheet is paper or polyester. Because of the mechanical way in which the print is structured, *it is primarily the subject recorded by the camera and interpreted in the darkroom by the photographer that registers in the viewer's mind when a gelatin silver print is examined.* A consequence of the sameness of the physical quality of virtually all modern photographs is that they are judged solely by the *subject* depicted, not by the photograph as an *object* that should be considered as a whole (image, paper, tone, matte or glossy surface, and so forth). How an image is presented — its physical character (for example, an oil painting versus a watercolor) — is a critical factor in any art form. An unfortunate by-product of the victory of "straight photography" over pictorialism was that photography divorced itself from the time-honored art of printmaking — and photography has been poorer for the loss.

Photographic Printing Processes

The aspect of the world under natural light is infinite in complexity and variety. And so is the mind and heart of the photographer. And almost so are the machines and materials of photography. The problem is to make them all work together.

Even the most casual visitor to an art museum can appreciate the difference between an oil painting, a watercolor, a chalk pastel, and a charcoal drawing. If an artist chose to interpret a scene using each of these four techniques in turn, four strikingly different images would result. It would be impossible for a viewer to look at a grouping of these works and register only the scene transcribed by the artist. The canvas or paper, the paint, charcoal, or pastel — in essence, the medium chosen by the artist — is an integral part of the work. The same is true in photography, and the rich possibilities offered by alternative ways of presenting images are worth exploring.

One of the objectives of this book is to probe the vast potential of historical and modern evolving photographic processes as a means of creating expressive photographs. The following examples are meant to introduce and illustrate a few of the creative possibilities that exist.

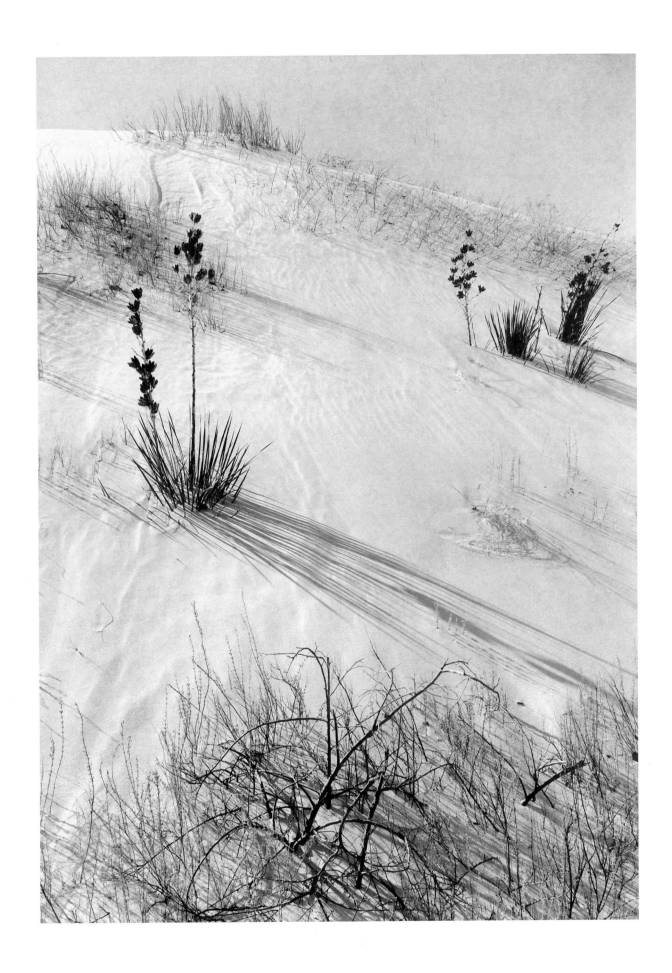

Figure 1.10: William Henry Fox Talbot, *The Haystack,* from *The Pencil of Nature, 1843.* An early example of a calotype.

Salted Paper (Calotypes)

The basic photographic printing process (there are numerous early variants) invented by William Henry Fox Talbot involves soaking a sheet of paper in a salt solution, then coating the dried sheet with a solution of silver nitrate. This forms a light-sensitive precipitate of silver chloride on and near the surface of the paper. After drying again, the paper is covered with a negative, placed in a printing frame, and exposed to strong light (sunlight or an ultraviolet lamp). The image *prints out,* that is, it becomes visible during exposure (often 10 minutes or more in bright sunlight), with no chemical development required. The progress of development is monitored by inspecting the appearing image periodically in subdued light (a portion of the paper is lifted off the negative surface to see if shadow and highlight details are appropriately defined). When development is judged to be complete, the print is washed in running water, fixed, and toned.

The silver image that forms during exposure acts as a *mask* and restrains the rate of further density buildup in areas where deposits accumulate. The effect of the "automatic masking" that takes place in all printing-out processes is that extremely delicate separations of tonal values in the shadow areas

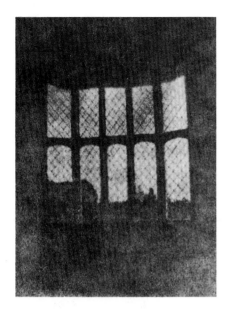

Figure 1.11: William Henry Fox Talbot, *The Oriel Window, Lacock Abbey, 1835.* This photograph was taken by Fox Talbot in August of 1835 and represents his first successful effort. He remarked with pleasure that with the aid of a magnifier it was possible to distinguish and count all of the glass panes in the window.

of a print can be achieved that are not possible with any other photographic methods except through the use of elaborate masking techniques or digital processing. A fine salted-paper print will display a wealth of detail in deep shadows. Midtones and highlights are nicely rendered, and the most subtle features of the negative are captured as delicate wisps of light.

A commercial version of salted paper is currently available as *printing-out paper (POP)* (available from Chicago Albumen Works; see page 376). POP is made by dispersing an emulsion of silver chloride in gelatin and then coating paper with it; contact printing results in a glossy print. POP has been used extensively by portrait photographers for contact printing negatives, since it does not require chemical processing and the proofs fade with time, both desirable properties for the purpose intended.

If a salted-paper or POP print is not fixed, it will continue to darken. The print can be made permanent by washing in water, fixing with very dilute hypo (sodium thiosulfate) solution, and toning with gold toner.

Print surface is an important aesthetic variable that should be considered when a print is conceptualized. Since a traditional salted-paper print (and others, such as platinum prints and cyanotypes) has a matte surface, and the image is both *on* and *in* the surface of the paper, it has a distinctly different "presence" than a glossy gelatin silver print. The reflectance of a matte-surface print is much less than that of its glossy counterpart. However, darker tones can be incredibly rich and moody, exhibiting a velvet texture and emphasizing and retaining details that may be sacrificed in a glossy print. Similarly, midtones and highlights lose the bold, often brassy feeling of brilliance that is a hallmark of a glossy print and are rendered as subtly different tonal separations rather than as prominent steps of gray values.

A characteristic of hand-coated photographic prints is that the definition of image details is softer. In a gelatin silver print the image consists of a microscopic suspension of silver particles that float above the white surface of the paper, enabling details to be resolved to a microcrystalline level. (The primary

Figure 1.12: Anonymous, *The Seven Sisters, c. 1880.* Literally millions of gold-toned images on albumen paper or printing-out paper were made by photographers and sold to tourists as souvenirs for inclusion in photograph albums. With the invention of simple box cameras and processing by Eastman Kodak these were displaced by the ubiquitous "snapshot."

Figure 1.14: Anonymous, *Portrait of a Young Lady, c. 1890.* This platinum print of a studio portrait is typical of the high-quality work done in the period. Tonal qualities and image permanence are two important characteristics of platinum prints.

characteristic of modern "papers" is that the surface is white and textureless. For ordinary commercial photographic applications the traditional paper base is being replaced by the plastic laminated sheets that constitute RC — resin-coated — papers.) With hand-coated prints the materials that form the image are entangled within the fibers of the paper. During the washing and drying process, these microscopic fibers "lay down" and the image has a feel that is not as hard-edged as a gelatin silver print, even though to the eye fine details are still well resolved.

Cyanotypes

Soon after the announcement by Fox Talbot of the process for making salted-paper prints in 1842, Sir John Herschel, an astronomer of note, discovered that certain iron salts were light sensitive and could be used as the basis for making photographs. Herschel found that paper coated with a mixture of ferric chloride or ferric ammonium citrate and potassium ferricyanide (all of which are inexpensive and readily available) is photosensitive, and an image of Prussian Blue prints out as an insoluble precipitate on the paper's surface during exposure. In its early days the process was used by architects and engineers to copy line drawings, hence the name "blueprints."

The print is processed by washing it briefly in water to remove any unexposed iron salts. The blue color deepens slowly on exposure to air, but a deep blue color can be achieved instantaneously by adding a few drops of peroxide to the wash water.

Printing negatives as cyanotypes is an excellent way to begin exploring alternative printing processes. The materials required are inexpensive and easy to work with, and you can quickly learn the mechanical skills needed (for example, coating papers with minimum amounts of solution to avoid waste of the sensitizer) for more demanding processes such as platinum and gum printing. Making cyanotypes also offers an excellent way to evaluate and compare different types of fine papers.

Because of its deep blue color, the cyanotype never became a popular vehicle for printing and creating fine photographs. For the appropriate subject, however, a cyanotype can be an effective way to present an image. Edward S. Curtis created a number of striking portraits as cyanotypes, and others continue to use the process creatively and to great effect. Nonetheless, the view expressed by Peter Henry Emerson more than a century ago — "No one but a vandal would print a landscape in red, or in cyanotype" — is generally accepted. But talented and clever vandals often merit attention, and occasional praise.

Platinum/Palladium Prints

Robert Hunt, expanding upon research initiated by Sir John Herschel, laid the groundwork in 1844 for what is probably the most elegant and beautiful of photographic objects, the platinum print. Hunt discovered that paper coated with a mixture of ferric oxalate and a platinum salt was light sensitive and could

Figure 1.13: Edward S. Curtis, *Cheyenne, c. 1900–1910.* Curtis often made cyanotypes from his negatives in the field as a proofing device. Many of these cyanotypes succeed as fine prints in their own right.

Figure 1.15: Peter Henry Emerson, *Cutting the Gladdon, c. 1885*. Emerson, often cited as the founder of contemporary photography, established photography as an important art form. His platinum prints continue to be numbered among the finest photographs ever made.

be used to make photographic prints. Approximately thirty years later William Willis perfected and patented a process that made platinum papers commercially available, and platinum printing was quickly adopted by most serious photographers seeking to make fine prints that were not subject to fading.

As with salt prints and cyanotypes, making a platinum print requires sunlight or a source rich in ultraviolet light; a very faint image appears during exposure. The print can be developed in several ways, but the most common technique is to immerse the paper in a warm solution of potassium oxalate; development is virtually instantaneous. Processing is completed by washing the print in a dilute solution of acid. Platinum prints (for reasons of cost, platinum salts are usually mixed with palladium salts, and the prints are actually platinum/palladium images) are the most stable photographic images known and, when well done, produce photographs that are breathtakingly beautiful.

The rising price of platinum metal during World War I drove the cost of commercial printing papers beyond the reach of most photographers. This, coupled with the ease of use and relatively low cost of silver-based enlarging papers, ensured the demise of commercially available platinum papers. However, it is a simple, satisfying, and not prohibitively expensive matter to

make platinum/palladium papers yourself. All of the required chemicals are readily available from several supply houses (see pages 376–377). The rekindling of interest in alternative photographic processes during the past two decades has resulted in a growing number of photographers who are once again creating extraordinary prints using this time-honored process.

Gum Prints

The observation that exposing paper coated with a mixture of a dichromate salt and gum arabic (a resin gathered from the wounds of acacia trees) to light converts the gum arabic to an insoluble film is the basis of one of the most versatile and widely used photographic processes of all time. When a pigment is mixed into the coating, exposure to light passing through the negative locks the pigment within an insoluble plasticlike matrix that forms — the pigment is retained within the matrix and on the paper surface in direct proportion to the exposure received. Washing the exposed sheet removes the unexposed gum and pigment and leaves a positive image attached to the paper.

Figure 1.16: Charles Palmer, *Grand Canyon, 1994.* Modern palladium printers hand coat fine paper to create images of unrivaled quality.

The power of gum printing is that pigments of any color can be used, the prints are as stable as the pigments themselves, and multiple printings on the same sheet of paper can lead to full-color images. The gum-printing process was a favorite of the pictorialists because it easily lent itself to manipulation. Multiple printings on a single sheet of paper enable the printmaker to intrude at will and alter the structure and colors of the image being created. In recent years interest in gum printing has revived, and extraordinary images are being created by photographers who are reexploring the method's potential.

Figure 1.17: Paul Strand, *Brunig Pass, Switzerland, 1912.* This example of a hand-colored platinum print was made by Strand early in his career to sell to tourists.

Figure 1.18: David Scopick, from the Mexican series, 1994. The starting point for this gum print is a 35mm black-and-white negative. It was scanned into a computer, and the image was colored by the artist using a paint program. The computer then generated halftone color separations, which served as the negatives required to make the full-color print.

Electronic Imaging

One of the great strengths of photography is that its technology component continues to evolve, thereby expanding the creative possibilities presented by the medium. The present-day photographer not only has a complete array of traditional printing techniques available to explore in a modern context but shares the opportunity to integrate features of these methods with the rapidly emerging field of electronic imaging.

The computer is a new tool that enables a photographer to make and apply the same considerations that go into the making of a fine print in the darkroom. All of the traditional decisions that you make — dodging and

Figures 1.19: Olivia Parker, *Game Edge, Toys and Games,* from the History of the Real series, 1995. Digital image.

burning-in an image; selecting the paper contrast, developer, and processing conditions; toning the image — have counterparts in the electronic imaging process. Coming to the computer with experience in photographic methods provides a background that will enable you to recognize and use the potential of this tool — *and create better and more creative photographic images* — in ways that are not obvious from the design-oriented manuals and approach now in vogue in computer education. If you do not have a basic understanding of the vast possibilities of the medium of photography, the computer can easily become an expensive toy rather than a powerful tool.

In an electronic image the scene is actually a finely divided grid of squares. As with the grain that constitutes a photograph, the size of the squares can be so small that the visible image is like a continuous-tone photo. Each square of the mosaic has an "address" defined by its location on the x (horizontal) and y (vertical) axis of the grid, and the space is called a pixel (a contraction of *picture element*). A computer keeps a record of the location and characteristics of each pixel and assigns to it numerical values corresponding to brightness and color. In a typical digitized image that can be handled on a personal computer (PC) or Macintosh (Mac) computer, brightness is defined by a 256-step gray scale and a color palette that divides the visible spectrum into 16.8 million hues.

The electronic image is displayed on the monitor, and its origin can be a camera fitted with an electronic recording device instead of film, a video camera, or a CD-ROM on which your photo dealer can arrange to place the digitized versions of your slides or negatives for a nominal charge. Alternatively, if

you start with a slide, negative, or print, you can translate these into an electronic image with a scanner. In turn, the electronic image can be printed using a color printer designed for that purpose, or the data in the computer can be written on a disk or tape and converted to a print or transparency by your photo dealer.

To appreciate the capabilities of electronic imaging, imagine being able to manipulate each grain of silver or cluster of dye in a photograph and changing its color, size, intensity, and location at will. With the appropriate computer equipment you can come very close to achieving this objective. In electronic imaging it is a straightforward matter to change color balance or image tone, retouch or merge images, change color to black-and-white and vice versa, make color separations, convert images to halftones — in short, to do *anything you are capable of conceptualizing*. With the aid of easy-to-learn and easy-to-use programs, a computer workstation can become an incredibly powerful darkroom waiting to respond to your imagination.

Figure 1.19 is an image whose origin resides in a photograph. The artist has used a desktop computer to alter the image and incorporate external elements into the final composition. This image represents work being done at the beginning of a new era in photography. Photographers and artists who choose to explore the potential of yet another way to express ideas and communicate emotions will encounter modern versions of the same frustrations and satisfactions that faced the early followers of Daguerre and Fox Talbot. If history is any guide, the coming decades will offer unparalleled opportunities to explore the realm of visual expression through techniques that have withstood time's test and others that remain to be discovered by the curious.

Yet a note of caution is in order. Photography's very accessibility leaves it vulnerable to abuse by the unthinking, the insensitive, or those who seek to create "art" but are unwilling to make a commitment to master its craft or respect its aesthetic sensibilities. A poorly conceived and poorly executed image does not become a work of art by presenting it on fine paper as a platinum print. The photographer who wishes to explore the potential of electronic imaging needs to guard against being seduced by the ease with which images can be manipulated on a computer screen. While the novelty of exploring new methods of creating and printing images is inevitably an exciting experience, the quality of what is produced is ultimately the only thing of importance.

Ansel put it very well when he wrote,

> *My approach to photography is restricted to the medium as an art-form. . . . As an artist, my interest lies in* pictures *and in the technical procedure required to produce them. I am a confirmed believer in the purity of photographic expression; photography, when restricted by logic and good taste to its own inherent qualities, equals in dignity and force any of the mediums of art — painting, sculpture, and the other graphic and plastic forms of expression. Photography should never attempt to imitate other forms of art. It should strive for complete and vital expression within its own limitations. It has an aesthetic "code" very much its own.*

Chapter Two

The Quest for the Perfect Negative

My approach to photography relates to the visualization of the end result — the print — prior to the moment of exposure. This requires a good understanding of the process in its technical and aesthetic aspects. What I describe as the Zone System is a practical interpretation of sensitometry; it makes use of the basic parameters of exposure and development of the negative to achieve optimum negative quality in reference to the desired results in the print or transparency. — ANSEL ADAMS

One approach to playing the piano is to learn to "play by ear," while the other is to learn to read music. Some highly creative professional musicians cannot read a note of music yet compose and perform superbly well. Despite this, the inability of a musician to read music excludes him or her from a vast body of musical literature and forms a barrier that can be overcome only at great cost.

Photography can also be learned by following a few basic instructions, exposing a lot of film at different camera settings, and seeing what happens with different developers. However, just as playing by ear will put a difficult piano concerto beyond reach of the most determined performer, photography by trial and error inevitably leads to lost opportunities the moment unusual situations — those that you want to capture on film — arise. The brief time spent in a systematic study and exploration of the basic properties of films, developers, and the use of a light meter is quickly repaid in time, money, and the satisfaction of translating a visualized image into a photograph that lives up to your expectations. When decisions regarding exposure and development are reduced to a simple routine whose outcome is predictable, concerns about the mechanics of making photographs will disappear.

Photography becomes a creative art when you decide which of an infinite possibility of choices you will use to interpret a subject. You are free to create a relatively literal documentation of the scene or to impose a marked departure from reality on what you see. To achieve predictable results it is useful to know how films and papers respond to exposure and development so that you can apply these insights before you take a photograph.

A manufacturer's instructions for films or developers are intended as guidelines that, when followed, will usually create an acceptable photographic record — and on the average, the results are very good. However, to deal with unusual lighting conditions, to capture or create moods that are expressed in nothing more than colors or tones of gray, to be certain that the essence of

Figure 2.1: Ansel Adams, *North House (End View), Taos Pueblo, New Mexico, 1929.*

what you visualize resides in the exposed film, you must understand the capabilities of each film with which you work and learn how to control and manipulate its response. The Zone System, as developed by Ansel Adams, offers a simple framework for understanding and using the basic properties of any film-developer combination to achieve negatives and prints that consistently capture the images you visualize.

The glistening metallic tones of Ansel's photograph *Forest Detail, Glacier National Park* (figure 2.2) are visually arresting and have transformed what might have been a commonplace image into a visual jewel. In writing about this photograph, Ansel states,

> *This particular photograph was made before sunrise on a quiet morning and is indicative of the limitless subject material of intimate quality to be found in nature. The light values were very low. . . . Development was 4 times normal, giving remarkable tone values. (Emphasis added.)*

Figure 2.2: Ansel Adams, *Forest Detail, Glacier National Park, 1948.*

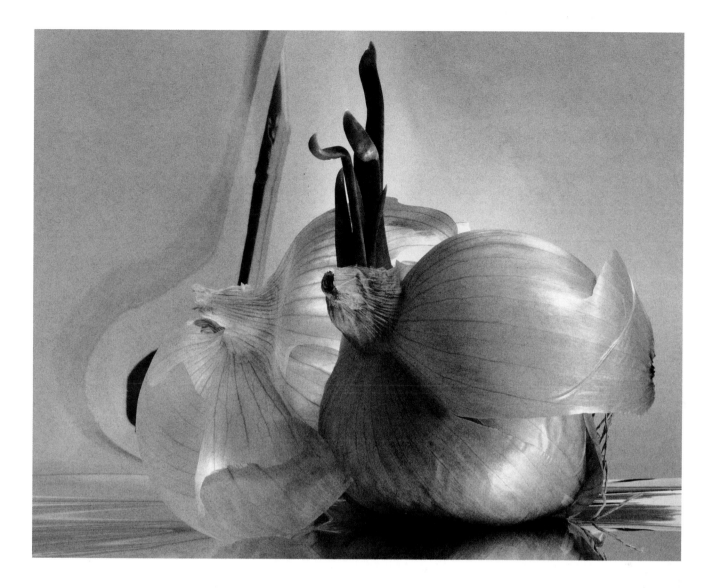

Figure 2.3: Alan Ross, *Onion, 1976.*
An exercise in reciprocity failure! The only
source of illumination for this scene was
a ceiling light in a white-painted kitchen.
At f/80 with about a 2x bellows extension
factor, the exposure indicated was about
5 minutes. Several Polaroid Type 52 prints
were made to assist in evaluating the image
with the lens stopped down. In order to
compensate for estimated reciprocity
failure, exposures of 20 minutes and 40
minutes were given. The 40-minute
exposure yielded the best negative, though
the 20-minute one is quite acceptable.

There is no suggestion in any of the literature that accompanies films and
developers that a processing time *four times longer* than that recommended by
the manufacturer is appropriate under any circumstances, yet Ansel knew that
a development time in excess of 30 minutes would result in an appropriately
scaled negative and produce the print he visualized before exposure. His
knowledge was the product of careful, straightforward studies of the materials
with which he worked, the same films and developers that every photog-
rapher uses. There are no magic tricks used in the making of Ansel's pho-
tographs. Anyone can learn to apply the principles that he routinely used.

Problems such as what exposure to use and how long to develop the film
require specific quantitative answers. The simplest way to resolve questions of
exposure and development is to (a) learn how to analyze a scene in terms of
subject brightness values; (b) learn how the film you use responds to light and
development; and (c) determine how to couple (a) and (b) to produce a nega-
tive that captures what you visualized for the photograph and that can later be
printed in the process of your choice. The procedures described in this chap-
ter and the ones that follow demonstrate how to achieve these goals.

The Zone System

The Zone System (as described in my Basic Photo Series*) relates to a rather precise control of exposure and related development, comprising a "bridge" between the exact science of sensitometry and practical applications of exposure theory in creative work. Preliminary to study in this relatively advanced domain we can consider some simpler approaches to exposure, and discover ways and means of exerting helpful controls.*

We should understand a few basic facts of photography; without this knowledge we can never be certain of what we are doing. First, we should have some idea of what our picture is to be — not only compositionally, but in terms of tone values and contrasts in relation to our subject and how we feel about our subject. . . .

Simply because a subject is of low or high contrast does not mean that our picture must be flat or harsh! . . . Our problem is one of visualizing the desired print, and then exposing and developing to get a negative which will yield such a print without complex manipulations (reduction of the negative or fussy adjustments in printing).

A fundamental property of an unmanipulated photograph is that *tonal values in the print closely parallel the luminance values of the scene.* The values do not coincide mathematically, but they are expressively related. The Zone System is an approach to photography that *couples visualization of the subject as a photograph with appropriate exposure* and *development controls.* The negative produced by applying the Zone System has a scale in which — for any given film and developer — shadow details, midtones, and highlight values each fall within narrowly defined ranges of density that, in turn, print as visualized subject tonal values.

The ultimate goal of the Zone System is *not* to create a "perfect" negative from which a "perfect" print can be made without dodging, burning-in, and the like. The perfect Zone System negative simply embodies the right amount of negative density and contrast to allow the photographer to create an expressive print with a minimum amount of effort and darkroom gymnastics.

Part of the framework of the Zone System is a gray scale in which the *continuous* transition from black to white is arbitrarily divided into ten steps, or zones. Exposure Zone 0 translates to maximum black in a print, exposure Zone IX corresponds to maximum white in a print, and exposure Zone V is roughly equivalent to "middle gray." To use the Zone System, a photographer needs to cultivate the ability to look at a subject and imagine approximate print tones (in terms of the gray scale) that correspond to the subject's various luminance values (see page 47 for a simple way to acquire this skill). Figure 2.5, by Alan Ross, presents an analysis of a scene that illustrates how Ansel would have applied the system in actual practice.

Recent clarifications of the terminology of the Zone System limit the use of the term Zone to the Exposure Scale, which we divided into nine or more sections, each relating to the other by a factor of 2 or ½ (geometric progression). This progression is the same as with the series of lens stops, as well as the series of shutter speeds on modern shutters. Therefore, we can describe the relative values of the zones as follows:

Figure 2.4: Ansel Adams, *Juniper Tree, Crags Under Mount Clark, Yosemite National Park, c. 1936.* Front-lit scenes in full sunlight are usually low in contrast, and a careless interpretation will result in a black-and-white photograph that is flat and uninteresting. High placement of the primary subject values in this image emphasized the silvery tones of the sunlit pine needles and the diffuse background.

Zone:	0	I	II	III	IV	V	VI	VII	VIII	IX
Exposure Units:	¹/₂	1	2	4	8	16	32	64	128	256
Relative Stops:	f/64	f/45	f/32	f/22	f/16	f/11	f/8	f/5.6	f/4	f/2.8

Zone:	Representing:
0	Total black in print (no negative density, except filmbase-fog density).
I	First step of value above black; first visible density above filmbase-fog density.
II	Print value and negative density sufficient to reveal some texture.
III	Low shadow values with textural content.
IV	Normal shadow value on [Caucasian] skin, dark foliage in sun, etc.
V	Middle gray ("pivot value"); 18% reflectance (the gray card) . . .
VI	Average [Caucasian] skin value (in sunlight, diffuse skylight, or artificial light). This represents about 36% reflectance.
VII	Light skin values; light gray objects.
VIII	Highest values in which some texture is discernible. [This value is used as the calibration value for film development.]
IX	Approaching pure white (Zone IX or higher, represents little or no density of the print image although negative density values can be anything higher than optimum density for Zone VIII exposure)

Luminance, Reflectance, and Exposure Zones

The concept of the "perfect negative" is both intriguing and exasperating to the student and photographer. If exposure and processing are both "normal," using recommended average techniques, it may seem that the negative should be "correct" even when it fails to yield the anticipated print. Such a negative may contain considerable information yet not be adequate for interpretation in terms of an expressive image. There is simply too much room for error in the use of "average" meter readings and processing; the ability to produce a fine print depends on greater precision.

As noted, an obvious characteristic of a black-and-white photograph is that it is a "likeness" of the scene from which it was made. The brightest areas of the subject appear as light gray tones and shades of white in the photograph, while the opposite is true for darker regions. In an illuminated negative the light values are the reverse of those in the subject or print. Understanding the relationships between the intensity of light reflected or emanating from a subject and the degree of blackening that occurs when film is exposed and processed is the critical key to creative control of exposure and development.

Luminance is a term used to describe and measure subject brightness. The historic unit of illumination is the foot-candle, a measure of the intensity of light generated by a "standard" candle at a distance of 1 foot. While the older

Figure 2.5: Alan Ross, *Upper Cascade Creek, Yosemite National Park, California, 1973.* Subject brightness values of the scene were measured using a spot meter, and the exposure was determined by placing the barely textured area of the dark rock at the middle left on Zone II. Additional readings of areas of spray in full sun indicated that these values would fall between Zones VIII and IX, thus indicating normal development. The relative reflectance of other areas within the scene are indicated and correspond to the difference in luminance values read on the meter relative to the Zone II placement.

Figure 2.6: John P. Schaefer, *Trail Dust Town, Tucson, Arizona, 1994.* Exposure value (EV) readings (a measure of *subject luminance values*) are overlaid on the positive image (A), and the corresponding *negative density values* are noted on the negative image (B).

photographic literature abounds with references to "foot-candles of light intensity," there are virtually no photographic situations where you need to measure the intensity of a light source in foot-candles. Most modern light meters used by photographers measure a subject's luminance or reflectance and present a readout as an exposure value (an EV number), a measure that incorporates film speed into the number displayed to make it directly applicable to work with cameras. Each unit change in EV corresponds to a difference of one step in the camera settings (one f-stop or one unit of exposure time), a doubling or halving of the amount of light striking the film.

For photographic negatives, the blackening of the silver emulsion caused by exposure and development is measured as *density,* a number expressed for mathematical convenience as a logarithm. The number specified for density is simply a measure of the decrease in light intensity that occurs as light passes through the exposed and developed film at any point. A density of zero means that the film is completely transparent; values of 1.0, 2.0, and 3.0 mean that the loss of light intensity corresponds to factors of $1/10$, $1/100$, $1/1000$, respectively.

A negative density value of 0.3 means that the intensity of a beam of light is halved as it passes through the developed film. The logarithm of ½ or 0.5 is 0.30. Each 0.3 of a density unit halves the light intensity. Adding logarithms is equivalent to multiplying the numbers they represent. Therefore the intensity of light passing through a point on a negative with a density of 0.6 (0.3 + 0.3 = 0.6) is reduced to ¼ (½ x ½ = ¼) of its original value, a density of 0.9 to ⅛, a density of 1.2 to $1/16$, a density of 1.5 to $1/32$, and so forth.

With photographic prints, the brightness of an area of the print is measured as *reflectance,* a value of the intensity of light reflected from the print surface. *Luminance, density,* and *reflectance* are all evaluated with specialized instruments. These meters are called *light meters* (occasionally they are referred to, erroneously, as exposure meters), *densitometers,* and *reflectance densitometers,* respectively. Each instrument is useful for exploring the sensitometric relationships between the subject, the negative, and the print, but the only one that a photographer needs is a handheld light meter, preferably a *spot meter,* which conveniently measures the reflectance of a small area of a subject.

Luminance and Negative Density

Figure 2.6 is a photograph of the facade of a building shown as both a positive (A) and a negative (B) image. The subject was chosen because there were large areas of uniform luminance whose values were easily measured with a spot meter. To examine the relationship between subject luminance values (measured as EV numbers) and negative densities, a sheet of film was exposed and developed using the manufacturer's recommended film speed and development time. Negative densities were measured at positions on the negative that corresponded to those in the scene for which luminance values were recorded. The data are plotted as the graph shown in figure 2.7, with light-meter readings on the horizontal axis and negative densities the vertical axis. The curve produced is a simple straight line for the range of data covered, showing, as you would intuitively expect, that a relationship exists between subject brightness and negative density: *negative density increases as subject luminance increases.*

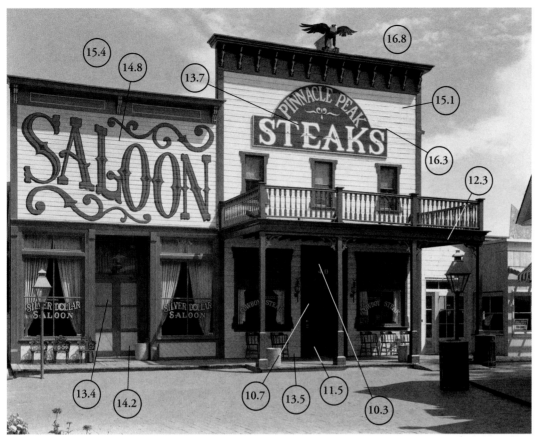

A

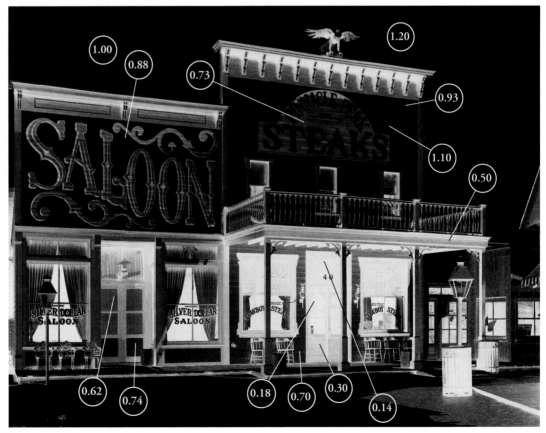

B

Figure 2.7:

**Light-Meter Readings
and Negative Density**

*The relationship between negative density and
EV.* The correlation of EV and negative
density demonstrates that negative density
is directly proportional to subject brightness:
as subject luminance increases, negative
density increases.

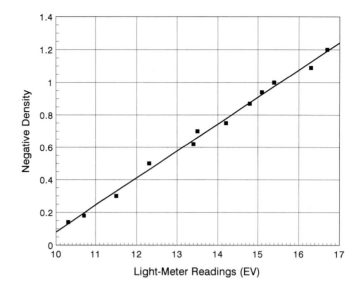

Figure 2.8:

**Exposure and Negative Density:
Varied Exposure, Identical Development**

Influence of exposure on negative density.
Increasing exposure causes the negative
density of each luminance value to increase
by the same amount. Decreasing exposure
does the opposite, except at low luminance
values, because density cannot fall below
zero.

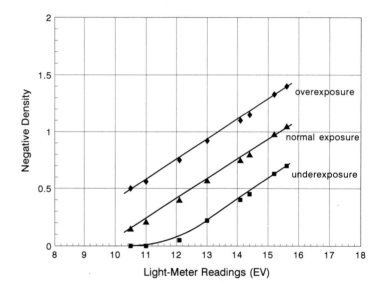

Exposure Effects on Negative Density The same scene was photographed
twice more, the first time giving the subject two stops more, the second time
two stops less exposure. The densities of the resulting negatives were measured
and plotted in a similar graph, shown in figure 2.8. Two conclusions can be
drawn from an inspection of the curves:

1. Overexposure increases the density of each point by the same amount
relative to the "normal" curve (about 0.38 units in the example shown).

2. The difference in density between any two points on either curve is
approximately the same.

The only important difference that you would notice if you tried to print
the two negatives is that the enlarging exposure time required for the overex-
posed negative would be more than twice that of the normal.

Figure 2.9: Alan Ross, *Golden Gate Bridge at Night, 1989.* This scene had all the makings for a nightmare of reciprocity failure. No area in the scene was either bright enough or large enough to register any reading with a Pentax Digital spot meter, and the exposure was determined by guess and bracketing. An aperture of f/16 was chosen in order to provide a modicum of depth of field without unreasonably lengthening required exposure times. Exposures of 6, 12, 18, and 22 minutes were given. Informal tests seemed to indicate that T-Max 400 had far less characteristic reciprocity failure than "conventional" films and so was chosen in advance for this image. The 6-minute exposure proved to be virtually ideal, with the longest exposures rendering grossly overexposed negatives.

A comparison of the "normal" curve to the underexposed example indicates that a similar pattern exists except in the shadow areas. Toward the higher end of the luminance scale, densities are systematically reduced by approximately 0.38 units at each point, but in the shadow areas, density values fall close to 0.0. The practical effect of this result is that a print of the negative will show the subject highlights in their correct relative positions, but for subject matter in the shadow areas, contrast is reduced and darker areas are featureless. This is why it is imperative to avoid underexposure — it is the one fatal error in photography that cannot be remedied by "darkroom magic."

The curves shown in figure 2.8 contain more information than would appear from a cursory examination. Consider for a moment what happens when you adjust the aperture of the lens but keep the exposure time constant in both of the following cases. A negative made by overexposing a scene by opening the aperture two stops is the same as one obtained if the luminance of the entire subject were doubled. Conversely, two steps of underexposure corresponds to closing down the aperture by two stops or reducing the overall luminance of a scene by half.

If you replot the data in figure 2.8 by shifting the top curve two steps to the right, and the bottom curve two steps to the left, figure 2.10 is obtained. This tracing, and each segment from which it was constructed, is a portion of the *characteristic curve* of the film, a curve that graphically presents the relationship between film exposure and negative density after development.

Figure 2.10:

Merged Curve Sections

Shifting curve segments. Overexposing (or its opposite, underexposing) a subject by two steps is equivalent to increasing (or its opposite, decreasing) the light intensity by two steps without changing the camera settings. Shifting the top line in figure 2.8 two steps to the right and the bottom line two steps to the left generates a "curve" that is identical to what you would measure if the original subject had an SBR that ranged between 8 and 18.

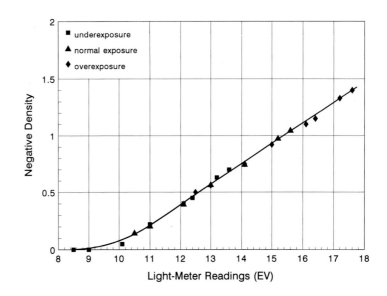

Development Effects on Negative Density To illustrate the effects of varying the development time, two sheets of film were given normal exposure and were developed for 75 percent and 133 percent, respectively, of the times recommended by the manufacturer. The measured density values are plotted in figure 2.11. Note that *with extended development, the slope of the curve steepens,* reflecting the increase in negative contrast that results from prolonged development. Reducing development decreases negative contrast and lessens the curve's slope.

Figure 2.11:

Exposure and Negative Density:
Identical Exposure, Varied Development

Development and negative density. Increasing film development increases both the negative density range and contrast. The rate of development of the negative is fastest for those portions of the negative that have received the most exposure.

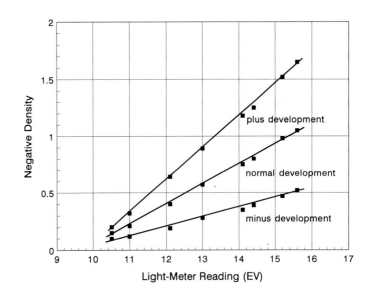

Figure 2.12: Alan Ross, *Burned Church, Las Mesitas, Colorado, 1995.* The extreme wide angle of the 120mm Nikkor-SW lens on 8 x 10 film helped establish the illusion of elements of the scene converging on (or emanating from!) the core of the burned-out church. The great covering power of the lens allowed enough front rise of the camera to avoid convergence of the vertical geometry, further adding to the building's feeling of presence.

Generating and analyzing curves that display the effects on negative density of varying film exposure and development require very little time or effort and no special equipment. The data obtained from experiments of this sort are the key to learning how to expose and process film so that the negative captures all of the details you have visualized for the photograph. Chapters 3 and 4 contain precise instructions for doing the required experiments and summarize some results for commonly used films and developers.

Precise exposure and development controls are critically important for subjects such as figure 2.12, where light contrast is extreme. The ability to interpret and capture scenes with dramatic and unusual lighting on a negative so that the necessary visual information can be translated into a print is a product of the careful study of the properties of films and developers. Characteristic curves provide a display of how films respond to exposure and processing.

Rock and Surf, Big Sur Coast, California, circa 1951

We explored a distance southward and I made several pictures of an exciting rugged fraction of the coast; the best is reproduced here. I do not recall what view camera or lens I used, but it could have been a Deardorff camera I was trying out. . . . The lens was probably my 145mm Zeiss Protar.

I am well aware of a compelling impulse of photographers to discuss, with collector's dedication, the equipment and materials they and their colleagues use, down to the smallest detail. I have never known painters to debate with such intensity the kind of canvas, paper, brushes, and paints used in their creative work. With photographers, however, such knowledge is traded in a kind of inner language of arcane significance. More meaningful would be discussion of such matters as the shapes, luminance values, and colors of the subjects. To know that an exposure was, say, $1/8$ second at f/32 has small meaning unless subject luminances, their placements on the exposure scale of the negative, and negative development are also indicated. . . . I am not averse to giving procedural details if I think they have significance, since I know many photographers find them helpful.

It was rather late in the day when this exposure was made. The sky was slightly hazy and the clouds not too distinct. With Isopan film at ASA 64, I used a Wratten No. 12 (minus-blue) filter. I placed the exposure fairly low on the scale and gave Normal-plus-one development. The filter darkened the rock shadows more than I had anticipated; note the slight difference in value between the shadow of the near rock on the sand and the shadowed face of the rock itself. The very dark central rock fell on or below Zone I and had no effective density. The highest textured value fell on Zone VII. The edges of foam are accented by the low sun, and the shutter speed was sufficiently short to arrest their movement, and thus hold some texture in their ebb and flow. . . .

The shapes and "movement" of the rocks seemed to await the appropriate configuration of the surf. Many waves broke on the sand and curled around the rocks before the one I photographed. The impulse to operate the shutter came at the appropriate fraction of a second before the foam curves met as we see them in the image. Anticipation is a very important part of the photographer's training, and is acquired only by much practice.

—ANSEL ADAMS

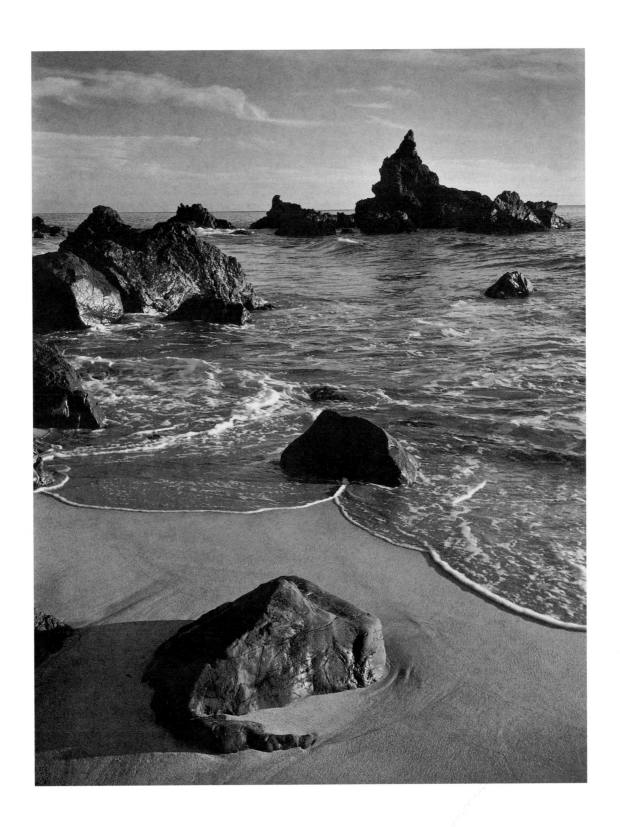

A Closer Look at Characteristic Curves

The scene chosen (figure 2.6) to generate the data for figure 2.7 had a relatively narrow subject brightness range, and the portion of the characteristic curve shown is a straight line. If the response of the film to a more extended range of light intensity had been measured, the graph would have looked like the generalized curve shown in figure 2.13.

Figure 2.13:

Idealized Characteristic Curve

Idealized characteristic curve. The toe of the curve, a region of low contrast, shows the film's response to exposure of the shadow values of the subject. Maximum tonal separation occurs in the straight-line section and diminishes as the shoulder is approached. Film speed is defined as the exposure needed to produce a Zone II density of 0.10 above the film base plus fog value inherent in the development of the film.

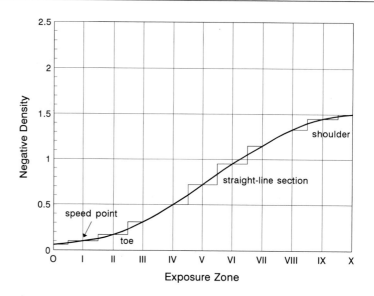

For purposes of discussion, characteristic curves are divided into three broad segments: the *toe,* the *straight-line section,* and the *shoulder.* These sections are marked on the graph. The threshold of light intensity at which useful exposure of the film for photographic purposes begins is known as the *speed point,* which we will define as *the exposure required to produce a Zone I density of 0.1 units above the density of the unexposed film base plus whatever chemical fog results from development.* No photographically usable information is recorded below this value.

The speed point of a film is what actually determines the ISO, DIN, or ASA rating, and an exposure index (EI) should be measured for each film-and-developer combination that you use. Most often the EI is not the same as the ASA, DIN, or ISO value recommended by the manufacturer. Photographers find that a "corrected" film speed must be used to reflect the difference between their equipment and working conditions and the highly controlled laboratory settings in which published film speed values are measured. It is not uncommon for a working film speed to differ from that reported by the manufacturer by a factor of two or more, which can lead to a substantial error in exposure.

The *toe* of a characteristic curve is the region where the first visible response of the film to exposure occurs. The toe corresponds to the shaded and darker areas of a scene, namely Zones I to III or IV. For a film with an extended toe region, the negative density increases very gradually as exposure is increased. This is illustrated in figure 2.13 by the graded steps that are drawn in to demonstrate that in the toe region, constant increases in light intensity result in relatively small increases in negative density. The slope of the curve at

any point on the toe is less than that of the straight-line section. The visual impact of placing exposures on the toe of the curve is that in the photographic print, dark objects or those falling in shaded areas display lower contrast than those that receive more exposure.

Changing the development time of a film from "normal" alters its contrast. As seen by earlier examples, increasing development increases contrast, while decreased development does the opposite. A typical family of characteristic curves that depict the effect of varying development times is shown in figure 2.14. ("Total development" represents the maximum contrast and density range that can be achieved for a negative through development. For practical purposes this point is reached by developing the film four to five times "normal." It is a useful technique for expanding negative contrast when the subject brightness range (SBR) of the scene is very low [two or three steps].)

Figure 2.14:
Development and the Characteristic Curve
Development and the characteristic curve. Negative contrast increases as development is extended. Maximum contrast is achieved through total development, which is useful for subjects that have a very narrow SBR.

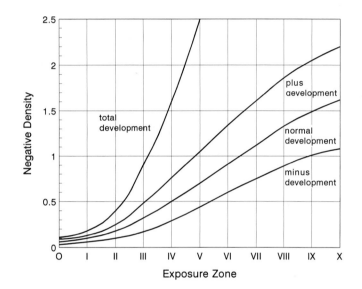

The *straight-line section* of the characteristic curve is the segment in which a stepwise increase in negative density occurs as exposure and development are increased. Tonal values are most clearly separated in this region. The slope of the straight line is the primary determinant of negative contrast: the greater the slope, the greater the contrast of the negative. Quantitative measures of contrast, such as the slope of the straight-line portion of the characteristic curve (known as *gamma*), are often discussed by photographers, but these are of little use in applying the Zone System.

Recommendations for development provided by most manufacturers target a density range and contrast so that the negative produced will print "normally" on a Grade 2 printing paper when a diffusion, or cold light, enlarger is used. For enlargers that utilize condensers, slightly less development, which leads to lower contrast, is suggested.

The *shoulder* of a characteristic curve is encountered when the film receives high levels of exposure (for example, if the scene has extremely bright highlights or is uniformly overexposed). As the shoulder is approached, the curve begins to flatten and negative density increases far less rapidly than

A

B

Figure 2.15: *Exposure and print values.*
(A) Correct exposure and normal development of the average scene generally places shadow values on the toe of the characteristic curve, and midtones and highlights on the straight-line section. If the film's characteristic curve has a pronounced shoulder and the highlights fall on it, their tonal values will be compressed. (B) Overexposure forces luminance values toward the shoulder of the characteristic curve, increasing the contrast of "shadow" values and seriously compressing midtone and highlight values.

before. As a consequence, tonal separation decreases in the highlights, and they are said to "block up." A situation where this might occur is a landscape photograph with brilliant cumulus clouds in the sky. Overexposure and development can lead to clouds that appear to be formless lumps of white dough rather than richly textured formations. (Blocked highlights in a print most often stem from a negative that has too long a density scale to be accommodated on the printing paper being used. Highlight details do appear in the negative, but they cannot be translated onto the paper without being burned-in. This problem can be avoided by appropriate exposure and development controls.)

The impact of having a portion of a scene recorded on the shoulder of the characteristic curve is demonstrated in the following example. Figure 2.15 shows two images printed from the same roll of film and where all of the negatives received identical development. The negative for A was given the exposure indicated by a handheld light meter that averaged the light intensity of the overall scene, while that for B was overexposed by *six* steps. The printing time of the negative for B, which has a very high overall density, was adjusted to achieve a near match with A for the tonal value of the brick sidewalk in the foreground. The extreme overexposure given to the film for B has pushed all of the highlights and some midtones well onto the shoulder of the characteristic curve. Note how the contrast of the image on the sunlit facade of the buildings has been compressed and that details in the shadow area, which fall on the straight-line section of the characteristic curve because of general overexposure, are clearly separated. These examples illustrate that when a scene has important details in the highlights, you must be careful to avoid overexposure if you expect to see distinct tonal separations in a print.

Figure 2.16:
**Exposure Placement
and Development Time**

*Exposure placement and the characteristic
curve: normal exposure.* With a Zone V
placement and normal development of an
average subject, the negative density range
can easily be interpreted on a Grade 2
printing paper. Selection of the development
time should always be dictated by the
negative characteristics best suited for the
printing process that you intend to use.

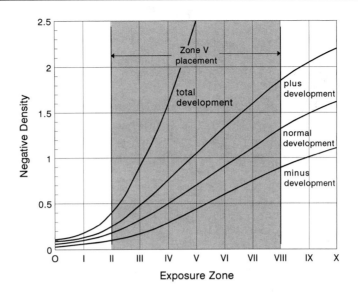

The Consequences of Varying Film Development

The luminance values of important features in figure 2.6 were measured with
a spot meter and recorded as EV numbers. The subject brightness range (SBR)
spanned six zones, and the luminance of a Kodak 18 percent gray card fell
halfway between the extremes (this need not be the case). Figure 2.14 shows
four characteristic curves for a film and indicates how the film responds to
minus, normal, plus, and total development. To understand the effect of expo-
sure placement and film development on the negative (and subsequent print),
the SBR has been indicated in figures 2.16, 2.18, and 2.20 by shading.

With a Zone V placement for the central tonal value, the remaining tonal
values fall in a range three zones above or below this point. The characteristic
curves for minus, normal, plus, and total development show that negatives
developed for these times would have density ranges of 0.78, 1.14, 1.61, and
2.30, respectively. These values are calculated by taking the difference between
the density values at the limits of the SBR (for example, for plus development,
the range is 1.81 – 0.20 = 1.61).

A Grade 2 printing paper printed by contact or with a diffusion enlarger
can accommodate a negative with a density in the range of 1.25 to 1.35 and
reproduce the full tonal range from deep black to paper base white. A negative
in which a density difference of 1.30 captures the tonal values of six zones
prints easily on a Grade 2 paper, realistically portraying the luminance values
of the subject. However, a print from a negative with a density range of 0.78
or less will lack either or both blacks or whites, and the image will look flat and
"muddy." Conversely, a negative with a density range of 1.61 or greater will
exceed the capacity of the printing paper to reproduce all of its tonal values.
Attempting to print the latter negative on a Grade 2 paper is akin to trying to
place an 18-inch ruler in a 12-inch box: one or both ends will not fit in. A
print will show excessive contrast, and details will be absent in the deepest
shadows or highlights, or both.

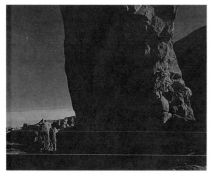

(A) Underexposure, normal development.

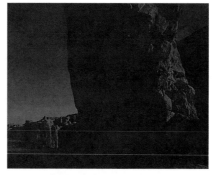

(B) Underexposure, minus development.

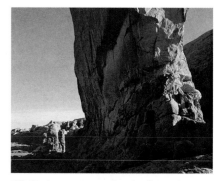

(C) Underexposure, plus development.

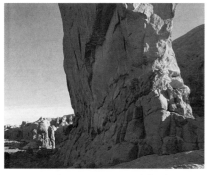

(D) Normal exposure, normal development.

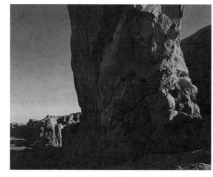

(E) Normal exposure, minus development.

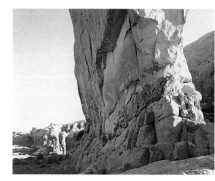

(F) Normal exposure, plus development.

(G) Overexposure, normal development.

(H) Overexposure, minus development.

(I) Overexposure, plus development.

Figure 2.17: Alan Ross, *Sunrise Arch,
Arches National Park, 1996.* These nine
photographs demonstrate the varying
effects of exposure and development.
The characteristic curves shown in figures
2.16, 2.18, and 2.20 are graphic displays
of the consequences of the exposure and
development choices that lead to these
images.

An examination of each of the above characteristic curves shows that all of the important tonal values of the subject lie well above the film's speed point. Consequently, acceptable prints could probably be made by using a Grade 1 paper for the high-contrast negative and a Grade 4 or 5 paper for the low-contrast image. However, the tonal relationships between identical subject matter within the print will be quite different from what you would observe by printing a normally exposed and developed negative on a Grade 2 paper.

The Consequences of Incorrect Zone Placement of the Subject

The most serious error in exposure is giving too little exposure, because detail is thereby lost in shadow areas that cannot be recovered through any processing or subsequent manipulation. For most photographs, therefore, we make the initial placement based on the darkest area of the subject where we want to preserve detail in the image.

Figure 2.18:

Exposure Placement and the Characteristic Curve

The consequences of underexposure. A Zone III placement of a middle gray value results in an irretrievable loss of shadow detail in the negative. For subjects with a narrow SBR (five steps or less), it is often useful to reduce exposure and increase development to increase negative contrast, but care must be taken to give sufficient exposure to record shadow values on the negative.

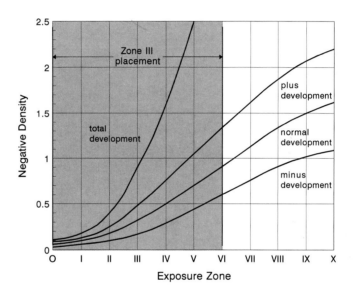

Figure 2.18 illustrates with characteristic curves what occurs if the luminance value of the gray card is placed on Zone III, and the exposure is based upon this reading. The lowest luminance values of the subject now fall below Zone I, and the brightest feature of the scene falls on Zone VI. The density ranges of the negatives for minus, normal, plus, and total development are 0.58, 0.84, 1.24, and 1.78, respectively, which are significantly less than those discussed above. While the previous general comments apply to these examples as well, a serious problem is evident with any print made from this series: the deepest shadows are empty blacks, void of detail because these luminance values fall below the film's speed point, the threshold of response to exposure. Furthermore, since the shadow values of the subject fall entirely on the toe of the film, contrast throughout the shadow values is very low. Figure 2.19 shows a scene that contains prominent shaded areas and provides a visual demonstration of what occurs when exposure is inadequate.

A

B

Figure 2.19: Alan Ross, *Park Avenue, Arches National Park, 1996.* (A) Correct exposure and development. (B) Under-exposure *always* results in the loss of shadow details. When a scene contains a bright, dominant mass, a light meter with a wide angle of view will be overly influenced by this feature, and *under-exposure* will occur if the meter reading is based on the scene's highest luminance values. (C) If the meter reading is too heavily weighted by the shadow areas, the scene will be *overexposed*.

C

Figure 2.20 shows the result of a Zone VII placement of the exposure. Negative density ranges are 0.86, 1.16, 1.44, and 1.88 for minus, normal, plus, and total development, respectively, and prints similar to those described for Zone V placement can be made, although print exposure times need to be increased because of the overall negative density gain that results from overexposure.

While a comparison of all nine prints that can be made on a Grade 2 printing paper is informative, the reproduction process used to print the photographs in this book limits the usefulness of visual comparisons. It is worth your doing similar tests to help you understand the connection between characteristic curves and photographic prints and appreciate the importance and potential of exposure and development controls.

Figure 2.20:
**Exposure Placement
and the Characteristic Curve**
The consequences of overexposure. Overexposure
results in excessively dense negatives and
alters the usual relationships between shadow
values, midtones, and highlights.

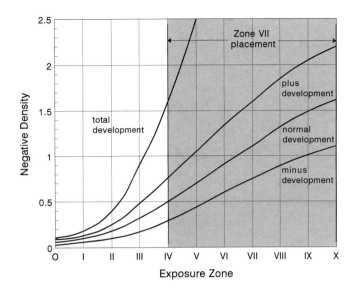

Subject Brightness Range and Film Exposure

It is not the luminance of the subject, but the placement of this luminance on the exposure scale of the film, that gives the density values of the negative. To repeat: a very low luminance and a very high luminance, both placed on the same point of the exposure scale (the same Zone), will yield negatives of the same value. Likewise, a low luminance value placed high on the scale will yield a negative of relatively high density; or a high luminance placed low on the scale will yield a negative of relatively low density.

The key to proper exposure is *not* in measuring the average luminance of a scene but in evaluating the *subject brightness range* and then determining what exposure and development conditions will produce a negative with a density range appropriate for the print that you visualized when you studied the scene. To demonstrate why subject brightness range is a critical factor, consider the characteristic curve shown in figure 2.18. As with units on the EV scale of a light meter, a change of one zone corresponds to a doubling or halving of the luminance value.

An average outdoor scene in sunlight will generally span six zones of luminance. If the exposure is chosen so that the midpoint of the range falls on Zone III, the scene will be badly underexposed and most of the important shadow details will be missing. What causes this kind of error? If the subject has a dominant bright spot, such as brilliant cumulus clouds topping a landscape, and a typical handheld meter is used to measure the average luminance of the scene, the meter can give an erroneously high reading if too much of the clouds is included in its field of view. The result is underexposure of the scene. This is probably the single most common and frustrating error made by photographers who use light meters that measure the luminance of a wide area.

Conversely, if the chosen exposure places the midpoint of a six-step range on Zone VII as in figure 2.20, a print of the scene's brighter values will be distressingly flat or "blocked." A typical situation where this may occur is with subjects in which dark or midtones dominate and important highlights are not

**GOSHEN COLLEGE LIBRARY
GOSHEN, INDIANA**

adequately weighed when a light-meter reading is made. An example would be a landscape with brilliant cumulus clouds in which the exposure is determined by pointing the light meter at the foreground. In these circumstances the meter reading will be unrealistically low and the scene will be overexposed, as in figure 2.19C.

Continuing with the same example, placing the midpoint of the exposure range on Zone V produces a negative in which shadow values and highlights have negative densities that allow the full range of *visualized* tonal values to be printed on a paper with a normal exposure scale.

Deciding on Exposure

The best way to ascertain exposure is to (1) measure the luminance values of all *important* elements of the subject to determine the subject brightness range; and (2) *place* the exposure so that all *important* values fall on the *appropriate* section of the characteristic curve. While step 1 is easy to accomplish with

Figure 2.21: Alan Ross, *Mausoleum of Sun Yat-Sen, Nanjing, China 1981.* With heavy rain outdoors, the illumination level in this great room was so low (and camera position so awkward) that precise composing of the image on the ground glass was extremely difficult. Several Polaroid Type 552 prints were made to assist in achieving the accurate framing required of the scene.

a spot meter, step 2 requires some analysis and interpretation of the scene. But that, after all, is the essence of photographic expression.

Just how do you decide where to place the exposure? To begin, you must know the exposure index or film speed to use with your camera for your working procedures, and this is easy to determine (see pages 56–60). Given the film speed and knowing that a light meter responds *as if* anything it is pointed toward has a reflectance corresponding to a Zone V luminance value, you can determine the correct exposure.

The easiest procedure for estimating exposure is to use an *incident light meter* (many handheld meters have a translucent dome that slides directly over the detector cell, thereby converting it from a reflectance to an incident light meter). While standing alongside the subject, point the meter directly toward the camera lens — the reading will indicate appropriate exposure/aperture combinations for an "average" subject using "normal" development. However, this procedure provides no guidance for what the *optimal* exposure and development conditions should be to achieve a visualized print.

Another approach toward exposure determination is to carry a gray card (such as that made by Kodak) with you when you photograph. The card has a reflectance of 18 percent and is by definition Zone V. If the scene is illuminated by a single light source, take a meter reading of the card's surface in the ambient light. For average subjects that have a normal distribution of light and dark areas — for example, a landscape with the sun behind the camera — the gray card reading will indicate the correct exposure (this procedure is equivalent to using an incident light meter to determine exposure). Negative density values of the shadow areas, midtones, and highlights will all be appropriate to the subject and will translate easily to a print.

While determining an exposure by placing a gray card reading on the meter's index (Zone V) ignores most of the features of the Zone System, it is an excellent way to learn how to visualize subject luminance in terms of "zones" and familiarize yourself with the way subject values in a scene fall once a single value has been placed. Using an incident light meter has none of these advantages.

When you have measured the EV of the gray card and used that reading to determine the exposure for a scene (thereby placing the gray card luminance value at Zone V), measure other subjects in the scene and note how much brighter or darker they are than your gray card measurement. If the brightness of a shadow under a tree reads three EV less, that is equivalent to being three zones darker than the gray card and means that the shadow falls on Zone II. You can then visualize that it will be a dark value in the print with a fair amount of substance but not much textural rendering. If you measure the reflectance of a cloud in the sky and note that its EV is two full numbers higher than the gray card, that means that the value of the cloud falls in Zone VII, and you can visualize it as a fully textured very light gray in the print.

For more complex subjects that are not "average" — for example, a forest with strongly contrasting areas of sunlight and shade — the simple use of a gray card will not work. A reading taken in the shade differs vastly from that taken in a beam of sunlight. Basing the exposure on either of these readings will usually result in over- or underexposure of the negative.

Figure 2.22: Alan Ross, *Seagate, Pfeiffer Beach, Big Sur, 1980.* Because of the unpredictability of moving water, a number of $^1/_4$- and $^1/_2$-second exposures were made of the scene, with the $^1/_4$-second exposure providing the desired effect. The film was developed Normal in Edwal TG7 without sulfite. The resulting negatives were lacking in inherent contrast. (Plus-1 development or more would have been preferable.) The selected negative was toned in Kodak Selenium Toner 1:3 for 5 minutes, and the resulting enhancement of contrast satisfactorily revitalized the image. (For a discussion of selenium toning, see page 96.)

The correct way to determine exposure for such a subject is to look at the scene and decide what the lightest and darkest areas are for the texture and details that should be displayed in the photograph. Next meter the scene's darkest segment for which you want only a hint of detail displayed in the print and assign that value Zone II. Then identify the brightest part of the scene and meter it. If it is six steps brighter than the Zone II reading, it will automatically fall on Zone VIII and will show highlight texture. All of the luminance values between these extremes will also fall in their appropriate places on the gray scale. If this interpretation of the scene is what you visualize, set the shutter speed and aperture on your camera so that the Zone II value falls on the correct place along the exposure scale. To do this take the settings indicated from metering the Zone II value and reduce the exposure by three steps (close down the aperture by three steps or increase the shutter speed by three steps, or use a combination of the two), keeping in mind that the light meter responded to the Zone II value as if it were Zone V (Zone V–II = three steps).

But what happens if the measured subject brightness range exceeds a six-zone interval? If no other changes are made, the luminance values of the higher zones will require either burning-in or a change to a paper with lower contrast, or they will be lost in the print and appear as textureless areas of white. While the density values of these zones are recorded on the negative, the density range of the negative will exceed the scale of the printing paper. One solution to this dilemma is to try to print the negative on a longer scale paper (Grade 0 or 1); however, a better alternative is to alter the development of the film, *by decreasing the development time* to compress the normal density range of the negative.

Alternatively, if the subject brightness range is very narrow — for example, spanning only two or three zones — the density range of the negative would be quite limited. In these circumstances it may be desirable to expand the density range by *increasing development time.* Precise details for how to determine the correct development conditions for varying circumstances are given in chapter 4.

Chapter Three

Film Testing Procedures

Photography, in the final analysis, can be reduced to a few simple principles. But, unlike most arts, it seems complex at the initial approach. The seeming complexity can never be resolved unless a fundamental understanding of both technique and application is sought and exercised from the start.

Photography is more than a medium for factual communication of ideas. It is a creative art. Therefore emphasis on technique is justified only so far as it will simplify and clarify the statement of the photographer's concept. . . . Our object is to present a working technique for creative photography.
—ANSEL ADAMS

The only certain way to know that your camera and film will capture a visualized image is to test them *before* you take them into the field. Unless you know the *film speed, how to use a light meter,* and *how development determines the visual information that is recorded on the negative,* you will be navigating through a photographic maze without a map. This chapter outlines easy procedures that anyone can use to measure the characteristic curve of a film and ascertain both the film speed and the negative densities that can be created by controlling development.

Every photographer quickly develops work habits and a personal style that reflect the features and limitations of his or her equipment and darkroom facilities. The quirks of camera shutters, the flare of a used but favorite and irreplaceable lens, the inevitable inaccuracies of a light meter all dictate that a few simple tests be done to enable you to account and compensate for photographic variables that can lead to disappointing results if they are overlooked or ignored during a field trip or studio session.

As you conduct these tests, it is important that the procedures you use be controlled and consistent, so that you can compare the results of various experiments and have confidence that they are accurate and reproducible. Keep the external variables to a minimum at the start by using the same camera, lens, shutter, film, and developer that you work with most frequently. Shutter speeds and light meters can be calibrated by a camera technician, and it is advisable to have this done as part of a routine maintenance schedule. An accurate darkroom thermometer is essential.

A well-organized notebook is also crucial to the success of your tests and experiments and to learning from them. Write down a complete description of each test that you perform and note any important details that might influence the results. A carefully kept notebook allows you to compare determinations

Figure 3.1: Ansel Adams, *Nasturtiums, Big Sur, California, 1951.*

made at different times with confidence, analyze results that may be unexpected, and correct any errors that you may have made. A typical entry should include the following:

1. a description or general reference to the basic test setup used
2. the distance of the camera and lens from the test target
3. the light-meter reading
4. the camera, lens, aperture, and shutter speed settings
5. the film used
6. the developer, processing temperature, time, and agitation pattern employed
7. a form to write in the measured negative densities as a function of subject luminance or exposure zones

General Setup for Film Testing

My intention in describing my procedures is not to impose them to the exclusion of others, but to allow the photographer to learn from my experience in whatever ways may be applicable to his personal expressive intentions. I believe it is important that the individual's progress in the medium be supported by a foundation of craft which, once mastered, can be applied as appropriate to the photographer's work.

Numerous techniques for testing film have been described in the photographic literature. The following procedures are those of the author and were developed so that they could be carried out in the simplest of darkrooms and would require no special equipment. The tests described will enable you to (1) define the exposure index (EI), or film speed, precisely; and (2) control the contrast of a negative predictably, so that you can either expand or contract its density range when this is desirable.

Setting Up the Target

All of the tests described require a uniformly illuminated test target. A sheet of cardboard or mounting board taped to a shaded outdoor wall works very well. A sunlit wall can be used, but extraneous glare and the more variable quality of direct sunlight may make it difficult to measure the reflectance of the target and be certain that it remains constant over the time it takes for you to make the required exposures.

If it is more convenient to work indoors you can use a blank wall as a target, or tape a sheet of mounting board to it. You will probably need to use supplemental lighting to raise the luminance of the target so that aperture/exposure values are reasonable (in these tests it is important to avoid long exposure times where reciprocity effects come into play). Prior to using artificial lighting you should check the manufacturer's data sheets for the spectral characteristics of the film. If the film has extended red sensitivity, for example, any tests done with incandescent lighting will not be valid for subsequent work outdoors in daylight.

Table 3.1

Sheet Film Density Record

Film: _____ Developer: _____

Exposure Index: _____ Processing Temperature: _____

Light Meter Reading: _____

Aperture Setting: _____ Film Base Density (F): _____

Shutter Speed: _____ EI (Measured): _____

Camera and Lens: _____

Step Number	Negative Density (D)	D-F
0		
1		
2		
3		
4		
5		
6		
7		
8		
9		
10		
11		
12		
13		
14		
15		
16		
17		
18		
19		
20		
21		

Note: Negative density is the measured value. D-F is the value obtained by subtracting the density increment due to chemical fogging of the film base during processing. This is determined by measuring the density of an unexposed edge of the film. Chemical fog plus film base density usually contributes about 0.1 unit to the overall negative density, but it will increase to higher values with extended development. The correction for chemical fog is necessary to determine the film speed because the speed point of a film is defined as being 0.1 density unit above the value of the density of the film base plus fog.

Tenaya Creek,
Dogwood, Rain,
Yosemite Valley, circa 1948

One cloudy spring day I was searching for dogwood displays, and as I was driving up the Mirror Lake Road I glimpsed an attractive possibility near Tenaya Creek. I parked the car and walked about six hundred feet toward the dogwood I saw glimmering in the forest. On reaching the creek I saw an inevitable opportunity; I returned to my car and gathered my 8 x 10 equipment.

A light rain began to fall, and I considered giving up for the day, but when I came to an opening in the trees and saw this subject open up before me I banished such thoughts of defeat and set up the camera under protection of the focusing cloth. The rain added a certain richness to the scene and suggested an atmospheric recession of values that would otherwise not be seen. It was fortunate that there was no wind, since the exposure was about ½ second, creating a slight blur in the water but showing no movement in the leaves and blossoms. . . .

The technical problems were apparent from the moment I set up the camera. In black-and-white photography the dominant problem is usually holding a subtle spectrum of grays. Striving for contrast can result in sooty shadows and chalky high values that defeat the desired impression of luminosity. There is a logical and expressive balance point of contrast that is often very difficult to achieve. In this case the exposure and development decisions were relatively simple, but the final print posed problems. The subtle dry-down effect can cause a serious loss of luminous quality, and careful printing for the high values is therefore necessary. In addition, the appropriate tone may not be attainable with certain papers. Many years ago I made a print of this negative on contact paper that, when fully toned in selenium, had a marvelous color. It is one of the most satisfactory prints I have ever made, and I have not been able to duplicate it with contemporary enlarging papers. . . .

The photographer learns to seek the essential qualities of his environment, wherever he might be. By this I mean that he should be tuned to respond to every situation. It is not enough to like or dislike; he must make an effort to understand what he is experiencing. To some, this location by Tenaya Creek on a rainy day might be merely damp and uncomfortable, and thoughts of returning to warmth and shelter would be enticing. To others, the cool calm rain and the forest light would be things to revel in, likely to initiate some creative reaction. My life is full of memories of experiences that are of greater importance to me than the mere recollection of things and happenings. Unless I had reacted to the mood of this place with some intensity of feeling, I would have found it a difficult and shallow undertaking to attempt a photograph.

— ANSEL ADAMS

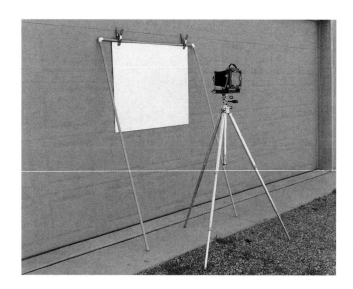

Figure 3.2: *Setup for film testing.* A sheet of mounting board in the shade serves as an ideal target for film testing. The camera should be placed close to the target with the lens focused to infinity.

Lighting the Target

Great care is required in placing lamps to light the target area to ensure even illumination. Your notes should record both the location and type of lamps used, so that the setup can be duplicated whenever you need to evaluate new films or developers. While the color temperature of indoor lighting may differ significantly from daylight (5,200°K), with panchromatic films the data obtained using artificial lighting can usually be applied without modification to outdoor settings.

Setting Up the Camera

The camera and lens should be mounted on a tripod and located close enough to the test target that its image fills the entire area of the viewfinder. Make certain that the camera does not cast a shadow on the test target or alter the intensity of reflected lighting. Lastly, focus the camera and lens at *infinity* to avoid recording any texture in the target subject and, in the case of a view camera, the complications that result from the need to apply a *bellows extension factor* exposure correction.

Procedure for Sheet Film

All chemical processes are sensitive to temperature to some extent. In photographic chemistry, development in particular occurs at a rate that is directly a function of solution temperature: an increase in temperature speeds up the process, thereby reducing the time needed to reach a certain degree of development. It is thus necessary to standardize both the time and temperature if predictable results are to be obtained with each developer.

The technique described in the following pages enables you to determine, with a single exposure, the film speed and the characteristic curve of any sheet film. For these experiments you need to purchase an inexpensive *twenty-one-step*

film strip from a graphic arts or camera store or Photographer's Formulary (see page 376). The strip is a graduated sequence of semitransparent patches in which the densities of neighboring steps differ by approximately 0.15. To calibrate the strip, measure the density of each step three times with a densitometer (or use the procedure described on pages 66–71), average the measurements, and write down the average density value adjacent to each numbered step on the envelope in which the strip is stored. You now have a calibrated density strip that you can use to determine both film speeds and characteristic curves.

The strip, which acts as a sequence of neutral density filters, decreases the light intensity passing through it in direct proportion to the step density when the strip is placed between the light source and a recording device — a light meter, a densitometer, or film. Furthermore, *each 0.30 unit of density reduces the light intensity passing through the strip by exactly one-half.* Thus, placing a 0.30 neutral density filter in front of a camera lens is equivalent to stopping down the aperture of a lens by one stop or halving the exposure time. It also corresponds to decreasing the intensity of reflectance of every element in a scene by one exposure zone.

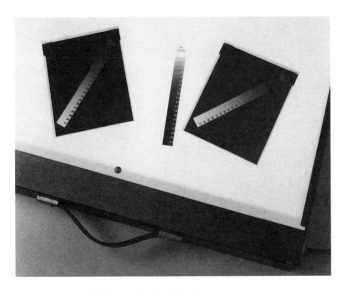

Figure 3.3: *Backlit view of a Stouffer 21-step calibrated density strip and two sheets of exposed and developed 4 x 5 sheet film.* Measuring the densities of the steps on the sheet film enables you to determine the film's exposure index and characteristic curve.

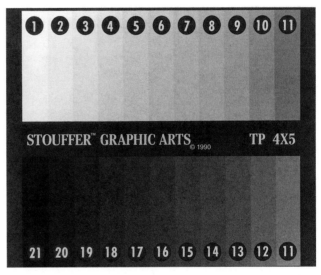

Figure 3.4: *A 4 x 5 sheet film version of the Stouffer 21-step density scale.* Contact printing this Stouffer film onto sheet film produces a positive from which the film's exposure index and characteristic curve are easily determined.

By taping a calibrated density strip to the emulsion side of a sheet of film it is possible *with a single exposure* to evaluate the results of twenty-one different exposure settings (approximately equivalent to a ten-zone spread in reflectance) and obtain more than enough data to determine both the film speed and characteristic curve of a film. To use this method, proceed as follows:

1. Set up the camera and target as described above. Meter the target using the film speed recommended by the manufacturer and set the lens and shutter speed at values corresponding to a *Zone X* exposure — *five stops more* than the settings indicated by your light meter.

2. Tape two small pieces (about ¼ inch square) of transparent tape to the ends of the calibrated density strip. Set the strip in a location that you can easily reach in total darkness when you load the sheet-film holder.

3. Following your usual procedure, in total darkness load a sheet of film into a holder. Take the calibrated density strip and place it diagonally across the emulsion of the film — it will fit comfortably on a 4 x 5 sheet of film. Press down the ends so that the strip is secured to the film and then insert the dark slide.

4. Take the film holder to your target setup, insert it into the camera, withdraw the dark slide, expose the film on Zone X, reinsert the dark slide, and return to the darkroom.

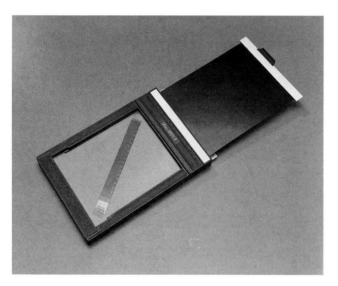

Figure 3.5: *Sheet film prepared for exposure.* After a calibrated density strip has been taped to the film surface in total darkness, the dark slide should be inserted into the film holder. Exposure of the film to the test target and development will result in an image similar to that shown in figure 3.3.

Figure 3.6: *Using the Stouffer 4 x 5 21-step density scale.* To evaluate the characteristic curve of a film using the Stouffer 4 x 5 21-step density scale, place it on the emulsion side of the film and slide the pair into a sheet-film holder. Insert the dark slide, then place the film holder in the camera and follow the exposure/development sequence outlined.

5. In total darkness remove the dark slide from the film holder, withdraw the film from the holder, and gently peel the strip from the film. (Once you are confident that your setup and the exposure you have selected are correct, you can repeat numbers 3 and 4 and expose as many sheets as needed to evaluate alternative developers, determine the effect of varying development times, and so forth.) Store the exposed sheets in a light-tight box and remove them as required for processing.

6. Process the film as recommended by the manufacturer of the film and developer, using your usual procedure. For the purpose of these tests, a 2-minute wash followed by rapid drying of the film with the aid of a blow-dryer will allow you to measure the film densities without undue delay.

7. Use a densitometer (or the procedure described on pages 66–71) to measure the density of the image of each step of the calibrated density strip and the density of a section of film that was not covered by the strip. Table 3.2 is an example of a typical data set from which a characteristic curve can be plotted. If you have a personal computer equipped with Harvard Graphics software, you can enter the data directly into your computer. The program plots the data for you as a characteristic curve.

Figure 3.7: *Backlit view of the Stouffer 4 x 5 21-step density scale and an exposed and developed sheet of film after contact printing.*

Figure 3.8: *Macbeth TR 1224 densitometer.* Placing the negative directly over the light cell and lowering the detector arm produces a direct digital readout of negative density. With a densitometer, the density values of all twenty-one steps can be measured in a few minutes.

8. To plot the characteristic curve by hand, use a sheet of graph paper to make a grid similar to that shown in figure 3.9. Because the density gradients of the calibrated strip subtract from the intensity of light striking the film, the densities of the steps are plotted along the horizontal axis as *negative numbers,* starting from a value of 0.0 at the far right. The average density of the portion of the negative not covered by the film strip is D(Max) and corresponds to the density produced by a Zone X exposure after development (or whatever other zone you may have given to the overall exposure). Each decrease of 0.30 units of density from the right axis is equivalent to one zone less of exposure. For example, the density values at –0.30, –0.60, –0.90, and –1.20 correspond to exposure zones IX, VIII, VII, and VI, respectively.

Figure 3.9:

Kodak T-Max 100 Sheet Film: Kodak HC-110 Developer (Dilution B)

Plotting a characteristic curve. Numerous computer programs automatically display graphs for data entered in an *x/y* format. This graph was produced using Harvard Graphics software.

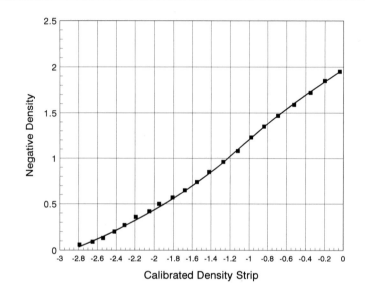

Figure 3.10:

Kodak T-Max 100 Sheet Film: Kodak HC-110 Developer (Dilution B)

Displaying a characteristic curve. This graph is a variation of figure 3.9 in a format more useful for using and discussing the Zone System.

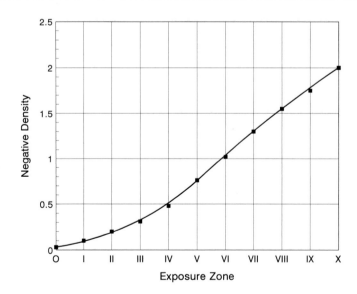

Table 3.2

Characteristic Curve Data

Step Number	Step Density	Zone	Negative Density (D)
D(Max)	None	10.00	1.98
1	0.04	9.87	1.95
2	0.20	9.33	1.85
3	0.35	8.83	1.72
4	0.52	8.27	1.59
5	0.69	7.70	1.47
6	0.84	7.20	1.35
7	0.98	6.73	1.23
8	1.12	6.27	1.08
9	1.27	5.77	0.96
10	1.42	5.27	0.85
11	1.55	4.84	0.74
12	1.68	4.40	0.65
13	1.81	3.97	0.57
14	1.95	3.50	0.50
15	2.05	3.17	0.42
16	2.19	2.70	0.36
17	2.31	2.30	0.27
18	2.42	1.94	0.20
19	2.54	1.53	0.13
20	2.65	1.17	0.09
21	2.79	0.70	0.06

Note: Step 1 is taken as the density of the clear film base of the strip. D(Max) is the average density of the negative not covered by the calibrated strip. Each 0.30 of strip density is equivalent to reducing the exposure of the film by one step or one exposure zone. Because it is easier to analyze curves when the horizontal axis units are in terms of exposure zones, this column is a translation of film strip densities to exposure zones. To translate the units, calculate how many steps a particular density corresponds to and subtract that number from the zone on which you place the exposure target. For example, a density value of 0.20 is .20/.30 = 0.67 step or Zone 10.00 − 0.67 = Zone 9.33.

Procedure for Roll Film

For uniform development it is important to insert the film all at once into the tank filled with developer, rather than pouring the developer through the tank lid. Immersion in developer normally follows a 30-second pre-soak. Once the film has been transferred to the developer, agitate for 30 seconds before starting the timer to allow the developer solution to replace the water in the emulsion. The tank can then be covered and processing continued with the lights on.

With the following procedure, each frame on the roll of film corresponds to a discrete exposure zone. The processed film is a sequence of full frames of uniformly gray patches of varying densities.

1. Measure the distance from the end of the leader to the end of the twelfth frame of a developed roll of film and mark off that distance with a strip of masking tape on a table in your darkroom. Place a second strip of masking tape at a distance that corresponds to a twelve-frame spacing without the leader. With these markings as guides in the darkroom you'll be able to cut the roll into sections that you can use to determine different characteristic curves without wasting film.

2. Load a cassette or roll of film into the camera and, using the manufacturer's recommended film speed, measure the luminance of the target with either the camera's built-in meter or a handheld meter. Use one of the indicated shutter speed/aperture settings that corresponds to a Zone V exposure to make your first exposure.*

3. Advance the film by one frame, decrease the shutter speed so that the next exposure falls on Zone X (five steps more exposure than the value indicated by the light meter), and make a second exposure.

4. Advance the film by one frame, increase the shutter speed by one step, and make a third exposure. Repeat this step until you have spanned a range of exposures from Zone X down through Zone I or less. (If you are testing 35mm film you can make two or three sets of twelve exposures on 24- and 36-exposure rolls.)

5. When the roll of film has been exposed, remove it from the camera, develop it, and measure the density of each frame. Record the data on a form such as that shown in table 3.3 and plot the characteristic curve.

Figure 3.11: *Darkroom setup for 35mm film.* The distances for twelve frames of 35mm film and twelve frames plus the length of the film leader have been marked off with masking tape on a darkroom table. This enables you to make three sets of exposures on a 36-exposure roll of 35mm film and evaluate three characteristic curves by cutting the film and developing each segment separately.

* Avoid using extremely fast shutter speeds (generally less than $1/500$ second), which are likely to be inaccurate. For most 35mm and roll-film cameras, a sensible strategy is to plan an exposure sequence by selecting the aperture associated with a shutter speed of $1/15$ second for a Zone V exposure. This allows you to keep the aperture constant and cover an exposure range of ten zones by varying the shutter speed incrementally from 1 second to $1/500$ second.

Table 3.3

Roll Film Density Record

Film:		Developer:
Exposure Index:		Processing Temperature:
Camera and Lens:		Film Base Density (F):
EI (Measured):		

Frame	Aperture	Shutter Speed	Exposure Zone	Density	D-F
1					
2					
3					
4					
5					
6					
7					
8					
9					
10					
11					
12					

Note: Density is the measured value for each exposed frame of film. D-F is the value obtained by subtracting the density increment due to chemical fogging of the film base during processing. This is determined by measuring the density of an unexposed edge of the film. Chemical fog plus film base density usually contributes about 0.10 unit to the overall negative density, but it will increase to higher values with extended development. The correction for chemical fog is necessary to determine the film speed because the speed point of a film is defined as being 0.10 density unit above the value of the density of the film base plus fog.

Jacques Henri Lartigue, Arles, France, 1974

I went to Arles to attend, at the invitation of Lucien Clergue, the photography workshop of the annual Arles Festival of the Arts. . . .

One day during the festival the photographic group visited the Camargue — a desolate hot plain near the coast noted for its cattle ranches. I found it despairingly drab and photographically uninviting. . . . I do not know what anybody accomplished at this desolate session under the hot gray sky except to talk, consume good wine and food, and make insistent attacks on each other with 35mm cameras. The heat was comparable to that of the San Joaquin Delta country in California, where it is often 100°F and more in the shade. But everyone was having a happy experience, and seriousness was cast upon the steaming air.

Jacques Henri Lartigue — a magnificent gentleman on all counts — was with us, and as he spoke English very well we got along splendidly. He had visited us in Carmel several years before the Arles experience. . . . Lartigue is strikingly handsome, and I was able to make several negatives of him that pleased me very much. . . .

As for the portrait reproduced here: it was made with a Hasselblad 500C and 120mm S-Planar lens on Ilford HP3 film, developed in Edwal FG7 and printed on Oriental Seagull Grade 2. As the camera was hand-held and the subject lively, all the negatives I made are not crisp. The cattle stockade was of darkly weathered wood; one of its corner posts had a thrusting noble shape which I used in several of my compositions. As often occurs — negatives beautiful, likenesses poor. A moved head, eyes closing or closed, a moment of a budding smile miscaught as a grimace — all photographers have these heartbreaking accidents to contend with. Three negatives out of the many were satisfactory.

Only recently was I able to achieve a print that approached my visualization. I visualized this photograph in stronger, more Nordic values than the negative provided. The light of southern France was very strange to me; everything seemed more luminous than it appeared in the photographs. Lartigue's white hair literally gleamed in the drab surround, yet the configurations and textures of skin, wood, and earth proved quite depressing as revealed in my normal negative. I should have attended my meter readings and adjusted exposure and development accordingly. But I was cautious and did not extend development into the "plus" level as my records indicated I should. I sometimes trust my intuitions over my meter, and not always with good results!

— ANSEL ADAMS

Determining Negative Density

In the most basic sense a negative is a light filter in which silver or dye particles have been arranged by the action of light, the lens, and developer to create an image. The intensity of light that passes through the negative depends upon its density at any point; the greater the density, the lower the intensity of transmitted light. For a light source of fixed intensity, the *time* required for a given quantity of light to pass through any portion of a negative *is proportional to the density.*

Precise Determination of Negative Density Without a Densitometer

The purpose of this approach is to simplify technique, to give the individual command of his own interpretative style, and to encompass a wide variety of photographic problems. It is the opposite of the empirical method, in which by long trial and error the photographer "finds out" the most effective ways and means to achieve his ends. My approach requires a serious attitude toward photography, and the willingness to spend considerable time and energy in basic studies. In this, however, photography in no way differs from any other serious art and craft, and the end result of the attitude and the willingness is greater freedom and spontaneity in actual practice.

When you make a print, as negative density increases, a longer exposure is needed to achieve a given gray tone on the printing paper. This fact can be used as the basis for a simple and extremely accurate two-step procedure to measure any negative density:

1. Measure and record the exposure time (t_1) needed to generate an arbitrary light gray tone (about Zone VII) on a sheet of enlarging paper *without* a negative (therefore, zero density) in the negative carrier of your enlarger.

2. Insert a test negative into the carrier and make a series of test exposures to determine the exposure time (t_2) needed to generate the identical gray tone produced in the first step.

The logarithm of the ratio of the two measured times equals the negative density:

Density = $\log_{10}(t_2/t_1)$ where t is exposure time

For most photographic applications it is not the absolute density of a negative that is important but rather the density minus the value of the film base plus fog [$D -$ (film base + fog)]. To obtain that value directly, place a sheet of unexposed, developed film in the negative carrier and base the reference time t_1 on that exposure. This simple process of comparing the exposure times required to achieve a common print tone can be used to determine the density of any negative (or point on a negative) without the use of a densitometer.

Figure 3.12: Ansel Adams, *Base of Upper Yosemite Fall, Yosemite National Park, California, c. 1950.*

Experimental Procedure for Determining Negative Density

The relative exposures required to produce equivalent print tones from negatives of different densities is a direct measurement of density differences.

1. In order to lengthen the exposure times to manageable and accurately repeatable durations (about 10 seconds) set the enlarger at its maximum column height and stop the lens down to its minimum aperture. If your enlarger has a color head you can dial in neutral density filtration to dim the intensity of the light source. Alternatively, place a piece of light-diffusing material, such as a translucent sheet of plastic, under the lens.

2. Prepare the solutions needed for printing. In the dark and with the safelight on, cut a few sheets of 8 x 10-inch RC printing paper into strips approximately 1 inch wide and 8 inches long. Store these in a light-tight box.

3. The first task is to find the exposure required to produce a very light gray tone (something in the range of a Zone VII to VIII print value). Insert a sheet (or portion thereof) or frame of unexposed, developed film in the negative carrier and make a test strip with a sequence of increasing exposures (for example, 4, 8, 12, and 16 seconds); develop and fix the strip. Find the exposure that produces a very light gray tonal value and choose that as your reference standard. Make any needed adjustments in the enlarger (for example, enlarger height, lens aperture, light intensity) at this stage so that the standard exposure time is 10 seconds, a long enough time to be accurately reproducible. Measurable changes of a few seconds of exposure will produce easily perceptible tonal changes in the test strip. (Using an exposure time of 10 seconds also simplifies the subsequent calculations of density values.) Finally, expose the full length of a test strip to serve as a standard reference and store the strip in a tray of clean water for the comparisons described below. Note the enlarger settings in your notebook and record the time required to produce your standard gray tone as t_S.

Figure 3.13: *Standard light patch.* The light intensity from an enlarger with a frame of unexposed developed film in the negative carrier was adjusted by varying the height above the baseboard and the lens aperture until a 10-second exposure of enlarging paper produced a very light gray tone after development. This patch was used as a comparison standard to determine negative densities. After a negative of unknown density was inserted in the negative carrier, a second strip of enlarging paper was exposed for 10, 12, 14, 16, and 18 seconds, respectively. The 14-second exposure is a close match of the standard. Therefore, the density of the negative is $\log_{10} {}^{14}/_{10}$ or $\log_{10} 1.4$, which is 0.15 (see table 3.4).

10-second standard

4. Replace the blank film segment in the negative carrier with the section of film corresponding to your Zone I exposure and *reproduce* the reference standard tone by exposing a new test strip at appropriate time intervals. The Zone I frame will probably be just distinguishable from the blank frame, and you should try exposures of paper for the standard time (t_s) and (t_s + 1 second), (t_s + 2 seconds), and so on, to produce a succession of patches on the strip.

5. Process the exposed strip as before and see *which wet patch most closely matches the reference standard gray tonal value*. Note the exposure time corresponding to that step.

6. Repeat this procedure for each frame of the roll of film being tested or each step on the image of the density strip if you are testing sheet film. As you reach negative densities greater than Zone I, exposure times get much longer. When the exposure time is much more than twice t_s, open the aperture one stop on your enlarging lens (thereby doubling the light intensity) to keep the exposure times in a reasonable range. You then need to double the values of these exposure times in subsequent calculations to correct for the change in light intensity. When you reach the negatives with the highest densities you may need to open the lens another stop or two. Note the time required for each determination, t, and divide it by the standard time, t_s. Read the density corresponding to that ratio from table 3.4 or use a calculator to find the logarithm of the ratio.

Table 3.4

Exposure-Density Values

t/t_s Time Ratio*	D Density	t/t_s Time Ratio*	D Density	t/t_s Time Ratio*	D Density
1.0	0.00	2.0	0.30	07.0	0.85
1.1	0.04	2.5	0.40	08.0	0.90
1.2	0.08	3.0	0.48	09.0	0.95
1.3	0.11	3.5	0.54	10.0	1.00
1.4	0.15	4.0	0.60	13.0	1.11
1.5	0.18	4.5	0.65	16.0	1.20
1.6	0.20	5.0	0.70	20.0	1.30
1.7	0.23	5.5	0.74	25.0	1.40
1.8	0.26	6.0	0.78	30.0	1.48
1.9	0.28	6.5	0.81	40.0	1.60

* This is the measured exposure time divided by the standard exposure time.

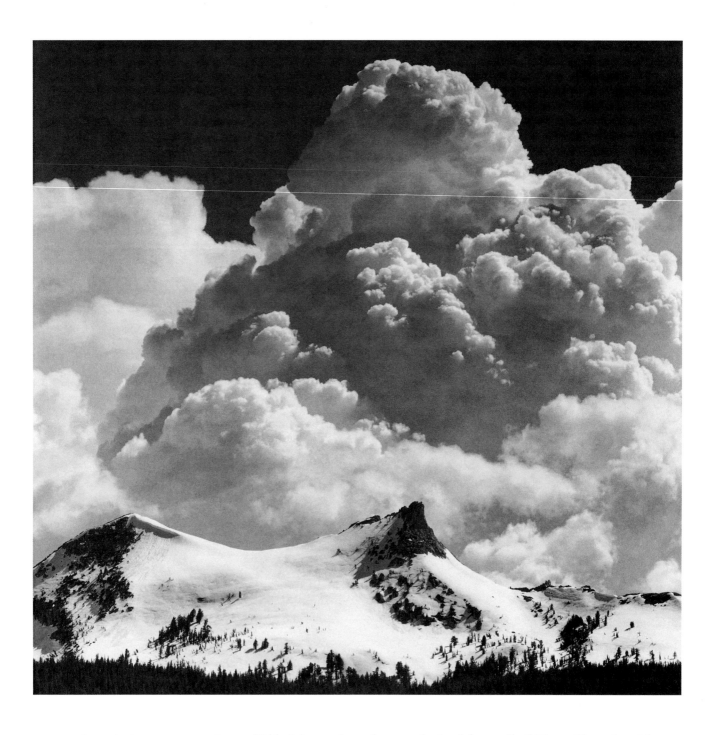

Figure 3.14: Ansel Adams, *Unicorn Peak and Thundercloud, Yosemite National Park, California, c. 1967.*

Table 3.5 contains a data set obtained for a roll of 35mm film using this procedure. Density values for the same film strip measured directly with a precision densitometer are listed for comparison. The correlation illustrates the extraordinary accuracy that can be achieved using these simple visual comparisons. It took about one half hour to measure the densities of a roll of film using this procedure. The data in the table contain all of the information that you need to plot a characteristic curve and determine the exposure index of the film that you are using. The data sets that can be generated from these tests also provide a record of how negative densities are influenced and can be altered by changing film exposure and development, the keys to converting a visualized image to a fine print.

The data in table 3.5 have been plotted on a graph in figure 3.15 as a characteristic curve. The curve illustrates how a film responds to exposure and development. The interpretation and use of characteristic curves is discussed in detail in chapter 4.

Table 3.5

Sample Data Set*

Exposure Zone	Camera Setting	Enlarger Exposure (Seconds)	Time Ratio t/t_S	Calculated Density $\log(t/t_S)$	Measured Density
Zone V	f/2.8; 1/125	50 sec.	4.17	0.62	0.62
Blank	unexposed	12 sec.	1.00	0.00	0.00
Zone –I	f/22; 1/125	12 sec.	1.00	0.00	0.00
Zone 0	f/16; 1/125	12 sec.	1.00	0.00	0.03
Zone I	f/11; 1/125	15 sec.	1.25	0.10	0.12
Zone II	f/8; 1/125	21 sec.	1.75	0.24	0.26
Zone III	f/5.6; 1/125	27 sec.	2.25	0.35	0.37
Zone IV	f/4; 1/125	39 sec.	3.25	0.51	0.49
Zone VI	f/2.8; 1/60	66 sec.	5.50	0.74	0.75
Zone VII	f/2.8; 1/30	104 sec.	8.67	0.94	0.95
Zone VIII	f/2.8; 1/15	184 sec.	15.33	1.19	1.20
Zone IX	f/2.8; 1/8	360 sec.	30.00	1.48	1.49

* The data in this table have been plotted as a characteristic curve in figure 3.15.

Note: Enlarger exposures are the times required to match the chosen gray value used as a standard. (t/t_S) is the matched exposure time divided by the time required to expose the standard (12 sec. in the above example). The logarithm of this ratio is equal to the film density. The measured densities were obtained by using a precision densitometer. This data set was obtained using Kodak T-Max 100 Film developed in Kodak HC-110 (dilution B). The film was rated at an exposure index of 100.

Figure 3.15:
Kodak T-Max 100 Sheet Film:
Kodak HC-110 Developer (Dilution B)
Characteristic curve. A smooth curve has been drawn through a graph of the data in Table 3.5 to illustrate the characteristic curve for the film and developer.

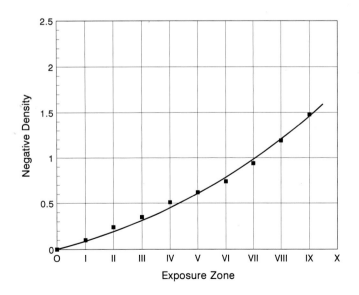

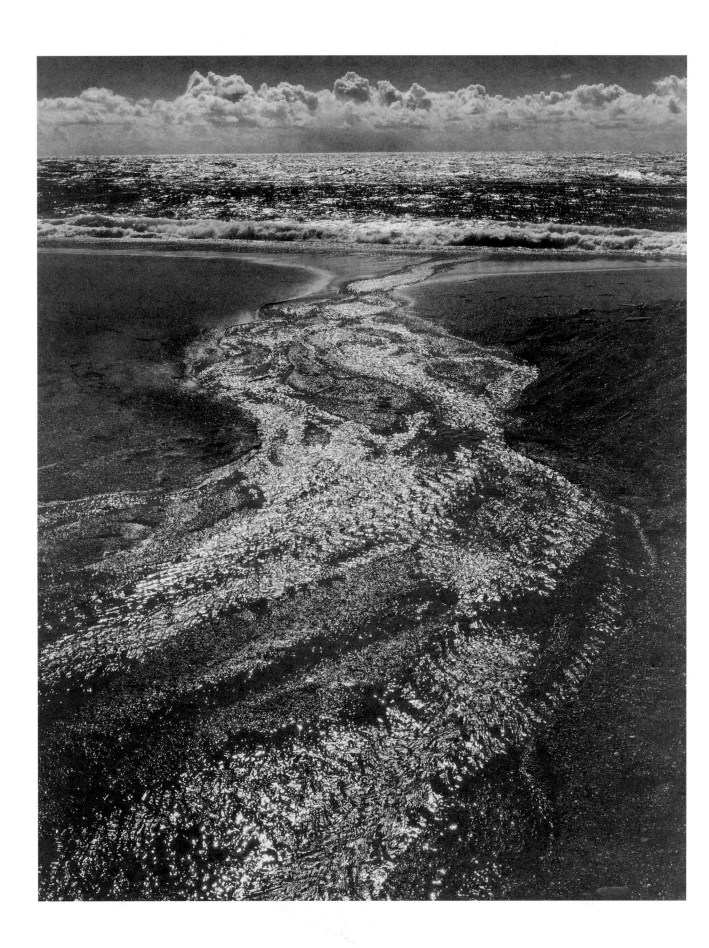

Chapter Four

Using Characteristic Curves to Evaluate Films and Developers

A single characteristic curve tells much about a film, but is probably of greatest use when compared with another curve. If you are familiar with the characteristics of one film and developer in practical terms, you can learn a great deal by comparing a curve representing this system with another curve that represents a new film you wish to try, or a modification in development time. With practice one learns to "read" curves and their comparative values with ease. — ANSEL ADAMS

Characteristic curves are useful tools for evaluating the capabilities of films and developers. They are road maps that steer a photographer directly toward the solution to exposure and development problems and help him or her avoid the countless trials and errors that are usually unproductive (and expensive) learning experiences. A simple analysis of the characteristic curves obtained by the methods outlined in chapter 3 will reveal the correct film speed to use, the correct development time, how films compare in their ability to separate shadow, midtone, and highlight details, how films respond to different types of developers, how subject contrast can best be controlled, and so forth.

As an example of how characteristic curve data might be used, figure 4.2 illustrates three simulated characteristic curves and photographic prints that might be obtained for a specific film type by using different developers. In a discussion of exposure and development within the context of the Zone System, it is important to remember that *film speed* is defined by the exposure required to produce a Zone I density of 0.10 above the film base plus chemical fog density value, and that *normal development* corresponds to the development needed to generate a Zone VIII density value of 1.30+/−.05 (above film base + fog).

In figure 4.3 the density values recorded at Zones I and VIII indicate that in each case the correct film speed and development time was used for the film. Relative to the median curve "A," processing with Developer B extends the toe of the characteristic curve and results in lower negative density at every exposure zone below Zone VIII. Compared to a print made from negative "A," a print from negative "B" would exhibit *lower* contrast (remember, contrast is the slope of the characteristic curve at any point) for darker tonal values (< Zone V), *higher* contrast in the lighter values (> Zone V), and *darker* print

A

Figure 4.2: Ansel Adams, *Zabriskie Point, Death Valley, National Monument, California, 1942.* An easy way to learn to appreciate the relationship between the shape of a characteristic curve and the corresponding image (A) is to view it on a computer equipped with an image-processing program, such as Adobe Photoshop. The computer displays the image and a "characteristic curve" in which the lowest and highest density values have been fixed by the computer program, and all of the print values are distributed along a line that spans black to white. The shape of the curve can be changed at will, and the altered tonal values of the image are displayed on the monitor screen. Figures B, C, and D show the impact of distorting the shape of the characteristic curve on the print values of the image.

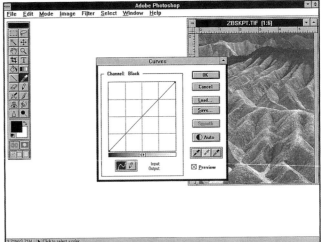

B

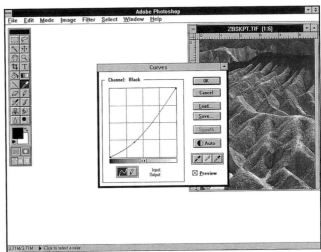

C

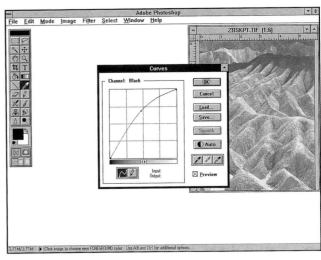

D

Figure 4.3:

Influence of Developers on Curve Shapes: Kodak T-Max 100 Sheet Film

Variations in curve shapes. While it is easy to fix the exposure and development times for films to meet the same density targets for Zones I and VIII, different film and developer combinations can result in substantial variations in midtone values.

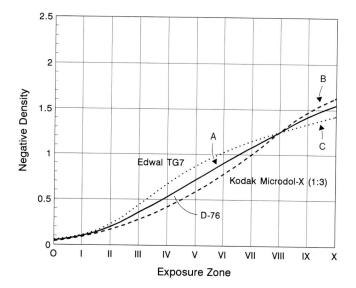

tones for every exposure zone up to VIII. Conversely, a print from negative "C" would show *higher* contrast for darker tones (< Zone V), *lower* contrast for lighter tones (> Zone V), and *lighter* print tones for every exposure zone up to VIII. Detailed analyses of curves later in this chapter will further illustrate how curves can be used.

All manufacturers have characteristic curve data for their films used with selected developers. These can be obtained by writing to the manufacturer, requesting them from your photo dealer, or, in the case of Kodak, purchasing a copy of *Kodak Professional Black-and-White Films* (Kodak Publication No. F-5). These "performance profiles" define how films respond to exposure, and you should carefully analyze them to reassure yourself that a film and developer are capable of delivering the photograph you visualize. If a film/developer combination has a curve featuring a pronounced and abrupt shoulder, for example, it will not be ideal for subjects where clear separation of highlight detail is needed. Conversely, portrait photographers often favor films with an extended "toe" because of the way in which they render shadow details. One of the main factors to consider in selecting films and developers is the mood that you want to convey in a print; being able to interpret the characteristic curves of various films can help you make those choices.

The characteristic curves provided by manufacturers are extremely useful guides, but you should determine the shape of the curve and the actual film speed for each type of film and developer using your own camera equipment and the standard procedures that you follow when you process your film. This is particularly advisable when your developer of choice is not one listed or recommended by the manufacturer of your film. Working film speeds are rarely identical to those reported by the film supplier because of differences in equipment and processing procedures and because a manufacturer's sensitometric standards may not always mesh with your personal Zone System methodology. Film performance for brand-name films is usually highly consistent from

batch to batch, and once you have determined the curve for a specific type of film and developer it should not be necessary to repeat the process unless some element of your system has changed (for example, a switch from tray- or tank processing to rotary processing).

Film Speed and Normal Development Time

Determining Film Speed

Light, to the accomplished photographer, is as much an actuality as is substance such as rock or flesh; it is an element to be evaluated and interpreted. The impression *of light and the* impression *of substance which are achieved through careful use of light are equally essential to the realistic photographic image.*

In practice, any details in a negative that have a net density of less than 0.08 to 0.12 will print as a textureless black devoid of visual details. The density value of 0.10 represents the effective threshold of a film's ability to respond to exposure and, by convention, is defined as Zone I. The exposure required to produce a Zone I density is, therefore, the practical determinant of film speed for photographers.

Using the method outlined in chapter 3, once you plot the characteristic curve of a negative it is a simple matter to assign the film a working speed (which we refer to as the exposure index, or EI, to avoid confusion with the ISO designation), which you should use to determine the appropriate exposure. Figure 4.4 is a characteristic curve that was determined for Kodak Tri-X Film developed in D-76 at 68°F, using an exposure based on an assumption that the film had an exposure index of ISO 400.

The assumed Zone V exposure patch was used as a reference marker. From an examination of the original curve, it is evident that it crosses the 0.10 density line at Zone II. Since Zone II is in fact Zone I, the entire curve is displaced by one zone to the right, and consequently the assumed Zone V is re-

Figure 4.4:
Kodak Tri-X Sheet Film: D-76 Developer — Correcting the Exposure Index
Shifting characteristic curves. Once a characteristic curve has been measured at an assumed film speed, it need not be redetermined. Simply shift the entire curve to the left or right until the density value of 0.10 falls on Zone I. The shifted curve will be identical to what you would have obtained if the correct EI had been used.

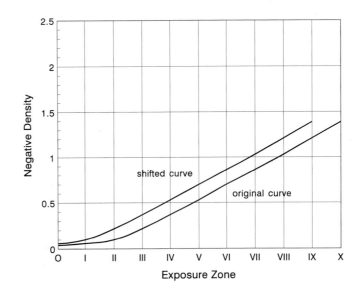

ally Zone IV, and so forth. This misalignment occurred because *the actual EI of the film as used and processed with my equipment* is half that suggested by the manufacturer, namely EI 200. Note that it is not necessary to redetermine the curve using the corrected film speed; simply replot it by shifting each point on the curve one zone to the left, which gives you exactly the same result you would get by repeating the experiment using an EI of 200 rather than 400. This is true because the film responds only to the amount of light and development it receives, without any regard for the numerical settings on your meter or camera. The "shift" therefore is what would have actually happened had you "used" a different film speed. A failure to make this correction would result in one stop of underexposure of a scene and a loss of detail in the shadow values.

As a general matter, when a curve needs to be shifted to the left to have a density value of 0.10 correspond to Zone I, the exposure index of the film must be reduced. Conversely, a shift to the right implies that a faster film speed should be used in calculating the exposure. Each *full-unit* shift of a zone corresponds to a *doubling* or *halving* of the film speed. If a *fractional* correction of the exposure index is in order, round it off to the nearest *lower commonly used index value*. For example, if you determine that an EI is approximately 75 (which does not appear as an option on a digital spot meter), use EI 64 rather than EI 80. A small amount of overexposure is always preferable to underexposure.

Determining Normal Development Time

Once the optimum film speed has been established you are assured that all portions of the negative scale receive appropriate exposure. The density of the high values is then controlled by the degree of development. Normal development is thus established by making a series of Zone VIII exposures and adjusting the development time until the desired density is achieved.

We must first establish the "normal" before we can depart from it in a useful way. Testing procedures . . . should be carried out and the results applied in practical photography to confirm their effectiveness. In general terms, I have found that approximate values for normal negative densities are about as follows:

	Diffusion enlarger, density above filmbase-plus-fog	*Condenser enlarger, density above filmbase-plus-fog*
Value I	*0.09 to 0.11*	*0.08 to 0.11*
Value V	*0.65 to 0.75*	*0.60 to 0.70*
Value VIII	*1.25 to 1.35*	*1.15 to 1.25*

After you determine the EI for a film, the next step is to ascertain the "normal" development time. Based upon his considerable experience, Ansel defined "normal" development as *those conditions that led to a target density above film base plus fog density (fb + f) in the range of 1.25 to 1.35 for a Zone*

Figure 4.5: Ansel Adams, *Poplars, Autumn, Owens Valley, California, c. 1937.* The subject brightness range of this strongly backlit scene exceeds six zones, and the print contains highlight values that exceed the range of the paper's ability to record detail. The photograph conveys the impression of brilliant light that Ansel visualized. Compressing the tonal range of the negative by shortening development could have been used to reveal highlight details in the leaves but would have sacrificed the light and airy feeling this print transmits to the viewer.

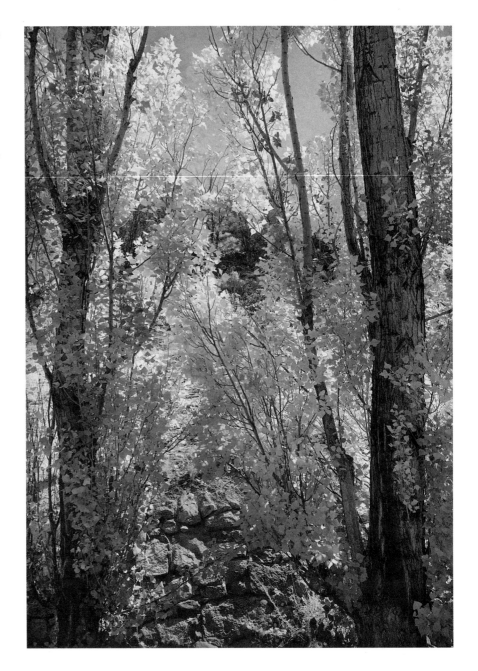

VIII exposure. A negative exposed and developed so that Zone I and Zone VIII have densities of 0.10 and 1.30 +/– 0.05, respectively, will contain appropriate details in the shadows, midtones, and highlights for most subjects. A negative with these features will produce a straightforward print on an enlarging paper with a Grade 2 contrast.

If you intend to work with alternative photographic processes such as cyanotypes, the "normal" development time for a negative will be vastly different, and an appropriate target density for Zone VIII is approximately 1.60. This would require extended development for the film. Detailed experimental procedures for determining both film speed and times for normal, expanded, and contracted development follow.

Figure 4.6:

Kodak T-Max 100 Sheet Film: Kodak Microdol-X Developer

Determining film speed and development time. The characteristic curve was determined assuming an EI of 100 for the film and using a development time of 6 minutes at 24°C. Because a density value of 0.10 is not reached until Zone II, the actual EI is 50.

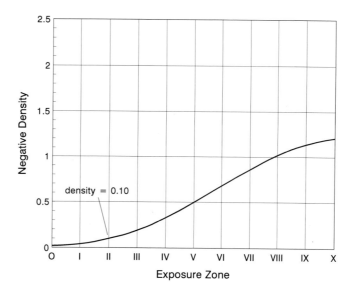

Determining Both Film Speed and Normal Development Time

The following procedure illustrates how to proceed when neither the film speed nor appropriate developer time is known. All of the films described in this chapter were developed in a drum using a JOBO rotary processor that included a water bath to regulate processing temperatures to +/– 0.1°C. In each case the film was soaked in water for 1 minute prior to beginning development. In the example shown, Kodak T-Max 100 4 x 5 sheet film and Kodak Microdol-X Developer* were chosen.

Several sheets of film were exposed using the calibrated film-strip procedure described in chapter 3. An EI value of 100 was assumed, and the exposure was based on placing the target on Zone IX. (If you are sure that the film speed will not be greater than the value suggested by the manufacturer, you can safely use a Zone X or XI placement and thereby obtain a little extra data. The only risk in giving the film too much exposure is that the density at step twenty-one may be too high — greater than 0.10 — to estimate the film's speed point accurately.) Instructions packaged with the film did not include any recommendations for processing in Kodak Microdol-X, so a development of 6 minutes at 24°C was guessed at by looking at data for other films and used in a trial run. The film was fixed, washed briefly, and rapidly dried with a blow-dryer.

The characteristic curve crosses the density value of 0.10 at approximately Zone II, one zone more than it should be if the assumption of ISO 100 was correct. Therefore the actual film speed is half the assumed value, and the exposure index that should be used with this film/developer combination is EI

* Kodak Microdol-X is a fine-grain developer that contains a high concentration of sodium sulfite, which acts as a mild silver solvent. The solvent effect is most pronounced where the concentration of silver particles is lowest, namely, in the shadow areas. The result is that film speed is usually fractionally lower than what you will find with other developers. An objection that some photographers have to this developer is that the quality of fine grain is purchased at the price of a slight loss of sharpness. Issues of fine grain and relative sharpness call for subjective judgments, and the user must weigh the trade-offs involved.

Figure 4.7:

Kodak T-Max 100 Sheet Film: Kodak Microdol-X Developer

Determining film speed and development time. The data in figure 4.6 were shifted one zone to the left to show how the curve would appear if the correct EI (50) had been used.

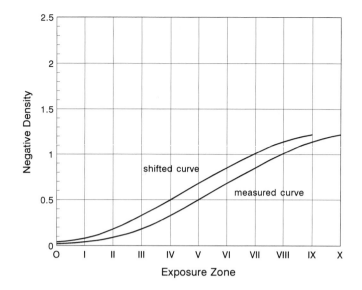

Figure 4.8:

Kodak T-Max 100 Sheet Film: Kodak Microdol-X Developer

Determining development time. To determine the correct development time, sheets of film were exposed at EI 50 and developed for 4, 6, 8, 10, and 14 minutes, respectively. The density target value for Zone VIII (1.30 +/– 0.05) falls between the curves for 6- and 8-minute development. The dashed line represents an interpolated curve for "normal" development, estimated to be 7 minutes.

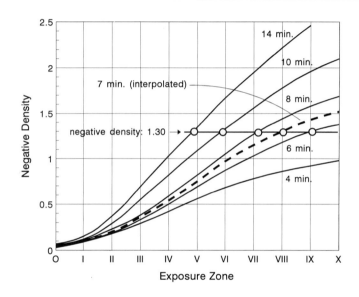

50. Figure 4.7 shows the original curve and a second curve for which each point is shifted to the left by 0.30 density units so that the density value of 0.10 falls on Zone I.

Figure 4.8 is a set of curves for Kodak T-Max 100 Sheet Film for a series of development times. "Normal development" for negatives to be used with a diffusion enlarger produces target densities in the range of 1.25 to 1.35 for Zone VIII exposures. Inspection of the curves shows that the low end of this range was nearly achieved with the guessed-at development time of 6 minutes — the density at Zone VIII was 1.20. A development time of 8 minutes increased that value to 1.45, which is a bit on the high side (a density range of 1.25 to 1.35 for Zone VIII is generally desirable for modern printing papers). Interpolating from these results, a development time in the range of 6.5 to 7.5 minutes should produce a negative that meets the criterion of "normal." As a practical matter for *this* film/developer combination, these working condi-

tions, and a subject with an average range of luminance values (for example, an outdoor scene with the sun behind the camera), a correctly exposed film developed *anywhere* in the range of 6 to 8 minutes would give a negative that would print relatively easily and show a full range of shadow and highlight details. Estimating the optimum development time from a few data points is adequate, and it is not worthwhile spending time doing additional exposure/development experiments to zero in on a more precise time. Slight modifications of procedures during the printing process are sufficient to compensate for small variations in possible negative development, and photographers should dedicate most of their efforts to making photographs, not refining characteristic curves.

Problems might begin to arise if there are important areas within the scene that fall on high luminance values. Under these circumstances longer development times may increase the negative densities of very bright features to values beyond the range of densities that the printing paper can accommodate, which would result in textureless chalky-white tones. By determining a range of characteristic curves for a film/developer combination, you can quickly gain a feel for the flexibility and control that the products have to offer.

Controlling Negative Contrast and Density Range

The contrast of a negative and its overall density range is controlled by the film development time at any given temperature. Using this principle enables you to expand or contract the apparent contrast of a scene at will. This is one of the most powerful interpretative tools available to a photographer working with black-and-white films.

To appreciate the quantitative effect of varying development time, the data for the sheets that were developed for 4, 6, 8, 10, and 14 minutes can be further analyzed. In figure 4.8 a line has been drawn across the family of curves at a density value of 1.30.

As expected, longer development times increase the negative density for each exposure zone. Furthermore, the change in negative density is proportional to the amount of exposure the film receives: the greater the exposure, the greater the increase in negative density caused by increased development. For Zone II, increasing the development time from 4 to 14 minutes elevated the negative density from about 0.18 to 0.38, a difference of 0.20, while for Zone VII, the value changed from 0.78 to 1.92, an increase of 1.14 density units. *What has occurred by increasing the development time is that the negative density value for a Zone VII exposure has been increased to that normally expected for a zone with a much higher luminance.* The differing responses of exposure zones to prolonged or reduced development form the basis for negative "expansion" and "contraction," an important aspect of the controls available when you use the Zone System.

Effects of Expanding the Development Time

In the language of the Zone System, an *expansion* of the density range of the negative by one zone from Zone VII to VIII is given the notation of *N+1*

Clearing Winter Storm,
Yosemite National Park, circa 1940

Weather, however spectacular to the eye, may present difficult conditions and compositions, especially when working with large cameras. Setting up the camera takes several minutes during which the first-promising aspects of light and cloud may disappear. . . . Clearing Winter Storm *came about on an early December day. . . . I set up my 8 x 10 camera with my 12¼-inch Cooke Series XV lens and made the essential side and bottom compositional decisions. I first related the trees to the background mountains as well as to the possible camera positions allowed, and I waited for the clouds to form within the top area of the image. . . .*

I focused on the foreground trees, and at a moderate aperture the mountains were in focus. A fairly short exposure was required to avoid showing movement in the clouds. As I recall, an exposure of ¹/₅ second was given at f/16 with Isopan film (ASA 64) and a Wratten No. 8 (K2) filter. After focusing I wiped a few drops of rain off the lens and kept it covered with a lens cap until the moment of exposure.

An average reading of a scene such as this, with normal development, gives a low contrast negative. The clouds were gray, and what sunlit areas appeared were pale and had very soft shadows. I knew from experience that, with normal development of such a negative, a Grade 4 paper would be necessary to approach the desired contrast. Although the scene was of low general contrast, my visualization of the final print was quite vigorous. The subject had a very dramatic potential. The image could not be simply contrasty; all the values required interpretation consistent with a deep, rich expression of substance and light. . . .

The highest textured value . . . in the scene was [placed] on Zone VII, [and] I found that the value of darkest trees on the right . . . fell on Zone I. The average value of the forest, with its light dusting of snow, fell on Zones II and III. The brightest areas were in the clouds, excepting the waterfall in the shaft of sunlight [which fell between Zones VIII and IX]; . . . and I knew it would show as a small white vertical shape in the final print.

I could have given two to four times the exposure to raise the value of the trees, but I would have probably lost a certain transparent feeling of light that I believe the print reveals. With this minimum exposure given the negative, the development instructions were Normal-plus-one. This moved the high values (placed on Zone VII) to Zone VIII, and a general crispness of all the values resulted.

— ANSEL ADAMS

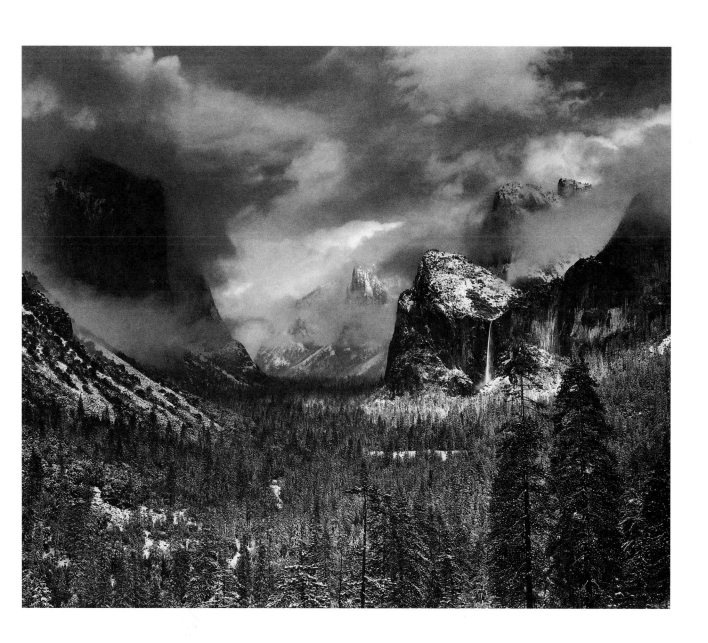

development. This means that the density range for Zone I to VII has been increased through extended development to correspond to that from Zone I to VIII on the normal curve. Similarly, N+2 development is that required to expand the density range for Zone I to VI to that normally found for Zone I to VIII. Expanding the contrast of a negative is often desirable when the luminance of a subject is confined to a narrow range (for example, a photograph taken in the shade) and a normally exposed and developed negative would lead to a print that is "flat" or "muddy" looking.

In figure 4.8 the line drawn along a negative density value of 1.30 and the black circles mark the point at which various zones fall. If a 7-minute development time is accepted as "normal," it is apparent that a development time of 8 minutes would increase the density value of a Zone VII luminance value to that normally found for Zone VIII without materially altering the value for Zone I. Similarly, a development time of 10 minutes will promote a Zone VI luminance to a Zone VIII density value (N+2 development).

Note that prolonged development also increases the contrast within a particular zone and that the effect is most pronounced for higher luminance values. A 14-minute development promotes a Zone V luminance to a Zone VIII density value, but the net density of the Zone I luminance has also been increased and approximates 0.20. In effect, the "effective film speed" has been increased by prolonging development, and effective expansion is actually less than N+3.

Effects of Decreasing the Development Time

Contraction of the development time has just the opposite effect of that described above: more exposure zones can be recorded within the normal density range. This approach is often useful when you photograph a high-contrast subject (for example, a sunlit scene with deep shadow areas). From the data presented in figure 4.8, it appears that a development time of about 6 minutes corresponds to N–1 development — that is, the luminance values of Zones I to IX will have been compressed to the density range normally seen for Zones I to VIII.

Potential Problems with Negative Contraction A few words of caution are in order when development time is reduced. Processing times of less than 4 minutes may lead to uneven development of the negative and introduce faults that are impossible to correct in printing. To achieve a longer development time, *dilute* the developer and determine the times that define N–1 and N–2 development. It is perfectly acceptable to "guess" at the time that should be used with increased dilution — your first test will show if you are close to your target time, and from there it will be easy to estimate the correct time when you use a diluted developer.

With some film/developer combinations, a shortened development time can result in a *considerable* loss of film speed. When you attempt negative contraction, carefully examine the characteristic curves and density values in the

Figure 4.9:

**Kodak T-Max 100 Sheet Film: Edwal TG7
and Ilfotec HC Developers**

Negative attributes. The properties of a
developer influence the film's response to
exposure, and the correct way to analyze film
behavior is to study its characteristic curves.
Single measurements of features such as
gamma to describe negative contrast are not
useful unless the profile of a curve approaches
a straight line.

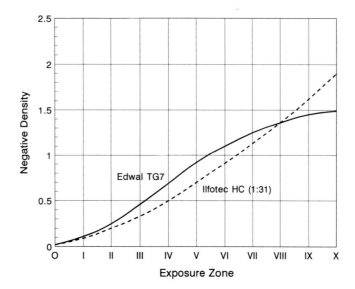

region of Zones I to IV. *If they are too low or if the toe is very long, more expo-
sure may be needed to record important shadow details on the negative.*

Characteristic curves for Kodak T-Max 100 Sheet Film were also deter-
mined for several other developers so that they could be compared. With
Ilfotec HC (1:31 dilution) and Kodak T-Max developers, the characteristic
curves were similar in profile to those experienced with Microdol-X. However,
Edwal TG7 exhibited moderated development of the higher tonal values
(above Zone VII), and this *compensating* action (see page 90) minimizes the
need for burning-in highlights.

Figure 4.9 also illustrates why a simple measure such as the "slope" of the
characteristic curve is an inadequate measure of negative contrast and does not
usefully describe the behavior of a film and developer. While the shadow val-
ues and Zone VIII densities are identical for the development in Edwal TG7
and Ilfotec HC developers, the values in the midtones differ substantially.
Edwal TG7 delivers more contrast — therefore a greater tonal separation — in
the middle gray tones, and reduced contrast ("blocking") in the highlights rel-
ative to Ilfotec HC. These differences are translated to the photographic print,
and this phenomenon could be a factor when you decide which developer to
use for a particular subject: if the subject has important tonal values in the
midtones that need to be separated cleanly, Edwal TG7 may offer an advan-
tage. On the other hand, if the separation of highlight values is of utmost
importance, Ilfotec HC Developer may deliver preferable results. While
a study of characteristic curves is useful for identifying properties of films
and developers, a few representative subjects should always be photographed
and prints closely compared to obtain a full appreciation of developer ef-
fects. Remember, a photographer's goal must always be the photograph.
Characteristic curves are merely useful tools to help the photographer achieve
a print that most closely approximates his or her visualization of the scene.

Figure 4.10:

Time/Temperature Curves

Ilford time and temperature chart. The chart correlates changes in development times for many Ilford films as a function of temperature. Most manufacturers provide similar data in a table or graph format for specific films.

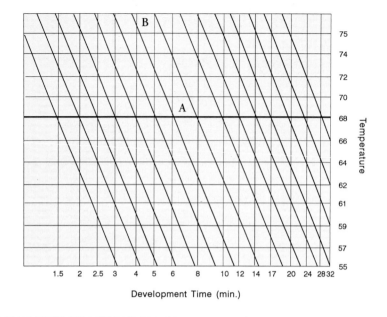

Development Time (min.)

Temperature, Time, and Normal Development

The chief problem [in making a photograph] is to preserve the illusion of light falling upon the subject. A print intended to convey an emotional impression may differ from a normal photographic record. You must visualize the final expressive print, expose for the desired values of the shadows, and control the high values by development.

The percentage change in development time that occurs when processing temperatures are raised or lowered is similar for most film developers. Ilford publishes a chart for each of its films, and once you know the processing time for a film, it is a simple matter to use the chart to determine the correct developing time at a different temperature (see figure 4.10). For example, if the recommended processing time for a film is 6 minutes at 68°F, and the temperature of your tap water makes it more practical to work at 75°F, find the diagonal line that crosses through the right angle made by the horizontal line from 68°F on the *y*-axis and the vertical line from 6 minutes on the horizontal axis (point "A"). Then move up along the diagonal until it crosses the horizontal line corresponding to 75°F (point "B"); the new development time, read by dropping a vertical line from point B to the *x*-axis, is estimated to be 4 minutes.

Other manufacturers usually include a data sheet with each film that tabulates the changes in development time as a function of development temperature.

Total Development

Texture is both a tactile and a visual quality; that is to say, it is three-dimensional. One cannot feel detail with the fingers, but texture is appreciated by both touch and vision; so let us say that a rough stone wall possesses texture, and that the photograph of the stone wall should reveal this texture in a more or less exaggerated way. . . .

If a photograph conveys the conviction of texture, it will usually convey the impression of substance and light.

If development is prolonged to several multiples of "normal," the shape of the characteristic curve approaches the profile of the face of Half Dome in Yosemite! Under these conditions virtually every particle of silver halide that has been exposed is reduced to metallic silver, and the negative achieves its highest possible contrast. These extreme conditions are referred to as *total development* (see figures 2.16 and 4.11).

Total development is extremely useful when you need to increase the contrast of a subject with a luminance range of three steps (three EV units) or less in light-meter readings. The side effects of total development are that fog and grain can increase substantially, and with some developers the oxidation products may begin to stain the negative, which results in longer printing times for the negative.

For subjects with a very limited contrast range, the highest textural values can be placed on Zone V or slightly less and given total development without blocking the highlights. If the range is 1:4 or less, the average value can be placed on Zone V. When total development is used, be cautious about allowing the higher luminance values to fall too high on the exposure scale and be certain that the deepest shadow areas for which detail is needed in the print are above Zone II.

Effects of Diluting the Developer Short processing times (generally less than 4 minutes) can lead to negatives with uneven densities. In assessing Kodak HC-110 as a developer for Kodak T-Max 400 Film using the recommended development time at dilution B (1 part of stock solution to 7 parts of water; 1:31 of concentrate) of 7 minutes at 75°F with rotary processing, I found that the resulting negative had far too much contrast for my normal printing conditions. (The contrast of Kodak T-Max films increases markedly with overdevelopment, a condition that is promoted by constant agitation during the development cycle.) Reducing the time in the developer to 4½ minutes improved the result, but left no room for negative contraction when

Figure 4.11:
Kodak Super XX Sheet Film: Total Development
Total development. Maximum tonal separation is achieved by total development (approximately three to four times normal), which is useful for scenes that have a limited SBR (two to three zones) and where the rendition of texture is important.

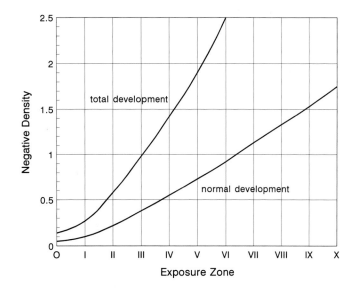

Figure 4.12:

Characteristic Curves: Kodak T-Max 100 Sheet Film and Kodak HC-110 Developer

Developer dilution effects. (A) The general shape of a characteristic curve is constant over a wide range of developer concentrations. Development times can be altered by changing the concentration of developer through dilution of the stock solution. (B) A series of characteristic curves determined for Kodak T-Max 100 Sheet Film and Kodak HC-110 Developer (dilution F, 1:19).

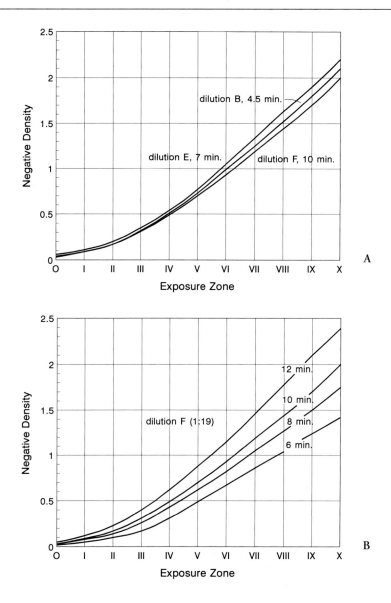

Figure 4.13: Ansel Adams, *Sequoia Gigantea Roots, Yosemite National Park, c. 1950.* **For subjects with a limited subject brightness range, using extended development increases negative contrast and adds brilliance to the mood of subdued light.**

it would be needed. In circumstances such as these it is best to further dilute the developer so that a "normal" development time in the range of 6 to 8 minutes can be used.*

To lengthen the normal development time, dilution F (1 part stock solution to 19 parts of water) was used, and development times of 6, 8, 10, and 12 minutes were tried. The family of characteristic curves obtained is shown in figure 4.12. The profile of the curve for a 10-minute development time is nearly identical to that obtained using dilution B for 4½ minutes at the same temperature. Inspection of the measured characteristic curves indicates that a development time of 6 minutes with dilution F produces a negative with the targeted density ranges of 1.25 to 1.35 for Zone VIII *after adjustment is made for the one-stop loss of film speed that occurs at this dilution and development time.* (An EI value of 400 was assumed when the film was exposed.)

* Development times can also be lengthened by reducing the developer temperature. Because the temperature of tap water in my area exceeds 80°F in the summer months, this is not a practical alternative for me.

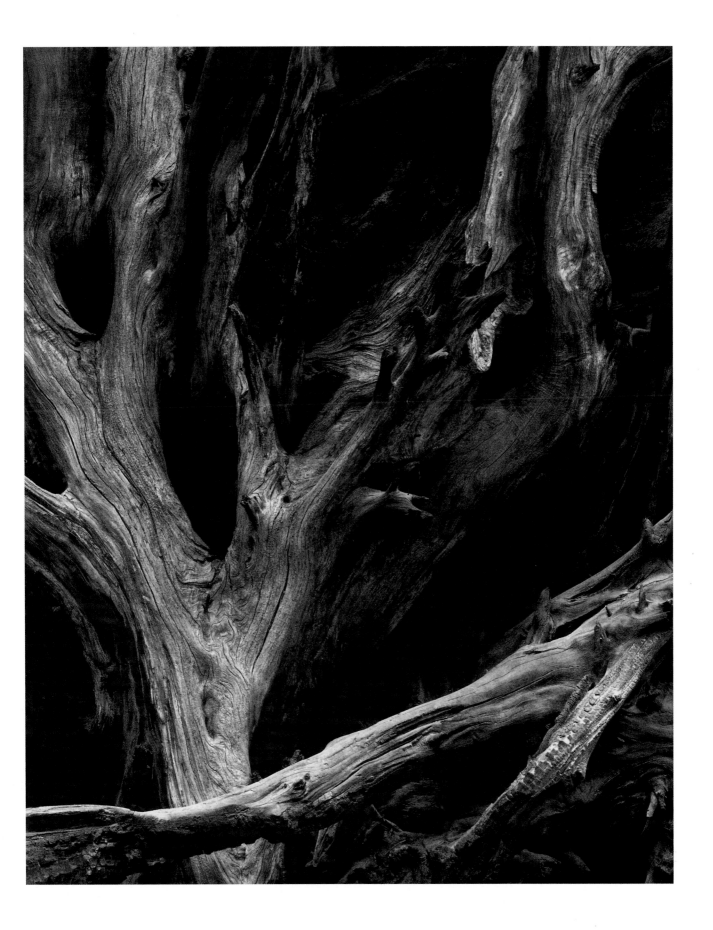

Compensating Development

The much abused term "compensating developers" properly suggests control of both very low and very high values. Such control implies satisfactory gradation in both low and high opacities in the negative, not merely an extremely compacted range, as given by ordinary soft development.

Several decades ago, film emulsions commonly used were richer in silver salts than their modern counterparts are, and the gelatin layer in which the salts were suspended was substantially thicker than the thin emulsion films now in use. The gelatin layer is a barrier through which the developer must diffuse before it can react with the exposed silver salts. The time required for developer diffusion limits the buildup of negative contrast. The effect, termed *compensating development,* is most evident in the areas of highest negative density, which correspond to the lightest tonal values in a print. With highly dilute developers, compensating development occurs because in the highly exposed areas of the film the developer is quickly exhausted. Fresh developer must continuously diffuse to the site to enable development to continue. In the shadow areas, which require relatively little development, development is completed relatively quickly. The compensating effect manifests itself as a shoulder on the characteristic curve with highly dilute developers and results in visibly lower contrast in the highlight areas of a print. Selecting a developer that delivers compensating action is often a useful way to prevent extreme highlight density in a negative.

With modern thin emulsion films that are virtually "all surface," the rate of chemical diffusion plays a lesser role in the development process. The characteristic curves of Kodak T-Max 400 Film developed in HC-110 at dilutions of 1:7, 1:11, and 1:19 from the "stock" solution to the same approximate contrast are virtually identical, indicating that compensating action beyond that inherent in the developer formulation is not increased by higher dilution in the range I explored (figure 4.12A).

An example of compensating development can be seen with the use of Kodak Microdol-X (others may work as well) as a developer with Kodak T-Max 100 Film. Microdol-X uses Metol as the sole reducing agent. Without hydroquinone and in the alkalinity range for which the developer is formulated, the developer does not convert highly exposed portions of the negative to high density values (it is the equivalent of using Kodak Selectol Soft as a developer for printing papers). However, superior ways to achieve a compensating effect are described in the following sections.

Divided Development

Divided, or two-solution methods of development, are worthy of serious consideration. There are three general types: 1. Divided solutions, each containing developer agents, in which the negative is immersed for various times depending upon the contrast desired; 2. A solution of developer agent and minimum required amount of preservative in which the negative is immersed until fully saturated, and then transferred to an alkaline bath which activates the developer absorbed in the negative emulsion; 3. A

Compensating Development: Kodak T-Max 100 Sheet Film

Compensating development. Compression of the tonal values in the more highly exposed regions of the negative limits the density range of the negative.

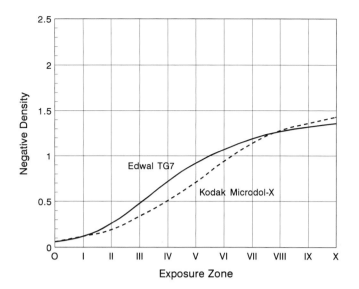

process whereby the negative is moderately developed in Kodak D-23, then immersed in a 1% Kodalk solution. . . .

The first two methods have merit and formulas for them may be found in standard reference books. The third method, in the opinion of the author, is superior in that it offers a positive system of high-value control consistent with the application of the Zone System.

Most commercially available divided developers are formulated with the reducing agents and an antioxidant in one solution (bath A), and an accelerator and preservative in a second (bath B). The most common way to proceed is to soak the film in bath A for 2 to 3 minutes to saturate the emulsion with the developing agents. Solution A is then poured back into its container and the developing tank is then filled with solution B, agitated, and allowed to stand for 2 to 3 minutes to complete development. Processing is finished by returning solution B to its container, rinsing the film with water, and fixing it in the usual way.

The advantages of divided development are manifold. When the procedure just described is used, no control of the *time* or *temperature* used to process the film is necessary. Characteristic curves determined by processing sheet film for this class of divided developers in a JOBO processor with constant agitation for both solutions A and B at 68°F and 80°F were *identical*.

Furthermore, with the possible exception of the new tabular-grain films, processing is identical for all films, and you can develop, for example, Kodak Plus-X and Tri-X and Ilford HP5 films simultaneously in the same tank. Because only a fraction of an ounce of solutions A and B are absorbed by the film with each use, a quart of developer will develop dozens of rolls or sheets of film before a new batch is needed.

The absence of strong alkali and the presence of a high concentration of antioxidant in bath A means that it keeps for literally years. Bath B will eventually discolor, but this does not impair its usefulness. The stability of a divided developer is an advantage if you develop a roll of film only occasionally.

Aspens,
Northern New Mexico,
1958

We were in the shadow of the mountains, the light was cool and quiet and no wind was stirring. The aspen trunks were slightly greenish and the leaves were a vibrant yellow. The forest floor was covered with a tangle of russet shrubs. It was very quiet and visually soft, and would have been ideal for a color photograph, with appropriate color-compensating filtration to remove the blue-cyan effect of the light from the blue sky.

In black-and-white photography, normal exposure and development would have produced a rather flat and gray image. I visualized the images as stronger, in accord with the mood of the hour and place. The colors of nature are of low saturation, and this often includes visually bright autumn leaves. I felt that a deep yellow Wratten No. 15 (G) filter would be appropriate. I knew it would reduce the shaded ground values, thereby enhancing the general contrast of the subject (ambient light was mostly from the blue sky). Strong side lighting from banks of brilliant clouds on both the left and right provided most favorable illumination of the nearly white tree trunks.

I placed the deepest shadow on Zone II and indicated Normal-plus-two development time. I selected pyro as the appropriate developer for this subject, because I knew it would give high acutance to the glittering autumn leaves. I knew I must use a higher-than-normal paper contrast for printing, since the highest values of the leaves fell on about Zones VI–VI$^1\!/_2$. As I recall, the exposure, with the No. 15 filter (factor of 3), was 1 second at f/32 on Kodak Panatomic-X film at ASA 32. With no wind this relatively long exposure was possible; had the aspen leaves been quaking I would have had a severe problem. . . .

The printing of [the image] is exacting; there is a very subtle difference between "too dark" and "too light." The appropriate values in an untoned print may become much too dark with even moderate toning.

— ANSEL ADAMS

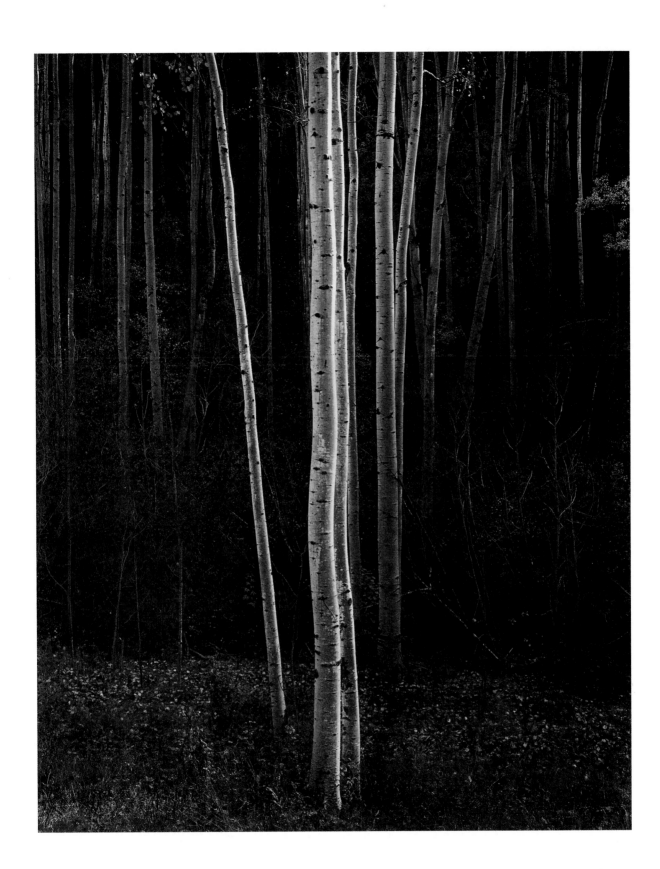

Figure 4.15:

**Divided Development: Kodak Tri-X Sheet
Film and Farber AB Developer**

Divided development. The Farber two-solution
developer produces a negative whose attributes
are very similar to film developed in D-76.

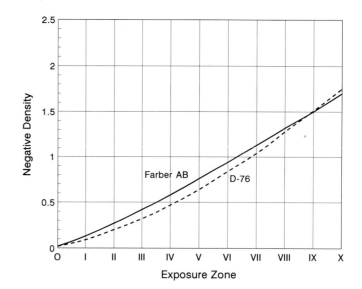

Most single-solution developers oxidize over time and should be discarded when they turn brown.

Are there any disadvantages to using a divided developer? The only drawback is that *with most A-B combinations* you cannot expand or contract the density range of a negative, since each film is developed to a predetermined gamma value dependent only upon the developer formulation. Furthermore, you do need to mix most of the developers yourself. While this takes a few minutes and requires the purchase of a few common chemicals and an inexpensive scale or chemical balance, the money that you save can quickly justify the time and effort.

A typical divided-developer formulation is the following:*

Solution A
Elon (Metol): 6 grams
Sodium sulfite (anhydrous): 50 grams
Hydroquinone: 3 grams
Potassium bromide: 3 grams
Sodium chloride: 5 grams
Water to make 1 liter

Solution B
Sodium sulfite (anhydrous): 10 grams
Sodium carbonate (monohydrate): 50 grams
Water to make 1 liter

* Figure 4.15 shows some typical characteristic curves obtained using this divided-developer formulation.

Note: This formula was suggested by Paul Farber and is often called the Farber AB developer. It produces fine-grain negatives with a contrast suitable for printing with a cold-light enlarger. Negatives of lower contrast can be obtained by using a less alkaline bath B formulated with either borax or Kodak Balanced Alkali (Kodalk) (10 grams per liter) in place of sodium carbonate.

Prepare the solutions by placing about 800 ml. of warm water (90–120°F) in a beaker and add the chemicals in the order listed. Stir the solution with a glass rod or plastic spoon until each solid dissolves completely before adding the next ingredient. After all of the chemicals have dissolved, add sufficient water to bring the total volume to 1 liter.

The following formulation of a divided developer was favored by Ansel:

Solution A (Kodak D-23)
Water (125°F, or 52°C): 750 ml.
Elon (Metol): 7.5 grams
Sodium sulfite (anhydrous): 100 grams
Water to make 1 liter

Solution B
Kodalk: 10 grams
Water to make 1 liter

Stir the Elon (Metol) into the water until it dissolves. Add the sodium sulfite, and when it has dissolved, add sufficient water to bring the volume to 1 liter. The B bath is a 1 percent solution of Kodak Balanced Alkali (Kodalk), made by dissolving 10 grams of the powder in 1 liter of water.

This formulation works very well with all modern films and produces negatives with a suitable range of density values for printing on papers of normal contrast. Greater negative contrast can be obtained by increasing the Kodalk concentration in bath B up to 10 percent. The film should be immersed in bath A from 3 to 7 minutes, followed by 3 minutes in bath B without agitation. Lengthening the time of submersion in bath A selectively increases the density of the higher values, but the grain of the negative also increases, which can be a serious drawback when small-format films are used. It is important to

Figure 4.16:
Divided Development: Kodak Tri-X Sheet Film and D-76 Developer
Divided developer formulations. Increasing the alkalinity of the B bath raises the overall negative density and contrast. In these experiments D-76 developer was used as the A bath, and after 2 minutes of development, the D-76 solution was replaced with the B bath.

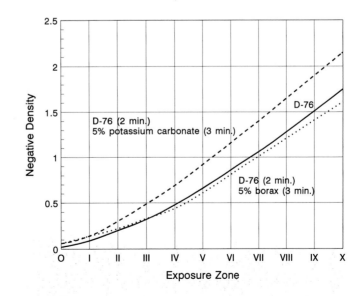

Figure 4.17:

Toning Effect on Negative Density

Selenium toning negatives. Selenium toning increases negative density proportionally, and the increase in contrast is approximately equivalent to N+1 development.

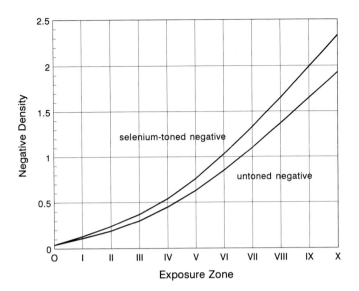

determine the characteristic curve of a film used in a divided developer to make certain that you use the correct film speed when the film is exposed and that the time of submersion in bath A results in the density range you desire.

Increasing Negative Contrast Through Toning

Selenium toning is used for archival processing of photographic prints and confers the additional benefit of deepening tonal values while it protects the silver image. Negatives can likewise be toned and their overall contrast increased by soaking them in a solution of Rapid Selenium Toner, diluted 1:10 with water. Toning changes negative densities in direct proportion to the original density of the negative, and increases approximating 8 to 10 percent occur for each tonal value (for example, with Kodak T-Max 400 Film, densities of 0.63, 1.04, and 1.16 increased to 0.68, 1.14, and 1.27, respectively, after toning). Very little density change is noted in the shadow areas, so that the result of selenium toning with some films is comparable to giving N+1 development to the original negative. The characteristic curves of a negative before and after toning are shown in figure 4.17.

Selenium toning should also be considered an option for protecting negatives intended for contact printing whenever prolonged exposure to intense light is involved. (If you decide to tone negatives as a matter of course you will need to adjust your development times to accommodate the density increases that occur.)

Summing Up

The tests and procedures described in this chapter are straightforward and can be carried out in any darkroom without the aid of special equipment. The few hours of effort you put into testing films and generating and evaluating characteristic curves will lead to insights about the properties and limitations of whatever films and developers you choose to work with. In turn these insights and your knowledge of these procedures will enable you to meet any technical challenge you may encounter and solve exposure and development problems that would otherwise prevent you from transforming your visualized images and concepts into photographs that embody what your mind saw.

As you work your way through the problems of exposure and development controls, these comments by Ansel are worth remembering:

As no two subjects present the same ratios of light and dark areas we see that experience and judgment must complement the indications of the exposure meter. Some "rules of thumb" are as follows (for "average" readings from camera position):

1. High contrast subjects: With preponderance of dark areas; give LESS than the indicated exposure. With preponderance of light areas, give MORE than the indicated exposure.

2. Low contrast subjects: If generally of high luminance (white painted wood, etc.), give MORE than indicated exposure. If generally of low luminance (dark cloth, stone, etc.), give LESS than the indicated exposure. In both cases INCREASE development time. If roll film is used, with varying exposures on the roll, give normal development time and realize that printing papers of varying contrasts must be used.

3. The "Golden Rule": In conventional black-and-white photography: EXPOSE FOR THE SHADOWS AND DEVELOP FOR THE HIGH VALUES. With color film [transparencies]: EXPOSE FOR THE HIGH VALUES.

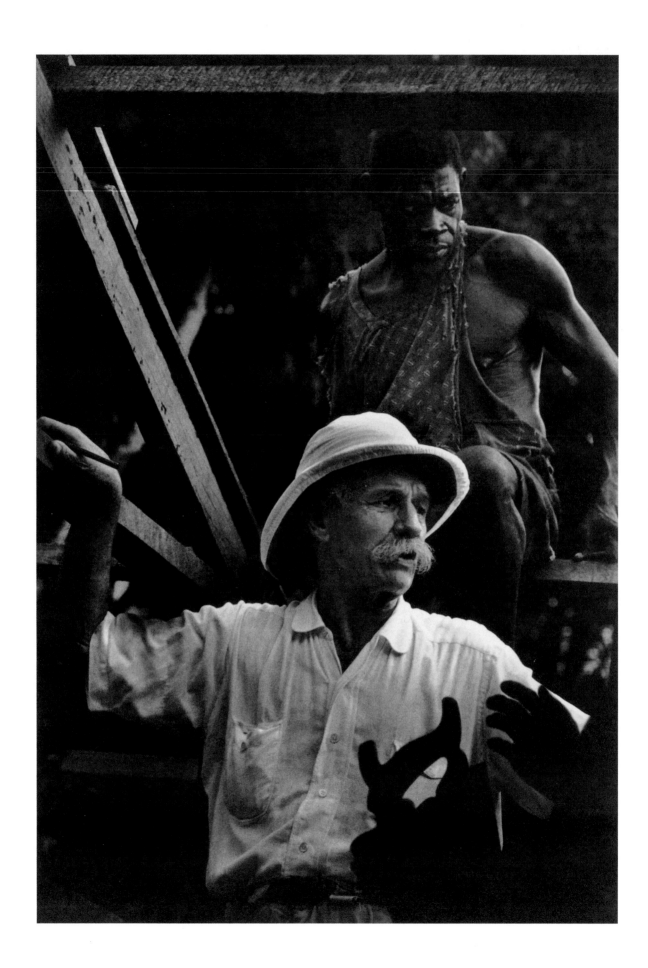

Chapter Five

Specialty Black-and-White Films

Most photographers work backwards *in making their photographs. Thinking only of* subject, *the* print, *instead of being conceived as the ultimate product, is considered as a more-or-less fortuitous accident. Through a juggling of the developing and printing processes, a picture is produced which in some ways bears a reminiscent relation to the original subject, aspect, and mood.*

Instead, the final print should be the Alpha and Omega of photographic procedure. It should be visualized before the negative is exposed. This may sound alarmingly difficult to do, but it is not as hard as one might suppose. Visualization is related to the fundamental approach to photography. The only phase of photography which really exists for the spectator is the print — the expression of the photographer's thoughts and feelings about the subject. Visualization does not imply something complete and inflexible; . . . There are countless details no one can be expected to visualize in advance. . . . What is important to visualize may be summed up as follows: —

The basic compositional aspects.

The basic tonal values and the emotional values of light and darkness.

The style *(the personal quality of the photographer's "seeing").*

— ANSEL ADAMS

Figure 5.1: W. Eugene Smith, *Albert Schweitzer, 1954.* This extraordinary photograph is a montage of 35mm images that Smith combined in an enlarged print. The print was selectively bleached to accent highlights and rephotographed on copy film. The final image was made by contact printing the large-format copy negative.

General-purpose films are intended for and used by amateurs and professionals for pictorial applications that range from landscape photography to photojournalism and portraiture. While there are clear differences among the various films and brands (for example, in film speed and grain structure), their basic characteristics and performance are similar, and they are virtually interchangeable.

Other films, however, have been tailored by the manufacturer to meet highly specific goals. For example, some are intended to be used by the printing industry for the reproduction of color or black-and-white images and type (litho film, copy film), while others have been designed for scientific applications that range from medical photography (X-ray film) to geological survey assessments and astronomy (infrared film). Some of these films have significant creative potential beyond the purposes for which they were formulated.

Photographic Copying

Many photographic printing processes involve contact printing rather than enlarging. For these applications, large-format negatives are generally needed. There are also occasions when the only photographic record is a print or when the original negative is damaged or has a density range that is too long or short to print on conventional photographic papers. A solution to all of these dilemmas is to make a new, or copy, negative from the image at hand.

Today, for most applications the best approach to making photographic copies of negatives or prints is digital scanning of an original followed by an appropriate output of the digital file. However, there are many situations where classical methods for copying are the most practical or only options. For example, some works may be too large to be placed on a scanner, or cost factors and accessibility to appropriate equipment may make the digital approach impractical.

When a surrogate, or copy, negative is being made, it is important to retain highlight and shadow details of the original image in the new negative. The keys to making excellent copy negatives are (1) choosing a film/developer combination that emphasizes the straight-line section of the characteristic curve; and (2) giving sufficient exposure to the film to boost *all* density values above the intrinsic toe of the characteristic curve.

Making a Negative from a Photograph

The nature of the characteristic curve of photographic materials tends to distort the scale of values of the subject, and this distortion is painfully apparent in the majority of ordinary copies of photographs. For a true rendition of values, all the values of the subject should fall on the "straight-line" section of the characteristic curve of the copy negative. Theoretically, this copy negative should be developed to a gamma of 1.0 [so that the contrast of the negative is the same as that of the original print]. Then, printed on a paper of appropriate exposure scale, the print should duplicate the values of the original photograph. Unfortunately this ideal procedure does not always work out; in fact, it practically never does under ordinary circumstances of work.

While taking a picture of a photograph may seem to be a simple way to make a copy negative, the tonal range of a print made from a second-generation negative usually makes it readily identifiable as a print *not* made from an original negative. The copying process tends to compress the tonal values of shadows and highlights and increase the separation of the midtones. These complications can be minimized if care is taken in the choice of film, exposure, and processing conditions.

Figure 5.2: *Copy stand.* A copy stand consists of a post on which a camera can be mounted, a baseboard, and two or more lamps that provide uniform illumination on the baseboard.

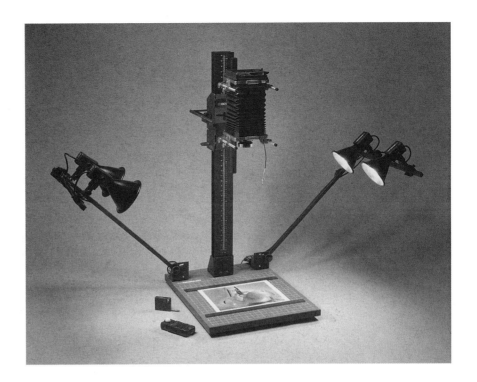

Copy Setup

Important! *The camera and subject must be placed and supported so that no vibration or movement of any kind is possible. The exposures will sometime be rather long, and walking about may jar the floor and the camera.*

The configuration of a copying setup is important, and it is critical that the photograph, the camera lens, and the film holder all lie in parallel planes to minimize focusing problems and geometric distortions. Commercial copy stands are available for 35mm, medium-format, and view cameras and may include a pair of lamps that ensure reflection-free lighting of the subject.

If copying work is an occasional event, tacking a sheet of dark-colored mounting board to a wall, fixing a print to the board, and photographing the assembly with a carefully placed camera on a tripod is satisfactory. Alternatively, you can purchase or make a galvanized-steel copyboard and attach it to the wall. Prints can be held in place on the steel copyboard with magnets or magnetized tape.

To eliminate skewing of the image, the camera lens must be directly opposite the center of the print being photographed, and the print, lens, and film must lie in parallel planes. The best way to proceed is to use a marking pen to rule a rectangular box about the size of the photo you will be copying on a sheet of paper (a sheet of graph paper is ideal since it contains an obvious grid) and attach it to the mounting board. Some fine scribbles in the center and corners can aid in focusing.

Place the tripod and adjust the camera until the lens is directly opposite the center of the copyboard and make whatever adjustments necessary to eliminate any signs of convergence that are manifested in the image of the grid that appears on the ground-glass focusing screen of the camera. The camera should

Figure 5.3: *Copy setup.* (A) A simple way to copy is to mount the image on a wall or tilted surface and use a view camera to photograph it. An enlarging lens makes an excellent copy lens since it is optically corrected to give maximum resolution at close film-to-subject distances. (B) To prevent distortion of the object being copied, the plane of the film must be parallel to that of the subject. A carpenter's leveling protractor is a simple way of measuring tilt angles.

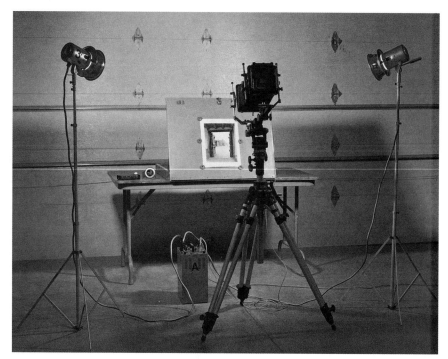

A

B

be close enough to the copyboard that when the print is attached to the board, its image fills most of the viewing area.

Setting up to make a copy of a photograph requires careful attention to details. If the purpose of photographing a print is to make a copy negative that is to be used for contact printing, a view camera that will produce a large-format negative must be used. The following general points need to be considered:

1. Environmental lighting degrades the blacks of the subject and casts a glare over the entire print surface. Copy work should be done in a dimly lighted room in which the only significant light on the print surface comes from copy lights that are focused directly on the print.

2. Two copy lights should be positioned facing the print and at a distance and angle that avoid reflections off the print surface. To check for surface reflections, set up the view camera to photograph, then remove both the lens and camera back and look through the camera's body to inspect the print for glare and reflections. A mirror of adequate size or a sheet of glass put in place of the photo to be copied will make any reflection immediately apparent.

3. Camera flare reduces image contrast. The print should be placed against a *black* background, and a lens hood should be used to shield the lens from any diffuse light.

4. A film with a long "straight-line" section or upward curving characteristic curve should be used, and *adequate exposure should be given* in order to place all print tones on this portion of the curve. In copy work, a step or two of "overexposure" enhances the tonal separation of the shadow values and forces the tonal values to fall on the straight-line section of the characteristic curve at the modest cost of requiring slightly longer printing times than usual for the copy negative.

Copy Lenses

A word about lenses for copying: The ideal lens for close-up work is a process-type lens (that is, a lens especially designed for highest quality images when working within distances up to several times the focal length of the lens). However, for all practical purposes a fine anastigmat will serve the purpose admirably. But for very close work (obtaining images of equal, or nearly equal size) the process-type lens has decided advantages. A good focussing magnifier is essential, and with subjects that are not sharp in themselves, focussing can be determined from a calling card or other small area containing sharp lines or characters, placed flush *with the surface of the subject.*

Figure 5.4:

Kodak Copy Film 4125: Kodak HC-110 Developer, Dilution E (1:11)

Copy film — characteristic curves. Copy film is preexposed during manufacture to ensure that any further exposure will be above the threshold film speed. The density ranges of the positives and copy negatives produced are influenced by both exposure and development times.

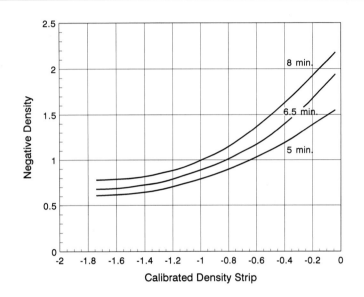

Figure 5.5:

Kodak Copy Film 4125: Kodak HC-110 Developer, Dilution E (1:11)

Copy film — exposure and development consequences. Precise control of the exposure of copy film is critical because small differences in exposure times will result in large changes in the density range and contrast of copy negatives and positives.

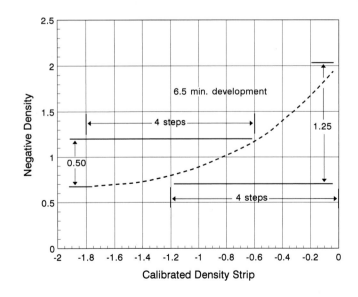

For ordinary camera lenses focused at any specific distance, the two-dimensional array described by connecting all of the points of *sharp focus is a curved surface, not a flat plane.* This means that when a lens is focused on the center of a flat object (such as a photographic print), the edges are out of focus and vice versa. *Process lenses,* specially made for copy work, are designed to *focus on a flat field* at a distance of eight times or greater than the focal length. With maximum apertures of f/9 to f/11, they are typically slower than normal camera lenses but can be stopped down to very small lens openings. A good process lens distributes light uniformly over the surface of the film, whereas with a typical camera lens there is a considerable fall-off in light intensity toward the edges of the film plane.

A high-quality enlarging lens fitted to a view camera is usually the best choice for copy work. Because exposures are often in the range of several seconds, a card covered with black velvet and held in front of the lens can serve as an appropriate shutter for time exposures.

Macro lenses for 35mm cameras are designed to photograph flat fields. If an ordinary camera lens is used for copy work, stop down the lens as much as is practical to ensure overall image sharpness. The trade-off for stopping the lens down is that diffraction begins to degrade image sharpness, and the longer exposures necessitated by the small aperture may require correction for reciprocity failure of the film.

Bellows Extension Factor When view-camera lenses, which are focused by adjusting the distance between the lens and the film plane, are extended beyond the infinity-focus position, the effective aperture of the lens is reduced, and the exposure must be increased to compensate for the decrease in light intensity that reaches the film plane. The formula for calculating the increase is simple:

$$d^2/f^2 = \text{exposure factor}$$

where d is the measured distance between the film plane and the center of the lens, and f is the focal length of the lens. For example, if a 12-inch (300mm) lens is extended to 18 inches, the exposure correction is as follows:

$$(18)^2/12^2 = 324/144 = 2.25$$

This means that the exposure given by taking a light-meter reading should be slightly more than doubled (if the indicated exposure is $1/60$ second, use an exposure of $1/30$ second). For ordinary work, round off the correction to the nearest step.

Lighting

Fluorescent lighting is excellent for black-and-white subjects if glare can be voided, and it minimizes the impact of grain if the original print has a textured surface. The most critical factor in lighting black-and-white or color prints for copying is to make sure that the light intensity is uniform over the entire surface of the subject being copied and bright enough to minimize exposure. An electronic flash works well for all films, but be careful to avoid reflections off

Figure 5.6: Alan Ross, *Lightstorm, Yosemite National Park, California, 1975.* The copy print (B) was made by photographing the original print (A), using the setup described in figure 5.3. Both Kodak T-Max 100 and Kodak Copy films were used to make copy negatives, which were subsequently printed. The Kodak T-Max 100 4 x 5 sheet film was exposed at EI 64 and given +2 development in Ilford Ilfotec HC 1:24. The shadow values were placed on Zone II, and the highest value fell on Zone VII. A 240mm enlarging lens set at f/22 was used on the camera, and illumination was by electronic flash. The quality of the copy print is extremely faithful to the original, and only a slight loss of detail in the extreme shadows and highlights can be found on close inspection of the image. A similar result was achieved using Kodak Copy Film.

A

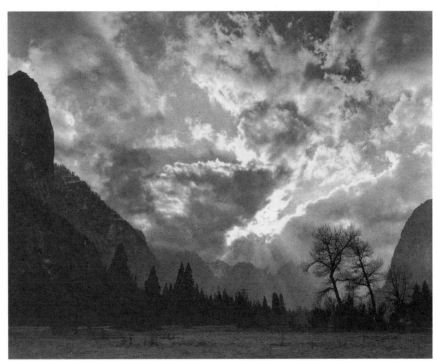

B

the surface of glossy prints — "modeling" lights make it easy to detect potential problems from flash units.

With color films, *particularly transparency films,* filters may be needed to compensate for the difference in the color temperature of the lighting and the color balance of the film. Any light source can be used to illuminate the print, but with color film be sure that the color temperature of the lighting matches

that of the film. The insert that accompanies each packet of color film specifies its lighting requirements and provides instructions and data that can be used to apply reciprocity corrections when necessary.

Films for Photographing Prints

In a typical photograph shadow values fall on the toe of the characteristic curve, where the separation of luminance values is compressed relative to the subject. When a negative is printed on photographic paper, *both* the shadows and highlights are further compressed. It is important when you make a copy of a photograph to select a film and development conditions that will undo as much tonal compression as possible while not adding to the separation that already exists in the midtones.

The characteristic curves of Kodak T-Max films have a short toe and a very long straight-line section, and the contrast of negatives from these films can easily be increased by extending the development time. These properties make them very suitable for use as copy films.

Several test exposures are almost inevitably necessary to determine the ideal exposure and development conditions for a particular subject. Work toward the best separation of highlight detail that you can achieve and give sufficient exposure to ensure that all important shadow details are recorded. Figure 5.6 shows an original print and a copy print made from a copy negative.

Electronic Scanning of Prints

With recent advances in the application of digital-imaging technology to photography, an alternative route to copy negatives is available. Prints can be scanned on a flatbed or drum scanner (see chapter 12), the data enhanced or modified as desired, and then output directly from a computer to a film recorder that produces a continuous-tone negative with extremely high resolution. Alternatively, the data in the computer can be converted by an image setter to a halftone negative that can be used to make copy prints that are faithful to the original image.

Modern image setters are capable of producing halftone negatives with resolutions of 3,000 dots per inch (dpi) or more on 400- to 600-line screens. This means that the dot pattern is discernible only if the image is closely examined with a magnifier. In short, for all practical purposes, a halftone negative of this quality behaves as if it were a continuous-tone negative with an extremely fine grain structure.

Making copy negatives by electronic scanning of an image is a service that is now routinely offered by modest-sized printing shops at reasonable prices. Because the vocabulary of the printing trade differs slightly from that of photography, you will need to take time to explain your needs and objectives to the person who operates the scanning and film-output equipment. A few trial runs may be necessary before you get a negative that has the characteristics needed for photographic printing rather than one optimized for transferring printer's ink to paper.

Figure 5.7: Ansel Adams, *Georgia O'Keeffe and Orville Cox, Canyon de Chelly National Monument, 1937.* (A) The 35mm negative from which this print originated slipped from its holder while it was drying in the darkroom and was seriously damaged. A print was made that showed deep scratches in the sky and other defects. Early prints were made by carefully retouching, spotting, and airbrushing out the flaws. The retouched print was then photographed to make a copy negative from which fine prints were made. (B) The reproduction print in this example was made by scanning the original image, making needed corrections on the digital file, and printing a copy negative. The image quality of a print from the digital file is vastly superior to that made from a traditional copy negative.

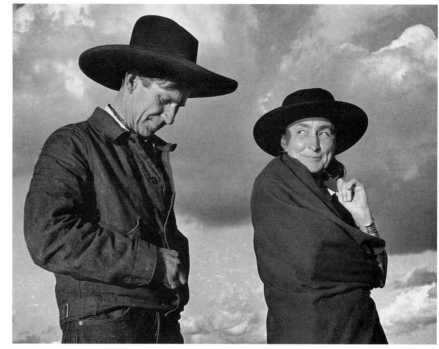

A

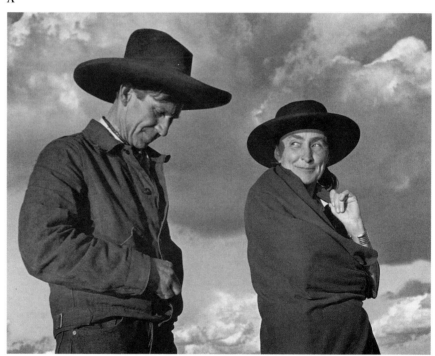

B

Making a Negative from a Negative

One-Step Method

Although the characteristic curve of photographic films is usually described as being S-shaped, this profile applies only to the portion of the curve used for the normal exposure and development conditions employed for traditional photography. A more extensive examination of the behavior of silver salts toward light and development reveals that their response is far more complex. While increasing exposure does first result in increased negative density, beyond a certain point, further exposure causes *a steady decrease in sensitivity* of the film. Taken to an extreme, grossly overexposed silver salts do not respond at all to developers. The full profile of a characteristic curve is more nearly bell shaped. The phenomenon of reversal is occasionally noticeable in landscape photographs where the sun is included as part of the image; its

Figure 5.8:

Characteristic Curves

Generalized characteristic curve. (A) The complete characteristic curve for a film is bell shaped. Beyond a certain point, additional exposure begins to desensitize the film and a reversal of normal tonal values is observed. (B) Kodak SO-339 Duplicating Film with DK-50 Developer is exposed during production, and any additional exposure given in the darkroom decreases negative density proportionally. Projecting a negative onto this film, followed by development, produces a copy negative in one step.

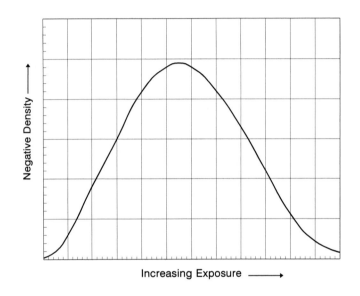

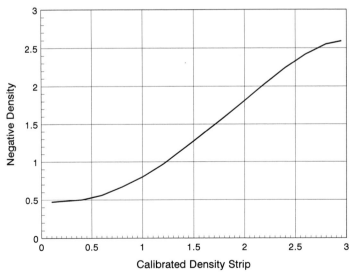

intensity brings about a reversal of tones, so that the image of the sun in the negative is a blank disk, and the sun prints as a black disk in the photograph.

Kodak's SO-339 Duplicating Film is an orthochromatic film (blue sensitive) that has been preexposed to the degree that *further exposure results in a proportional decrease in negative density* upon development (that is, the film's sensitivity is shifted over to the downslope of the characteristic curve). The result is that exposing Kodak SO-339 Duplicating Film automatically reproduces the original image rather than its opposite; projecting a negative on the film produces a copy negative directly upon development. The contrast of the image is controlled by development: increasing development increases contrast. Unlike with ordinary photographic materials, however, more exposure lightens the overall image, while less exposure darkens it. The film is considerably slower than enlarging paper, and exposures typically lie in the region of 30 seconds or more at f/11 for an image projected from an enlarger. Determine the correct exposure by evaluating a series of test exposures on a sheet of film, made in the same way you make a test print. Be certain that adequate detail is reproduced in both the shadows and highlights and remember, increasing exposure *lightens* the image, in contrast to the behavior of photographic papers. Local density corrections can be made by using dodging and burning-in techniques, but again, the effects are the opposite of those observed in making a print: dodging increases negative density; burning-in decreases it.

Kodak recommends that a clearing agent *not* be used after washing the developed film. Instead, wash the film in running water for 30 minutes and hang it up to dry. If the film is to be exposed to intense light for prolonged periods of time (as is typical in platinum printing and the like), additional protection can be provided by toning the negative in a 5-percent solution of Kodak Rapid Selenium Toner for 3 minutes after fixing and washing. Toning does increase negative contrast, and you may need to decrease the development time for the film if increased contrast is a problem that cannot easily be compensated for during printing.

Kodak SO-339 Duplicating Film is an excellent way to make copy negatives closely mimicking the originals in tonal range and values. However, it is difficult to reproduce *both* highlight and shadow details for long-scale images. Negative highlights can be enhanced by swabbing them selectively with a dilute solution (1:10) of Kodak Rapid Selenium Toner. Selenium toning can increase negative density by 20 to 25 percent, and, with care, highlight contrast (for example, cumulus clouds) can be elevated substantially without altering the contrast of the remainder of the image.

Two further limitations of Kodak SO-339 Duplicating Film are that it is available only in sheet film sizes up to 8 x 10, and it is moderately expensive (approximately $5 per sheet for 8 x 10 film). If you can work within its limitations, however, it is an excellent product and convenient to use. Figure 5.10 provides a comparison of prints made from an original and a Kodak SO-339 copy negative.

Two-Step Method

Although more effort is required, better copy negatives can be generated by enlarging or contact printing a negative onto a sheet of film to make an *interpositive* (the same as a positive, but often called an interpositive when its purpose is to produce a copy negative). This interpositive film is then used in the identical procedure to expose and print a copy negative. The extra work involved in the two-step process is justified because tonal values can be controlled at each stage. For example, burning-in and dodging can be used for local density control, and the overall image contrast can be altered by controlling development when you are making either or both the positive and negative. Retouching can be done on the interpositive, which looks like a black-and-white transparency, where it is easier to judge the effect of changes.

To minimize the image degradation that is inevitable with enlargement, the best way to proceed is to make the interpositive by enlargement. The copy negative can then be produced from it by contact printing. While almost any film type can be used to make interpositives and copy negatives, for accurate tonal reproduction, films with a short toe and a long straight-line section are best.

Kodak Commercial Film 4127 is a convenient and excellent choice for copying work. It is orthochromatic, which means that it can be handled under a safelight like enlarging paper, and it has very fine grain. Other excellent choices are Kodak Technical Pan Film, which has extremely fine grain and whose contrast is readily controlled by developer selection and the exposure conditions, and the Kodak T-Max films, which have characteristic curves with long straight-line sections. Kodak Technical Pan Film is also well suited for

Figure 5.9: John P. Schaefer, *Black Sun, Lake Rotarua, New Zealand, 1990.* The exposure was based on the measured luminance values of objects in the foreground. The several-thousandfold relative brightness of the sun caused a reversal in tonal values, and its image appears as a blank disk on the negative, which prints as a black disk in the photograph.

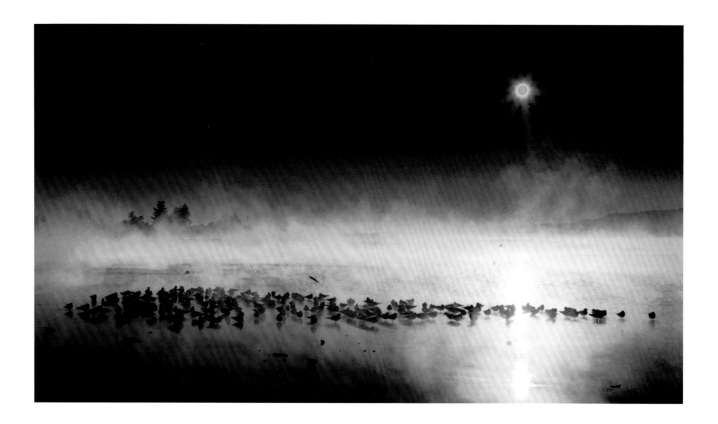

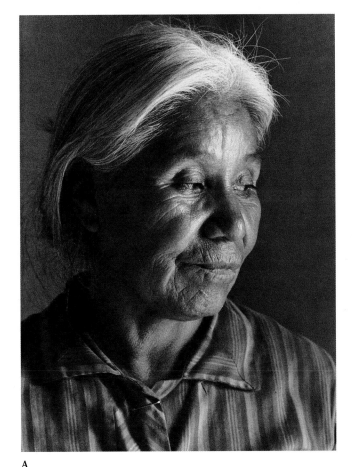

A

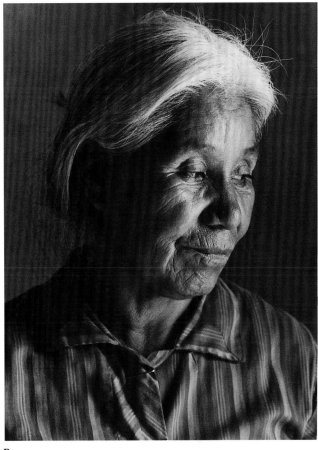

B

Figure 5.10: John P. Schaefer, *Papago Madonna, Sonora, Mexico, 1978.* (A) A print made by direct enlargement from a 35mm negative. (B) An 8 x 10 contact print made by enlarging the 35mm negative on Kodak SO-339 Duplicating Film.

copying black-and-white or color photographs and for making negatives directly from prints. With any film used for copying, to increase contrast, increase the development time; to decrease contrast, do the opposite. With care and effort a print from a copy negative made by the two-step process can approach the quality of one made from the original negative.

Preliminary Tests for Two-Step Copying The following procedure is a guide to determine optimal exposure and development conditions for two-step copying of negatives. You need an enlarger, a contact printing frame or a sheet of ¼-inch plate glass, and a calibrated density strip (see page 57) in addition to the standard equipment and supplies used for processing sheet film.

1. Purchase a box of *orthochromatic* sheet film in the size desired for the duplicate negative. Orthochromatic films enable you to work under a dark red safelight, which greatly simplifies darkroom operations throughout all of the steps that follow. If you choose to work with a panchromatic film, all operations with the film must be carried out in total darkness, but the end result will be the same.

Figure 5.11: John P. Schaefer, *Facade, Mission San Xavier del Bac, Tucson, Arizona, 1978.* (A) Print from the original 4 x 5 negative. (B) The original negative was contact printed onto a sheet of Kodak Commercial Film 4127 (orthochromatic) to make a positive. The positive was enlarged by exposing it on an 11 x 14 sheet of Kodak Super XX Film. The important shadow and highlight values are retained in the contact print made from the two-step copy negative. An even closer match could have been achieved by careful dodging and burning-in.

2. In order to lengthen exposures to manageable times (5–10 seconds), set your enlarger to its maximum possible height. Focus the enlarger on the baseboard, then set the enlarging lens to its smallest possible f-stop. Alternatively, place a piece of diffusing material, such as diffusing Plexiglas, under the lens or dim the light intensity of the enlarger by using neutral density filtration.

3. Prepare the developer, stop bath, and fixer and arrange the trays as you normally do for processing sheet film.

4. Turn off the room lights (you can leave on a dark red safelight if you are using an orthochromatic film), remove a sheet of film from its box, and cut it into a series of strips about 2 inches wide. Put these in a light-tight box or wherever you normally store printing paper, making note of which side of the film contains the emulsion. (Keep the strip with the code notch as a reference if you have trouble identifying the emulsion side and orient all of the strips in the same direction. Alternatively, hole-punch each strip in the upper right-hand corner to identify the emulsion side of the film.)

5. Take a film test strip and lay a calibrated density strip over it and in contact with the emulsion side of the film. Put the two in a contact-printing frame or cover the sandwiched pair with a sheet of plate glass and place the assembly directly beneath the lens on the baseboard of the enlarger. *Be certain that the emulsion side of the film faces the enlarging lens and that the calibrated strip is between it and the lens.*

6. The targets you are seeking are the correct exposure and development times for the film required to reach the *same* contrast range as the original. Make a trial exposure of 10 seconds, then develop the film strip for 5 minutes at 68°F in Kodak HC-100, dilution A, or a comparable developer.

7. Complete processing in the usual manner, turn on the room lights, dry the film with a blow-dryer, measure the density of each visible step on the film, and plot the characteristic curve.

8. Interpret the curve. On a twenty-one-step calibrated strip, steps eleven and twelve have density values in the range of 1.6 to 1.75. On a correctly exposed sheet of film, these steps are among the last that you should be able to distinguish, with density values for higher numbered steps being 0. If the density value of step twelve is greater than 0.1, exposure needs to be reduced; if the density value is less than that, exposure needs to be increased.

Find the step in which the density value is 0.1 above (film base + fog), note its number, and divide the difference between that number and twelve by two; the answer is the number of steps of exposure correction you must apply to future exposures (remember, two steps of the calibrated strip equals approximately 0.3 density units, which is equivalent to one exposure step).

As an example, suppose that for a test strip, step sixteen has a density value of 0.1; the film has obviously received too much exposure. Since 16 − 12 = 4, divide 4 by 2 ($^4/_2$ = 2) and *reduce* the exposure for the next test strip by two steps (that is, cut the exposure from 10 seconds to 2.5 seconds). Conversely, if step nine has a density of 0.1 above (film base + fog), you would

A

B

need to *increase* the exposure by 1½ steps by changing the exposure time to 30 seconds or by opening the lens aperture one stop and increasing the exposure time to 15 seconds.

9. Ideally, the contrast of the characteristic curve should be the same as that of the calibrated density strip. If the density range of the negative is less than that of the calibrated strip, increase the development time for the next test strip; if it is greater do the opposite.

10. Repeat number 6, above, using the new estimates for exposure and development time. If the results are close to what you are aiming for (maximum density = 1.6 – 1.75, with step-twelve density approximately 0.1), expose several test strips and develop them for times greater and less than that normally required to achieve an estimate of magnitude of development times that will produce negatives with higher and lower contrast if you subsequently decide to alter the image contrast. In the process of making copy negatives or interpositives, about two steps of *overexposure* is always desirable, because it forces the information contained in the densest portion of the starting negative (or interpositive) off the toe of the characteristic curve of print film and onto the straight-line section, which results in superior tonal separation of shadow values and highlights in a print made from a copy negative.

Making an Interpositive and a Copy Negative

To make a copy of a negative that is the same size as the starting negative, you must first make an interpositive by contact printing and then make a negative from the interpositive by following the same steps.

If you want an enlarged copy negative you have two options: (1) make an enlarged interpositive on film by projection and then make the copy negative by contact printing the interpositive; or (2) make an interpositive by contact printing the negative, then make the copy negative by projecting the interpositive onto a sheet of film.

An advantage of the first option is that you can dodge and burn-in the image as if you were making a print, thereby making local corrections of tonal values that will carry over to the new negative. A disadvantage of this approach is that more expensive large sheets of film are used in both steps, and costs can rapidly mount. If you are starting with a small-format negative, however, option (1) gives the best results.

As with any printing process, the image inevitably has defects that arise from dust spots, pinholes, and so forth. Correct these on the interpositive by taping it to a light box and carefully spot, bleach, and etch it as you would a fine print.

Contact Printing Method

Contact printing can produce a more faithful copy of an original because projecting an image through a lens inevitably degrades image quality. In printing, however, great care must be taken to avoid introducing imperfections such as dust spots, which will be magnified when the interpositive is subsequently enlarged.

1. Thoroughly clean the negative (or interpositive) you wish to print on film and store it in a dust-free location. Placing it in a folded Mylar sheet makes it easily accessible and prevents dust from accumulating on its surface.

2. Prepare the solutions that you need for processing film. Turn off the darkroom lights, remove a sheet of film from its box, and place it emulsion faceup on the baseboard of your enlarger, using the same setup described in numbers 6 through 10, above, to determine exposure and development times.

3. Place the negative (or interpositive) to be printed facedown on the film and put the assembly into a contact printing frame or cover it with a heavy sheet of plate glass. The emulsions must be in intimate contact during exposure.

4. Use the time previously determined in your film tests as a guide for the approximate exposure required and use an opaque card to make a series of exposures just as if you were making a test print. Remember, one or two steps of overexposure is desirable to ensure that all of the photographic information contained in the starting negative (or interpositive) falls on the straight-line section of the characteristic curve of the copy film.

5. Process the film using whatever development time you judge is needed to adjust the contrast of the final enlarged negative. After the interpositive is dry, examine it carefully on a light box and choose the best exposure. Inspect both the highlights and shadow areas to make certain that details are clearly defined. Choose an exposure in which the highlights appear somewhat veiled and contain appropriate details with sufficient contrast.

6. Make the interpositive (or copy negative) using the exposure and development times that were determined in the above tests. Make any necessary local corrections to the interpositive by dodging and burning-in the image just as you would if you were making a contact print on photographic paper.

7. Process the film and retouch any imperfections as you would with a fine print.

Enlargement Method

Careful work habits are essential for making high-quality copy negatives. The extra effort required to ensure that the starting negative is absolutely clean will save hours of time needed to remove imperfections introduced from the interpositive or copy negative.

1. Set up an enlarger as if you were going to make a black-and-white print. Place the negative to be copied in the negative carrier, remove any visible traces of dust, and insert the carrier into the enlarger. Adjust the blades of an enlarging easel to the appropriate size, cropping and focusing the image on a sheet of white paper. Stop down the aperture of the enlarging lens to ensure corner-to-corner sharpness of the projected image.

2. Insert a sheet of film into the easel and make a series of test exposures as you would with a trial print. Process and dry the film and evaluate it carefully as described in number 5 of the previous method. The interpositive produced should be about two steps overexposed to ensure that details from the densest portions of the starting negative are recorded above the toe of the film.

3. Using the exposure and development times that you have determined to be appropriate, expose and process the interpositive. Again, dodge and burn-in the image to achieve whatever local controls are desirable.

4. Use any necessary postprocessing procedures to eliminate obvious defects.

The techniques for making copy negatives or interpositives by contact printing or enlargement are quick and reliable. While both the interpositives and copy negatives made by this procedure will have an overall density that is greater than you would normally desire, overexposure results in better reproduction of shadow values and highlights. To compensate for the higher density, you will need to increase the printing time, but this is a minor inconvenience that is easily compensated for by the superior print quality that results. With care, the copy negatives should retain all of the details present in the original.

Litho Film

Litho film, more properly called *process film* to reflect its intended use with a process camera (that is, a large-format view camera used primarily for making halftone negatives in the printing trade), is a high-contrast film used extensively in the graphic arts. With the exception of Kodak Contact Process Pan Film, litho film is orthochromatic and can be handled safely in red or amber light. It has approximately the same emulsion speed as black-and-white enlarging paper and can be exposed either with the emulsion faceup or through the back of the film, which requires about twice the normal exposure. Litho film's most distinguishing characteristic is that, when exposed and developed as recommended by the manufacturer, the transparency produced (negative or positive) is the ultimate in high-contrast imagery. Essentially, no intermediate gray tonal values are produced — the film is either an opaque black or clear.

Litho film is most often used to make halftone plates or films for the printing industry when printed images are either typeface or photo-reproductions generated by creating a mosaic of dot patterns that simulate the continuous tones of a photograph when viewed from a distance. However, photographers have explored the properties of litho film and have learned how to shape its properties to achieve their own ends.

Litho film is a special-order item for camera shops, but it can usually be found in stock in graphic arts stores that supply the printing trade. Many manufacturers (for example, Kodak, DuPont, Agfa, 3M) make litho films and special developers for their products. Any one of these will work for photographic applications, even though specific films and developers will differ slightly in performance. Consult a catalog for descriptions of the film characteristics before you make a selection. Litho developers contain a much higher percentage of restrainers such as potassium bromide than is found in ordinary film or paper developers. The restrainer inhibits the development of subject matter that would normally fall on the low end of the characteristic curve, where shadow details are recorded.

Figure 5.12:
Kodaline Litho Film:
The Effect of a Restrainer
on Development
Restrainers and litho film. Litho film developers are formulated with a high concentration of a restrainer that compresses the effective exposure range of the film to one zone. With highly dilute traditional developers the tonal range and sensitivity of litho films can be expanded.

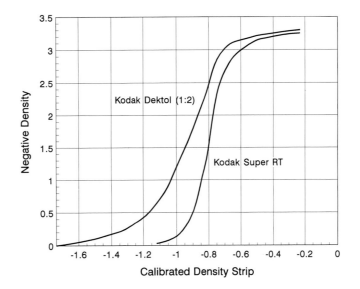

Figure 5.12 graphically displays the restraining influence of potassium bromide on the development of litho film. With Kodak Super RT Developer, which is rich in potassium bromide, the transition from virtually unexposed film to opaque (density > 3.0) corresponds to an exposure difference of less than 0.2 of a negative-density unit (less than one f-stop). If the film is developed in Dektol (diluted 1:2), some intermediate tonal values between black and white are clearly distinguishable in the negative. Adding 10 ml. of a 10-percent potassium bromide solution to each 100 ml. of Dektol prior to dilution causes the developer to behave more like Kodak Super RT and increases the negative contrast.

Useful developing times range from 1.5 to 3 minutes for litho films in high-contrast developers. Stock solutions of developer components are prepared as two separate solutions. These are mixed in equal portions just prior to use, because the developer undergoes rapid air oxidation after the two parts are combined. Depending upon conditions, the developer has a useful life of 30 minutes to an hour, and for this reason you may prefer to mix only small quantities as it is needed and use it as a "one-shot" developer.

The agitation pattern used during development of litho film influences the image that is produced. Constant agitation can initiate development beyond the dark edges of an image where exposure occurred and cause small gaps in the image to be filled in with reduced silver. This is especially important if the image contains fine details — these may be lost if constant agitation is used. Follow the agitation pattern recommended by the manufacturer of the film and developer that you use.

Kodalith Fine Line Developer has properties that emphasize fine structural details in the image. The recommended agitation cycle is to gently rock the film in a tray of developer for the first 20 to 40 seconds, then allow it to stand motionless for the next 2 minutes. Complete processing in the normal manner.

In a correctly exposed negative the image begins to appear after about 30 seconds, then continues to darken for the next 1 to 2 minutes. Overdevelopment

results in opacity in unwanted areas, while underdevelopment often produces streaks in the image (which can usually be eliminated by adding a few drops of Kodak Photo-Flo to the developer). Exposures are best judged by making a test strip following exactly the same procedure you would use to make a photographic print. When working with litho film it is imperative to remember that the details of the image recorded on the film are controlled *primarily by exposure,* not development. The dodging and burning-in procedures that are used when making a photographic print can be used in the same way when litho film is being exposed.

Use a very dilute stop bath (add just a spritz of acetic acid to 1 liter of water) after development (a stronger stop bath will cause pinhole blemishes in the developed film) and then transfer the film to a fixer. Because of the ultrafine grain of the silver halide emulsion, fixing is very rapid, and the film clears within 15 seconds. Be sure to agitate the film in the fixer for at least twice the time it takes to "clear the film," or remove the white milky coating that you can see with the safelight on. Wash the film for 3 minutes in running water, rinse it in a bath of water containing a few drops of Kodak Photo-Flo, and hang it in a dust-free area until it has dried. Any pinholes or unwanted black spots can be removed by applying Opaque, using a marking pen, or by scraping off the emulsion with a sharp knife.

Continuous-Tone Negatives from Litho Film

With extremely dilute solutions of Dektol (or any other traditional film- or paper developer) and careful exposure and development, it is possible to make good-quality continuous-tone negatives and positives with litho film. Photographers often use litho film to make enlarged "copy negatives" by first enlarging the original negative to make a "positive," then making a contact print of the positive to generate an enlarged negative. The relatively low cost and ease of working with litho film makes this approach appealing, and if the enlarged copy negatives are to be used in any of the alternative printing processes described in the following chapters, it is a simple matter to tailor the contrast of the copy negative to the particular process.

Figure 5.13 illustrates a family of characteristic curves for Kodaline Litho Film developed in Kodak Dektol at a dilution of 1:15 (72°F). The curves have a well-defined S shape with a clearly distinguishable toe, a straight-line segment that spans up to 1.2 units of negative density reasonably well before it transitions into a pronounced shoulder. The curves' features indicate that litho film can be used to make continuous-tone copy negatives if you are willing to accept some compression of tonal values in the shadows and highlights of the image.

Figure 5.13:

Kodaline Litho Film: Kodak Dektol Developer (1:15 Dilution)

Continuous-tone negatives from litho film. Highly dilute soft-working developers can be used with litho films to produce continuous-tone images. The quality of the images is poorer than what can be achieved with films intended for pictorial purposes.

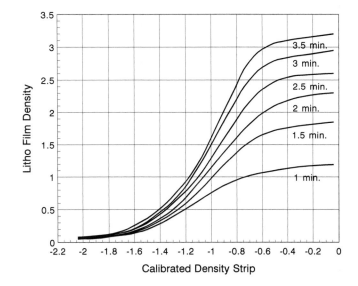

A *significant* improvement in tonal reproduction can usually be achieved with litho film by preexposing the film prior to the main exposure. Giving the film an initial overall exposure *just sufficient to reach the exposure threshold of the film* helps to ensure that all density values in the starting negative will be recorded on the litho film with sufficient exposure. To determine the correct level of preexposure, use your enlarger to make a series of exposures on a strip of litho film and develop the film as you normally would. The threshold exposure level of the litho film will by marked by a sudden transition from blank film to a patch with noticeable density. For example, in a series of exposures of 1, 2, 3, 4, and 5 seconds, no developed density might be noted until the 4-second patch is reached. Under these circumstances use a preexposure time of 3 to 4 seconds prior to making the basic exposure of the film to the negative.

Figure 5.14:

Preexposure of Kodaline Litho Film: Continuous-Tone Development with Ilfotec HC Developer (1:100)

Preexposure of litho film. Preexposing litho film results in far better tonal reproduction of shadow values and should always be done if copy negatives are being made.

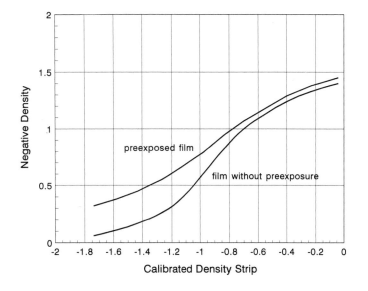

The Golden Gate from Twin Peaks,
San Francisco, 1954

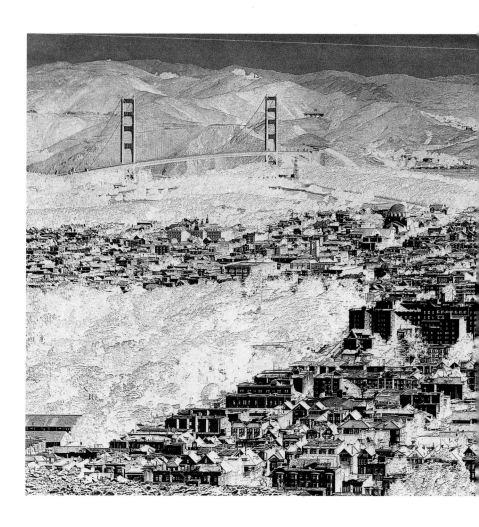

When I set out to design a new letterhead for myself, circa 1947–48, I found out that Eastman Kodak had published a book that included information on a special negative-making technique for photolithography. Basically, it consisted of making a "soft" (underexposed) positive from the original negative, binding the two together in register, and placing that ensemble in a contact printing frame on a sheet of Kodalith film. Registering a weak positive image with a negative in effect creates a surrogate negative with an extremely low contrast. The frame was placed on a revolving platform (I used a small potter's wheel) and exposed to light placed at about 45 degrees from vertical. This procedure has the effect of allowing only a thin sliver of light to pass through the negative/positive sandwich along the edges of imaged objects in the original negative. The exposed Kodalith was then processed in high-contrast litho developer.

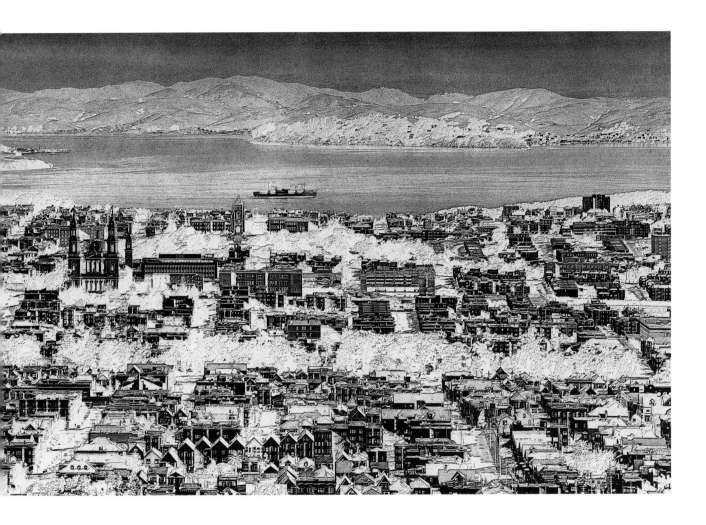

With careful control of the exposure/development procedure it was possible
to print out only the image highlights on the Kodalith film. The image that
appears on litho film is determined solely by exposure. There are no "rules" for
precise exposure control since a slight variation in exposure produces a different
aesthetic effect. After a few trials I decided that by starting with a low-contrast
original negative I got the best end results. For the project I chose a slightly
overcast but clear day to make the original negative for the print shown.
The characteristics of the litho films that were subsequently generated could be
determined only by trying various combinations of exposures until a satisfactory
result was achieved. Kodalith films are orthochromatic, so all of the exposures
could be carried out under a red safelight. Test strips to evaluate the effect
of varying exposures were made for each exposure in the same manner as for
making a photographic print.

Original 8x10 negative.

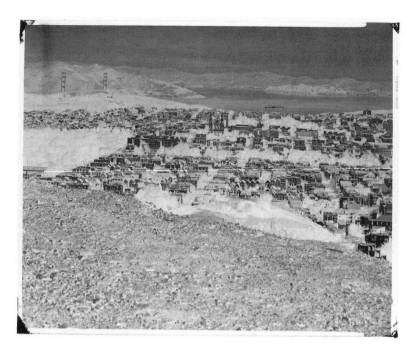

Soft interpositive on continuous-tone film.

> To aid the registration of negatives and positives I scratched lines at the edges of the original film with a pushpin. Extra care had to be taken to avoid dust, finger marks, and Newton's Rings throughout the process, since any defects were magnified in subsequent steps. The technique for making tone-line images inherently lends itself to experimentation. I sometimes tried variations such as making subsequent generations of Kodalith films, reexposing the Kodalith for a Sabatier effect (solarization of the image), and exposing the film at angles other than 45 degrees. The exposures and development were often not too controlled, and some of the "accidents" that occurred were so visually exciting that I used these instead of what I had naively set out to do.

Sandwich of original negative and interpositive.

Tone-line positive on litho film from sandwiched negatives.

One of the qualities that I found intriguing about the process was the degree to which enlargements from Kodalith negatives could be made. The final print exhibited virtually nothing in the way of conventional "grain" structure, and tremendous enlargements could be made without the typical disintegration of detail usually associated with such magnifications. I often made very large prints from small portions of my tone-line films.

— M. HALBERSTADT

Figure 5.15: *Litho film effects.* This set of illustrations demonstrates some basic uses and transformations that are possible with litho films. Virtually all applications are variations of these fundamental operations. (A) A full-scale print from the original negative. (B) Positive image made by enlargement of the original negative onto litho film; exposure 8 seconds; f/16. (C) Positive image; exposure 10 seconds; f/16. (D) Positive image; exposure 12 seconds; f/16. (E) Positive image; exposure 14 seconds; f/16. (F) Negative image made by contact printing B. (G) Negative image made by contact printing C. (H) Negative image made by contact printing D. (I) Negative image made by contact printing E. (J) Positive line image made by registering images D and H and contact printing the sandwich on a new sheet of litho film. (K) Negative made by contact printing J. Each sheet of positive or negative litho film can be used separately or in combination to generate new images on color or black-and-white paper.

Examples of the Use of Litho Film

In figure 5.15, A is an unmanipulated print from a 2¼-inch square negative. Figures B through E illustrate the influence that small changes in exposure (f/16; 8, 10, 12, and 14 seconds, respectively) have on the positive image produced. Note that none of these images displays tonal values other than white or black; the image content is determined solely by exposure. Figures F through I are made by contact printing the positive film images onto another sheet of litho film to bring about a complete reversal of tonalities.

Overlaying a positive and a negative image produces an opaque sandwich that permits a minute amount of light to "leak" around the internal boundaries of the image. When the sandwich is contact printed with a fresh sheet of litho film by holding the printing frame beneath the enlarger and tilting it in random fashion so that the light strikes the surface of the film at an angle, a "line drawing" that marks all of the black and white boundaries results when the film is developed (J). This technique is commonly referred to as the *tone-line process.* Contact printing variation J again reverses the tonal values (K).

High-contrast images are often valued in their own right, but they usually serve as intermediates for the construction of more complex images. Litho negatives and positives can be cut up and reassembled as collages to create new images from various fragments. Alternatively, a set of different exposures of the same image can be registered and printed sequentially on black-and-white or color paper to create a "posterized" photograph (images in which negative-density ranges are arbitrarily assigned colors so that the printed photograph resembles a poster).

Still Development of Litho Film

Litho film has the ability to reproduce extremely fine details, although it cannot generate a continuous-tone image with a wide-ranging tonal scale. Under the proper circumstances it is possible to convert the midtone values of the gray scale into a microscopic pattern of grain that mimics intermediate tones by creating a tightly defined grain structure. Subjects that have a lot of fine detail often lend themselves to interesting interpretations by using the following technique.

1. Insert a negative into the enlarger and focus the image on a sheet of paper that has been taped to the *baseboard* of the enlarger. Use a grain magnifier to ensure that the image is in sharp focus. Outline the corners of the projected image with a pencil so that you will know where to place the litho film.

2. Stop down the enlarger lens and turn off the enlarger lamp.

3. Position a sheet of litho film, emulsion side up, on the sheet of paper and cover the film with a sheet of frosted glass, rough side down.

4. Wipe the smooth surface of the sheet of frosted glass with a handkerchief using moderate pressure. This generates a small amount of static electricity and causes the film to cling to the glass.

5. Make a series of test exposures in the same way you would expose a print in the enlarger.

A

B

C

D

E

F

G

H

I

J

K

6. Lift up the sheet of frosted glass by one edge and allow the film to drop down and detach itself.

7. Slide the film into Fine Line Developer or a comparable product, agitate the film for about 10 seconds, then allow it to sit *undisturbed* in the developing tray for 2 to 2½ minutes of "still development."

8. Complete the film processing in the usual manner and evaluate the film to determine the correct exposure.

9. Repeat the exposure and processing steps to generate the litho positive.

The positive litho image created by this sequence can be used to make a print or generate a litho negative through contact printing or further enlargement and still developing of that film. See figure 7.17.

Infrared Films

Vision is the art of seeing things invisible. — JONATHAN SWIFT

The human eye detects radiation only in a relatively narrow region of the electromagnetic spectrum, whereas silver salts respond to a range that begins with X rays, passes through the ultraviolet and visible, and extends into the infrared. Special dyes are added to the film emulsion to extend its normal sensitivity beyond the visible spectrum and out into the infrared. While infrared film was developed primarily for scientific applications, it has been used extensively by photographers in pictorial work.

Infrared film responds not only to infrared radiation but to the entire ultraviolet and visible spectrum as well. With the use of strong red filters, the film's exposure by the visible spectrum and shorter wavelengths of light can be drastically muted or completely eliminated. For example, filters such as the Wratten #87 or #88 are opaque to all visible wavelengths of light and pass only the infrared. Infrared effects are most dramatic when a #87 or #88 filter is used, but because they are opaque, they work best with cameras that use a rangefinder for viewing (you are unable to see through a single lens reflex [SLR] system, and automatic exposure features cannot be used). If you use an SLR camera you need to focus on the subject prior to attaching the filter to the lens and set the exposure manually. Filters such as a #25 or #29 or an orange filter do cut off a portion of the visible spectrum and are practical alternatives to a #87 or #88.

Because infrared rays have a measurably longer wavelength than visible light, a small adjustment in camera focus is needed for infrared film. To bring a point of focus that has been made in visible light to the proper infrared focus, the lens focus point must be extended an additional ¼ of 1 percent. Most 35mm lenses have both a visible and infrared focus position marked on the lens barrel. When the camera is loaded with infrared film, focus the lens as you normally would, then reset the focus point to the infrared scale (usually indicated by a red dot on the lens barrel) before the exposure is made. With a view camera, focus the lens at maximum aperture, then extend the bellows by ¼ of 1 percent. For example, with a 300mm lens, the bellows should be extended

an additional 0.75mm (300 x 0.0025 = 0.75). Stopping the lens down to a small aperture helps to minimize any errors in focusing.

Unfortunately, stopping down a lens with infrared film imposes a new penalty on the user, namely increasing image diffraction, which occurs whenever a beam of light passes near the edge of an object or through a small aperture. The physical interaction that occurs between the light rays and an edge scatters the bundle of rays, so that at the point of sharp focus the image is a diffuse disk rather than a point of light. Diffraction accounts for the soft-focus quality of pinhole images, and it becomes more serious with lens photography when very small apertures are used. In addition to lens aperture, diffraction is directly proportional to the wavelength of light passing through the lens. The wavelength of infrared radiation is two to three times that of ultraviolet and visible light, which means that diffraction effects are increased two- or three-fold. Some of the soft-focus ethereal aura of infrared photographs is due to diffraction, which is often a sought-after quality in pictorial applications. To maximize the diffuse-image quality, expose the film at the smallest possible aperture; to maximize sharpness, focus carefully and make the exposure at the widest practical aperture.

Contrary to the almost universally held belief among photographers, infrared film does not respond directly to heat, but rather to the *infrared radiation* that is emitted by the subject. For example, regardless of the ambient temperature, the chlorophyll in living plants absorbs ultraviolet radiation from sunlight and is an extremely strong emitter of infrared radiation. Photographing healthy green vegetation results in a high degree of exposure on infrared film, and the dense black negative results in foliage printing as a bright white tone. Because dead foliage is not an infrared emitter the film is often used as a means of monitoring the health of a forest or landscape. Photographing a building that has surfaces heated by the sunlight will show very little, if any, infrared response. With a little experimentation you will soon learn those substances that are strong emitters of infrared radiation and those that are not (for example, blue sky or bodies of water).

Care and Handling of Infrared Film

Infrared film does degrade rapidly and will fog badly if it is subjected to high temperature for prolonged periods of time. At temperatures in the range of 65°F to 85°F I have kept infrared film in a 35mm camera for up to a week, cutting off a small strip of film each day and developing it to check for fog. By the fourth day fog was detectable on the film, but it was still perfectly usable at the end of the week.

Infrared film should be stored in a freezer until it is ready to be used, and its history prior to purchase is important. A dealer should keep film stored in a freezer (if it is displayed on a rack, look elsewhere), and it is best to order it in the winter rather than the summer. If it is shipped in the heat of summer and spends several days in a hot truck or on a loading dock, there is a good possibility that the film may be seriously fogged and degraded. If you have doubts about the integrity of a batch of film, buy a single roll, develop a strip

The Grand Canyon of the Colorado, Grand Canyon National Park, Arizona, 1942

[Infrared photography] is a large field in itself. . . . I shall give a few suggestions applicable to the use of infrared in ordinary landscape work of expressive rather than technical objectives. . . .

1. *The usual exposure and development recommendations for optimum results with infrared film are based on a rather extreme contrast result, which to my way of thinking is often very unpleasant in the interpretative sense. Merely removing the air between the camera and a mountain range a hundred miles away — or photographing a green tree as plaster-white — does not necessarily achieve more than a superficial startling effect. However, in imaginative hands, I freely admit that magnificent departures from reality are possible.*

2. *I have had gratifying luck in using infrared film with a Wratten A filter [red, #25], giving twice the recommended exposure and about 10 minutes' development in Kodak D-23 developer. This procedure yields great atmospheric clarity but avoids the extreme contrasts that obtain with conventional procedures.*

3. *I believe it best to avoid large areas of sky and water in the field of view, as these are inevitably rendered extremely dark. However, when you are photographing into the sun . . . the sky near the horizon will be rendered quite light in value. . . .*

Some details of procedure:

a. *Do not fail to extend lens-to-film distance a slight amount when using infrared film. . . . Most miniature-camera lenses have a small index mark indicating the necessary adjustment of focus. In general, most lenses require an extension of from $^1/_{75}$ to $^1/_{200}$ of their focal length to compensate for the longer-than-visual wavelengths.*

b. *The ordinary exposure meters cannot be used with infrared film. The exposures recommended by the manufacturer are quite adequate for almost all conditions. (Note my personal recommendations . . . for doubling the exposure and giving soft development.)*

c. *Note that recommended exposures are for sunlit subjects; the exposure for objects in shadow is enormously long, as infrared rays have very feeble scattering power. Hence the extremely black shadows so apparent in ordinary work. However, when you are photographing into the sun, the distant shadows are supported by the intense atmospheric glare.*

d. *Do not keep infrared film in the holder long before exposing, and process as soon after exposure as possible.*

— ANSEL ADAMS

without exposing it, and check the fog level. If the film base shows a low-level fog, it is likely that the remainder of the batch is fine. Kept frozen (below 32°F), infrared film is usable for at least two years beyond its expiration date.

The felt light traps on 35mm cassettes or in sheet film holders are *very* vulnerable to penetration by infrared rays. It is good practice to load and unload 35mm film into the camera in the dark or in subdued light. With sheet film *do not pull the dark slide completely out of the film holder when you make an exposure* or else the film is highly likely to be heavily fogged. If possible, position the camera back so that the slide end of the film holder faces away from the sun.

Exposing infrared film carries with it a degree of uncertainty because light meters respond to visible, not infrared, radiation. The insert that accompanies infrared film suggests starting points for exposures made under common lighting conditions with specific filters attached to the camera lens. Manufacturers also suggest an exposure index (EI) to use with your light meter to estimate the approximate exposure under differing lighting. While atmospheric conditions may differ for various times and places, the results obtained by using these suggestions are generally quite good. Bracketing exposures is highly recommended with infrared film until experience allows you to have confidence in your exposure estimates. Infrared film should be processed as soon as possible after exposure. As a precaution, keep the camera and film or film holders in a cooled insulated ice chest on long trips.

Infrared Film Characteristics

The two infrared films currently available are made by Kodak and Konica, and they are quite different in their performance. Kodak High Speed Infrared Film has pronounced grain that is clearly visible, even with modest degrees of enlargement. It has a suggested "film speed" of EI 60. In contrast, Konica IR 750 is slightly sharper, far less grainy, and has a "film speed" of EI 8. The infrared response of the two films also differs substantially. With the Kodak High Speed Infrared Film, green leaves are rendered close to a pure white in a print; with Konica's infrared film they are shades of light gray. The Konica film is also far less sensitive to ambient lighting and heat than Kodak High Speed Infrared Film and can be handled like any other black-and-white film. Konica film is available in both 35mm and roll-film formats, while Kodak's infrared film is produced for 35mm applications and in sheet films (but not as roll film). Konica's infrared film is produced only once a year and should be ordered in December or January if you want film that is guaranteed to be fresh.

Figure 5.16: Alan Ross, *Our Lady of Light, Northern New Mexico, 1996*. Infrared film creates an ethereal feeling of enveloping light that cannot be achieved with ordinary black-and-white films.

Chapter Six

Alternative Photographic Printing Processes: General Considerations

The making of a print is a unique combination of mechanical execution and creative activity. It is mechanical in the sense that the basis of the final work is determined by the content of the negative. However, it would be a serious error to assume that the print is merely a reflection of negative densities in positive form. The print values are not absolutely dictated by the negative, any more than the content of the negative is absolutely determined by the circumstances of subject matter. The creativity of the printing process is distinctly similar to the creativity of exposing negatives: in both cases we start with conditions that are a "given," and we strive to appreciate and interpret them. In printing we accept the negative as a starting point that determines much, but not all, of the character of the final image. Just as different photographers can interpret one subject in numerous ways, depending on personal vision, so might they each make varying prints from identical negatives.

— ANSEL ADAMS

The genesis of photography was closely linked to the desire of professional and amateur artists to capture the image of a moment, preserving both the spirit and detail of what was seen. The successes of 1839, which witnessed the announcements of the invention of both the paper print and the daguerreotype, and the years that followed astounded and pleased the practitioners of this new form of image making. As the original salt prints of Fox Talbot gave way to albumen prints in the 1850s and with the discovery that other substances besides silver salts could be used to create photographic images, new visual voices became part of the vocabulary that photographers could exploit. The cyanotype process invented by Herschel in 1843 proved to be a simple and straightforward method of making a print from a negative. The image, however, is a brilliant blue — generally not deemed a suitable color for most "works of art."

Figure 6.1: John P. Schaefer, *Tarahumara Violin, 1994.* Platinum print.

Figure 6.2: *Albumen prints.* Albumen prints were the staple of portrait photographers for much of the nineteenth century. (A) Cabinet cards had 4 x 5$\frac{1}{2}$-inch gold-toned albumen photographs mounted on a slightly larger board, often with elaborate advertisements on the reverse side, as shown below. (B) Larger formats (Promenade, Boudoir, and Imperial Panel) were produced for more affluent customers.

A

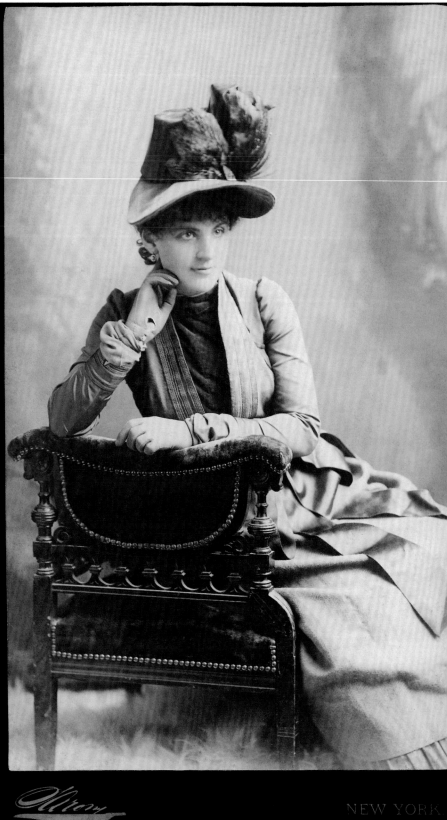

B

Figure 6.3: John P. Schaefer, *His Nibs, 1995.* The cyanotype is a medium ideally suited for making photograms and for learning the techniques used for creating handmade prints.

The photosensitivity of iron salts was soon coupled with the chemistry of the noble metals platinum and palladium, and in the latter third of the nineteenth century, platinum/palladium prints set new standards for stability and beauty. Regrettably, the cost of the metals and the fact that prints could be made only by contact printing, not by enlargement, limited the general adaptability of the process.

The *gum dichromate process* is based upon the photosensitivity of chromium salts. When dichromate salts and certain colloids like albumin or gum arabic are mixed and exposed to light, the colloids become insoluble. If pigments such as lampblack or iron oxide (burnt sienna, burnt umber, and the like) are mixed with gum arabic and a chromium salt and exposed to light through a negative, a positive image forms. Besides being inexpensive, gum prints made with light-stable pigments have the virtue of permanence and are as long-lived as the paper upon which they are printed.

Nonsilver photographic processes offered a multitude of opportunities for the printmaker to achieve artistic effects by using brushwork or special development techniques, and the pictorial photographs that were created around the turn of the century so mimicked the works of painters that the singular virtue of the straightforward photograph was relegated to simple reportage and studio portraiture.

The arguments that were eloquently put forth by professionals and amateurs alike debated the fundamental nature of photography. The literature in the latter part of the nineteenth and the early decades of the twentieth century abounds with passionate articles defending or lambasting like-minded or opposing schools, voiced with an intensity difficult to appreciate in our time. The fundamental issue was framed as follows: Could a photograph that faithfully presented an image visualized by the photographer and captured by the camera meet the standards by which fine paintings and other works of art are judged?

The issue was largely resolved through the commitment and leadership of Alfred Stieglitz, who was one of the first in America to champion the cause of modern art and who succeeded in defining photography in its modern form. Through his influence, which was nothing short of an aesthetic crusade, and the efforts of Edward Weston (who independently arrived at a similar vision of photography), Paul Strand, and Ansel Adams, the "straight print" came to define photography. The gelatin silver print, with its unrivaled ability to trans-

Figure 6.4: John P. Schaefer, *Chairs, Castle Combe, England, 1984.* Platinum and palladium prints are unrivaled in their ability to display subtle shadow details along with delicate nuances in highlight values.

Figure 6.5: David Scopick, from the Mexican series, 1994. Gum printing is the most versatile photographic process, and it offers photographers enormous opportunities for creative expression.

late pure tones and finely rendered details into images of breathtaking beauty, became photography's voice and through a multitude of examples defined for the public "a photograph," making moot the question "But is it art?" So complete and overwhelming was the victory of the "straight print" that by the 1930s gum prints, cyanotypes, platinum/palladium prints, and the like were generally regarded as relics of the past, a part of photographic history occasionally found in a museum.

But victory also implies loss. If one returns to the images of the past produced by the best of the pictorialists (including Stieglitz himself) and views those efforts in the absence of the rhetoric that escalated into a bitter war of words over the photographic aesthetic, it is inescapable that many pictorialist images are exquisitely beautiful, though the aesthetic is not that of straight photography. Some are clearly works of art, worthy of study, and represent a realm of imagery open to further exploration by photographers interested in the broader subject of "printmaking." For this pursuit, photography should be viewed as a beginning that uses the traditions and techniques of printmaking to achieve its own ends. Each image must be judged individually by the same standards that we apply to any creative effort that aspires toward art.

Printmaking

There are different schools of thought in photography that emphasize different palettes of print values, and it would not be appropriate to insist on a particular palette for all photographs. Some photographers stress extreme black and white effects with very strong print contrasts, perhaps disregarding what the basic mood of the subject or the image itself may be. Others work for softer effect; Edward Weston's prints are much "quieter" than many realize. Their power lies in the "seeing" and the balance of values Weston achieved. Such contemporary photographers as Lisette Model and Bill Brandt express themselves with great intensity, yet their image characteristics are completely different and not interchangeable. A print by Alfred Stieglitz from 1900 is different in many ways from a print by Brett Weston in 1980, although both are compelling expressions in their differing styles.

Any photographer who has made a traditional gelatin silver photograph either by contact printing or enlargement has engaged in a form of printmaking. The aesthetic of the gelatin silver print emphasizes the pure tonal qualities characteristic of particles of silver suspended in a gelatin matrix and displayed against a textureless white background. In reality, the image is suspended in space. Visually, nothing is allowed to compete for the viewer's eye but the image itself; the medium is not meant to compete with the message.

Photographers who want to explore alternatives to gelatin silver prints do so because of the possibilities of integrating the medium with the message, thereby strengthening the power of the image and adding to its visual impact. It is important to understand, however, that a poorly conceived and executed image will not be transformed into a work of art by presenting it as a platinum print made on fine paper. In photography, the medium can never transcend the message.

Practicing the craft of printmaking requires a photographer to consider far more variables than those inherent in making gelatin silver prints. For many alternative photographic printing processes the choice of paper is critical to the potential success of the final image, because the paper's texture is part of what the eye sees. For example, with platinum and palladium prints, the image not only lies on the surface of the paper but penetrates its fibers as well, creating a visual impact vastly different from an image that floats above the paper's surface. The "look" of a platinum print is as different from a gelatin silver print as a watercolor is from an oil painting.

Selective development, akin to dodging and burning-in, creates other visual effects, as does selective toning. Pigment choice in gum printing radically alters an image's color and impact. Each printing process gives a photograph a distinctive character. Each technique, including the use of gelatin silver papers, has strengths and weaknesses, and it is important to match the visualized image to the printing technique chosen. An image that works well as a cyanotype may lose its charm as a gelatin silver print.

The skills necessary to learn the techniques and processes described in this chapter are easy to acquire, but mastery, as always, is the product of commitment. Careful attention to detail will be rewarded by results that are predictable and reproducible.

Equipment for Printing

Because the techniques that are described in the following chapters involve making contact prints on hand-coated papers, a few special items are needed. While all of the operations can be adapted to the traditional darkroom, virtually every procedure described can be carried out in a room illuminated with ordinary incandescent lighting. Most of the equipment needed is "low" technology and easy to use.

Printing Frames

The single most important piece of equipment for making contact prints is a printing frame. A good frame should be rigid, have a spring back or clips that ensure firm and uniform contact between the negative and printing paper, and be comfortable to handle. Frames made fifty or more years ago, during an era when contact printing was common practice, are usually of excellent quality and are worth searching for in shops that deal in used photo equipment. The best frames are made of hardwood with corners that are firmly set by interlocking joints. If the joints are snug and tight and the frame is not warped, it will work well. Chipped, scratched, or broken glass can easily be replaced at any glazing shop for very little money.

Printing frames with a hinged split back are a virtual necessity, since they enable you to monitor the progress of an exposure. You can open half of the frame and raise the print off the negative without disturbing the registration because the other half of the print remains firmly locked in contact with the remainder of the negative. When the back is closed again, the original registration of the negative and paper is reestablished.

Modern hinged printing frames usually need to be special-ordered. They range in price from $35 to several hundred dollars, depending upon their features and the materials used for construction. Pages 376 and 377 contain a product source directory that you may wish to consult. A well-made printing frame will last a lifetime, and it is worthwhile to spend as much as you can comfortably afford to buy the best available.

Conduit Manufacturing produces contact printing frames in sizes ranging from 5 x 7 to 16 x 20. One series of Conduit frames includes a pin registration system that allows you to separate the negative and printing paper completely and then reregister the negative and print for further exposure. This capability is especially desirable for processes such as gum dichromate printing, where multiple applications of emulsions are often necessary.

Doran Enterprises makes aluminum contact printing frames largely intended for student use that are inexpensive and durable. Frame sizes vary from 8 x 10 ($35) to 16 x 20 ($64) and are painted black to minimize light scattering. These do not have split backs, which is a serious disadvantage for many applications.

Douglas Kennedy makes oak frames in 11 x 14 ($100), 16 x 20 ($185), and 20 x 24 ($225) sizes. These are beautifully constructed and feature a spring-back system that ensures excellent contact between the negative and paper.

Figure 6.6: *Contact printing frames.* The spring back of the printing frame holds the negative and printing paper in firm contact. A split back enables you to open up half of the frame to inspect the developing image without disturbing registration of the paper and negative.

Figure 6.7: *Attaching a negative to printing paper.* If two sheets of plate glass are being used to make a contact print, tape the sensitized paper to the glass, then tape one edge or three corners of the negative to the paper with drafting tape.

Figure 6.8: *Plate glass printing assembly.* Cover the negative and printing paper with a second sheet of plate glass. Exposure can be monitored by lifting up the negative and inspecting the developing image at intervals.

Mottweiler Photographic produces an 8 x 10 contact printing frame made from fine hardwoods. In addition to a well-constructed hinged back, the frame has rubber feet that enable it to be tilted at an angle against the wall for sun exposures. The window opening is 10 x 12, which allows printing for 8 x 10 negatives with adequate borders for the paper.

For very large prints it may be impossible to find a hinged frame, or you may prefer to improvise with an inexpensive alternative to a printing frame. Purchase two sheets of ¼-inch- or ⅜-inch-thick plate glass of the appropriate size from a glass supply shop. Have the edges beveled and sanded by the glass cutter so that the glass sheet can be gripped without danger of cutting yourself. A strip of duct tape around the edges may help you to handle the glass.

To the surface of one sheet of plate glass tape the paper to be exposed *emulsion side up.* Place the negative directly on the coated surface and use a strip of drafting tape to tack three corners or an edge of the negative to the paper. Cover the assembly with the second sheet of plate glass. Exercise care when handling plate glass: it is heavy and fragile. Pick up and move the glass sandwich into the light source used for exposing the paper.

To monitor the progress of the exposure, move the assembly away from the exposing light source, remove the top sheet of plate glass, and carefully raise the negative away from the surface of the print. If further exposure is judged necessary, smooth the negative back into place, replace the plate glass, and return the assembly to the light source.

Light Sources

The printmaking processes described in this chapter all involve contact printing and require ultraviolet light sources thousands of times more intense than an ordinary enlarger. The least expensive light source is the sun, and although there are several drawbacks to relying upon sunlight (changing light intensity over the course of a day, passing clouds, the inability to work at night), it is an effective, highly efficient, and inexpensive way to begin exploring the realm of printmaking. Typical exposure times range from 1 to 2 minutes in direct sunlight to 5 to 10 minutes in shade.

One difficulty with using a light source of variable intensity is determining when the correct exposure has been achieved. However, if you place a calibrated density strip alongside the negative being printed, it is relatively easy to use it as a guide for exposure time.

Excellent high-intensity light sources are worth considering if you intend to do much in the field of printmaking. These can be found at businesses that deal in the needs of graphic arts, printers, and newspapers. A cabinet unit such as the PRINTO can accommodate negatives up to 24 x 36. It has a vacuum easel to ensure intimate contact between the negative and printing paper (no contact printing frame is necessary if the exposure unit has a vacuum easel incorporated into the housing), and it incorporates digital exposure controls that enable you to specify the units of exposure to be given a print just as you would set the timer on an enlarger. The cabinet is equipped with a cooling fan and a dark red window that filters out stray ultraviolet light yet enables you to watch the progress of the exposure. The duration of a typical exposure is 1 to

Figure 6.9: *Exposing the print.* Sunlight is a fast and highly efficient light source for contact printing. One or 2 minutes is usually sufficient to fully expose a print for most alternative printing processes. Open shade takes longer (5–10 minutes) and leads to lower image contrast.

3 minutes. The cost of a new unit in 1998 is about $2,000 (less than the cost of a good enlarger), but you may be able to find a used one for considerably less money.

Mercury-vapor yard lamps are highly efficient sources of ultraviolet light and are available at most hardware stores. Other inexpensive light sources are Sylvania's RS Sun Lamp or black-light fluorescent tubes. If you have the ability to carry out modest construction projects, you may want to build an exposure cabinet that incorporates one of these light sources. Care must be taken when using any of these lamps to shield your eyes from any exposure to ultraviolet radiation; it can cause eye damage and extremely painful burning of the cornea that becomes apparent several hours after exposure has occurred. If this happens, see an ophthalmologist immediately. At all times avoid looking directly at any of these light sources.

Safelights Virtually all of the alternative printing processes described in subsequent chapters require intense light sources to expose the print. Consequently, the sensitized coatings are relatively impervious to moderate exposure to ambient lighting. A lamp fitted with a 60-watt bulb can be safely used to carry out the coating process, and even fluorescent lighting can be used if exposures are kept to a few minutes. Coated papers should be stored in the dark, and exposure to daylight should be avoided to prevent degradation or fogging of highlight values.

Printing Papers

Unlike the enlarging papers that are used almost universally in photography today, sensitized papers for use in the alternative printing processes that are described in this book are generally not commercially available and must be created by the photographer from fine paper and appropriate chemicals. Choosing a paper is an important part of printmaking, since the paper is an integral part of the photograph. Furthermore, high-quality paper is expensive. Well-stocked art supply stores have knowledgeable personnel who are familiar with the properties of various kinds of paper and who can assist you in selecting suitable fine papers for the processes you want to explore.

Modern paper production is the product of centuries of effort and continuing refinement. A well-made sheet of paper has distinctive character, defined in part by its surface texture and tone. Properly stored, fine paper lasts for centuries. Selecting a high-quality paper that complements and enhances the presentation of an image is an important part of printmaking. Fine printing papers are expensive, and you should test them to be certain that they are suitable for a particular application before you purchase a large quantity.

Several dozen very fine papers suitable for the printing processes described in the following chapters are available, and your choice should reflect your personal tastes and aesthetic judgment. From a practical perspective, any paper must have adequate strength when wet because it needs to withstand long periods of prolonged soaking and washing. Most watercolor papers and drawing papers meet these criteria, but avoid laminated sheets that are referred to as bristol board. These are made by gluing together layers of paper with a

water-soluble adhesive; the paper blisters and separates when it is soaked in water.

Paper thickness is denoted by weight. Papers in the weight range of 80 to 140 pounds have sufficient substance to withstand the handling required in photographic printmaking. If the entire sheet of paper is to be displayed in the final print, heavier papers are desirable.

The best papers are made from rags, *but not all 100-percent rag papers are desirable for printmaking.* Papermaking involves a series of steps in which a pulp of wood or cotton fibers, water, binders, fillers, and special additives are created as a result of cooking and chemically treating the raw material (wood or cotton fibers). The pulp is then spread on a fast-moving wire screen, covered with a felt blanket, drained, and dried. During processing the cellulose fibers of the paper tangle and mesh, giving the paper its strength.

The process leaves a residue of additives intermingled with the fibers, binders, and fillers, some of which can destroy the integrity of the paper. Many papers, particularly those that are inexpensive, are manufactured and sized with an alum-rosin mixture. Unfortunately, alum and rosin generate acids that discolor the paper and damage its fibers. Papers incorporating alum-rosin mixtures are generally unsuitable for long-term image stability and should be avoided. The best papers for printmaking and photography are alum-free and made solely from cotton or linen fibers.

Some papers are buffered with additives such as calcium carbonate to counteract the effect of residual acidity and acids present in the atmosphere. These additives can interact with the chemicals used to coat and sensitize the paper for printing and can lead to unexpected and undesired results.

Fine writing paper available from stationery stores is suitable for printing, but care must be taken not to tear it. Cranes AS 8111 is delicate to handle when wet, but it has an attractive surface and is suitable for everything but gum printing. Cranes Artificial Parchment is a heavier paper and has been used extensively by printmakers in recent years. It is excellent stock for all printing processes and needs no additional sizing.

Rives BFK is also a widely favored paper. It is sold in unsized and lightly sized versions, but most printing processes benefit if this paper is sized before use. Any of the sizing techniques described below work well.

Arches Aquarelle is an all-rag paper of the highest quality and is sold in pads of various sizes. The hot-pressed version needs no additional sizing, is easy to coat, and has a beautiful surface character.

Shrinking and Sizing Paper

In some printmaking processes, multiple applications of emulsions are required to achieve an image with a desirable tonal range or color. Because paper shrinks when it is wet and redried, whenever multiple coatings are needed, the paper should be soaked in water and dried prior to use. This procedure ensures that the paper will redry to the same size and that the negative can be accurately reregistered over the image for a second exposure. (For processes that require only a single exposure, as in making a cyanotype or platinum print, presoaking is not necessary.)

Figure 6.10: *Reading a watermark.* Examining a sheet of printing paper against a strong light source makes it easy to find and read the watermark. When the watermark reads correctly (not backward), the surface of the paper that you are looking at is the front side.

Every sheet of paper has two distinct surfaces. The face of the paper that was against the felt blanket during manufacturing has the better surface for printing. The wire mesh often leaves a slight imprint on the surface that is quite noticeable after the paper is soaked in water and dried. The mesh pattern is distracting and mars the beauty of a print. Before you begin working with a paper, determine which is the front side and then mark the back lightly in pencil for reference.

Fine papers usually have a watermark impressed into the fabric of the paper. Hold the paper up to a strong light and read the watermark. If it reads correctly, the surface facing you is the front of the paper; a reversed watermark means you are looking at the screen side of the paper. If there is no visible watermark, brush the surface of the paper lightly with your fingertips. The screen side should feel slightly rougher. Alternatively, view both surfaces of the paper at a sharp angle to a bright light; the screen side is usually less glossy than the front side. Papers sold in block pads are always packed with the felt side up.

Shrinking (and sizing) should be done with the largest sheets of paper that are convenient to handle. Fill a tray large enough to hold the paper with the hottest water you can comfortably touch and submerge the sheets one at a time in the water. Interleave the sheets occasionally and allow them to soak for approximately 30 minutes. If you do not intend to size the paper, remove one sheet at a time from the tray, place negative clips or clothespins on two of the corners, and hang the sheets up to dry as if they were laundry. Unlike writing paper, fine papers used for watercolor painting will dry uniformly to produce an unwrinkled surface. Any residual buckling can be removed by pressing the sheets in a warm (about 100°–110°F) dry-mounting press for a few hours.

If a paper proves to be too porous and absorbs an excessive amount of the applied sensitized coating, the image that will be produced upon printing will be relatively faint and weak. *Sizing* is an additive that coats the individual fibers, fills the spaces between them, increases the paper's strength, and prevents excessive penetration of the surface by inks or other liquids. Both gelatin and starch are commonly used as sizing for fine papers. In some printmaking processes, sizing influences the photochemistry, altering both the contrast and tonality of the final image.

Many watercolor papers are well sized by the manufacturer and are ideal for photographic printmaking processes; no further sizing is required. For gum printing, additional sizing is occasionally needed to prevent staining of the paper by the pigments. In any alternative printing process, an inadequately sized paper literally acts like a blotter and absorbs any coating applied to the surface. Consequently, the printed image is faint and unsatisfactory. An ample number of well-sized papers can be found in any art supply store. Start your exploration of the printmaking process with one of these papers.

Gelatin Sizing To apply additional gelatin sizing to a paper, you can either soak the paper in a gelatin solution or brush gelatin solution onto the front of the paper.

Figure 6.11: *Sizing paper.* After soaking a sheet of paper in a tray of sizing solution, remove excess solution by dragging the paper over one edge of the tray.

Soaking Method. To size the paper by soaking in a gelatin solution, proceed as follows:

1. Prepare a sizing solution by adding 1 ounce or 30 grams of gelatin (plain gelatin is available from a grocery store) to a pot containing about 1 quart (or liter) of cool water. If the gelatin is not completely dissolved in 10 minutes, warm the water and stir the mixture until no lumps remain.

2. Pour the warm gelatin solution into a prewarmed tray (rinse the tray in hot water first) and transfer the paper to be sized into the gelatin solution. *Make sure the bottom (screen) side is faceup.*

3. Shuffle the papers by removing the bottom sheet from the pile in the tray and placing it on top. Press it down gently with your fingertips until it is completely immersed, then repeat the process by removing another sheet from the bottom of the tray.

4. After all of the paper has been cycled at least twice, allow the stack to soak for about 5 minutes. If the gelatin solution begins to gel, warm it on a stove or hot plate as needed to keep the solution free flowing. Remove the top sheet by picking it up by the nearest two corners and then dragging the sheet gently toward yourself over the lip of the tray so that the tray's lip wipes off the excess solution as the sheet is withdrawn. Take care not to crease the damp sheet, since a permanent wrinkle will result.

5. Hang each sheet of paper from two corners with clothespins or film clips, wipe any excess gelatin solution from the back side of the paper with a damp sponge, and allow the paper to air-dry. Discard the gelatin solution or store it in a refrigerator if you intend to size more paper within the next few days. The solution will gel, but can be reliquified by warming.

After the sized paper is dry, the gelatin coating can be hardened with a formaldehyde solution before the surface of the paper is used for printing. *Caution! Formaldehyde is a known carcinogen and must be handled with caution. Do not attempt to use a formaldehyde solution in anything but a well-ventilated fume hood.* Use latex gloves to avoid skin irritation. Add 25 ml. of a 37-percent formaldehyde solution to 1 quart (or liter) of water and soak the gelatin-coated sheet in this solution for 10 minutes. Lift the sheet from the tray by a corner and allow the excess solution to drip back into the tray. Hang the sheet *in the fume hood* from its corners to dry. The diluted formaldehyde solution can be bottled and saved for further use.

Brush-Coating Method. An alternative to soaking entire sheets is to brush the gelatin sizing onto the front surface of the paper around the area that you intend to use for printing.

1. Pin the sheet of paper by its corners onto a clean sheet of mat board or a drafting board.

2. Dip a wide brush (an inexpensive brush from a hardware store is suitable) in hot water to soften the bristles, shake it out thoroughly, then dip it into the gelatin sizing solution and coat the paper by brushing on the sizing, using both horizontal and vertical strokes to ensure a uniform coating.

Figure 6.12: John P. Schaefer, *Grass and Hoarfrost, New Zealand, 1990.* For comparison this image was printed as a cyanotype (A) and a platinum print (B); both are visually appealing.

A

B

3. Allow the coating to air-dry.

4. Next (optional), *in a fume hood,* brush on a second coat of gelatin solution to which 25 ml. of 37-percent formaldehyde solution has been added for each liter of gelatin.

5. Allow the paper to air-dry in the fume hood. When the paper is dry it is ready to use. Discard the gelatin solution to which the formaldehyde has been added.

Figure 6.13: Bobbe Besold, *Solar Eclipse II, n.d.* This image is a Vandyke brownprint (see chapter 8) made on a fine rag paper. After printing, the artist hand colored the image and added to the original photographic content.

Starch Sizing An alternative to gelatin sizing is starch. Unlike gelatin, starch cannot be chemically hardened, and paper sized with starch is not recommended for processes that require multiple coatings. Starch sizing is excellent for making cyanotypes, silver, platinum, and palladium prints.

1. Stir 20 grams of powdered starch (available in grocery stores and elsewhere) into 1 quart (or liter) of water, pour the suspension into a saucepan, and bring the mixture to a boil for 3 to 5 minutes.

2. Pour the starch solution into a tray and size the paper by using either of the gelatin-sizing methods described above.

Some printers use aerosol cans of spray starch solutions, but these are difficult to apply uniformly and alter the visual properties of the paper surface in a way that is not aesthetically pleasing.

While sizing paper is time consuming, it requires no special mechanical aptitude. For some papers and printing processes it is unavoidable. If you're a beginner, a reasonable approach is to select papers that produce satisfactory results without sizing. Once you've learned the mechanics, chemistry, and exposures associated with each printing process, then find a paper that meets your aesthetic requirements for a fine print and undertake its sizing if necessary.

Figure 6.14: *Coating brushes and sponges.* A variety of brushes and sponges are satisfactory for coating papers with sensitizer solutions. With processes that use precious metals, it is best to avoid using brushes with a metal band around the bristles.

Figure 6.15: *Coating rods and tubes.* "Puddle Pushers" are a convenient way to coat sheets of paper and use minimum amounts of sensitizer in the process. With practice the applied coatings are remarkably uniform and free of defects.

Coating Paper

To print an image a paper must first be coated with a photosensitive emulsion. The traditional way to apply an emulsion is to paint it onto the paper with a suitable brush. With processes that use precious metals (platinum, palladium, and silver), avoid brushes that bind the bristles to the handle with a metal collar, because metal salts will react with the metal, corrode the collar, and contaminate the sensitizing solution. For this reason it is best to choose a brush in which natural bristles are sewn into the wooden handle.

Your brushes should also have relatively short bristles to avoid absorbing too much of the emulsion into the brush hairs before it can be spread over the paper. If a brush is too thick, remove some of the bristles by trimming them off at the handle with a razor blade. The brush should be stored in water prior to use. A wet brush will limit the tendency of the bristles to absorb additional solution, but be aware that too much water will dilute the emulsion. With experimentation you'll quickly learn to judge the degree of wetness necessary to achieve efficient coating and minimize waste.

New brushes must be thoroughly washed in warm water before use because they tend to shed bristles (and hairs embedded in the emulsion are obviously undesirable). This problem can be minimized by tugging gently at the tips of the wet brush to remove loose bristles, then brushing a blank scrap sheet of paper or cardboard with water until the brush stops shedding. A brush about 1 inch wide is adequate for quickly covering an area up to 8 x 10; for larger negatives a brush 1 to 2 inches in width is easier to use.

Some photographers prefer to use inexpensive sponge brushes to coat papers. These brushes can be trimmed and thinned with a razor blade to minimize absorption of the coating solution. Because sponges are far more abrasive than brushes, however, care must be taken not to roughen or scour the surface of the wet paper, a defect that will be readily apparent in the print.

Another alternative is to make a "brush" out of a small piece of velvet by folding it over the tip of a plastic handle or sponge brush and stitching or taping it in place. A velvet brush will apply a smooth coating on the paper without abrading the surface or absorbing much of the emulsion.

For general coating work, after much experimentation my personal preference is to use a brush made from natural bristles. With a little practice, sufficient emulsion to print an 8 x 10-inch negative can be applied in less than 45 seconds with a minimum of waste. Wash your brush thoroughly in warm running water after each application to keep it from discoloring and degrading. If you are coating several sheets of paper in sequence, store the brush in a cup or cylinder of water while the emulsions are being dried.

Coating Techniques The objective of any coating technique is to minimize wasting solution as a uniform coating of sensitizing solution is applied to the paper surface.

Brush-Coating Method. The primary mechanical skill needed for printmaking is the ability to hand coat a sheet of paper. While many techniques have been used, the most satisfactory method is brush coating. With a little practice a

sheet of paper can be coated in less than a minute. The amounts of coating solution needed are small and should be measured out with an eyedropper. A 4 x 5 print requires about twelve drops of solution; an 8 x 10 print needs four times that amount (forty-eight drops). Prepare all stock solutions in 1- or 2-ounce brown medicine bottles fitted with screw caps and eyedroppers. If the instructions for preparing a sensitized coating call for equal amounts of two solutions, simply measure out, for example, six drops of solution A into a 1-ounce plastic cup, then add six drops of solution B to it. Swirl the cup gently and the solutions will be mixed and ready to use.

1. Trim a sheet of paper so that when the negative you want to print is placed and centered, there is at least a 1-inch margin all around. Using push-pins, pin the paper to a sheet of clean cardboard (the sides of a cut-up corrugated cardboard box are fine for this purpose). (If the paper being used is not prone to severe curling as the coating is applied, you may not need to pin it to the cardboard; simply hold down two corners with your fingertips as you brush on the solution.)

2. With a soft pencil make a few guide marks on the paper to outline the edges of the negative and define the area to which the sensitized coating should be applied. Return the negative to its storage sleeve.

3. Saturate the brush in clean water, then remove the excess water from the bristles by snapping it as you would crack a whip.

4. Pour the measured sensitizing solution into the center of the area of paper to be coated and *immediately* begin brushing the solution over the paper's surface, first lengthwise, then from side to side. Complete coating by brushing the paper at right angles to the original pattern. The tips of the bristles should barely and gently touch the paper to avoid abrading the surface. Do not allow puddles to remain on the paper, because their outlines will inevitably appear on the final print.

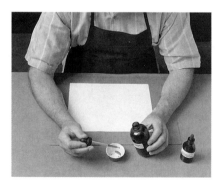

Figure 6.16: *Measuring the coating solution.* (*Note:* The photographs in this book were simplified for illustrative clarity. In practice, *whenever any toxic materials are handled you should wear thin rubber gloves and work in a well-ventilated fume hood.* Read all of the precautions accompanying every chemical that is used and handle all chemicals with care and respect.)

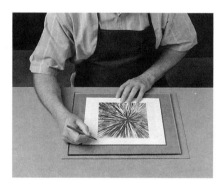

Figure 6.17: *Marking the paper.*

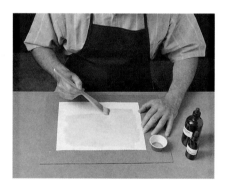

Figure 6.18: *Brushing the coating paper.*

5. When the surface of the paper is uniformly wet and the sensitizer shows signs of being absorbed by the paper, stop brushing and allow the sensitizer to sink into the fibers of the paper.

6. Put the brush into a cylinder or cup of clear water, and allow the paper to dry. If the process you are using does not require multiple printings, you can use a blow-dryer on a warm setting to dry the coating. (Air-dry it for multiple printings.) Hold the dryer away from the surface and direct the jet of air across the surface of the paper, moving the dryer constantly to avoid excessive heating of the sensitized coating. When the paper is only slightly damp, remove the pushpins, hold the paper by a corner and continue to dry the paper from the back side until it is bone dry. Dry both the front and back of the paper to ensure that no residual moisture is present before you make an exposure. (Damp paper will stick to a negative and may ruin it for further use.) The sensitized paper is ready to be exposed.

Wash the brush *thoroughly* in running water after each use and store it in a cup of water for further use during a printing session.

The "Puddle Pusher" Method. A new device for coating papers is the "Puddle Pusher," available from Bostick & Sullivan. It consists of a length of glass tubing affixed to a glass plate that serves as a handle. To coat a sheet of paper, lay the glass rod on the sheet of paper and use an eyedropper whose tip touches the glass rod to transfer the coating solution to the paper. A linear bead of liquid will form along the paper–glass rod boundary. Grasp the "Puddle Pusher" by the handle without lifting it off the paper surface and wipe it back and forth across the sheet of paper once or twice to spread the emulsion. Then sweep any excess solution off one edge of the paper. It takes very little practice to produce high-quality, uniform coatings on paper, with the added advantage that only about $2/3$ of the normal amount of coating solution is required. For platinum printing this amounts to a substantial saving of money.

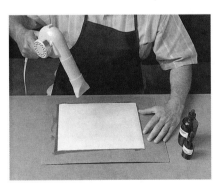

Figure 6.19: *Drying damp paper with a hair-dryer.*

Figure 6.20: *Applying the coating with a "Puddle Pusher."*

Figure 6.21: *Spreading the coating with a "Puddle Pusher."*

Orchid, 1992

Much of the charm and challenge of the platinum/palladium process stems from its inability to produce the inky blacks and brilliant whites of modern silver papers. The process favors subjects with subtle gradations in the central portion of the gray scale; harsh lighting often results in images with muddy shadows and washed-out highlights. I prefer subjects that at first glance have a limited contrast range and are illuminated with soft indirect light. The challenge is to expand a relatively narrow range of subject tones into the full gray scale of the platinum print. The small orchid in this print is just such a subject.

I photographed this orchid, no more than 3 inches high, with a 135mm lens on my 8 x 10-inch camera. Designed for 4 x 5-inch work, this lens fills the 8 x 10-inch frame when used as a macro lens. The image has the qualities of a pinhole photograph: the focus is slightly soft, and the depth of field is extreme, especially considering the 8 x 10 format. These effects were achieved with a 1mm Waterhouse stop, which I made out of brass shim stock. I composed with the lens wide open, then placed the 1mm stop in the lens for exposure, resulting in an effective aperture of about f/500. Thus, I achieved the effect of a pinhole camera, with the luxury of being able to compose on the ground glass at f/5.6.

In order to achieve good separation of tonal values and get negatives with high contrast, I used development times that are extreme even by platinum standards. For softly illuminated subjects, I develop the negative to completion so that no further development is possible, just as is done with silver printing papers. In this case, the Kodak T-Max 400 Film was developed for 15 minutes in D-76 at 75°F with continuous agitation in a drum processor.

The maximum density of such negatives can be very high — too dense for conventional platinum printing techniques. In order to get print detail from the denser areas of the negative, I burn-in much of the print. I do this with a series of masks, which are placed on top of the contact printing frame. These masks are made of glass or acetate and painted black over the portions of the print that are to be protected from further exposure. Even though the mask is only ¼ inch from the print surface, the edges of the painted areas of the mask cast soft shadows, because the UV fluorescent tubes in my printing light provide a very diffuse light source. I use this masking technique for most of my work, with as many as eight different glass plates used sequentially on a single print. The orchid was printed with four masks; areas printed with the last mask received four times the exposure of those zones printed with no mask.

These techniques result in an image that has the characteristic softness of a platinum print yet gives a feeling of heightened contrast and an almost palpable sense of surface textures, which would otherwise be difficult to achieve in such a subject.

— CHARLES PALMER

Judging Exposure with Coated Papers A difficulty in working with hand-coated papers is that the speed of the coated emulsion can vary from one sheet to the next. Such factors as a slight change in the coating's composition or in the surface characteristics of the paper, partial dilution of the coating solution with water from the coating brush, aging of the sensitized paper, the variability of the intensity of the light source, and so forth may change the exposure time needed to print a particular negative.

If you attempt to determine the correct exposure by making a test strip, following the procedure used for making enlargements on gelatin silver papers, and use that time for subsequent prints, you will find that out of six prints two may be fine, two may be slightly underexposed, and two may be slightly over-exposed — not a desirable outcome!* With experience and efforts to control the printing variables, the percentage of successful prints will increase, but despite the care taken, some failures are inevitable. The only sure way to estimate the correct exposure is to monitor it *as the exposure takes place.* Fortunately, this is not difficult to do.

Coat a sheet of paper with the intended emulsion and cut the sheet into strips about 1 inch wide. Cover a strip with the negative to be printed (place the emulsion side of the negative against the paper emulsion) and place the pair in a contact printing frame; close the frame and begin the exposure. At intervals of 2, 4, 6, 8, and 10 minutes, slide a sheet of cardboard over a portion of the negative. This creates a series of distinct exposure bands on the print. At 10 minutes cover the entire negative, remove the printing frame from the light source, and process the strip of paper. Evaluate the dried test strip carefully to determine which step of the strip displays tonal values that represent the best exposure for the negative. If none appears to be close, repeat the procedure using a second set of exposures.

When the approximate exposure (accurate to the nearest minute) has been found, coat a sheet of paper, covering an area large enough that a calibrated density strip can be placed alongside the negative. Expose the print and adjacent calibrated density strip for the previously estimated exposure time, then remove the print from the frame; a faint but distinct latent image of the test strip and negative will be visible. Mark the last step you can clearly see on the image of the calibrated density strip with a pencil, then process the print. For many of the processes that are described in the following chapters, the image lightens considerably during development and washing, then darkens as it dries, so the latent image differs significantly from the final print. In the case of a cyanotype, for example, as many as six steps of the latent image of the calibrated strip that are clearly visible immediately after exposure will disappear as a result of processing.

Evaluate the print carefully and determine if the exposure needs to be increased or decreased. Proceed as follows if more exposure is called for to make a satisfactory print.

Take a new sheet of coated paper and expose it and the calibrated strip as before for the previous exposure time. Remove the printing frame from the light source and open only half of the frame to inspect the development of the

* The step-by-step procedure is explained in my previous book, *Basic Techniques of Photography, Book 1* (Little, Brown, 1992), pp. 264–266.

A

B

Figure 6.22: *Using a calibrated density strip to monitor exposure.* (A) A pencil mark has been placed alongside the last visible step (16/17) on the image of the calibrated density strip of this exposed but unprocessed cyanotype. (B) This shows the same section of the print as A after processing. The last visible step is between 10 and 11, and the processed print is correctly exposed. In future printings, the development of the latent image at steps 16/17 of the calibrated density strip would be used to monitor the progress of the exposure.

image of the density strip. Look for the step that you marked on the previous trial. If, for example, step ten was clearly darker than step eleven, but step eleven was indistinguishable from step twelve, and higher numbered steps are unexposed, additional exposure is needed. Close the printing frame again and give the negative another interval of exposure. Reopen the frame and note if additional steps of the strip now show signs of a printed-out image. If so, mark the break point; if not, continue the exposure.

When the exposure is judged to be adequate (that is, higher-numbered steps of the calibrated strip are visible), process the print. Examine the dried print to see if the exposure is correct. If another trial exposure is needed, you should be able to make a very close guess as to which step of the strip to monitor to achieve the correct exposure. From that point on, you should be able to make any number of identical prints by using the calibrated density strip to signal the correct exposure. (If the initial print is overexposed, follow the same steps described, but begin by decreasing the initial exposure by several steps.) This image of the calibrated density strip can be trimmed off the final print before mounting.

After you make a few prints, you will be able to look at a negative and judge the approximate exposure time required (this is another compelling reason to work on standardizing your technique for exposing and developing film). In practice, exposures tend to fall within a relatively narrow range, and very little effort is necessary to zero in on the correct time needed to make a fine print.

Controlling Contrast with Coated Papers Gelatin silver papers are available in a spectrum of contrast grades, enabling you to print negatives of different density ranges. With hand-coated papers, contrast control is more difficult, but with some processes (for example, platinum printing), oxidizing agents can be added to the sensitizer or developer to achieve an increase in print contrast. Changing the print contrast by means of chemical additives in either the sensitizing solution or developer also lowers the printing speed of the paper, and you will need to monitor both the exposure time and print contrast.

Procedures for contrast control are discussed in subsequent chapters for each printing process. The best strategy for contrast control is to expose and develop each negative or copy negative so that its inherent contrast is suitable for the intended printing process.

Chemicals, Weights, and Measures

All chemicals used by photographers should be handled with care, stored in a safe location, and kept out of reach of children. Having issued these warnings, be assured that the materials used in photographic processes are safe to handle as long as the manufacturer's precautions are followed. *Safe working habits are the only desirable habits to have in a darkroom setting,* and they are a prerequisite for making fine prints.

Many of the procedures described in the chapters that follow require you to weigh out or measure small quantities of chemical reagents. In addition to specific chemicals and supplies that you can purchase through your photo dealer or specialists such as Bostick & Sullivan or Photographer's Formulary, Inc. (see page 376 for addresses and telephone numbers), you will need items such as medicine eyedropper bottles, small graduated cylinders, plastic spoons, 1-ounce plastic cups, brushes, trays, a hot plate, a blow-dryer, cardboard sheets, pushpins, masking tape, and so forth. As a convenience, Bostick & Sullivan sells weighed amounts of chemicals in bottles — all you need to add is a measured amount of water.

Metal spatulas (or plastic spoons) are needed to remove powders from jars for weighing. Filter paper circles are useful for protecting balance pans when chemicals are weighed out. Brown storage bottles should be used for all photosensitive solutions, and those fitted with eyedroppers can be used to measure out drops of solutions directly into plastic medicine cups.

Graduated pipettes allow the precise measurement and delivery of small amounts of liquids. *Caution! Always use a pipette bulb to fill and evacuate a pipette. Never attempt to fill a pipette with chemical solutions by aspirating it with your mouth!*

Weighing Chemicals

A sensitive scale or balance is needed to weigh out chemicals. The Micro Beam™ balance is an inexpensive (1998 price $63) single-pan balance that weighs items from $1/50$ gram to 116 grams (4 ounces), and it is ideal for photographic applications. It can be ordered from the Edmund Scientific Corporation (see page 376 for details). A better (though more expensive) alternative is an electronic scale, also available from Edmund. The Acculab Electronic Digital Scale (1998 price $99) has a capacity of up to 300 grams and is accurate to 0.1 gram. The scale has a digital electronic readout and is fast and easy to use. Electronic postal scales accurate to 1 gram are available from office supply stores and are adequate for many darkroom needs but cannot be used to measure out fractions of a gram.

Regardless of the type of balance, *never* put chemicals of any kind directly on the weighing pan. Cover the pan with a small sheet of filter paper and

Figure 6.23: *Supplies for mixing and measuring chemicals.* Chemicals, filter paper, plastic cups, graduated cylinders, brown eyedropper bottles (2- and 4-ounce), a plastic beaker, pipettes, spatulas, and a pipette bulb are all useful accessories for photographic printmaking. Most of these items can be purchased from chemical supply houses, pharmacies, or Photographer's Formulary.

Figure 6.24: *Pelouze R-47 double-pan balance.* This simple, accurate balance conveniently weighs up to 100 grams of material.

Figure 6.25: *Acculab electronic balance.* Electronic balances are fast and accurate and have a digital readout calibrated in grams or ounces.

weigh materials by spooning them onto the sheet of paper. When the correct weight (that is, the weight of the sample plus the sheet of paper) has been measured out, lift the sheet of paper from the balance pan and transfer the crystals to the solution being prepared. To avoid contamination of your supplies when a solution with several components is being prepared, weigh out each item separately on a clean sheet of paper and wash the plastic spoon used to scoop powders from a bottle after *every* contact it has with a chemical. If you spill material on the balance pan, wipe it up immediately with a damp paper towel to avoid corrosion.

With a double-pan balance, such as the Pelouze R-47 (see figure 6.24), use the left pan for the items you intend to weigh and the right pan for calibrated weights. Place equal-sized sheets of paper on each pan (their weights will balance out), add the desired weights to the right-hand pan (or set the sliding scale on the front of the balance for weights up to 3.2 grams), and then add the item to be weighed to the left pan. When the pointer at the back of the balance returns to its central position, the weight of material on the left pan equals that on the right. With inexpensive balances, the knife edge on which the balance beam rests can occasionally catch. To make certain the pans are truly balanced, tap one of them slightly to see that the pointer oscillates freely in both directions at the balance point.

In many ways, I find printing the most fascinating aspect of black-and-white photography. It is especially rewarding to me, when I am going through the thousands of negatives I have never printed (at least in fine-print form), to find that I can recall the original visualization as well as discovering new beauty and interest which I hope to express in the print.

I do not believe that anyone can (or should) attempt to influence the artist in his work, but the artist should always remain alert to comment and constructive observations — they just might have potential value in prompting serious thought about the work. Artists in all media find themselves in "grooves" at times, and some never escape. It is best to leave to critics and historians the dissecting of subtle differences in our work over time. The photographer should simply express himself, and avoid the critical attitude when working with his camera. Only when it is complete should we apply careful objective evaluation to our work.

Print quality, then, is basically a matter of sensitivity to values. What is important for all photographers is that the values of the image suit the image itself, and contribute to the intended visual effect. Perhaps the best guideline I can give is for you to look carefully at your prints and heed the first impressions that enter your mind.

Chapter Seven

The Cyanotype

The greatest achievements in photography have been derived from a thorough comprehension of the medium on the part of photographers. The cumbersome equipment of the earlier days was a limiting factor — but within these limitations was obtained an amazingly rich and intense expression, in many ways more important than contemporary work. Modern facility is both a boon and a detriment; we are too prone to rely on the mechanical capacities of the instruments and materials to produce pictures in spite of us *rather than to remember that any creative expression depends on knowledge, vision and taste, and on the complete domination of the medium by imagination and skill.* — ANSEL ADAMS

Photography is an invention derived from the observation that certain silver salts form a coating of metallic silver on the surface of the crystals when they are exposed to light. The usefulness of this discovery was extended when it was found that some silver compounds can be transformed into silver (and, therefore, into a visible image) by chemical development after a brief exposure to light. The processes described by both Daguerre and Fox Talbot made use of these phenomena and continue to be the basis of modern black-and-white and color photography.

Many other metals and chemical compounds are also light sensitive and can be used as the basis for photographic processes. For example, silicon detectors are used for video imaging. Iron salts serve as sensitizers for a family of printing techniques ranging from cyanotypes to platinum and palladium photographs, while the photosensitivity of chromium compounds is the basis of gum printing.

A cyanotype is a continuous-tone image made by creating a mixture of inorganic dyes — Prussian Blue and Turnbull's Blue — through a photo-chemical reaction of iron salts. While the first application of the cyanotype process by its inventor, Sir John Herschel, in 1842 was to reproduce complex mathematical tables, Anna Atkins, the first professional female photographer, used cyanotypes in her book titled *Cyanotypes of British and Foreign Flowering Plants and Ferns.* Her images are actually *photograms,* made by laying the plant directly on sensitized paper, covering it with glass, and exposing it to sunlight. The most widespread commercial use of the cyanotype historically has been to make the *blueprint* (now made by a different photographic process) used by architects and engineers, for which a line drawing on transparent tissue serves as a negative.

Figure 7.1: Diane Farris, Untitled, 1979.

Cyanotypes vary from light blue to deep blue and are permanent, light-stable images. The photograph is formed by coating paper or cloth with a mixture of potassium ferricyanide and ferric ammonium citrate (other formulations are possible and work just as well), covering it with an appropriate negative, and exposing it to a source rich in ultraviolet light. During exposure, the citrate ion reduces the ferric ion to the ferrous state. The latter ion combines with ferricyanide to form the insoluble Prussian Blue. Processing is completed by washing the print in water, which removes any unreacted substances from the paper. Cyanotypes slowly undergo a transformation from light to dark blue on exposure to air, but this change can be brought about instantaneously by adding a few drops of hydrogen peroxide to the wash water. Cyanotypes decompose on exposure to alkali; therefore, papers chemically buffered to be acid free should not be used.

Chemicals and Supplies

The two key chemicals for making cyanotypes are potassium ferricyanide and ferric ammonium citrate (*green* crystals, not brown!). These can be obtained from a photo dealer, a graphic arts store, or from a supplier such as Photographer's Formulary. While distilled or purified water is not a necessity, it is good practice to use it to mix all the solutions used in this book. It is inexpensive and can be purchased at most grocery stores in gallon-sized plastic bottles. Using purified water avoids the uncertainty often associated with contaminants in local tap water. A small bottle of 3-percent hydrogen peroxide, along with a supply of brown glass eyedropper bottles and plastic medicine cups, can be purchased from a pharmacy. None of the materials used to make cyanotypes is especially toxic, but you should observe the same precautions you use when handling any photographic products. Cleanliness and caution are basic to good technique.

The solutions used for making cyanotypes do not react chemically with the metals used to bind bristles to brush handles, and the usual caution against using these types of brushes can be ignored. High-quality bristle brushes from China are found in most art supply stores. These are inexpensive and ideal for applying cyanotype sensitizer. Rinse them thoroughly when you are finished

Figure 7.2: *Preparing solutions.* Mix the weighed portion of ferric ammonium citrate into water and stir until the crystals dissolve.

Figure 7.3: *Transferring solutions.* Carefully pour each solution that you prepare into a labeled brown eyedropper bottle. If spillage occurs, wipe it up with an absorbent paper towel.

with them. Brushes do discolor over time, but this does not impair their usefulness. To avoid possible contamination of coating solutions, confine the use of a brush to a single type of process — for example, do not use the same brush for making cyanotypes and platinum prints.

Preparing Stock Solutions

Mixed solutions of sensitizer keep for only a day or so, and therefore it is best to prepare stock solutions of each component and combine them just prior to use. These stock solutions are stable for six months or more when stored in a cool, dark storage cabinet or refrigerator dedicated *only* to photographic supplies. Ferric ammonium citrate solutions are the most susceptible to decomposition. If mold forms or if the solution changes color, discard it and mix a new batch. To prepare stock solutions, you need the following items:*

potassium ferricyanide	ferric ammonium citrate (green)
potassium dichromate	gum arabic solution (optional)†
scale or balance	beaker or measuring cup
graduated cylinder	plastic measuring spoons or metal spatula
purified water	4 2-ounce brown eyedropper bottles

Do all of the following operations on a sheet of newspaper or a tabletop that is easily cleaned. While the weights of compounds are specified precisely, significant variations in formulations will still lead to satisfactory results. However, careful preparation of stock solutions is one key to achieving reproducible and predictable results.

Cyanotype Solution A: 20% Ferric Ammonium Citrate Cover the pan of a scale or chemical balance with a clean sheet of paper and weigh out (see figures 6.24 and 6.25) 10 grams of ferric ammonium citrate. Use a plastic spoon to scoop the crystals from the jar and return any excess to the jar. Reseal the jar and store it in a cool, dark place. Measure 50 ml. of water into a graduated cylinder and pour the water into a clean beaker. Transfer the crystals of ferric ammonium citrate into the beaker and stir the solution with the plastic spoon until the crystals dissolve. Pour the stock solution into a clean 2-ounce

* These solutions are sufficient to make the equivalent of approximately fifty 8 x 10 cyanotypes when the coating procedure described on pages 147–151 is used. Because the per-print price of the chemicals for cyanotypes is negligible, some workers prefer to mix the sensitizing solution in bulk and coat the paper by floating a sheet on the surface of a tray of solution. Alternatively, a large number of sheets can be sensitized simply by dipping a paintbrush into a beaker of the mixed reagents and painting over their surface. While these methods work well, they are not practical for printing processes when expensive reagents are used.

 Aside from the intrinsic beauty of the print itself, the cyanotype process is an excellent vehicle for learning coating techniques that conserve and minimize the use of the sensitizer. It is far less expensive to practice making cyanotypes than it is either platinum or silver prints.

† Published recipes for making cyanotypes do not call for adding gum arabic to the emulsion. In my experience the quality of the coating and developed image is often improved by the addition of a small amount of gum arabic to the sensitizer, which seems to act as a sizing agent.

brown eyedropper bottle and date it and label it "Cyanotype Solution A, 20% Ferric Ammonium Citrate." Discard the sheet of paper used for weighing and clean, rinse, and dry the beaker and spoon.

Cyanotype Solution B: 8% Potassium Ferricyanide Place a clean sheet of paper on the balance pan and weigh out 4 grams of potassium ferricyanide. Measure and pour 50 ml. of water into a clean beaker. Add the crystals of potassium ferricyanide to the water and stir until they dissolve. Pour the solution into a clean 2-ounce brown eyedropper bottle and date it and label it "Cyanotype Solution B, 8% Potassium Ferricyanide." Clean up the work area and wash the beaker and spoon thoroughly.

Cyanotype Solution C: 1% Potassium Dichromate On a clean sheet of paper weigh out ½ gram of potassium dichromate and add it to 50 ml. of purified water. Stir the suspension until the crystals dissolve, and pour the solution into a clean 2-ounce brown eyedropper bottle. Date it and label it "Cyanotype Solution C, 1% Potassium Dichromate." In the absence of contact with organic matter, this solution keeps indefinitely.

Gum Arabic Solution Gum arabic can be purchased as crystals or as a prepared solution containing a preservative from any graphic arts supply store. The prepared solution is stable and, although optional, recommended for use in all of the photographic applications described in this book. Fill a 2-ounce eyedropper bottle with the solution and label it "Gum Arabic Solution."

Sensitizing the Paper

Coating paper for cyanotypes can be done in a brightly lit room without fogging the paper, so work in a room bright enough to enable you to see clearly. A cyanotype requires intense exposure to generate a permanent image.*

Spread a sheet of newspaper on a tabletop and lay a sheet of cardboard on it that is larger in area than the sheet of paper that you intend to sensitize. Make a few guide marks on the sheet of paper to serve as an outline for the area to be coated. Use a sheet of paper that allows at least a 1-inch margin around the edges of the negative. Wet the brush that will be used to apply the sensitizer and store it in a jar or beaker of clean tap water.

To make a 4 x 5 print, place six drops of Cyanotype Solution A, six drops of Cyanotype Solution B, and one drop of Gum Arabic Solution (optional) into a 1-ounce plastic medicine cup and swirl the cup gently to mix the solutions. Remove the coating brush from the water, shake off the excess moisture, and pour the sensitizer onto the center of the paper. Quickly spread the solution by using a few diagonal strokes, then work to distribute the sensitizer

* To evaluate the degree of exposure that results from exposure to room lighting (which manifests itself in the degradation of print highlights), place a calibrated density strip over a coated sheet of paper in a printing frame and allow it to sit in the room for at least 30 minutes. Develop the paper as described below and see if any traces of an image remain on the paper. Generally a 30-minute exposure in a room illuminated with fluorescent lighting produces a faint image that disappears as soon as washing is initiated.

evenly over the surface by using rapid, light strokes along the length and width of the area defined by the negative's size.

Do not allow puddles to accumulate, since their outlines will be quite obvious as imperfections in the final print. Continue to brush the emulsion until the surface of the paper is uniformly coated. There should be no signs of brush marks on the surface of the paper. If the brush sheds a bristle while the emulsion is being applied, use the brush to nudge it toward the edge of the paper and rework the area until it blends with its surroundings.

After the sensitizer has been applied, place the brush back in its storage vessel and use a blow-dryer on a warm setting to dry the paper. Hold the paper down by its corners and direct the stream of warm air back and forth across

the surface. Feel the back of the paper to make certain that the paper is completely dry. Cyanotype papers are very heat tolerant and the action of the blow-dryer will have no adverse effects. The dried emulsion has a yellow-green appearance; if it has a blue tone, some of the iron salts have undergone reduction and the paper should be discarded. Coated paper should be used immediately or stored in a cool, dry place. It keeps for several days in a light-tight box.

Certain papers, especially those used as writing paper, curl badly the moment one side is wet with the sensitizer. It is best to tack these to the cardboard with pushpins. Thicker papers bow slightly as the emulsion is applied but are easily restrained by holding down the corners as the emulsion is spread on the surface.

The borders of the sensitized surface will be uneven, and will clearly show the signs of brushwork. Some workers consider this desirable, reflecting the handmade character of the print. For cyanotypes with sharply defined edges, use four strips of *drafting tape* (not masking tape!) to define the print area. Coat the paper within these boundaries, and when the emulsion is dry, peel off the drafting tape.

Printing Cyanotypes

Cyanotype emulsions have a low inherent contrast. A print with a full scale of tonal values from deep blue to white can easily be printed from a negative with a density range of 1.6 or higher. This corresponds to N+1 or N+2 development for negatives of subjects with a normal subject brightness range. A typical negative for a cyanotype would require a contrast Grade 0 paper if it were to be printed on an ordinary silver-based enlarging paper. For negatives with a more limited density range, print contrast can be increased by adding a few drops of the potassium dichromate solution to the sensitizer. The addition of potassium dichromate to the sensitizer will require a significant increase in exposure time.

Making a cyanotype is a *printing-out process,* that is, the image forms as the paper is exposed to light, and no chemical development is needed. A cyanotype emulsion requires an intense light source, and even sunlight exposures may require up to 15 minutes, depending on the time of day and year. The lemon-yellow emulsion rapidly turns green, then blue-gray, as exposure increases. When the image highlights begin to appear, the tonal values of the shadow areas actually *reverse* and take on the appearance of a textureless blue-gray mass. This "apparent overexposure" is necessary because the image lightens considerably during washing and processing, and highlight tones will disappear unless they are well defined in the initial image.

As noted previously, variations in light intensity and the composition of the emulsion and paper make it impossible to predict precise exposure times for cyanotypes and other alternative printing processes. The appearance of the latent image of a calibrated density strip is one of the best ways to follow the progress of image development. Place a negative and a calibrated density strip side-by-side on the sensitized paper and begin the exposure by placing the frame in the light source.

To monitor the progress of development take the frame out of the path of the light source, open one-half of the printing frame, and gently lift a portion of the paper away from the negative. If highlight details are not clearly visible, close the frame again and continue the exposure. When you estimate that sufficient exposure has been given (highlight details should be clearly defined), take the exposed print out of the frame and examine the image of the calibrated strip. Look for the first step that is darker than the background, mark that step with a pencil, and process the print (see below). After the print is dry, mark the lightest step that is visible on the paper. This step will be approximately five to six steps lighter than the tone you originally marked.

Next, find the step of the calibrated scale that corresponds most closely to the highlight density of the negative (do a visual comparison on a light box, which is accurate enough for these purposes, or measure the highlight density with a densitometer). In future printings expose the print so that the step corresponding to the highlight density is five to six steps darker than the first visible tone. A print using this exposure time should have highlight values with the appropriate tonality. With experience you will be able to dispense with

using the calibrated strip for cyanotypes and evaluate the exposure by visual examination of the highlights. If care is taken in the preparation of solutions and in the exposure and development of the film used to produce negatives, print exposure times will fall into a narrow and consistent range.

Processing the Print

To process the print, slide it into a tray of tap water and gently rock it back and forth. The white areas of the image clear quickly as the unexposed and soluble iron salts are washed from the surface. Place the print in a tray of running water and wash it in running water for 2 to 3 minutes. Do not allow a stream of water to fall directly onto the paper, because it is very fragile while wet and punctures easily. At this stage the whites should be clear and the darkest tones a pleasing blue.

Washing is most easily accomplished in a tray fitted with an automatic siphon, such as the Kodak Tank and Tray Siphon. This kind of tray, however, can be unreliable and can cease draining properly with slight changes in water pressure. Always place the tray in a sink to avoid flooding the darkroom in the event of a malfunction. An alternative to a siphon is a plastic developing tray in which a series of ¼-inch holes spaced about 1 inch apart have been drilled along one side approximately 1 inch from the tray's bottom. A hose from the faucet can be used to feed water into the opposite end of the tray. The flow of water washes the print efficiently.

After washing for about 2 to 3 minutes, transfer the print to a tray of water to which a small splash of 3-percent hydrogen peroxide has been added, or simply add a splash of peroxide to the siphon tray. The image will turn deep blue as it comes into contact with the oxidizing agent. Continue to wash the print for another 5 minutes. Drain the print and hang it by clips to dry. Alternatively, lay it on a clean sheet of glass; blot away excess water with a photo blotter or a clean, soft sponge, and dry the print using a blow-dryer.

Controlling Contrast

Cyanotype contrast can be increased by adding an oxidizing agent to the sensitizer prior to coating. One to two drops of the 1-percent potassium dichromate solution added to each milliliter of sensitizer results in an increase in contrast equal to the loss of approximately two steps on the calibrated density strip. You need to experiment to find the exact amount of oxidizer necessary to achieve the desired result.

Adding oxidizer to the sensitizer changes the speed of the emulsion as well as contrast. The exposure time will differ significantly from values previously determined in the absence of dichromate solution.

Troubleshooting Cyanotypes

The characteristics of a fine cyanotype are rich color, appropriate tonalities, and fine detail. When a print lacks these features, there are several possible sources of difficulty.

Figure 7.6: John P. Schaefer, *Sydney Opera House, 1993.* This grouping of twelve different photos was printed to create a collage of cyanotype images.

Coating A common failing is uneven coating of the emulsion. Splotches of light areas or streaks that are darker than the average background tone are usually due to problems in coating technique. Too much emulsion leads to puddle formation on the paper surface and deeper and uneven penetration of the coating into the body of the paper. When the print is exposed and developed, these areas appear as dark spots or bands. Rapid and even spreading of the emulsion minimizes these problems. Use a brush wide enough to accomplish this task: while a ½-inch brush is satisfactory for a 4 x 5 print, a 1½-inch or wider brush produces more consistent results for larger prints.

Another source of visible coating defects is damage to the paper surface during manufacture or subsequent shipping and handling. Uneven pressure affects the structure of the paper and compresses fibers in selected areas so that the emulsion does not penetrate evenly. Always store paper in flat stacks and do not place heavy objects on top of the pile.

Graininess Graininess not associated with the negative being printed often manifests itself in cyanotypes and other alternative printing processes to an extent that the image may appear to have been photographed during a sandstorm. This problem usually stems from the nature of the paper and its sizing. The easiest way to eliminate this problem is to try another kind of paper or to size the surface with a coating of gelatin (see pages 143–145).

In my experience Arches Aquarelle hot-pressed paper is excellent for making cyanotypes, as are selected papers from Strathmore, Cranes, and Canson. The best way to choose a paper for any alternative printing process is to purchase a small selection of sheets of fine paper from an art supply store, print the same negative on each, and compare the results. Papers that work well for one process may prove to be totally unsuitable for another. As mentioned in chapter 6, some papers require additional sizing to prevent the emulsion from soaking too deeply into the paper.

Contrast Image contrast can be controlled and increased by adding a few drops of potassium dichromate to the sensitizer. This enables negatives of relatively normal contrast to be printed as cyanotypes with an expanded range of tonal values.

Making a Cyanotype: A Step-by-Step Guide

The basic manipulations and procedures used for making a cyanotype are applicable to most other alternative printing processes too. Variations associated with other methods reflect differences in chemistry and necessary processing conditions, but the core of the approach detailed below is generally useful.

Method A

The two methods described follow the same steps for the most part. The one advantage to Method A is that precise alignment of the negative and coated area of the paper is easier.

1. Select one or more papers for testing and use in printing. The best papers for making cyanotypes are high-quality 100-percent rag watercolor papers, unbuffered, with a smooth surface and in the range of 80- to 140-pound weight.

2. Prepare Solution A: a 20-percent solution of ferric ammonium citrate (10 grams to 50 ml. of purified water); Solution B: an 8-percent solution of potassium ferricyanide (4 grams to 50 ml. of purified water); and Solution C: a 1-percent solution of potassium dichromate (0.5 grams to 50 ml. of water). Store and label each solution individually in a 2-ounce brown eyedropper bottle. To make each solution:

 a. weigh out the required amount of crystals

 b. transfer the crystals to a beaker containing 50 ml. of purified water and stir until the crystals dissolve

 c. transfer the solution to its storage bottle

 d. date and label the bottle

3. Cover a tabletop with a few sheets of newspaper. Place a sheet of cardboard or plate glass on top of the newspaper to serve as a working surface for coating the paper.

4. Place the sheet of paper to be coated on the cardboard or glass and use the negative that you intend to print to make light marks on the paper to indicate where the emulsion will be applied.

Figure 7.7: *Taping paper to plate glass.* Unlike masking tape, drafting tape peels off paper without tearing it and can be used to define image edges while holding the paper in place during exposure. The outlines of the negative have been lightly marked on the paper with a soft pencil.

Figure 7.8: *Loading the printing frame*
Lay the frame on a flat surface with the back facing toward you. Place the sheet of paper, sensitized side faceup, on the back and position the negative on the sensitized coating. If you intend to use a calibrated density strip to monitor the exposure, place it beside the negative.

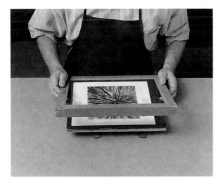

Figure 7.9: *Closing the printing frame*
Place the clean, dust-free glass of the printing frame over the negative and lower the printing frame over the assembly. Hold the back in place, turn the entire assembly over, and lock the spring back. (The advantage of Method A over B is that precise alignment of the negative and the coated area of the paper is easier.)

5. For clean borders, use strips of drafting tape to define the edges of the coating.

6. Papers lighter than 80 pounds tend to curl badly when one surface is wet, and it may be necessary to use pushpins or drafting tape at the corners to hold the paper in place during the coating process.

7. Select and wet a brush. Store it in a jar of clean water.

8. Measure equal parts of solutions A and B into a 1-ounce plastic medicine cup or other suitable container. For small volumes, count out equal numbers of drops of each solution. If several sheets of paper are coated in sequence it is easier to use a small graduated cylinder. Mix the solutions by swirling the container.

9. Remove the brush from the storage jar and shake off the excess water.

10. Pour the coating onto the surface of the paper and *immediately* begin to brush it across the surface with light, rapid strokes, first in one direction, then perpendicular to it. Alternatively, use a "Puddle Pusher" (see page 149) to spread the sensitizer on the paper. In either case strive for a uniform distribution of the solution and look closely at the paper to make certain that no areas of the paper have been missed (see figures 6.18 to 6.21).

11. Rinse and return the brush to the storage jar. Change the water as it becomes discolored.

12. Give the coating a minute or so to soak into the paper and air-dry, then use a blow-dryer on warm heat to dry the coating thoroughly. Check the back of the paper: if it is cool and damp, the paper requires further drying.

13. Peel the drafting tape from the surface of the dried paper and discard it. If you prefer, the tape can be left in place during exposure and removed prior to washing the print.

14. Remove the back of the contact printing frame and place the back faceup on the table. Clean the glass if necessary.

15. Place a coated sheet of paper, *emulsion side up,* on the surface of the back of the printing frame.

16. Place the negative (and calibrated density strip if one is being used) *emulsion side down* directly on the coated paper.

17. Lower the glass of the printing frame onto the negative/paper assembly and back. Make certain that nothing shifts in the process and that the negative covers the emulsion.

18. Lower the printing frame onto the glass.

19. Holding the back of the frame in place with your fingertips, turn the frame over and lay it on the surface of the table.

20. Depress and twist the spring steel clamps into place.

21. Turn the contact printing frame over and examine the assembly. If anything has shifted out of place or if dust has found its way into the assembly, undo the back and repeat steps 14 through 20.

22. Expose the print. Use highlight development to assess the progress of the printing-out process.

23. Remove the print from the contact printing frame and slide it, emulsion side up, into a tray approximately one-third filled with tap water. Tilt the tray from side to side in a gentle rocking motion. The water quickly discolors as it dissolves the unexposed chemistry.

24. After about 1 minute pour out the first wash water.

25. Carefully pour an equivalent amount of fresh water into the tray (not directly onto the surface of the print!) and resume rocking the tray. Repeat this cycle two or three times until the water remains relatively clear.

26. Connect a siphon to the side of the tray and wash the print for 2 minutes.

27. Add a small splash of 3-percent hydrogen peroxide to the incoming stream of water. The print will turn a deep blue as the oxidizer comes into contact with the cyanotype, and the highlights will brighten. Agitate the print in the running water if necessary to ensure that the entire print surface is uniformly oxidized. (*Never* use a chlorine bleach to oxidize a cyanotype since it can have a long-term deleterious effect on the paper unless it is thoroughly washed after treatment.)

28. Continue washing the print for 5 minutes. The dye will continue to leach out of it as long as washing is continued, but after the first few minutes the rate slows drastically.

29. Remove the print from the wash and hang it from two corners to drip-dry. Drying can be accelerated by using a blow-dryer.

30. Evaluate the print.

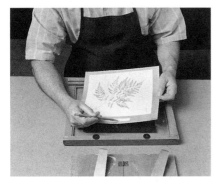

Figure 7.10: *Test exposures and the calibrated density strip.* The latent image of a cyanotype is clearly visible. The shadow areas of a properly exposed print usually show signs of a "reversal" of tonal values. Mark the last distinguishable step on the image of the calibrated density strip prior to initiating processing of the test exposure.

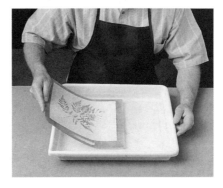

Figure 7.11: *Processing a cyanotype.* Begin "development" by sliding the print into a tray of tap water. The image color changes from blue-gray to blue immediately, and print density decreases substantially.

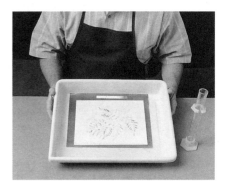

Figure 7.12: *Washed and oxidized cyanotype.* After you complete the washing sequence, the print is light blue in color and dye stops leaching from the print if it is held up and allowed to drip from a corner.

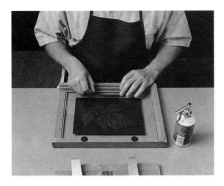

Figure 7.13: *Loading the printing frame.* For Method B, place the printing frame and glass facedown on a table, use compressed air to remove any dust particles from the surface of the glass and negative, and lay the negative (and calibrated density strip if one is used) *emulsion side up* on the clean glass surface.

Method B

Method B follows the same directions as Method A through step 13.

14. Remove the back of the printing frame and place the frame with its glass facedown on a table.

15. Place the negative and, if one is being used, the calibrated density strip — *emulsion side up* — on the surface of the glass.

16. Place the sensitized paper, *emulsion side down,* on the glass so that the negative and strip are covered by the emulsion. This may require a few attempts if the negatives move as the paper is lowered and the area of the sensitized coating is not much larger than the negative itself.

17. Hold the back of the sheet of paper in place with one hand to keep the negative/paper assembly in place and set the spring back of the frame in place with your other hand. Keep pressure on the back while the springs are set in place.

18. Turn the frame over to make certain that the paper, calibrated density strip, and negative are in the correct position. If they have shifted, open the back and repeat steps 14 through 18.

19. Follow the directions given in steps 22 through 30 of Method A, above, to complete processing of your print.

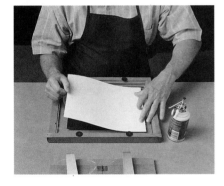

Figure 7.14: *Placing paper in the printing frame.* For Method B, place the sheet of sensitized paper *facedown* over the negative without disturbing the underlying negative and calibrated density strip.

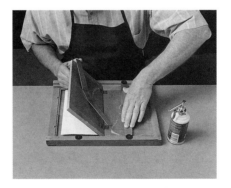

Figure 7.15: *Closing the printing frame.* For Method B, put the spring back in place and clamp the back shut by swiveling the metal prongs into position.

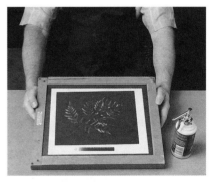

Figure 7.16: *Loaded contact printing frame.* A properly loaded contact printing frame ready for exposure. In all alternative printing processes, a visible change in the sensitized coating takes place during exposure. With experience it is a simple matter to judge when the correct amount of exposure has been achieved.

Figure 7.17: John P. Schaefer, Barrel Cactus, 1975. An enlarged litho film negative was used to make this cyanotype. A low-contrast positive was made by contact printing the original negative onto Kodak Commercial Film. The positive was placed in a negative carrier, and its image was focused on a sheet of paper placed on the baseboard of the enlarger; the paper was taped in place, and outlines of the projected image were marked. A sheet of litho film was placed on the paper and covered with a sheet of ground glass, rough side down.* The film was exposed and developed in litho developer for 2 minutes without agitation after the first 10 seconds (see "Still Development of Litho Film," page 124). The resulting negative appears to be continuous tone, but close inspection reveals that the image is a mosaic of minuscule grains that only mimic the tonality of an ordinary negative.

* A large sheet of ground glass can be made by purchasing two sheets of ordinary window glass and a few ounces of very fine Carborundum grit (available at hobby shops). Cover a countertop with several sheets of newspaper, place one sheet of glass on the paper, sprinkle a small amount of grit and water on the glass, and cover them with the second sheet of glass. Press down firmly on the glass and rub the top sheet against the bottom in a random pattern. Add more grit and water as needed during the grinding process. It takes about 5 minutes to produce two perfectly ground sheets of glass.

Photograms

Making a photogram is a useful introduction to alternative printing processes and provides a good evaluation of your coating skills. Photograms have a broad expanse of uniform tonality for a background, and any variations in tone due to uneven application of the sensitizer are all too apparent. Exposure problems are simplified, and concerns about contrast and negative density scale are irrelevant, since objects take the place of the negative. Furthermore, arranging simple transparent or opaque objects, such as leaves, lace, pencils, drinking glasses, and other items that can readily be identified by their profiles or outlines, in a visually pleasing composition is a challenging task and stimulates creative visual thinking.

If the chosen objects are thin and flat, a hinged printing frame will hold them in place and in contact with the sensitized paper as if they were a photographic negative. Clean the glass of the printing frame thoroughly and place a sheet of paper faceup on the back of the frame. Put the objects being used on the surface of the paper. When you are satisfied with the arrangement, cover it with the sheet of glass, and carefully lower the frame over the assembly. Turn

the printing frame over, holding the assembly tightly with your fingers, and secure the hinges in place. If the items are not flat, a printing frame cannot be used, and they should be stacked directly on a sheet of sensitized paper that has been taped to a sheet of glass or cardboard. Expose until the paper turns to a blue-gray color, then process the paper as previously described. The image will have only two tones (blue and white), unless some of the objects are translucent, in which case you will see gradations of blue.

Summing Up

Making a cyanotype, or using any of the other alternative printing processes described in the following chapters, is an experience that is fundamentally different from commonplace darkroom activities. There are no boxes of carefully standardized papers and emulsions that require a 10-second exposure under an enlarger and routine processing to produce, if necessary, dozens of identical prints. Making a cyanotype is an unhurried process.

Each handmade print is an individual project and must be carefully crafted. After a paper is chosen and the chemistry prepared, the sensitized emulsion must be applied by brush. Exposure and processing requires more than ordinary care, though working in a well-lit room is an unanticipated luxury. Subtle differences in papers, emulsion, or exposure manifest themselves in the print. As you move from the first tentative images to prints that are a measure of the inherent beauty of the process, your technique and appreciation for careful work habits will improve dramatically and carry over to all of your photographic efforts.

Yet the reward for making fine handmade prints goes beyond this. In an age of mass production, where the daily output of photographs is counted in the millions, printmaking represents the voice of the individual, of personal expression. It is a photographic voice speaking in a timeless language.

Figure 7.18: John P. Schaefer, *Fern, 1996.* A convenient way to make photograms is to create the basic image by exposing an object on a sheet of litho film and contact printing the resulting negative. During the 1840s, Anna Atkins, the first professional female photographer, made a series of more than four hundred cyanotypes, many of which were published in her monumental and creative work titled *Cyanotypes of British and Foreign Flowering Plants and Ferns.*

Chapter Eight

Alternative Silver Printing Processes

All progress in art is based on the existence of "movements," "Schools," and styles (definitions of trends of thought). The innovations of one period are the safe conventions of the next, and perhaps the objects of scorn of a subsequent era. After a sufficient interval of time, the intellectual analyst seeks, in the work of an earlier age, the factors which appear logical and even emotional; once accepted, these factors become "classical" and may be integrated into the basis for a new approach, or as the foundation of reactionary opinion and criticism.

The "Factual" period of photography (we may call it the "Classical" period) which closed with the ascendancy of the Pictorial school, revealed the basic capacities of the medium, comparatively unaffected by the trends of the other arts. Photography of that period was difficult and limited, and yet nothing has surpassed the magnificent work of Hill, Atget, Brady, and Nadar in the clarity and directness of their message and the honesty of their craftsmanship. — ANSEL ADAMS

The original photographs made by Fox Talbot and his colleagues were named *calotypes* or *talbotypes* but are now generally called *salt prints*. Fox Talbot's observation that silver chloride in the presence of an excess of silver nitrate is photosensitive and darkens on exposure to an intense light source such as sunlight is the basis of the original photographic process that he invented. It differs from commonly used modern processes in that no developers are employed — the action of light alone converts the silver salt to metallic silver, thereby forming a visible image. Photographs made in this way are classified as *printed-out* to distinguish them from those that are *developed* from invisible latent images by chemical reducing agents that transform exposed silver salts to silver metal. Printing-out processes involve contact printing large-format negatives, because no practical enlarger can generate the intensity of light required for the length of time necessary to convert a silver halide to metallic silver without the aid of chemical developers.

Photographic papers that are or could be used as a variant of Fox Talbot's formulation were soon manufactured commercially. *Albumen* paper, which used egg white as the medium for coating the surface, came into use in the 1850s and was the favored paper for making photographic prints in the nine-

Figure 8.1: Betty Hahn, *Dried Flowers,* from the Cut Flowers series, 1978. Vandyke print.

teenth century. Albumenized paper as purchased by photographers consisted of boxed sheets of fine paper that had been machine coated with a mixture of albumen and a salt solution (usually ammonium chloride or sodium chloride, as well as some sodium citrate). These salted papers, however, had to be made photochemically active (that is, sensitized) by the photographer just prior to use. Salted paper is unaffected by exposure to light — it becomes photosensitive only after the salt is converted to silver chloride by soaking or otherwise coating the sheet with silver nitrate. This is done by floating a sheet of the salted paper, albumen side down, on the surface of a bath of silver nitrate solution, which reacts with the salt contained in the albumen and forms a suspension of silver chloride that is trapped within the albumen coating. After drying, the paper is ready to be exposed and processed.

Albumen prints have a glossy surface and an overall brilliance and contrast range that cannot be achieved with a matte surface paper. The glossy albumen print became the universal standard for commercial photographs for almost fifty years. Until the advent of the color snapshot, the number of albumen photographs in existence far outnumbered those of all other kinds combined. One factory alone in Dresden, Germany, used egg whites from over six million eggs a year to make albumen paper. It is little wonder that photographic journals in the nineteenth century published recipes for making cheesecakes using egg yolks only! A disadvantage of sensitized albumen paper is its lack of stability; it must be exposed and used the same day it is made.

Printing-Out Paper

During the 1880s a variant of the albumen and salt print, a gelatin-coated, silver chloride based paper, was formulated and sold commercially as *printing-out paper* (POP). POP does not need to be sensitized prior to printing and does not have the disadvantage of instability that plagued albumen paper. POP keeps for long periods of time if it is stored in a cool, dark place. Because of the advantages of POP over albumen paper, it was quickly adopted by commercial photographers as the printing medium of choice.

As ways were found to increase the speed of photographic papers, and a system for chemical development of latent images evolved, a series of fundamental changes in the practice of photography occurred. The ease and simplicity of making prints by enlargement did away with a basic limitation of contact printing, namely that the size of a print is equal to the size of the negative. Miniature cameras that were easy to handle and operate became a favored alternative to view cameras. While contact prints have aesthetic and physical attributes (for example, superior sharpness and distinctive tonal qualities) that cannot be duplicated by processes that use enlargement, the convenience of the latter has ultimately relegated contact printing processes to a minor role in ordinary photographic applications.

With the changing approach to photography, the use of POP gradually declined. Its production by Kodak was discontinued in 1987, much to the dismay of photographers who cherished its unique tonal qualities. In 1988, a French company began production of POP, and it is available as a single- or double-weight paper from the Chicago Albumen Works (see page 376). The

Figure 8.2: John P. Schaefer, *Forest, New Zealand, 1990.* Printing-out paper is used for contact printing and develops on exposure to intense ultraviolet light sources or sunlight. Colors ranging from red-brown to blue can be generated by toning. Negatives with an extended density range are required to span the tonal range of the paper.

quality of these papers is superb, and they are an ideal way to learn the intricacies of contact printing, exposure control, processing techniques, and toning that are used in many of the alternative printing processes described in this book. The high and uniform quality of the POP available from the Chicago Albumen Works eliminates any problems that may arise from shortcomings or variability in personal coating techniques, sensitizer formulations, and so forth, and your attention can be focused on print exposure and processing.

Negative Characteristics

A print made on POP that is to display a full scale of tonal values requires a negative with a density range in excess of 1.8, which is beyond the recording capability of even a Grade 0 enlarging paper. Negatives intended for printing on POP should be given full exposure and extended development to achieve an appropriate density range. Negatives with a shorter density scale can be used if a more limited spectrum of print tones is desired, but there is a danger that the print may look flat and muddy.

Paper Characteristics

Unlike ordinary papers used for making enlargements in the darkroom, printing-out papers can safely be handled for short periods of time (several minutes) in ordinary room lighting. If the paper is to be stored, however, it should be tightly sealed in a plastic pouch and kept in a refrigerator.

Chemicals and Supplies

The requirements for processing POP are minimal. In addition to a printing frame and light source, you will need a supply of sodium thiosulfate crystals or ammonium thiosulfate (packaged as *rapid fixer* in most camera stores — one bottle contains a buffered solution of ammonium thiosulfate; the other is a hardening agent that you add when the fixer is to be used to fix films or enlarging papers). *Note:* Do not add the hardener to the solution when working with any kind of salt print! You'll also need selenium or gold toner and a washing aid (any brand of hypo clearing agent). A calibrated density strip is a useful accessory when you first begin to make prints.

Mixing Chemical Solutions

Fixer. The fixers that are normally formulated for films or prints *should not be used* with salt prints because they will rapidly bleach the image. The key to fixing POP or other kinds of salt prints is to keep the fixer *decidedly* alkaline. If you use rapid fixer, take one part of rapid fixer stock solution and dilute it with ten parts of water. Add 1 teaspoon of *sodium carbonate* to each 500 ml. of diluted fixer and stir until the crystals dissolve (some fizzing might occur when the sodium carbonate is added to the fixer).

Clearing Agent. Any of the commercially available clearing agents are satisfactory and can be used without modification.

Selenium Toner. Kodak Rapid Selenium Toner will stabilize the silver image and produce print tones that can range from red-brown to gray. The image will bleach if toning is carried out too long or if the concentration of toner is too high. Dilute one part of Kodak Rapid Selenium Toner with five hundred parts of water.

Gold Toner. The supplies for gold toners can be purchased in kit form or as individual components from Photographer's Formulary (see page 376). Two types of gold toners can be used: alkaline gold toner and a gold toner–thiocyanate solution.

ALKALINE GOLD TONER. Pour 500 ml. of purified water warmed to 100°F (38°C) into a beaker and add 4 grams of borax. Stir the solution until the crystals dissolve. To this solution add 8 ml. of 1-percent gold chloride solution, mix it thoroughly, and transfer the solution to a brown glass bottle fitted with a *plastic* screw cap. (Gold-toning solutions decompose in the presence of most other metals and degradable organic matter.) If toning takes place too rapidly to control, dilute the toner with distilled water. Label the solution "Alkaline Gold Toner."

Figure 8.3: *Printing-out paper in a contact printing frame.* The negative, a calibrated density strip, and a sheet of printing-out paper are inserted into a contact printing frame, ready for exposure.

Figure 8.4: *Evaluating exposure.* Printing-out paper should be exposed until highlight details are clearly defined. Monitor the progress of development by opening half of the printing frame and inspecting the image. Some print density is lost during processing.

Figure 8.5: *Exposed, unprocessed printing-out paper.* Printing-out paper has a very long exposure scale. Using a calibrated density strip will help you learn the degree of overexposure that is needed to compensate for the losses in image density that occur during processing.

GOLD TONER – THIOCYANATE SOLUTION.

Solution A. To 500 ml. of purified water add 10 grams of sodium thiocyanate. Stir until the crystals dissolve, transfer the solution to a clean bottle (glass or plastic will do) fitted with a *plastic* screw cap, and label it "Thiocyanate Toner A."

Solution B. To 500 ml. of purified water add 1 gram of gold chloride. Stir the solution until it is thoroughly mixed and transfer the solution to a clean bottle fitted with a *plastic* screw cap. Label it "Thiocyanate Toner B."

Exposing POP

Use either sunlight or a light source rich in ultraviolet radiation to expose the print. POP prints develop during exposure, but the degree of exposure required depends upon how you decide to process the print. If the print is to be toned immediately after washing (see page 179), expose the print until the highlights have clearly defined texture. Alternatively, if you plan to tone the print after both washing and fixing, exposure must be carried on until highlight densities are considerably more intense than would be desirable in the final print, because substantial print density is lost during the washing and fixing steps. A calibrated density strip allows you to measure the number of steps lost in processing, so that you can compensate for that difference in future exposures.

Exposure can also be used to control the contrast of the final image. Print contrast is influenced by the fraction of ultraviolet light in the exposing light source: the greater the percentage of UV light, the lower the print contrast. Sunlight is an effective light source and produces a relatively low-contrast image after a short exposure. Printing the same image by removing it from the path of direct sunlight and placing it in the shade with the printing frame facing the open sky increases both the exposure time and print contrast. With artificial light sources that have a high UV content, you may need to compensate for lower print contrast by increasing the contrast of your negatives.

Washing POP

To begin processing the print after exposure, slide it into a tray filled with about ¼ to ½ inch of tap water and gently tilt the tray back and forth. The deep purple tone of the exposed print changes to a red-brown color as soon as it is immersed in water, and the water quickly turns milky as unreacted silver nitrate combines with the salt that leaches from the paper and forms insoluble silver chloride. After about 1 minute, pour the milky water into the sink, refill the tray with tap water, and continue to agitate the print. After three or four changes of water, the wash water will be clear. Excessive washing reduces the image intensity, so it should be terminated as soon as the wash water ceases to be milky. However, it is important to remove all of the excess silver nitrate from the print before toning, since it precipitates (and wastes) gold from the toning bath. After washing it, you can either tone the print and then fix it or immediately fix the print and tone it at a later time. Note, however, that the end results of reversing the toning and fixing processes will not be the same.

Toning POP

The stability of POP of any kind is enhanced by toning, though an untoned print processed to archival standards and stored with reasonable care will keep for many years. A major reason for toning POP is to control or generate print colors; untoned fixed prints have a yellow-brown hue. The toner you select (for example, gold or selenium), its concentration, and the duration of toning determine whether the final image is red-brown, blue-gray, or somewhere between these extremes.

Toning is complicated by the fact that the wet image has a color-and-contrast range that is often considerably different from that of the dried print. You cannot predict the final appearance of a print without considerable experimentation and experience, and for this reason it is important to keep careful notes of your observations and the processing procedure that you use. The following variables affect the color of the final print:

1. *Duration of the toning process.* Extensive toning of POP in a borax-gold toner results in a blue-gray print, while a shorter toning time produces a red-brown to brown image. Full toning of a Vandyke brownprint results in a red-brown image, and the final color depends upon the nature of the printing paper and the sizing used in its manufacture. Toned prints vary from chocolate brown to red-brown. Generally, the longer the duration of toning, the colder the tone of the dried print. If the print tones too quickly, dilute the toner by adding water.

2. *Acidity of the toner.* Alkaline toning solutions produce warmer images with a coloration that tends toward the red, while more acidic formulations result in cold-toned prints with a blue-gray hue. The borax bath described above is alkaline and is stable indefinitely. It can be replenished by the addition of small amounts of a 1-percent gold chloride solution as the toning bath begins to lose its effectiveness. Toning baths using thiocyanate are less alkaline, act as silver solvents, and are fast and effective but must be mixed from stock

solutions just prior to use. The mixed solution will keep for several hours but then should be discarded.

3. *Printing process.* One determinant of color is the size or dimension of the aggregate particles of silver that constitute the physical substance of the image. Particle size is a function of the chemical and physical processes by which they were generated. Images that are "developed out" rather than "printed out" will have different colors even though the chemical compositions of the deposited metals are the same.

4. *Paper sizing.* Gelatin sizing favors warm tones, while starch sizing produces cold-toned images.

Toning Procedures Superb century-old gold-toned prints attest to the beauty and effectiveness of the gold-toning process. The literature abounds with various formulations and methods for gold toning, many of which stem from a time when the price of gold was much lower. Photographer's Formulary sells moderately priced kits for gold toning that are easy to use. The cost of gold toner varies with the fluctuations in the price of gold. Approximate prices are $40 for 1 gram of gold chloride and $10 for 10 ml. of 1-percent gold chloride solution. A kit that will make at least one hundred 8 x 10 POP prints costs approximately $20 and contains sufficient gold toner to treat all of the images. Separate solutions for other toning applications can also be purchased.*

If prints are to be gold toned, *trim off the surrounding exposed border of the print prior to washing* and leave just enough paper around the print edges for safe handling. This minimizes wasting gold on nonessential portions of the image. Avoid touching the surface of the print, since the emulsion is extremely delicate and sensitive.

Toning should be carried out at room temperature and with constant agitation. The toner is ruined by any trace of fixer, so if you elect to fix a print prior to toning, it must be thoroughly washed first. When toning is done prior to fixing, the print should be washed in running water for 5 minutes before being placed in the toning bath. Either of the following two toning baths works well.

To tone a print using the alkaline gold toner (see page 176), place it in a clean, *unstained* plastic tray containing the toning bath. Agitate the print by tilting the tray occasionally. Depending upon the age of the toning bath and the concentration of gold, toning can require times that vary between 1 and 12 minutes. The greater the duration of toning, the more pronounced the shift toward a colder blue-gray color in the final print. Pour the remaining toner back into its storage bottle. After several prints have been toned it may be necessary to add more gold chloride solution to the toning bath to increase its activity.

When the print is fixed and dried, a further color shift takes place (you will find that if the print looks just right in the toning bath, it will prove to be greatly overtoned, which can be very frustrating). The best way to estimate the *approximate* effect of toning is to prepare a series of test strips, tone all but one

* Prints can be toned with other noble metals such as platinum, but these elements are often more costly than gold and offer no practical advantage. It is preferable to use platinum for making prints directly, rather than for toning.

for varying times (describing the transient colors as best you can in your notebook), fix, wash and dry them, and compare the series to an untoned standard. These "standards" plus the benefit of experience will help you to evaluate the progress of print toning effectively.

To tone an 8 x 10 print with the thiocyanate toner (see page 177), add 50 ml. of solution A to 900 ml. of *purified* water, followed by 50 ml. of solution B. A bright red color forms as B is added, but this quickly dissipates, and the mixed solution becomes colorless. Slide the print into the toning bath and agitate it by gently rocking the tray. After approximately 1 minute the print will have a yellow-orange color. As toning continues, the color shifts toward blue-gray. The shorter the toning time, the warmer (a red-purple hue) the final print tone. Additional photographs can be toned by replenishing the solution with approximately 8 ml. each of solutions A and B for each 8 x 10 print. To reiterate, the print tone cannot be judged accurately until it is fixed and dried. Discard the toning bath after you have processed the last print — the mixed toner does not keep for more than a few hours.

Fixing POP

Toned or untoned salt prints must be fixed for permanence in a bath of sodium thiosulfate or ammonium thiosulfate. The following procedure is recommended for POP and can be adapted for processing other types of salt prints.

For an 8 x 10-inch print prepare the fixer by adding 25 ml. of rapid fixer to 250 ml. of water and then add a teaspoon of sodium carbonate to the solution. Stir the solution until the sodium carbonate dissolves and then pour the fixer over the surface of the print; the color will change immediately to a light yellow-brown. Agitate the print by rocking the tray for 5 minutes, then discard the fixer (after the initial color change, very little change in the visible image will occur with this fixer formulation). Repeat this procedure with a fresh batch of fixer, then rinse the print in tap water, soak it for 2 minutes in a hypo clearing bath, and wash the print for a half hour in running water prior to toning. The emulsion of POP is thicker and richer in silver than modern enlarging papers, and thorough washing and fixing is needed prior to toning with selenium, or else the print will stain. Selenium toning produces prints with a wonderful spectrum of possible colors and is the least expensive toning process to use.*

* In their 1997 production of POP (Centennial™), Chicago Albumen Works recommends fixing the print in a plain hardening fixer such as Kodak Fixer. Using two fixing baths for 5 minutes each results in very little bleaching of the image. The paper tones beautifully in any of the usual gold-toning formulations or in dilute (1:500) Rapid Selenium Toner.

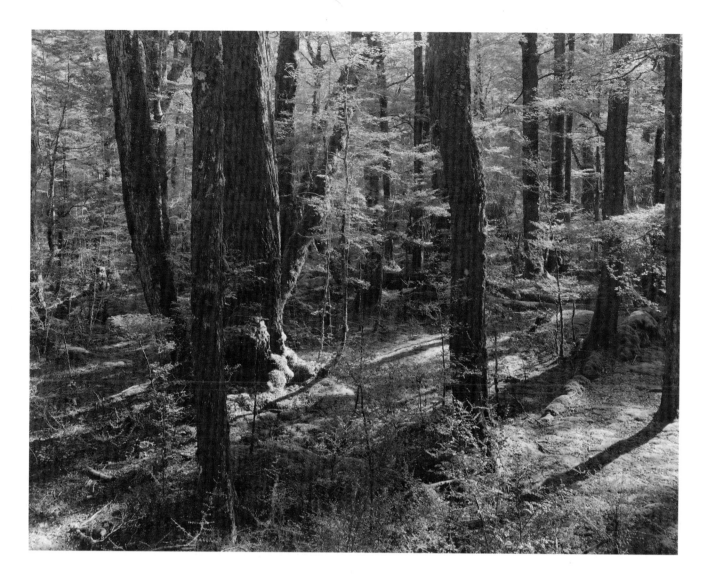

Figure 8.2: John P. Schaefer, *Forest, New Zealand, 1990.* Printing-out paper is used for contact printing and develops on exposure to intense ultraviolet light sources or sunlight. Colors ranging from red-brown to blue can be generated by toning. Negatives with an extended density range are required to span the tonal range of the paper.

quality of these papers is superb, and they are an ideal way to learn the intricacies of contact printing, exposure control, processing techniques, and toning that are used in many of the alternative printing processes described in this book. The high and uniform quality of the POP available from the Chicago Albumen Works eliminates any problems that may arise from shortcomings or variability in personal coating techniques, sensitizer formulations, and so forth, and your attention can be focused on print exposure and processing.

Negative Characteristics

A print made on POP that is to display a full scale of tonal values requires a negative with a density range in excess of 1.8, which is beyond the recording capability of even a Grade 0 enlarging paper. Negatives intended for printing on POP should be given full exposure and extended development to achieve an appropriate density range. Negatives with a shorter density scale can be used if a more limited spectrum of print tones is desired, but there is a danger that the print may look flat and muddy.

Paper Characteristics

Unlike ordinary papers used for making enlargements in the darkroom, printing-out papers can safely be handled for short periods of time (several minutes) in ordinary room lighting. If the paper is to be stored, however, it should be tightly sealed in a plastic pouch and kept in a refrigerator.

Chemicals and Supplies

The requirements for processing POP are minimal. In addition to a printing frame and light source, you will need a supply of sodium thiosulfate crystals or ammonium thiosulfate (packaged as *rapid fixer* in most camera stores — one bottle contains a buffered solution of ammonium thiosulfate; the other is a hardening agent that you add when the fixer is to be used to fix films or enlarging papers). *Note:* Do not add the hardener to the solution when working with any kind of salt print! You'll also need selenium or gold toner and a washing aid (any brand of hypo clearing agent). A calibrated density strip is a useful accessory when you first begin to make prints.

Mixing Chemical Solutions

Fixer. The fixers that are normally formulated for films or prints *should not be used* with salt prints because they will rapidly bleach the image. The key to fixing POP or other kinds of salt prints is to keep the fixer *decidedly* alkaline. If you use rapid fixer, take one part of rapid fixer stock solution and dilute it with ten parts of water. Add 1 teaspoon of *sodium carbonate* to each 500 ml. of diluted fixer and stir until the crystals dissolve (some fizzing might occur when the sodium carbonate is added to the fixer).

Clearing Agent. Any of the commercially available clearing agents are satisfactory and can be used without modification.

Selenium Toner. Kodak Rapid Selenium Toner will stabilize the silver image and produce print tones that can range from red-brown to gray. The image will bleach if toning is carried out too long or if the concentration of toner is too high. Dilute one part of Kodak Rapid Selenium Toner with five hundred parts of water.

Gold Toner. The supplies for gold toners can be purchased in kit form or as individual components from Photographer's Formulary (see page 376). Two types of gold toners can be used: alkaline gold toner and a gold toner–thiocyanate solution.

ALKALINE GOLD TONER. Pour 500 ml. of purified water warmed to 100°F (38°C) into a beaker and add 4 grams of borax. Stir the solution until the crystals dissolve. To this solution add 8 ml. of 1-percent gold chloride solution, mix it thoroughly, and transfer the solution to a brown glass bottle fitted with a *plastic* screw cap. (Gold-toning solutions decompose in the presence of most other metals and degradable organic matter.) If toning takes place too rapidly to control, dilute the toner with distilled water. Label the solution "Alkaline Gold Toner."

Salted-Paper Prints

Salted-paper prints are the earliest examples of images that use the photographic process invented by Fox Talbot, and they offer a dramatic visual demonstration of the printing-out process. However, it is a humbling experience to attempt to make a salt print by the hand-coating methods described in the literature, and the effort will leave anyone with a deep appreciation for the remarkable images produced by early photographers such as Hill and Adamson and Fox Talbot himself. An excellent salted-paper print calls for patience in the pursuit of perfection, but the image quality that can be achieved is an ample reward for the dedicated photographer.

Three key determinants control the successful creation of a salt print: the qualities of the negative being printed; the characteristics of the selected paper; and the quality and consistency of the sensitized paper coatings that are made by the photographer.

You simply cannot take an "off the shelf" negative used to make a favorite gelatin silver print and expect to create a salt print that captures the spirit and tonal range of a modern print. Indeed, the image from such a negative will look exceedingly drab and dismal by comparison. A salt print requires a high-contrast negative in which highlight densities may run as high as 2.0 to 2.4. The new T-Max films are well suited for this purpose. This means that the negative from a normally illuminated scene must be given at least N+2 development to produce a salt print with a full range of tonal values. Negatives of this type are generally not useful for other printing processes and should be exposed and developed with a salt print as the visualized objective.

A second and critical variable in making a salt print is the paper. It must be well sized so that the silver chloride coating remains close to the paper surface. The relatively few serious photographers who pursue salt printing as an art form size the paper surface prior to sensitizing it for printing. Even though Cranes Artificial Parchment and similar papers intended for platinum printing (available from Bostick & Sullivan; see page 376) work moderately well without additional sizing, the results that you can achieve will improve substantially simply by adding a small amount of gelatin to the salting solution. As you gain experience you will want to explore the impact of sizing on image quality and color in salt prints.

A third determinant in making salt prints stems from the higher level of skill that is required to achieve a satisfactory coating of the emulsion when the procedures commonly referred to in the literature are attempted. Traditional brush coating simply does not provide a reliable route to salt prints. These procedures are generally wasteful and unsatisfactory and, if brush coating is pursued, result in prints that quickly discourage all but the most dedicated printmakers. However, by following one of the procedures described below for making hand-coated salted-paper prints, these problems can be bypassed without too much difficulty.

An Untitled Image by William Robert Baker, circa 1856–1862

I have chosen to make a print from a waxed-paper negative made by William Robert Baker of Bayfordbury, who between 1856 and 1862 took many fine images in France, Switzerland, Italy, England, and Wales. During photography's early years, negatives were made by exposing a sheet of paper in a camera, which produces a negative image. The paper was then heavily waxed to make it translucent, and positives were then made by contact printing the waxed negative. Early waxed negatives are valued as art in their own right and are actively collected.

For all historical negatives the first step is to make a simple contact positive on a continuous-tone orthochromatic film. This interpositive should replicate in inverted form the tonal range of the original from which it was taken. This Baker negative has a density range of 1.7. From the interpositive image a secondary printing negative was made from which the print shown here was taken. With this particular negative no masking was required because the full range of tones evident in the original were replicated and present in the copy negative.

For the print illustrated here, I used WT Hollingsworth, Kent Stag Superfine paper made sometime in the 1930s. The paper was produced using only the best white "superfine" rags and animal-gelatin sizing.

Only a negative with a full range of tones can withstand the rigors of being printed in the full, strong light of the midday sun. This photograph of the Welsh Rocking Stone is a particularly fine image. In this instance I preexposed the sensitized sheet of paper to diffused indirect light in the printing frame for 2 to 3 seconds without the negative. The paper was then removed and reinserted into the printing frame, sandwiched beneath the copy negative, and exposed for 3 to 4 minutes covered with an opaque diffusion sheet. For the rest of the main exposure (about 16 minutes), the diffusion sheet was removed and the image was exposed to the direct light of the full midday sun.

In my view the salt-print process produces the best results from calotype and waxed-paper negatives, while an albumen print gives the best results when made from glass negatives, especially if gold toned "without," as Linneas Tripe remarked in the Bengal and Madras Photographic Journal, *"sparing the sovereigns."*

— MICHAEL GRAY

The primary source of trouble in the salted-paper process is that coating the paper by brushing on a solution of silver nitrate produces an insoluble, creamy white precipitate of silver chloride on the paper's surface. Continued brushing of the paper surface to ensure complete coverage with silver nitrate disturbs the precipitated silver chloride and leads to pronounced streaks that cannot be seen until you have exposed the print. Additional complications arise because both the silver nitrate and salt solutions are colorless, making it easy to miss areas of the paper, which results in blank spots on the print.

The Salted-Paper Process

The chemical reaction between silver nitrate and a salt such as sodium chloride or ammonium chloride forms a photosensitive precipitate of silver chloride. The sensitivity of silver chloride to light depends upon whether an excess of salt or silver nitrate is present when the reagents are mixed. In the presence of excess silver nitrate, silver chloride is converted to metallic silver relatively quickly when it is exposed to actinic light (that is, light rich in the ultraviolet region of the spectrum). If the salt concentration is greater than that of silver nitrate, the photosensitivity of the silver chloride produced is virtually nil, though it will undergo change over long periods of time. The desensitizing effect of salt on silver chloride was used by Fox Talbot to "fix" his early prints, but he discovered to his chagrin that a print "fixed" by immersion in salt water would continue to darken over a period of months even when stored in the dark. It was not until he began to use sodium thiosulfate ("hypo") as a fixer that his salt-print images became "permanent."

The visual image of a salt print consists of ultrafine particles of silver that form on the surface of the silver chloride, which is either embedded in a gelatin or albumen matrix or coated onto the fibers of a sheet of paper. The image forms as the silver salt is struck by light. The shadow areas of the photograph (corresponding to areas of low density in the negative) print out first, and the layer of silver that forms on the paper's surface acts as a filter or mask and moderates the intensity of the light penetrating deeper into the emulsion. As a result, tonal values in the shadows, though rich and detailed, are *compressed,* while the midtones and highlights are well separated. A gelatin silver print made by enlargement will have a perceptibly different tonal scale than one made on POP.

The ultrafine particles of silver in a salt print are extremely susceptible to the ravages of time, the atmosphere, and degradation by any trace chemicals present in the paper, but with proper fixing and toning (preferably with gold), the print should last as long as any other silver image.

Traditional Technique
for Preparing Sensitized Salted Paper

Historically, the most-favored technique for preparing sensitized salted paper is a two-step flotation technique. First the paper is saturated with a salt solution and then the salt is converted to silver chloride, which is photochemically active.

Salting the Paper To salt a sheet of paper, float it *front side down* in the salt solution. (Look for the watermark by holding the paper toward a light — if it reads correctly you are looking at the front side; if the words are reversed, you are looking at the back side. Make a light pencil mark on the back of the paper for future identification.)

1. Prepare the salt solution by dissolving 20 grams each of sodium chloride (or ammonium chloride) and sodium citrate in a liter of water. Gelatin (begin with 6 grams of hardened gelatin per liter of water) — available from Photographer's Formulary (see page 376) — should be added to the salt solution to serve as a binder that prevents the silver chloride from forming too deeply beyond the surface of the paper. Gelatin is a key additive when porous papers are used, because print contrast decreases dramatically when the emulsion is absorbed by the paper. Citrate salts shift the print color slightly toward the red and provide a small increase in contrast and brilliance.

2. Float the paper in a tray containing the salt solution for 3 minutes. At the end of this time remove the paper from the tray, hang it from a film clip, and allow it to dry. Flatten the dried paper if necessary by inserting the sheet between two sheets of mounting board and place the sandwich in a warm dry-mount press. Dried salted paper is not light sensitive and keeps indefinitely. It should be sensitized by coating it with silver nitrate (see below) immediately prior to exposure for the best and most consistent results.

Sensitizing the Paper The simplest way to sensitize salted paper is to float it *front side down* in a tray on the surface of a 12-percent solution of silver nitrate for 3 minutes, which converts the salt embedded in the paper to silver chloride. After it dries, the paper is ready for exposure. Sensitized paper keeps for a day or two only, and should be used as soon as possible.

While the dual-flotation procedure works well, it requires a large quantity of silver nitrate to make sufficient solution to float 8 x 10 and larger prints, a requirement that greatly increases the cost of the process. Furthermore, during sensitizing some salt in the paper inevitably leaches into the silver nitrate bath and forms a milky precipitate of silver chloride that settles on the surface of the tray and in the storage bottle. As additional paper is sensitized, the concentration of silver nitrate in the sensitizing bath decreases and must be replenished. As the number of prints being made increases, it is also necessary to measure the concentration of silver in the sensitizing bath, which is a complicated analytical procedure. All these factors are a nuisance and make the traditional coating process unnecessarily complicated.

Recommended Technique for Preparing Sensitized Salted Paper

The following flotation technique, which I have not found described elsewhere, is a straightforward, economical method for making sensitized salted paper. It produces predictable and consistent results at a fraction of the traditional cost and avoids the complexities mentioned above as well as those encountered in brush-coating paper.

Preparing the Sensitizing Solutions Most recipes for salting solutions recommend incorporating gelatin into the salting solution to act as a binder, an additional sizing to minimize the absorption of silver into the body of the paper. Ultimately, the use of gelatin in the salting formula is a matter of personal preference or is dictated by the surface characteristics of the paper: poorly sized papers require gelatin; well-sized papers do not. The solutions described below were prepared using a kit for making salt prints that was purchased from Photographer's Formulary (see page 376), and the directions given follow their suggested outline. These kits are an economical introduction to alternative printing processes and allow you to explore various techniques for printmaking at a reasonable cost. If you intend to pursue intensively any of the processes described throughout this book, it is more economical to purchase the individual components in bulk and prepare the solutions yourself.

Salting Solution. The salting solution requires the following items: 3 grams of plain gelatin (optional); 11 grams of sodium citrate; and 11 grams of ammonium chloride. Pour 100 ml. of water into a 16-ounce or 500-ml. bottle and add the gelatin. Let it stand for about 10 minutes to allow the gelatin to soften, then add 400 ml. of hot water. Stir until the gelatin dissolves; warm the solution further, if necessary, to dissolve all of the gelatin. Add the sodium citrate and ammonium chloride. Gelatin decomposes over time, depending upon the storage conditions; discard the solution when it begins to look cloudy or darkens. If the solution gels, warm it before use. The salting solution can also be prepared and used without the gelatin. Label the bottle "POP Salting Solution."

*Silver Nitrate Solutions.** Prepare the first sensitizing solution by dissolving 13 grams of silver nitrate in 100 ml. of purified water. Transfer 50 ml. of the solution into a 2-ounce brown eyedropper bottle, label it "13% Silver Nitrate," and store it preferably in a cool, dark place. Add the remaining 50 ml. of solution to 500 ml. of purified water, pour it into a brown bottle, and label it "1% Silver Nitrate."

Traces of chloride in the water may cause a small amount of cloudiness in the solution due to the formation of silver chloride. This will settle out after a few hours and can usually be ignored. The coating procedure will lead to an additional accumulation of some silver chloride precipitate in the 2-percent silver nitrate solution, which can be filtered off if it causes a problem.

* The most frequently asked question of printmakers who work in alternative silver printing processes is "How do I get silver nitrate stains off my hands and clothes?" Despite great care and the best intentions, it is nearly impossible to work with silver nitrate solutions for any period of time and avoid stains. They will go unnoticed until black spots of silver (harmless) appear on your skin or your favorite shirt, skirt, or pants. The effects on the skin are cosmetic and disappear within a few days — if they appear, wear them as a badge of honor, but do your best to avoid them. If you knowingly spill silver nitrate solution on your hands, wash them immediately with soap and water. This will usually prevent staining.

No amount of laundering will remove silver nitrate spots from clothing, though soaking the area in a dilute solution of potassium ferricyanide (10 ml. of 1-percent solution per liter of water) and sodium thiosulfate (25 ml.) (called Farmer's Reducer) may help. (It may also replace the black spot with one of another color.) Prevention is the only real cure: *wear old clothing or an apron whenever you handle silver nitrate solutions.*

A

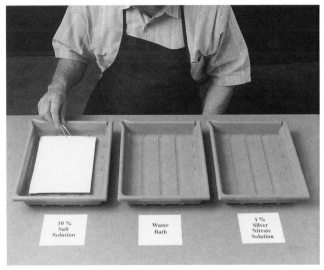

B

Figure 8.6: *Preparing and sensitizing salted paper.* (A) Preparing salted paper. Mark off the border of the image area with strips of drafting tape and coat the paper (use a brush or Puddle Pusher) with a 13-percent solution of silver nitrate. To complete the salting and sensitization steps, set up three trays as shown: (1) a 10-percent solution of table salt; (2) tap water; (3) a 1-percent solution of silver nitrate. (B) Sensitizing salted paper. (1) Gently lay the silver nitrate–coated sheet on the surface of the 10-percent salt solution. (2) Pick the sheet of paper up by a corner and allow the excess salt solution to drain from a corner. Float the sheet in the tray of water for a few minutes to rinse away the excess salt. Repeat this step with a tray of fresh water. (3) Drain the sheet of paper and float it on the surface of a 1-percent solution of silver nitrate for 1 minute. Drain and dry the paper, which is now photosensitive and should be handled in subdued light.

Potassium Dichromate Solution. Dissolve 2 grams of potassium dichromate in 30 ml. of purified water and pour the solution into a 1-ounce brown eye-dropper bottle. Label it "POP Contrast Control Solution."

Sensitizing the Paper All of the following operations can be carried out under normal artificial lighting.

1. *Coat the paper with silver nitrate.* Trim a sheet of paper to be coated so that there will be a ½- to 1-inch margin around the negative. Lay the paper on a sheet of plate glass and center the negative on the paper. Mark the locations of the negative corners on the paper with a pencil dot. Use these dots to mask off the negative area with 1-inch-wide strips of drafting tape.

For a 5 x 7 negative, transfer twenty drops of 13-percent silver nitrate solution and four drops of gum arabic solution (optional) to a 1-ounce medicine cup (change the amount proportionally for larger or smaller negatives). Mix the solutions by swirling the cup and coat the paper in the usual fashion, using an appropriate brush* or "Puddle Pusher" (see page 149). The gum arabic gives the solution a slightly oily appearance, which makes it easier to see and spread across the paper. When the surface of the paper is no longer glossy from the solution, dry the paper with a blow-dryer and peel it off the glass plate, leaving the drafting tape attached to the paper.

* Use a brush that does not use a metal ferrule to bind the hairs to the wooden handle. Silver nitrate reacts with most metals, and a black coating of silver will quickly be deposited on the metal surface as it dissolves and will contaminate the sensitizer. The impact on the print may be slight, but it makes no sense to introduce additional uncertainties to a complex process when they are easy to avoid.

2. *Convert the silver nitrate coating to silver chloride.* Pour the previously described salt solution (see page 185) into a flat-bottomed plastic tray so that it is filled to a depth of at least ¼ inch. Grasp the drafting tape on the paper coated with silver nitrate by the left and right margins and gently lay the paper, facedown, on the surface of the salt solution. Raise and lower the ends of the paper so that it bows slightly, ensuring that the entire surface has been wet by the solution. (Try not to get any of the salt solution on the back surface of the print.) The instant the paper makes contact with the salt solution, the silver nitrate that has previously been absorbed by the paper is converted to an insoluble precipitate of silver chloride, which is enmeshed within the fibers of the paper. (This emulsion is not photosensitive because of the excess of chloride ions.)

3. *Rinse away the excess salt.* Lift the paper from the salt bath and float it on the surface of a tray of tap water. Let it rest on the surface of the water for 1 minute to allow the excess salt to diffuse from the paper into the water. Repeat for a second time with a fresh tray of water.

4. *Sensitize the coating.* Silver chloride is usefully light sensitive only when there is an excess of silver ions on the surface of the crystals. To sensitize the paper lift it from the rinse water, hold it by a corner to allow the excess surface water to drain off, then float it in a tray on the surface of a 1-percent silver nitrate solution for 1 minute. Use clean tongs to lift the paper from the solution and hang the paper from a corner to allow the excess silver nitrate solution to drain from the surface. Place the sheet of paper on a paper towel and dry it using a blow-dryer.

5. Peel the drafting tape off the dried paper. The emulsion will be visible as a faintly off-white rectangle. The paper is now ready to be exposed and processed, using procedures that are identical to those previously described for printing-out papers (see pages 177–180).

"Wash Coating" Salted Paper

Michael Gray, curator of the Fox Talbot Museum at Lacock Abbey, has spent more than a dozen years researching and making salt prints of unsurpassed quality from the original calotype negatives of Talbot and other photographers of that period. One of the keys to his success is his coating technique, which is adapted from watercolor painting. *Practice this technique using plain water tinted with watercolor and a sheet of unsalted paper until you master it.* Usually, a few tries will give you a feel for the technique — what it takes to produce a uniform wash, and how much solution is needed to coat a given size of paper. Proceed as follows.

Pin a sheet of paper (previously salted and dried if you are preparing to sensitize it for printing) to a sheet of cardboard and tilt it toward you at a relatively steep angle (about 45 degrees), using an easel or other support to keep it in place. Take a small test tube and add a few milliliters of 13-percent silver nitrate solution (or tinted water if this is a practice session). Stuff a wad of cotton snugly into the end of the test tube so that a generous tuft protrudes from the end. Tilt the tube so that the plugged end faces down and the solution saturates the cotton plug. Use the tube as a brush and touch the cotton plug to the

Figure 8.7: John P. Schaefer, *Aspens, Wasatch Mountains, Utah, 1975*. The original negative was recorded on 4 x 5-inch sheet film. An enlarged high-contrast negative was made by enlarging the image onto Kodak SO-339 Duplicating Film and developing the copy negative for 5 minutes in 1:1 Kodak Dektol. The salt print was toned in a gold/borax toner.

surface of the paper near an upper corner. Draw it lightly from left to right across the surface of the paper and, when you reach the opposite corner, reverse the direction of the stroke, making certain that there is a slight overlap with the earlier path. As solution flows out of the tube it paints a swath about ½ inch wide, and a small beaded edge of solution gathers along the bottom of the stroke. This bead is immediately erased on the next pass of the cotton as the direction of the stroke is reversed.

When the bottom edge of the paper is reached, the paper should have a uniform coating of silver nitrate solution on its surface. Remove the plug from the test tube with tweezers and discard it and the remaining solution. Dry the paper in the usual way and trim it to size before exposing the negative. Done properly, the paper will be uniformly coated and show no evidence of streaking.

Helpful Hints for Making Salt Prints

Making an excellent salt print requires finely honed technique and the correct starting materials:

1. a properly exposed negative (see chapters 2, 3, and 4)
2. a fine, well-sized paper
3. correct exposure
4. controlled toning
5. complete fixing and washing

The process also requires more determination and skill than any of the other alternative printing processes, but the outcome more than justifies the effort. The following hints and reminders will help you achieve success in salt printing:

Paper quality. Lighter papers (good stationery stock or *slightly* heavier papers) are better suited for salt printing than heavier stocks, but the paper must have sufficient wet strength to allow handling and prolonged soaking in water. Additives that are incorporated into the paper during manufacture can be a serious source of difficulties when you are making a salt print. Some papers may stain badly wherever silver nitrate solution contacts it, and these stains will ruin any print. If you suspect that the paper may be creating problems, try another.

Paper surface. When the paper is salted, the quality of the surface may be disturbed such that fibers rise up and alter it from a smooth to a matte texture. Additional sizing or squeegeeing the paper onto a smooth glass surface before drying may help to restore some of the original surface quality.

Preparation of the solutions. Fox Talbot found that the ratio and concentrations of salting solution and silver nitrate sensitizing solution were critical to the outcome of the printing process. He obtained optimal results with a 3-percent salting bath and a 12- to 13-percent solution of silver nitrate as a sensitizer. Care in the preparation and application of solutions to the paper is very important with salt prints, in contrast to other alternative printing processes, where less precision often leads to acceptable results.

Coating of the paper. Drops or streaks of silver nitrate solution on the back of the paper must be avoided. These develop out during exposure and will be visible in the print, especially when thin papers are used.

Toning. Gold toning both protects the print and alters the color of the image; you will need to evaluate the trade-off. With care in processing and thorough washing, an untoned salt print is as stable as any silver print can be. Superb examples of untoned salt prints made 150 years ago exist and show little sign of deterioration.

Fixing and washing. The stability of any photograph is largely determined by how effectively chemical contaminants are removed from the paper base. At all costs avoid any fixing process in which an acidic fixer is used — the image will vanish before your eyes if the fixer is not alkaline (see page 176).

Salt prints are especially susceptible to the ravages of time, because the minute amounts of atomic silver aggregates that form the image are highly reactive and are slowly attacked by chemicals that remain within the paper or are present in the atmosphere. Toning with an inert metal such as gold and thorough washing are excellent safeguards against future chemical degradation.

Contrast control. Experienced printers have found that the best way to control image contrast is by proper exposure and development of the negative, but if after making a salted-paper print, you find that the contrast of the image is too low, one option is to change the formulation of the coating for future printings.

An element of contrast control can be achieved by adding potassium dichromate, which serves as an oxidizer, to the salting solution. Some experimentation is necessary to determine how much solution must be added to obtain the desired increase in contrast. The oxidizer acts primarily on the lighter print tones, and a significant increase in exposure time is necessary. Too much dichromate is undesirable, since paper damage can occur and the color of the image may be altered as well.

Subtle refinements in contrast are also possible by controlling the light source used for exposure. Sources rich in UV light, such as the sun, lower print contrast, but the image appears quickly. Negatives printed in the shade manifest themselves more slowly, but the image has greater contrast.

Figure 8.8: *Print edges.* Some photographers like to include and show brush marks to emphasize the nature of a handmade image, while others prefer sharply defined edges.

Iron-Silver Printing Processes

The Vandyke print, or brownprint, and the kallitype both belong to a family of prints in which an iron salt is used as a catalyst to produce a silver image. It is probably the easiest of all of the alternative silver printing processes to learn. When ferric ammonium citrate is used as the reducing agent, the photograph is referred to as a *Vandyke print;* if ferric oxalate is used, the image is called a *kallitype.* These processes never became a commercial success because they were introduced well after platinum papers were in vogue and at a time when developing-out papers were gaining popularity. Kallitype and Vandyke prints also suffered from the common misconception that they were not permanent (this is not true if proper processing is used) — a fatal flaw in the eyes of most photographers.

The concern about image stability was not without merit, however, because the original description of the kallitype process by W. W. J. Nichol used ammonia as a fixer, which by itself is insufficient to reduce the concentration of silver and iron salts to a low enough level to ensure permanence. Subsequently, when sodium thiosulfate was used as a fixer, the brownprint image proved to be as stable as any other silver print, but the tarnished reputation of the kallitype lingered.

Figure 8.9: Linda Fry Poverman, Untitled, from the Natural Selection series XVI, 1985. The artist creates Vandyke prints from enlarged negatives and uses these images as a photographic canvas that she hand colors.

Figure 8.10: John P. Schaefer, *The Mitten, Monument Valley, Arizona, 1990.* This kallitype was made on Cranes Artificial Parchment paper by the method described on page 198. The color of a kallitype can be controlled by toning the print after development, which also serves to ensure its permanence.

Vandyke Prints

The Vandyke process is a hybrid of cyanotyping and salted-paper printing. Paper is prepared for printing by sensitizing it with a solution of ferric ammonium citrate, tartaric acid, and silver nitrate. Sensitizing can be carried out in a room lit by artificial illumination. The coated paper is not heat sensitive, and drying can be hastened with a blow-dryer. The dried paper is pale yellow where the coating has been applied. On exposure to actinic light (light rich in ultraviolet) a yellow-brown image prints out. Exposure should be continued until the midtones are defined. The final print will be considerably darker than the transient image that you see immediately after exposure, so avoid overexposure. Processing and toning procedures are similar to those described for salt prints or POP.

The processing and drying procedure for Vandyke prints results in a significant shift of tonality and density from the printed-out image. The contrast of the initial image decreases after processing, while the density of the shadow areas increases, with a concurrent loss of tonal separation. When you first make Vandyke prints it is worthwhile to keep an exposed but unprocessed print as a reference to help you to judge when the desired level of exposure has been achieved.

Negatives for the Vandyke process should have a density range of approximately 1.8 to 1.9 if a full range of tonal values in the print is desired. Some degree of contrast control is possible by adding small amounts of a dilute solution of potassium dichromate to the coating solution.

A fine Vandyke print is a straightforward, inexpensive, and effective way to achieve a photographic image that has much of the feel and character of a platinum/palladium print.

Preparing the Solutions To make Vandyke prints, the following chemicals are required: ferric ammonium citrate (green), tartaric acid, silver nitrate, sodium thiosulfate, and (optional) EDTA (tetrasodium salt).*

Weigh out and add 9 grams of ferric ammonium citrate to 100 ml. of distilled water. After it has dissolved, add 1.5 grams of tartaric acid to the solution, followed by 4 grams of silver nitrate. Label the solution and store it in a brown bottle in a cool, dark place. It has excellent keeping properties and is stable for many months with proper storage.

Prepare the alkaline fixing bath described on page 176.

Sensitizing and Exposing the Paper The choice of paper has a pronounced effect on print contrast. Highly absorbent papers reduce the effective contrast of the image because too much of the sensitizer is absorbed into the body of the paper. Sizing the paper helps to increase the contrast, but sizing often destroys much of the inherent character of the paper surface. Try to find a cold- or hard-pressed paper to use and then work to create negatives that print well on that surface.

Most well-sized papers can be used to make Vandyke prints. The emulsion is easily applied using any of the standard techniques — if you use a brush select one that does *not* have a metallic band. Coated paper can be stored in the dark for several days prior to use.

Expose negatives by contact printing in sunlight or a suitable artificial light source. In a correctly exposed print from a full-scale negative, the highlight values should show detail in the image that prints out. Overexposure may cause "bronzing" in the darker areas of the image as those features take on a metallic sheen.

Processing the Print
Washing. Slip the exposed print, emulsion side up, into a tray of tap water and begin to wash it by tilting the tray from side to side for about 30 seconds. The water will take on a yellow-brown color, and a milky white precipitate of silver chloride may be generated by a reaction of silver nitrate with chlorine contained in the water.

Pour out the wash water and wash the print in a tray in a gentle stream of running water for 5 minutes. During the washing cycle the print will

* EDTA is a chemical chelating agent that bonds strongly to iron and other metals and forms a soluble complex that is easily washed from the paper. If all of the iron is not removed from the print, the paper may discolor over time, causing the highlights to yellow and brown spots to appear ("foxing"). Elimination of all traces of iron salts is as important as removal of excess silver.

darken slightly and take on a pronounced yellow cast. Color bleeds from the print during the wash cycle.

Toning. Prints can be gold toned using the same procedures described for salt prints and POP (see pages 178–180). Toning is best done immediately after the initial wash of the print in water and before fixing. Transfer the print into a borax-gold toning bath and tone it for 5 to 10 minutes. The print undergoes a remarkable visible transformation in the toning bath. The highlights are quickly transformed and take on an almost phosphorescent whiteness; the midtones and shadow areas lighten and details are strengthened. When toning is complete, fix and wash the print as described on page 180. Very little change will be noted during fixing if the print is first toned. As the print is dried the color shifts from a light brown to a deep red-brown.

Fixing. Prepare a quantity of fixer described on page 176 and dissolve a teaspoon of EDTA (tetrasodium salt) in each 500 ml. of fixer. Drain the water from the print and add about 250 ml. of the diluted fixer/EDTA solution to the tray for each 8 x 10 print. The print darkens and turns brown the instant it contacts the fixer. Use tilt-tray agitation to slosh the fixer across the surface of the print for 5 minutes. Drain the print and add the second half of the fixer to the tray. Continue to agitate the print for another 5 minutes and discard the fixer. Repeat the cycle a third time with a fresh batch of fixer. Thorough fixing in this bath is necessary to remove all traces of silver and iron salts, which will otherwise lead to degradation of the print over time.

Clearing. Rinse the print and tray in fresh tap water, then soak the print for 2 minutes in a hypo clearing bath. Discard the hypo clearing bath and wash the print in running water for 30 minutes or longer, depending upon the weight of the paper being used.

Drying. Drain and dry the print. A blow-dryer can be used to shorten the drying time.

Troubleshooting Vandyke Prints Evaluate the print in terms of its overall tonality and contrast and make whatever adjustments necessary for subsequent prints.

Tonality. If the print is too dark overall, you can try to bleach it by soaking it in a very dilute solution of Farmer's Reducer — potassium ferricyanide (10 ml. of 1-percent solution per liter of water) to which 25 ml. of sodium thiosulfate has been added. The print must be rewashed thoroughly after it has been bleached.

Contrast. Print contrast can be increased by adding a solution of potassium dichromate to the first wash water. Ten drops of a 10-percent solution added to 500 ml. of water increases the contrast by approximately one step on the tonal scale of a Kodak No. 2 density scale. As stated previously, however, exposure time must be increased when dichromate is used. Contrast control is best achieved by exposing and developing negatives such that their density range exactly complements the characteristics of the paper used and the Vandyke process.

Il Cancello, Venice, 1992

My discovery of antique photographic printing techniques was a boon to me. Immersing myself completely in the printmaking process has served to enhance the experience of making a photograph. The printmaking process itself, with all of its various steps and complications, has become a delightful event, more satisfying in many respects than either taking the picture or even seeing the final print that I had originally visualized. The finished print is really a by-product of all of the previous stages, proof that the steps necessary in the printmaking process were carried through skillfully.

The photograph Il Cancello *was taken on my first trip to Europe. After years of photographing in New Mexico, essentially in my own backyard, it became important for me to seek new subject matter and experiences. My first glance of Venice so moved me that I sat on the steps that lead from the train station to the Grand Canal with my large-format camera, wooden tripod, and luggage at my feet and wept. The visual splendor was so foreign to me that I wondered if I would be able to capture any of the spirit of what I was seeing — the light glancing off the surface of the water, gliding boats, or the graceful arch of a bridge.*

After days of wandering along the alleyways, canals, and bridges in a state of visual overload, I began to photograph tentatively, feeling like a complete novice. When I returned home and developed my film, I found that the grandeur I had beheld had been left behind. The cathedrals and astounding vistas were curiously absent from my collection of images. Instead, the images that I had gleaned from Italy were of more human, mundane proportions — simple details of the commonplace. Il Cancello *is a simple passageway and gate that people walk through daily, an object unseen and unsung. Visually, I had managed to reduce all of the overwhelming splendor that I experienced into simple images that could easily have been taken in my own backyard.*

On the day I am going to print, I drop by a local farm, stock up on fresh eggs, and take them to my studio, where I separate the yolks from the whites. To the egg whites I add ammonium chloride or salt, then coat the paper with that mixture. It takes patience to get the albumen on the paper just right. I float the paper in the tray of albumen without getting any on the back side (which would cause it to print out on both sides after it is sensitized with silver nitrate). Once the paper is coated with silver nitrate, I hang it up to dry. The dried paper has a glossy surface, and I try to use it within 5 to 6 hours of coating. Albumen paper has a very long exposure scale, so the negatives I make have high contrast. I generally use Tri-X film and develop it in D-19 to achieve the needed contrast. All of my negatives are printed using the sun as my source of light.

— ZOE ZIMMERMAN

Kallitype Prints

A well-made kallitype has the visual characteristics and tonal qualities of a plat-inum/palladium print, and it is the most versatile of all of the iron/silver print-ing processes. Unlike the Vandyke brownprint, a kallitype must be "developed" and, depending upon the solution chosen and the toning procedure used, print color can fall anywhere in the range of blue-black to brown or sepia. With care in processing, a kallitype should be as permanent as any silver print.

The kallitype makes use of the photochemical properties of ferric oxalate to generate a photographic image. On exposure to actinic light (light rich in ultraviolet), ferric oxalate is reduced to a slightly soluble, faintly visible precip-itate of ferrous oxalate, which is the "latent image." When the exposed print is placed in the developer, any silver ions that come into contact with the ferrous salts are in turn reduced to the metallic state, forming a visible image. Processing is completed by rinsing the print in a clearing bath to remove iron salts, fixing it to eliminate unreacted silver salts, and washing the print thor-oughly to remove all remaining traces of metals and thiosulfate. *Print perma-nence depends upon complete removal of iron and silver salts and thiosulfate.*

The extensive literature pertaining to kallitypes is often more reminiscent of an alchemical treatise or the witches scene from *Macbeth* than a rational description of a chemical process. Why developers such as Rochelle salts or borax were chosen is not immediately obvious from a chemical perspective — but they do work. The following facts are known: the color of a silver print is largely determined by the size of the silver particles on the paper's surface, and *all* traces of iron and silver salts must be eliminated from the print for it to be stable. With the benefit of a century of hindsight and a little knowledge of modern chemistry, the traditional kallitype process can be greatly simplified.

In my view, the following is the easiest and most flexible procedure for making kallitypes.

Preparing the Solutions The chemicals required for kallitype printing are ferric oxalate, silver nitrate, potassium oxalate, sodium thiosulfate, EDTA (tetrasodium salt), and potassium chlorate. Prepare and label the solutions listed below.

10% Ferric Oxalate Solutions. Dissolve 10 grams of ferric oxalate in 100 ml. of distilled water. The powder dissolves quite slowly but can be hastened by heat-ing and swirling the vessel containing the powder and water in a bath of near-boiling water. Ferric oxalate is light sensitive and decomposes in light to form ferrous oxalate. While a small percentage of the latter in the stock solution is inevitable and tolerable, a higher concentration will manifest itself as fog on the print highlights and will give the image a muddy appearance. To test the quality of ferric oxalate, dissolve a small crystal or two of potassium ferri-cyanide in 1 ml. of water, and in subdued light add a drop of ferric oxalate solution to it. The resulting solution should be orange to yellow-brown. A trace of ferrous oxalate will turn the solution a pale green, while higher con-centrations will result in a deep blue solution. (Expose the solution to sunlight for a few moments to see the rapid development of the blue color as the ferric

oxalate undergoes its photochemical transition.) This color test should be used to monitor the quality of the ferric oxalate solution. If more than a trace of ferrous ions are indicated, prepare a fresh volume of ferric oxalate solution.

Divide the solution in half, transfer each half to brown glass eyedropper bottles, and label one bottle "10% Ferric Oxalate — Solution A." To the other bottle add and dissolve 0.3 grams of potassium chlorate and label it "10% Ferric Oxalate — Solution B."

Kallitype Developer. Dissolve 5 grams of silver nitrate in 500 ml. of distilled water. In a well-ventilated area and with constant stirring add detergent-free household ammonia to the solution *(Caution! The fumes are noxious)*. A brown precipitate will form immediately, but it will redissolve and the solution will clear as more ammonia is added. Approximately 50 to 100 ml. of ammonia solution will be required. To this solution add 50 grams of potassium oxalate and bring the volume to 1 liter. Transfer the solution to a plastic storage bottle and label it "Kallitype Developer." *Note:* This solution will stain your hands and clothing. Wear rubber gloves when you work with it. If you get any of the solution on your skin, wash the area immediately with running water.

Making a Kallitype Negatives that are suitable for ordinary black-and-white enlargements print well as kallitypes. Print contrast is controlled by the ratio of solution B to solution A: increasing the percentage of B increases print contrast. Use equal amounts of solutions A and B as a standard and vary the formulation as needed and judged from a trial print. The formulation given for making a kallitype prints quickly and requires about 10 percent of the exposure necessary to make a cyanotype.

Sensitize the paper. In an area illuminated with a 25-watt tungsten lightbulb (fluorescent lighting will fog the print), coat a sheet of well-sized rag paper with a solution of 10-percent ferric oxalate (a 50:50 mixture of ferric oxalate solutions A and B). Dry the paper using mild heat from a blow-dryer.

Expose a negative. Make a test strip in the usual way and expose the negative for various time intervals. The latent image appears and intensifies during exposure, and exposure should be continued until highlight details are clearly visible.

Develop the print. Under weak incandescent lighting, place the exposed print, faceup, in a dry, flat-bottomed tray. In one smooth motion pour the kallitype developer over the surface of the print. A black-silver image appears immediately, and the developer picks up the red color of ferric hydroxide, which precipitates out of the solution over time. Drain the excess developer into a beaker. On standing, the kallitype developer will throw down a gelatinous precipitate of ferric hydroxide that can be removed by filtration. The developer can be reused until it ceases to be effective.

Rinse the print. Rinse thoroughly in tap water until the water in the tray remains clear.

Fix the print. Dissolve 3 teaspoons of EDTA and 3 teaspoons of sodium thiosulfate in a liter of water and pour about one-third of the solution into the tray.

Figure 8.11: John P. Schaefer, *Petrified Forest National Park, Arizona, 1992.* These kallitypes were made using the ferric oxalate procedure. The color of the final image was controlled by toning: (A) Gold toning produces a print with a pleasing blue-gray tone; (B) Toning the kallitype in a 1-percent solution of Kodak Rapid Selenium Toner results in a print with rich brown hues.

A

B

Agitate the print by continuously tilting the tray back and forth for 5 minutes. During this time the brown stain of ferric hydroxide will gradually lighten and disappear. After 5 minutes pour the solution out of the tray, rinse the print briefly in tap water, and add the second third of EDTA/thiosulfate solution.

At this stage the room lights can be turned on. Continue to agitate the print in the clearing solution for 5 minutes, pour out the solution, rinse the print in tap water, and add the last portion of clearing solution. After an additional 5 minutes of agitation the print should be rinsed in tap water, allowed to soak in a standard solution of hypo clearing agent for 2 minutes, then washed for at least 15 minutes in running water before toning. The three EDTA/thiosulfate treatments and washing are needed to remove all traces of iron and silver salts from the paper and print to ensure its permanence.

Tone the print. Kallitype prints can be toned using any of the procedures previously described (see pages 178–180) to alter their color and provide further protection in either a gold- or selenium-toning bath.

Troubleshooting Kallitypes Problems that arise when printing kallitypes are relatively easy to resolve with a bit of determination, detective work, and perseverance. The rewards of working with kallitypes are photographs with an elegance that rivals platinum prints' in visual quality and eloquence at a fraction of the cost.

Ferric Oxalate. To a large extent, the success of kallitype printing depends upon the quality of the ferric oxalate solution used. Ferric oxalate solutions deteriorate with age and form ferrous oxalate, which manifests itself as fog when the print is developed. If the color test for ferrous salts indicates a high concentration in solution, discard it and prepare a fresh solution.

Development. If the exposed print is not covered with the developer in one quick motion, "tidal" lines may form on the surface of the print. The print cannot be salvaged if this happens. To avoid the problem, use an adequate volume of developer and a large enough tray to enable the solution to slosh over the surface of the print in one rapid uniform motion.

Salt Prints

An Essay by Michael Gray, Curator, The Fox Talbot Museum, Lacock Abbey

William Henry Fox Talbot announced the method he used to make his "Sun Pictures or Photogenic Drawings" in a paper read before the Royal Society of London on January 31, 1839. It was headed, "Some Account of the Art of Photogenic Drawing," in which he wrote,

> *I proposed to spread on a sheet of paper a sufficient quantity of the nitrate of silver, and then to set the paper in the sunshine, having first placed before it some subject casting a well-defined shadow. The light, acting on the rest of the paper, would naturally blacken it, while the parts in shadow would retain their whiteness. Thus I expected that a kind of image or picture would be produced, resembling to a certain degree the object from which it was derived.*

Naturally enough, Talbot's scientific friends who had heard his paper were, to say the least, curious to know the method by which the paper was sensitized and how, once an image had been obtained, it was fixed. In response to requests for such details, Talbot wrote "An Account of the Process Employed in Photogenic Drawing," a letter to the Secretary of the Royal Society, which was read before the Society on February 21, 1839. In his letter, Talbot specified that paper "of a good firm quality and smooth surface" should be used.

First it was immersed in a weak solution of common salt and wiped dry; then it was coated on one surface only with a solution of silver nitrate. This solution was made by diluting a "saturated solution" of silver nitrate six or eight times with distilled water. When dry, the prepared paper was ready for use. The sensitivity of the paper, Talbot noted, could be increased by repeating the process one or more times.

The biggest problem facing earlier workers had been preserving the image. Talbot stated that his first successful experiments were with potassium iodide "much diluted with water." He argued that by washing a photogenic picture with the solution, "an iodide of silver is formed which is absolutely unalterable by sunshine."

Talbot's first photogenic drawings were preserved using potassium iodide, and they exhibit a characteristic pale yellow tint in the highlights. However, he said that his usual method of preserving the image, discovered shortly afterward, was to immerse the picture in "a strong solution of common salt." Pictures treated in this way, dried, and then exposed to direct sunlight quickly undergo a color change: the white parts "color themselves of a pale lilac tint, after which they become insensible." Talbot's experiments showed that "the depth of this lilac tint varies according to the quantity of salt used relative to the quantity of silver."

It is quite easy to repeat the process of photogenic drawing in exactly the same way Talbot described. The results display a variety of color that is very difficult to produce by modern photographic techniques, and the pictures have a charm all of their own. Talbot noted that slight variations in the proportions of the chemicals used led to just such a variety of tints and hues in the finished pictures, and this, coupled with the slight imperfections inevitable in the silver nitrate coating, ensures that each picture is unique.

If you would like to make your own photogenic drawings, the following procedure, based on Talbot's specifications, may be used as a guide toward achieving satisfactory results and as a basis for experimentation:

 good-quality writing or drawing paper
 sodium chloride [common salt]
 silver nitrate crystals
 distilled or de-ionized water
 white blotting paper
 soft brush or cotton wool [cotton batting]
 3 photographic developing trays
 contact printing frame

Mixing the Solutions

Solution A. Make a stock solution by dissolving as much table salt as possible in 300 ml. of hot water. Allow the solution to cool — the excess salt will crystallize out to give a saturated solution. For use in salting the paper, dilute one part stock solution with eighteen parts water.

Solution B. Dissolve 5 grams of silver nitrate in 40 ml. of distilled or de-ionized water.

Preparing the Paper

Wash the paper in clean water to remove as many as possible of the impurities left over from the manufacturing process.

Immerse the paper in the salt solution and soak for a minute or two. Lift

the sheet from the tray and allow any excess liquid to drain from the surface of the salted paper. Blot the sheet and allow it to dry.

Cover a piece of corrugated cardboard with a sheet of blotting paper (newspaper will do). Pin the dried sheet of paper to the cardboard with stainless steel glass-headed pins.

In subdued artificial light, brush one side only of the salted paper with the silver nitrate solution. Use a soft brush or a wad of cotton wool [cotton batting] and apply the solution evenly over the surface. Care should be taken not to get silver nitrate on the skin, as it leaves a brown or black stain that is difficult to remove. To avoid confusion, put a pencil mark on the sensitized side of the paper so that it can be correctly identified when it has dried. Allow the paper to dry.

When the paper has dried sufficiently, its sensitivity and depth of color can be intensified by fuming with ammonia, which should be carried out in a well-ventilated room. Construct a small light-proof box with a hinged lid for this purpose. Inside the box, place a sheet of muslin on which to suspend the sensitized sheet of paper without exposing it to daylight above a lower sheet of blotting paper that has been soaked in household ammonia for 2 minutes. (A 15-watt tungsten bulb will not fog the freshly sensitized paper unless the paper is left out for 15 minutes or more.)

The coating of silver chloride that is produced in this process is very sensitive to light. On a sunny day the paper will turn almost black in less than 5 minutes. Until required for use, the sensitized paper should be kept in a light-proof container such as a black plastic bag used to store conventional photographic material.

Exposing the Image

To make a photogenic drawing of an object such as a leaf or negative, place it in contact with the sensitized side of the paper either in a printing frame or under a sheet of glass, and expose the paper to the sun for 15 to 30 minutes. A printing frame with a hinged back enables you to remove the image from direct sunlight and inspect half the image to monitor progress during the printing-out process. If you plan to gold tone after washing but before fixing, stop the printing-out process when the density of the image appears to be correct. On the other hand, if you plan to tone as the final step, you must overprint the image because it will bleach out somewhat during its time in the fixing bath.

Fixing the Image

To prevent the paper from being further affected by the light and the image from being ruined, the image must be fixed (or stabilized) by further chemical treatment. First wash the paper in running water for 5 minutes or until the wash water is no longer milky; afterward immerse it in a strong solution of salt for a few minutes (use the stock salt solution diluted 50 percent). Again wash the paper in water. The image can now be viewed by daylight without being oblit-

Figure 8.12: Anonymous, *Ross Church and Royal Hotel, River Wye, Herefordshire,* from a family album, c. 1880. Gold-toned albumen print.

erated for at least a year, unless it is exposed to ultraviolet or direct sunlight (you will find, however, that the highlights turn a violet color after a few hours in normal conditions). Fix the image using the procedure described on page 180.

Gold Toning

Toning with the noble metal has several advantages apart from the primary aim, which is to impart a greater degree of permanence to the final print. It can effect subtle and beautiful tonal shifts across a broad spectrum that varies from a steely blue resembling a platinum print to several distinct colors including peach, brown-purple, and green-blacks. It is best to first experiment with proprietary gold-toning solutions available from Kodak, Tetanal, Speedybrews, or Fotospeed. These kits should, in general, be diluted at least 1:1 with additional distilled water, because their action with both salt paper and albumen prints is far too quick and cannot be easily controlled.

Should you wish to mix your own solutions, I would recommend that you consult an early edition of *Wall's Dictionary of Photography*. The 1895 edition devotes considerable space to a gold-toning formula that I have found to be accurate and sound.

Color control is achieved primarily by the type and choice of the secondary alkaline compounds that affect and alter both the speed of toning and the chromatic range. In general, alkaline toning also increases the contrast and density of the final image; for example, an ammonium thiocyanate gold toner raises the highlight values while it increases the tonal separation of shadow details. The greatest danger lies in the overzealous use of toning solutions. It is easy to end up with a very hard, cold, steel gray print. If this point is reached, nothing further can be done as this process is irreversible. The coloration of all photographic prints becomes progressively colder as they dry. With the salted-paper and albumen print processes, the effect is even greater, and it is only through practice that the necessary experience is gained to make these fine judgments and distinctions. – MICHAEL GRAY

Summing Up

In terms of difficulty, the increasing order of printing skill required to make a fine print by one of the alternative processes described is POP, Vandyke, kallitype, and the salt print. While the processes that call for hand coating of paper are not child's play, it would be misleading to overstate the difficulties involved. The mechanical skills are not hard to learn and master. Brush coating, using a glass bar as a solution spreader, or sensitizing a sheet of paper by flotation becomes second nature after a few attempts, and mixing and handling the chemicals used is uncomplicated. Even so, if a fine print resulted on a first attempt at any of these processes, the occasion would be worth commemorating.

Each variety of paper has unique characteristics and will produce a print with distinct features. The skill that a printmaker needs to develop is the ability to analyze a print's shortcomings and devise strategies for improvement. If the surface of the paper is too absorbent, contrast will be low and the overall image

Figure 8.13: John P. Schaefer, *Agave, 1993.* The original pinhole negative was enlarged to 8 x 10 inches on Kodak SO-339 Duplicating Film. Negative contrast was increased by development in Kodak Dektol (dilution 1:1) for 8 minutes at 70°F. The salt print was made on gelatin-sized Cranes Parchment paper.

density weak. Can the situation be improved by sizing the paper with starch or gelatin? Or is the problem the fault of the chemistry used? Was the exposure adequate? Did the toning bath produce the desired print color? And so forth . . .

It is important to keep good notes and to put an identifying mark on each print. Ultimately, failures teach as much as successes. By working systematically, the moves needed to improve print quality will become apparent as your experience increases.

Keep a reproduction of a fine print made by Fox Talbot or one of his colleagues on the wall of your workroom. Look at it whenever you run into difficulties and remind yourself of what these remarkable photographers were able to do more than a century and a half ago with equipment and supplies of far lower quality than anything we have at the present time. Then make another print.

Chapter Nine

Platinum/Palladium Prints

Nature is full of pictures, and they are to be found in what appears to the uninitiated the most unlikely places. Let the honest student then choose some district with which he is in sympathy, and let him go there quietly and spend a few months, or even weeks if he cannot spare months, and let him day and night study the effects of nature, and try to produce one picture *of his own, which shall show an honest attempt to probe the mysteries of nature and art, one picture which shall show the author has something to say and knows how to say it, as perhaps no other living person could say it; that is something to have accomplished. Remember that your photograph is a rough index of your mind; it is sort of a rough confession on paper.*
— P. H. EMERSON

A fine platinum print has a presence and visual eloquence that cannot be duplicated by any other printing process.* The gradual transitions within the tonal scale and the subtle gradation of monochromatic colors, each highlighted on finely crafted paper, enable a photographer to create images whose signature is not the brilliance of a gelatin silver print but the graciousness of quiet light. Though care is needed, the skills required to make a platinum print are less difficult to master than those required by many of the alternative silver printing processes described in chapter 8. The challenge, as always in photography, is to create an image that is a measure of the potential of the medium.

Platinum printing became a commercial reality as a result of the explorations of William Willis, an Englishman who received a first patent on his invention in 1873. Later in the decade he formed the Platinotype Company, which made and sold platinotype paper to photographers. However, Guiseppe Pizzighelli and Baron Arthur von Hubl, two Austrian army officers, determined the course followed by those who practice the art of platinum printing today. In 1882 they published *Die Platinotype,* which described methods by which photographers could coat and print their own platinum papers. A subsequent English translation (available from Bostick & Sullivan) led to widespread use of the techniques detailed in the book, which are only slightly changed after more than a century.

Figure 9.1: Laura Gilpin, *Narcissus, 1928.* Platinum print. Much of Laura Gilpin's (1891–1979) early work consists of exquisite landscapes, portraits, and still lifes in platinum prints that reflect the pictorial mood of the time.

* Most modern platinum prints are actually made from a mixture of platinum and palladium salts. In this text, the term *platinum print* generally means an image consisting of a mixture of platinum and palladium metals.

Figure 9.2: Anne Brigman, *The Glory of the Commonplace, 1912.* Platinum print. A free spirit, Anne Brigman (1869–1950) created a body of soft-focus, romantic, and pictorial images, many featuring the nude in dramatic natural settings. She was much admired by Stieglitz.

Commercial production of platinotype papers in America ceased around 1917 because the price and availability of platinum made the paper too expensive for use by the average photographer. Platinum papers continued to be produced in Europe through the 1930s, but these were discontinued with the advent of World War II. A fine machine-coated platinum/palladium paper is now being made and sold by The Palladio Company, Inc. (see page 376).

An Overview of Platinum Printing

Platinum and palladium are closely related metals with similar chemical and physical properties. Most printers use the metals in combination to achieve a desired print color, to minimize processing problems associated with working with pure platinum (such as graininess), and to save money — the cost of palladium is considerably lower than for platinum. The mechanics of platinum printing are based on the photochemistry of iron oxalate, since platinum and palladium salts do not undergo useful photochemical transitions by themselves.

To make a print, a solution containing ferric oxalate, potassium chloroplatinite, and/or palladium chloride is brushed onto the surface of the paper. Exposure of the sensitized paper to actinic light creates a faint provisional image of ferrous oxalate that must be developed in an appropriate medium — usually an aqueous solution of either potassium oxalate or ammonium citrate. Upon immersion in the developer, the ferrous ions reduce the platinum or palladium salts to the pure metals. Print tones can range from black to sepia and are influenced and altered by developer temperature and composition; they can also be varied by additives such as mercuric or gold chloride, which can be incorporated into the developer or sensitizer. Subsequent toning of a developed platinum print, if desired, can alter the basic image color to the extremes of blue or red.

It is possible to work with either pure platinum or palladium salt to make prints, but most printmakers mix the two. The reasons are both economic and aesthetic. The cost of palladium is less than platinum, and a pure palladium print has a warm brown tone. Palladium prints can produce darker tonal values than platinum can, but the inherent contrast of a palladium image is lower than that of a pure platinum print. Under certain circumstances, platinum prints can exhibit a pronounced and distressing graininess, a problem that is

Figure 9.3: Douglas Frank, *Ecola Rock, Oregon, 1982.* Platinum/palladium print. Rich blacks and brilliantly detailed whites are hallmarks of fine platinum/palladium prints.

less prevalent with palladium and can be minimized when a mixture of the two metals is used. A print made with a 25/75 to 50/50 mixture of the two metal salts has an aesthetically pleasing tone and all of the desirable properties of a pure platinum print.

Selective development of a platinum image is possible, and it was used extensively by the pictorialists as a form of "burning-in and dodging" and as a way of achieving control over the selected portions of the image. Selective development begins by coating the exposed paper with glycerin, then applying the developer with a brush to selected areas of the print. By altering the developers used for different parts of the photograph and by using toners, you can make multihued platinum prints. This advantage plus the general versatility of the platinum process were major reasons for its popularity with the pictorialists and printers who strove for artistic effects. However, the words of Paul L. Anderson in the *Handbook of Photography* are worth remembering:

> *A layer of glycerin having been placed on the glass, the print is plastered down on this. A rather thick coat of glycerin is then painted over the surface of the print; the graduates are filled — one with clear developer, one with equal parts of developer and glycerin, and one with clear glycerin. The various areas of the print are then developed by brushing one or another of the solutions over the surface, as required, and blotting freely from time to time. The function of the glycerin is to retard development and give opportunity for what local bringing up of values may be desired. When the operation has gone to the desired point, the print is cleared and washed as usual, the final operation being generally to place the finished print facedown in the ash can. . . . However, it must be admitted that very fine pictures have been produced by this method.* — PAUL L. ANDERSON

Negative Characteristics

An ideal negative for platinum printing should be exposed to give full shadow detail and developed to a density range of approximately 1.4, although negatives with more or less contrast are easily handled by using simple contrast-control techniques (see page 191). In a very real sense platinum prints are the forerunners of variable-contrast printing papers.

Tonal reproduction of negative densities in platinum/palladium prints differs from that of silver-based enlarging papers. Dick Arentz, a master of the art of platinum printing, has studied the sensitometry of platinum printing extensively and has found the following:*

1. The black tones achievable with pure platinum are far less intense (D_{Max} = 1.5) than with silver (D_{Max} = 2.0).

2. The transition from white to textured white is gradual, which results in superb separation of highlight tones.

3. Midtone separation is linear, which results in excellent tonal separation of these values.

* Arentz's pamphlet, *An Outline for Platinum Palladium Printing* (1990), is available at Photo Eye in Santa Fe and at other stores that specialize in books on photography.

Figure 9.4: William E. MacNaughton, *The Connecticut River, c. 1914.* Platinum print. This soft-focus image is typical of landscape photography during the pictorial period.

4. A pronounced shoulder (see page 39) results in poor separation of tonal values near maximum black.

5. The exposure scale is easily controlled by the addition of an oxidizer to the sensitizer, so that negatives in the density range of 1.0 to 1.9 are easily accommodated.

The distinctive visual qualities of platinum/palladium prints are largely due to characteristics 2 and 3.

Papers

Papers for the platinum process should be of the best quality and well sized (see pages 141–146). Cranes Platinotype 100% Rag (available from Bostick & Sullivan) and Arches Platinotype are both excellent papers and can be used without additional sizing. Two classic papers that continue to be used extensively are Cranes Kid Finish (a 32-pound paper) and Cranes Parchment Wove 100% Rag (a 44-pound paper). Because of contrast-control problems and the

Figure 9.5: John P. Schaefer, *Saguaro Cactus Skeleton, 1975.* Platinum/palladium print. The matte surface of platinum prints softens the appearance of the image.

cost of the sensitizer and materials (the cost of materials for a typical 8 x 10-inch platinum print is about $5), it is important that the sensitizer remain close to the paper surface and not be absorbed into the body of the fibers. Other fine papers that have been favored by printers are Strathmore 500 Drawing, Southworth Parchment, Masa, Gallery 100 Vellum, Arches Aquarelle (hot pressed), Rives BFK, and Jean Perrigot Arches (the last two do need additional sizing for optimum results). Discovering and exploring the printing capability of a new paper is a joy that is shared only by those who pursue alternative photographic processes.

Chemicals and Supplies

The costly items required for platinum printing are potassium chloroplatinite and palladium chloride (or sodium tetrachloropalladate or sodium palladium chloride). Bostick & Sullivan (B&S) caters to the needs of platinum printers and offers these items at competitive prices, as does Photographer's Formulary (see page 376). B&S's 1998 prices for 50-gram or higher quantities were $9.50 per gram for the platinum salt and $7.50 per gram for the palladium salt. B&S also sells ready-to-use solutions of the metals. Prices for 50 ml. of the platinum and palladium salt solutions were $127.50 and $65, respectively, and these are sufficient to make sixty to eighty 8 x 10-inch prints. Platinum and palladium kits are also available, and these afford an excellent introduction to platinum/palladium printing. These kits contain all of the chemicals needed for printing and processing.

The key to successful platinum/palladium printing is the quality of the ferric oxalate used to sensitize the paper. It is best to purchase it as a dry powder ($54 for 100 grams), since it keeps indefinitely in this form when stored in a cool, dark place. To prepare the sensitizer, a small quantity of oxalic acid is needed to add to the ferric oxalate.

Either ammonium citrate ($13.20 for a quart) or potassium oxalate ($14.30 for a quart) can be used as a developer. The former produces cold-toned prints, while the latter gives warmer tones. Each has an indefinite life-span, and the developing quality of the bath is thought to improve with age as metal salts accumulate. Do not discard the developer simply because of its dark and cloudy appearance.

To clear a print after development, hydrochloric acid, oxalic acid, citric acid, phosphoric acid, or EDTA can be used, none of which is expensive. In addition, a small quantity of potassium chlorate is needed for contrast control.

Figure 9.6: Jed Devine, *Interior with Pantry, n.d.* Platinum print. Devine's presentation of this image as a platinum print reveals the innate beauty of a subject that might otherwise be overlooked.

Solutions

Solution A — 27% Ferric Oxalate. Ferric oxalate dissolves *extremely* slowly and requires frequent stirring and warming to bring it into solution. This is best done by using a brown eyedropper bottle as the mixing vessel, placing it in a pan of hot water, and shaking the solution every few minutes. To prepare the 27-percent solution of ferric oxalate, add 15 grams of dry powder and 1 gram of oxalic acid crystals to a brown 4-ounce eyedropper bottle and pour in 55 ml. of distilled water heated to approximately 150°F. Agitate the solution intermittently until the suspension dissolves. (Photographers who work extensively in platinum find that the purchase of a magnetic stirrer–hot plate is an excellent investment and saves hours of drudgery in preparing quantities of ferric oxalate solution.) Label the bottle "Pt/Pd Solution A" (for the symbols for the elements platinum and palladium). Store this solution in a cool, dark place after it has been prepared. Its shelf life depends upon the storage conditions and varies from several weeks to a few months. Signs of decay are fogged highlights and uneven tones in the print highlights.

Solution B — 0.6% Potassium Chlorate. Dissolve 0.3 grams of potassium chlorate in 55 ml. of distilled water. Pour the solution into a brown 2-ounce eyedropper bottle and label it "Pt/Pd Solution B."

Solution C — 20% Potassium Chloroplatinite (available as a prepared solution from B&S). Dissolve 10 grams of potassium chloroplatinite crystals in 50 ml. of distilled water. Pour the solution into a brown 2-ounce eyedropper bottle and label it "Pt Solution." Solution C keeps indefinitely, but visible crystals of potassium chloroplatinite may form on standing. Warming and shaking the eyedropper bottle in a tray of hot water quickly dissolves any crystals that are present.

Solution D — 15% Sodium Tetrachloropalladate (available as a prepared solution from B&S). Dissolve 5 grams of palladium chloride and 3.5 grams of sodium chloride in 55 ml. of distilled water. Pour the solution into a brown 2-ounce eyedropper bottle and label it "Pd Solution."

Potassium Oxalate Developer (available as a prepared solution from B&S). Prepare this solution outdoors or in a well-ventilated area to avoid breathing the dust. Add 300 grams of potassium oxalate to 1 liter of distilled water and stir the crystals until they dissolve. *Caution! Continuous contact with this developer occasionally causes a skin rash. Use rubber gloves to minimize exposure.* Store the developer in a plastic bottle and label it "Potassium Oxalate Developer." It will turn black after being used, but this does not affect its performance.

Ammonium Citrate Developer (available as a prepared solution from B&S). To 150 grams of ammonium citrate add 1 liter of distilled water and stir until the crystals dissolve. Transfer the solution, which has a syrupy consistency, into a plastic storage bottle and label it "Ammonium Citrate Developer." It darkens with use but retains its effectiveness as a developer. *Note:* Ammonium citrate by itself is not toxic, but the solution becomes toxic as heavy metals (platinum and palladium) accumulate in it after several prints are developed. Developer toxicity is not a problem as long as ordinary care is used in handling the materials and the solutions are not ingested.

Clearing Agents A clearing agent is needed to remove all traces of iron salts from the print and to prevent paper degradation and staining. Early workers favored the use of a 1-percent solution of hydrochloric acid, but the concentrate is dangerous and unpleasant to work with. It is the most effective clearing agent, however, and if you are comfortable handling it and work in a well-ventilated room, by all means use it. Any one of the following solutions can be used to clear the print.

1% Hydrochloric Acid. To 1 liter of tap water add 20 ml. of 32-percent hydrochloric acid (available from a swimming pool supply store, $4 for 2 gallons). If you spill any of the concentrated acid on yourself, flush the area with water. This bath is *not* recommended for use with palladium prints, since they may bleach excessively — a more dilute solution can be used effectively. *Note:* Fumes from a bottle of concentrated hydrochloric acid are extremely corrosive and will rust or attack most metallic objects. *Never open a bottle of the acid in a darkroom or indoors.*

1% Oxalic Acid. Dissolve 10 grams of oxalic acid crystals in 1 liter of tap water.

2% Phosphoric Acid. Add 24 ml. of phosphoric acid (75 percent) to 1 liter of tap water. Double the concentration for palladium prints. Phosphoric acid is not volatile and is easy to handle and very effective as a clearing agent. It's my personal choice for both platinum and palladium printing.

EDTA. Use 1 tablespoon of EDTA (tetrasodium salt) per 750 ml. of water. Some printers express reservations about the effectiveness of EDTA as a clearing agent and find that, in some circumstances, print stains result that cannot be removed by prolonged washing. I have had excellent results with EDTA and the papers I have used. Lack of clearing with EDTA may be due to the presence of chemical buffers in the paper that convert the iron salts to ferric carbonate or ferric hydroxide; both of these extremely insoluble compounds are difficult to remove from paper fibers with EDTA. Iron salts are decomposed by strong acids, and if yellow highlights persist after treatment of the print in the EDTA clearing bath, switch to an acidic clearing bath.

Making a Platinum/ Palladium Print

Whatever you can do, or dream you can, begin it. Boldness has genius, power, and magic in it. — JOHANN WOLFGANG VON GOETHE

All of the skills described in previous chapters for making prints on hand-coated papers are applicable to making a platinum print. It is wise to master the techniques of coating paper, exposing negatives, and processing and handling wet prints with a process such as cyanotyping or Vandyke printing, since "the price of experience" is a fraction of that involved with platinum. Dick Arentz ruefully notes, "Every platinum printer I know has a shelf loaded with imperfect prints that are not good enough to show but too valuable to throw away." It makes little sense to add needlessly to the height of the pile.

Organ Pipe Cactus,
Diablo Mountains,
Arizona, 1991

Platinum prints, regarded as representative of the finest photographs ever created, are made by a contact printing process from standard silver-based films; if enlarging is desired, it must be done through copy negatives (see pages 114–116). In either case, the film is developed for greater contrast than is suitable for modern silver papers.

By 1991 I had worked in the 12 x 20-inch format for eight years and felt a need for change. I chose another of the traditional banquet camera formats, 7 x 17 inches. To gain experience in working within a more extended rectangular space I made a number of exposures with a 6 x 17-cm. roll-film camera. The negatives were interesting but too small for my contact printing needs. My particular way of working is to compose the photograph in its final form and size on the ground-glass viewing area of the camera, and I do not crop or enlarge negatives.

On a visit to the Diablo Mountains to test the 7 x 17 Korona camera, I came across an interesting singular organ pipe cactus and began to plan and compose a photograph. Visualization varies with the chosen medium. Just as a color photograph seldom translates well into black-and-white, seeing must be modified from silver-based photography to platinum or palladium. Furthermore, filling an unusual photographic space (7 x 17 inches) requires practice and experimentation.

The response of film and silver-based papers to light is not linear, and gelatin silver prints often depress shadows and midtones and have a limited ability to render delicate gradations of near-white tonal values. With platinum and palladium papers, tonal separation is visible far into the highlights of the print. The essence of the image of the Organ Pipe Cactus *resides in its mid- and higher-tonal values. The photograph was visualized as a palladium print in which the intonations of sunlight subtly traverse the structure of the cactus. A gelatin silver print of the subject fails to capture these qualities.*

For adequate depth of field with my 14-inch lens at a distance of 6 feet from the subject, an aperture of f/90 was required. I used a medium yellow filter to lighten the yellow-green tones of the plant relative to the blue-tinted shadows. A bellows extension correction was applied, and the scene was given an exposure of 3 seconds.

The intense but flat lighting of the desert presents a challenge in negative preparation because a high-contrast negative is needed for platinum/palladium printing. I rated Kodak Tri-X Professional Film at an EI of 800 and processed the film in undiluted D-76 for 20 minutes at 85°F, the equivalent of N+2 development for palladium printing. The negative had a density range of 1.7, which is ideal for palladium but beyond the range of a silver gelatin paper.

A suitable, well-sized rag paper was hand coated with a sensitized palladium salt and dried in heated air. The negative was sandwiched between glass and the coated paper and exposed for approximately 5 minutes to intense ultraviolet light. The print was developed in a solution of potassium oxalate warmed to 110°F to ensure the production of a warm-toned image. The print was cleared in successive acid baths, washed thoroughly in running water, drained, and allowed to dry faceup on a screen.

The finished print consists of pure palladium metal embedded upon and inside the fibers of the paper at a considerably greater thickness than can be laid on the paper's surface by machine coating. The delicacy of the tonal scale, image color, and depth are all enhanced by a process that, while still photographic, is basically a hands-on printmaking experience.

— DICK ARENTZ

The procedure for making a platinum/palladium print involves the following steps:

1. determining the density range of the negative
2. determining the optimum sensitizer composition
3. sensitizing the paper and exposing the negative
4. developing the print
5. clearing the print
6. washing and drying the print

Determining the Density Range of the Negative

To select the correct sensitizer, the density range of the negative must be known. If you have a densitometer, measure the negative density values of the points that will correspond to the lightest and darkest tonal values in the print. The numerical difference in these numbers is the density range of the negative.

If a densitometer is not available, you can use either the procedure for measuring densities described on pages 66–70 to determine the difference or a calibrated density strip to make an intelligent estimate of the range. Do the latter by placing the strip and the negative against a light source. Visually estimate the density range by comparing the negative to the comparable density values on steps of the calibrated strip. Take the difference in step numbers corresponding to the highest and lowest density values, multiply that number by 0.15 (the average difference in density between steps on a Kodak No. 2 density strip), and the product will be the approximate density range of the negative. For example, if the lowest important negative density is the same as that of step two and the highest value is about that of step twelve, the density range is 0.15 (12 − 2) = 0.15 x 10 = 1.50.

Determining the Optimum Sensitizer Composition

The sensitizer used for making a platinum or palladium print is a mixture of solutions A, B, C, and/or D, and the ratio of A to B that is needed is determined by the density range of the negative. A total of about twelve drops of sensitizer is required for each 20 square inches of print surface. This means that approximately twelve drops are needed for a 4 x 5 print, forty-eight drops for an 8 x 10, and so forth (there are about 20 drops to 1 milliliter of solution). Table 9.1 presents guidelines on mixtures to use for contrast control in printing. For example, if the density difference is 1.3 (slightly lower contrast than normal for a platinum print), to make a 4 x 5 print, use two drops of A, four drops of B, and six drops of either C or D or any mixture of the two.

The recommendations in table 9.1 (for a 4 x 5 print) are intended to serve as a starting point only. For larger print sizes, adjust the number of drops accordingly.

Sensitizing the Paper and Exposing the Negative

Because of the cost of a platinum print, it is obviously desirable to limit the number of test prints to as few as possible. With a little experience, a test expo-

sure on a strip of paper and processing the strip through forced drying will take about 15 minutes — 15 minutes that will pay off in saved time and money.

The easiest way to proceed is to sensitize a strip of paper wide enough and long enough to cover representative highlight and shadow values of the print. Coat the strip with the appropriate sensitizer and dry it using a blow-dryer. Cover the sensitized strip with the appropriate segment of the emulsion side of the negative and expose the strip in a contact printing frame. Monitor the exposure by checking the image intermittently and continue to expose the test strip until details in the highlights of the latent image are barely perceptible. Note the exposure time and process the test strip (see page 57).

Table 9.1

Sensitizer Composition as a Function of Negative Contrast for Platinum Prints*

Negative Density Range	Solution	Drops
1.8	A†	6
	B	0
	C and/or D‡	6
1.6	A	5
	B	1
	C and/or D	6
1.5	A	4
	B	2
	C and/or D	6
1.4	A	3
	B	3
	C and/or D	6
1.3	A	2
	B	4
	C and/or D	6
1.2	A	1
	B	5
	C and/or D	6
1.1	A	0
	B§	6
	C and/or D	6

* If palladium is used instead of platinum, the weight of potassium chlorate should be doubled when solution B is prepared, since it is a less effective contrast-control agent with palladium.

† The absence of any restrainer in the first formulation generally results in some fogging of the highlights when this mixture is used.

‡ Either solution C or D or any combination of the two may be used.

§ The time needed for the exposure of a negative *increases* substantially as the percentage of B in the sensitizer increases. The last formulation in the table may require twice the normal exposure time.

A platinum print *lightens* in the clearing agents but *darkens* when it dries, so the test strip must be cleared, washed briefly, and dried before it can be evaluated meaningfully. If the processed and dried strip has the correct tonal values and density range, use the same exposure and processing procedures to make the final print. If the tonal values of the strip are unsatisfactory, change the exposure and/or the composition of the sensitizer and make another test strip. Remember, *a change in the sensitizer composition alters the exposure time, increasing it as the concentration of B increases.*

Developing the Print

Develop the exposed print by immersing it in the developer as quickly as possible.* This can be done either by sliding the print into the tray so that it slips under the surface of the developer in one smooth motion or by pouring the developer over the print surface so that it is covered by a rapid even flow of solution. A flat-bottomed plastic or enamel tray works best; trays with ridges can cause papers with low wet strength to tear during processing. Make certain that the tray is clean and that there are no exposed metal surfaces.

Development is instantaneous, but agitate the print gently for 1 minute to allow most of the unreacted metal salts to leach into the developer bath. Then pour the developer from the tray back into its storage container.

Run enough tap water into the tray that the developed print floats freely and tilt the tray back and forth so that the water sloshes across the print surface and rinses off most of the excess developer. Pour out the wash water and repeat this step twice more.

Clearing the Print

Three trays of clearing bath are needed. Make up a large volume of your preferred clearing agent and half fill three clean trays with the solution. As in the case of the developer tray, flat-bottomed plastic or enamel trays are best.

Gently lift the print from the developer tray and lower the print into the first clearing bath. Agitate the first clearing bath by gently rocking the tray and lifting the print occasionally to ensure efficient contact of the print with the solution. The print lightens perceptibly in the clearing bath.

After 5 minutes in the first clearing bath, transfer the print into the second tray of clearing agent and continue to agitate the print and tray intermittently for another 5 minutes.

* A common fallacy about platinum developers is that they render the ferrous oxalate soluble, so that it can reduce the platinum or palladium salts and produce a visible image. In fact, oxalate salts do just the opposite, namely, they lower the solubility of ferrous oxalate, thereby keeping it as a moist precipitate on the paper's surface. As the soluble salts of platinum or palladium come into contact with the insoluble salt, they are reduced to the metal. The ferric salt that is concurrently formed then passes into solution because of its high solubility (in contrast to ferrous oxalate, which is virtually insoluble).

Figure 9.7: Meridel Rubenstein, *Penitente, 1982*. Palladium print. This extraordinary and creative image combines several photographs and is the work of a master printmaker.

Move the print into the third bath and repeat the above procedure. The third bath should be completely colorless at the end of the clearing cycle.

After a few prints have been processed, the first bath will begin to discolor. Discard it, move the second bath into the first position, the third bath into the second position, and prepare a fresh batch of clearing agent to serve as the third bath.

Washing and Drying the Print

Gently lift the print from the last clearing bath after 5 minutes and wash the print in a tray of running water for 15 minutes. A tray such as the 11 x 14 Doran Rapid Print Washer directs gentle jets of water over both surfaces of the print and is a highly efficient washer for a single print. Wet prints are extremely delicate, and it is best to wash one at a time.

Drain the print and lay it faceup on a clean blotter or a drying screen. Drying can be hastened by the use of a blow-dryer. Evaluate the dry print for exposure and contrast and make whatever adjustments needed in further printings.

Figure 9.8: Barbara Crane, *Rubber Bands in a Bowl*, from the Objet Trouvé series, 1983. Hand-colored platinum/palladium print. The soft pastels penciled in by the photographer harmonize with the muted tonal qualities of the print and subject.

Print Quality and Tones

Print quality and tones in platinum and palladium prints are controlled or influenced by the properties of the paper, the composition of the sensitizer, the temperature and choice of the developer, the addition of specific additives, and toning and spotting after processing.

Paper Quality

One of the most unpredictable aspects of platinum printing is the impact that the printing paper will have on the qualities of the final print. Papers sized with starch tend to produce warm-toned prints, while gelatin sizing favors colder tones. Other additives that are incorporated into the paper during processing may have undesirable side effects, such as chemically reacting with the sensitizer and rendering it useless or producing a print with pronounced grain. If you have confidence in your coating and processing techniques and in the quality of the chemicals being used yet encounter a persistent problem that

does not yield to reasonable efforts at resolution, the fault may lie in the printing paper. The best strategy at this point may be to change papers.

A file of prints made on different papers of a negative that you select as a "standard" is useful and informative. Choose a negative that contains a range of density values that covers the spectrum of black to white and make a fine print on the paper of choice. Record all data on the sensitizer formulation, exposure, and paper brand and lot in pencil on the back of the print and label it as your "standard."

Use the identical formulation of sensitizer solution and exposure to make comparison prints on other papers. If the overall print densities and/or print contrasts differ, make whatever adjustments necessary in the sensitizer formulation and exposure to achieve as close a match as possible. Record the data on the sensitizer formulation, exposure, and paper type in pencil on the back of each print. By doing this for several different kinds of paper you will quickly appreciate that papers vary markedly in such qualities as whiteness, absorbency (influenced by the sizing of the paper), surface smoothness, and chemical composition, and that each of these has an impact on the print produced. A visual comparison of the prints will provide a basis for choosing a paper that produces the print quality you visualized.

When you find a satisfactory printing paper, purchase as large a lot as you can comfortably afford. Manufacturers often change the formulation of a paper over time, so the performance of new lots differs from that of the same brand used in the past.

Sensitizer Composition

A pure platinum print usually has neutral black tones that can be biased toward brown-black by the choice of developer and the processing conditions. Pure palladium prints have a distinctive brown tone. By printing with a mixture of platinum and palladium and varying the ratio of the two metals in the sensitizer, considerable control over the print tone is possible. Sensitizing the paper with a 1:3 mixture of platinum and palladium produces a print with a warm black tone and deeper blacks than can be achieved by using palladium alone. Using mixtures of metals that are richer in palladium reduces the cost of a print substantially, and by selecting the appropriate developer it is impossible to distinguish a platinum/palladium print from one made with platinum alone.

Developer Choice

Print tone is affected by the selection of the developer and the developer temperature. To achieve blue-black tones, an ammonium citrate or potassium oxalate developer can be used at 70°F. As a developer is heated, the resulting print tone shifts toward brown, the effective printing speed is higher (less exposure is therefore needed), and image contrast is reduced. It is important that prints be processed at the same conditions used to evaluate any test strips, or else the results will not be comparable.

Toning

A blue-black print tone can be produced by using a 4-percent solution of gold chloride (1 gram of gold chloride in 25 ml. of water) to tone the print after development. Begin by coating the surface of the print with glycerin and then gently brush the toner onto the print until the entire surface has been covered. After the gold chloride solution has been applied, wash the print in running water to remove the glycerin and excess gold, then immerse the print in a solution of any standard film or paper developer for 1 minute to reduce any traces of gold that may be present. Complete the processing by washing the print thoroughly in running water for 30 minutes.

Alternatively, a drop of gold chloride can be added to each milliliter of sensitizer. Gold chloride cools the print tone and often helps to reduce grain when pure platinum is being used for printing.

Other toning formulas in the literature can be used with platinum prints to produce colors anywhere from blue to red. However, toning a platinum print should be done with restraint, since a fine platinum image needs no help to convey its beauty.

Spotting

As with all printing processes small spots of black or white are almost inevitable. White spots on prints are best spotted using very soft charcoal drawing pencils. These can be purchased at any art supply store and come in a range of colors. Sharpen the pencil to a narrow point by rolling the tip on a sheet of fine sandpaper. Fill in any print defects by brushing the pencil point lightly across the print surface. While the older literature recommends spotting platinum prints with watercolors, pencils are simpler to use.

Black spots can be removed by using the point of a razor blade or scalpel to scrape off the unwanted blemish.

Processing a Palladio Print

*Men give me credit for some genius. All the genius I have is this:
When I have a subject in mind, I study it profoundly. Day and night
it is before me. My mind becomes pervaded with it . . . the effort
which I have made is what people are pleased to call the fruit of genius.
It is the fruit of labor and thought.* — ALEXANDER HAMILTON

Palladio Velvet DX™ Paper

In 1987 the Palladio Company in Medford, Massachusetts, was formed and began to produce a machine-coated platinum/palladium paper for sale to the public. The current version of paper is sold under the name of Palladio Velvet DX™. It is a medium-weight paper with a pleasing smooth surface and is capable of producing deep blacks and superb tonal values in the midtones and highlights. Palladio Velvet DX™ replaces earlier papers, Palladio Eggshell and Palladio Velvet, and it has greater contrast and much more intense blacks than the earlier papers ($D_{Max} = 1.72$ vs. $D_{Max} = 1.48$). It is available in all of the

Figure 9.9: Douglas Frank, *Veils, Oregon, 1984*. Platinum/palladium print. The beauty of Douglas Frank's print as an object imparts a mystical quality to this simple subject.

common format sizes. This paper can be purchased in conveniently packaged units (1998 prices for 10 sheets: 5 x 6, $27; 7 x 9, $50; 9.5 x 11.5, $75; 13 x 16, $162.50; 16 x 20, $250). Both cold-tone and brown-tone developers are available. The Palladio clearing bath is EDTA based and is recommended, since standard clearing baths can create difficulties.

Palladio paper is shipped in a sealed envelope and, under reasonable storage conditions, it has a shelf life of more than one year. Its stability is a function of the moisture content of the paper, which must be kept dry while it is stored. Between printing sessions the paper should be placed in the original sealed bag with its pouch of silica gel (a desiccant that absorbs moisture). Before using Palladio paper, "rehumidify" it by briefly steaming it (see below).

Negatives for Palladio Velvet DX™ The sensitizer formulations given for making hand-coated platinum prints target a negative with a density range of 1.4, with variations then given for negatives of greater or lesser range. With Palladio Velvet DX™ paper, a negative with a density range of up to 2.75 will

span the spectrum of maximum black to paper base white. However, negatives with a far more restricted density range (for example, those that print well on a typical Grade 2 enlarging paper) will easily produce prints with a satisfying and appropriate tonal scale.

As with any photographic printing process, it is best to determine the optimal negative density for a print and then plan exposures and development to accommodate the properties of the paper. To take advantage of Palladio's — and any platinum print's — ability to convey details in the shadows and highlights, a fully developed and detailed negative is desirable. As a starting point, a negative intended for Palladio Velvet DX™ paper should be given twice the normal exposure and developed 30 to 50 percent longer than normal (N+1 or N+2 development). Changes in print contrast are easily made by adding small amounts of hydrogen peroxide to the developer. Palladio prints can also be "fine-tuned" using this device.

Humidifying Palladio Velvet DX™ Just prior to printing, Palladio paper must be "moisturized" to restore the contrast and print speed to that which prevailed at the time of coating. The easiest way to restore the paper's activity is to use an ultrasonic humidifier (available from a pharmacy) that produces a cool mist. Hold the print about 1 foot in front of the nozzle and allow the water vapor to play over the surface of the paper for 1 to 2 minutes. The paper will lose its stiffness as moisture is absorbed and become quite flexible.

Alternatively, heat a pan of water to a low simmering boil on a hot plate and hold the paper, emulsion side toward the water, about 1 foot from the surface, so that the vapors gently waft over the paper. The steam rising from the surface should be pleasantly warm, not hot enough to make your hands uncomfortable. Do not boil the water too vigorously, or else water may spatter onto the paper and ruin the coating.

Moisturized paper does not keep and should be used within a few hours. The best results in terms of print density, contrast, and printing speed are obtained when the paper is used within a few minutes of being humidified. Do not humidify more paper than you intend to use during a printing session and do not return the paper to its original pouch once it has been humidified. Store it in a Ziploc plastic bag.

Note: Each package of paper contains a number of test strips, which are the trim from the paper. These should be humidified by the same procedure before a test strip is exposed.

Palladio Developers

While traditional platinum developers can be used with Palladio paper, the developers sold by the manufacturer are designed so that the addition of 10 ml. of a 3-percent solution of hydrogen peroxide to 1 liter of developer prior to processing increases the effective print contrast by the equivalent of one paper grade. As the effective contrast of the paper is increased by the addition of the oxidizer, a reduction in printing speed occurs, and the exposure must be lengthened to produce the correct overall print density. If the developer is allowed to stand for a few days, the peroxide decomposes and the solution

returns to its original state. It is advisable to prepare several batches of developer before a printing session so that the contrast of a print can be fine-tuned through development in the correct bath.

Virtually every print is enhanced by the addition of a small amount of peroxide in the developer, since separation in the darker tonal values is improved. As with other platinum developers, as the temperature of the bath is raised, the print color shifts toward a warmer brown.

Follow these steps to prepare the developer:

1. Once you have chosen and mixed the developer of choice in a clean tray, adjust its temperature to at least 70°F.

2. Expose the print, then slide the paper, emulsion side up, into the developer in a single continuous motion and allow it to remain there with little or no agitation for 4 minutes. If bubbles form on the surface, give the paper a gentle shake to release them. Handle the paper by its edges, since the print surface is fragile.

3. After development is complete, transfer the print to a clean tray and rinse it in tap water for 1 minute, taking care not to let the stream of running water fall directly on the surface of the print but rather flow across it.

4. Clear the print by soaking it in Palladio Clearing Bath (an EDTA solution) for 5 minutes.

5. Wash the print in running water for 15 to 30 minutes.

6. Dry the print by placing it, faceup, on a drying screen or by hanging it from a corner with a clamp or clothespin.

Palladio sells two developers, both of which are citrate based and nontoxic before they are used to process a print and accumulate heavy-metal salts:

Palladio Standard Developer This developer produces a warm black image, but the print tone can be modified to an even warmer tone if you add an enclosed additive to the developer. A side effect of the additive is that it reduces print contrast, so some hydrogen peroxide must be blended with the developer to compensate for the loss.

Palladio Cold Tone Developer™ This cold-tone developer produces a print with neutral black tones similar to those found in a pure platinum print. It increases both the grain and print contrast and, therefore, requires less hydrogen peroxide for contrast control.

The consistent high quality and reproducibility of Palladio paper is a significant advantage to anyone interested in exploring the realm of platinum printing. While the flexibility of using a variety of papers is lost, the frustrations associated with sizing and coating paper are avoided. The slight premium in cost for Palladio paper is offset by the predictability of its performance, which results in less waste, a saving in the long run.

Chapter Ten

Gum Dichromate Printing Processes

The discovery of photography was announced in 1839. Quite optimistically, many artists held the view that it would "keep its place" and function primarily as a factotum *to art. But this was both presumptuous and futile. The medium was so en* rapport *with the mentality of a large and growing section of the public which prided itself on mechanical achievement, and not less with the growing preoccupation of artists with truthful representation, that it could hardly be relegated to an inferior position. It is not surprising, during an age in which the efficacy of the machine would appear to be one of the essential virtues, that the authority invested in a machine by which nature could take her own picture would impinge on art in the most fundamental way.* — AARON SCHARF

The astounding reproduction of the tens of millions of photographs seen in newspapers, books, and magazines around the world each day is not due to the photochemical properties of silver but rather chromium. As Fox Talbot struggled with the question of how images captured as photographs could be transferred to copper plates, inked, and reproduced in book form as inked images, he made two significant discoveries. The first was that when gelatin is mixed with a solution of potassium dichromate and exposed to light, the gelatin becomes insoluble. Further studies showed that the *degree of hardening* of the gelatin *was proportional to the exposure received* — a necessary condition for any potential photographic process and, ultimately, the basis for the gum dichromate process. This property of light sensitivity in the presence of chromium salts is shared by other colloids and gums, notably *gum arabic,* a resin obtained from the acacia tree.

The second discovery was that if the gelatin–potassium dichromate coating on a copper plate is covered with a screen, a mosaic of insoluble "dots" similar to a halftone printing screen is formed on exposure to light. Immediate reexposure of this coating with a negative or other object (such as a leaf) in place of the screen results in all of the exposed areas of the coating becoming insoluble, while those regions shielded by black areas of the negative or object remain unexposed. Washing the plate in cold water removes the soluble gelatin and leaves behind a mosaic of dots in which the form of the negative is visible. The areas of the plate not covered by hardened gelatin can then be etched

Figure 10.1: David Scopick, from the Mexican series, 1994.

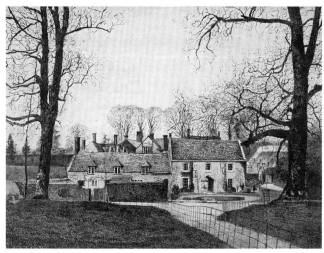

Figure 10.2: *Dorsetshire Photographically Illustrated, c. 1850.* John Pouncy combined what was known about the photosensitivity of gum arabic and chromium salts to develop the first photomechanical printing process. The printed images have been extensively retouched and are a hybrid of photographs and the engraver's art.

Figure 10.3: *Bingham's Melcombe,* from *Dorsetshire Photographically Illustrated, c. 1850.* This image is one of the first examples of the use of photolithography, a process that enabled photographs to be reproduced in books and newspapers for the first time.

away with acid. Inking and wiping the plate forces the ink into the etched surface of the plate, which can be transferred to paper by applying pressure to the plate and paper in a press. While the printing process has undergone numerous technical refinements over the past century, its basis remains rooted in the early work of Fox Talbot.

Although the precise origin of the photographic *gum print* (often called a "photo aquatint" in the early literature — a name that has, regrettably, fallen out of use) is shrouded in the mists of history, it appears that sometime in the period of 1856–1859 John Pouncy combined various threads of discovery and formulated the *gum dichromate process* (often called "gum *bi*chromate" in the older literature, reflecting an earlier chemical nomenclature). Integrating Mongo Ponton's observation that dichromates are light sensitive, Fox Talbot's work on the action of light and dichromate on the hardening and loss of water solubility of colloids, and Alphonse Poitevin's addition of pigment to the colloid, Pouncy invented a new way to make photographic images.

The family of gum dichromate processes had considerable commercial value and formed the basis for making *carbon prints* (prints that use lampblack as the pigment) and *carbro prints* (in which three layers of pigments are used to produce the most permanent full-color images known). For both carbon and carbro prints, special tissues must be made or purchased that contain the pigment dispersed in a gelatin matrix. The tissue is sensitized in a dichromate bath, exposed with a negative by contact printing, and, in subsequent steps, the image is transferred onto a sheet of paper. The procedure is complex, and considerable skill in handling the materials is required to make a fine print. With the evolution of new and simpler technologies, these processes are now rarely used.

The gum dichromate process, or *gum printing,* reached its peak of popularity at the end of the nineteenth century and coincided with the emergence of pictorialism as an important movement in the art world. The aesthetic that shaped the taste of most nineteenth-century photographers was rooted in England, where the highly romantic images of the Pre-Raphaelite painters dominated the art scene. The Pre-Raphaelite movement, which began in 1848, had quickly become the dominant force in English painting. The members of

the painting establishment rejected all that was "modern" in art and argued for a return to the values seemingly cherished during an earlier age in painting, namely, fidelity to nature, truth, sincerity, virtue, and so on. Their paintings reflected a highly romanticized, simplistic worldview, motivated in part by a rejection of the changes in society that were being wrought by the industrial revolution. And much of the photographic world followed their lead.

The straightforward images and photographic records of earlier days lost favor as the "salons" lauded and rewarded photographs that mimicked Pre-Raphaelite values. Pristine forests, children radiating purity and innocence, hovering mothers, and demure young women became the subjects of photography, all softly focused with any disturbing elements in the scene brushed away by whatever chemical or physical means the photographer favored.

Figure 10.4: August Sander, *Der Geiger Schonenberg (The Violinist Schonenberg), 1922.* Sander printed this portrait using the gum dichromate process.

Figure 10.5: David Scopick, from the Mexican series, 1994.

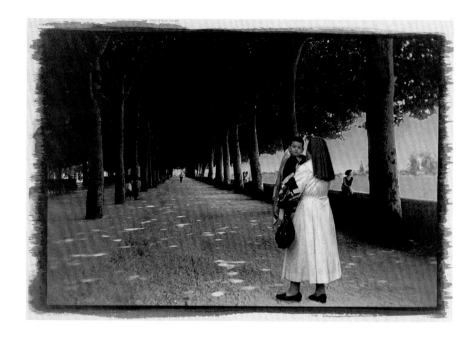

Gum printing is unquestionably the most versatile of all photographic processes. A gum print can be made in any color, including black-and-white, and if inorganic pigments are used, it will have archival permanence. When color-separation negatives are used in conjunction with cyan, magenta, and yellow pigments, a full-color print results. Its tremendous versatility made gum printing an ideal medium for pictorialist photographers because it allowed photographers to exchange the literal constraints of the traditional photographic print for the freedom of the canvas that a painter enjoys. Regrettably, the inevitable rejection of pictorialism that came in the twentieth century also led to the demise of its closest ally, the gum print. However, the gum dichromate print has enjoyed a renaissance in the last few decades as printmakers have rediscovered its potential as a vehicle for photographic expression.

Overview of the Process

Gum printing is a simple and straightforward procedure, though making a fine gum print can require hours or days of effort; it is a process that requires patience and dedication and is not adaptable to mass production. Each print should be considered a unique work of art. Care, consistency, and a degree of mechanical skill that evolves over time are all needed to achieve predictable results.

When a mixture of gum arabic and a dichromate salt is exposed to light, the gum arabic is converted to an insoluble polymer; the degree of insolubility is proportional to the intensity and duration of exposure. The process of mixing the gum arabic/dichromate solution with a pigment (for example, lampblack or a quality watercolor pigment), coating a sheet of paper with the resulting emulsion, and exposing it through a negative to light ensnares the colored substrate in the polymer matrix and attaches it to the paper surface.

After exposure (this is a contact printing process that requires a UV light source or sunlight), the latent image is "developed" by soaking the print, face-

down, in still water *(automatic development)*. During the soaking step, pigment is leached from the print surface wherever the gum arabic has not been hardened by the action of chemicals and light. The surface of the print can be brushed gently to remove pigment selectively from areas of the print *(brush development)* or washed more aggressively by directing a stream of running water over portions of the print surface. Processing is completed by soaking the print in a clearing agent and then washing and drying it further.

The pigment that remains attached to the paper surface is a positive image of the negative with tones corresponding to the color of the pigment used. The density of the pigment layer is directly proportional to the degree of exposure.

Negative Requirements

Negatives that are satisfactory for ordinary silver printing are suitable for gum printing. It is difficult (but sometimes possible) to achieve the densities

Figure 10.6: Brian Taylor, *Indian Ruins, Chaco Canyon, New Mexico, 1985.* This striking image combines cyanotype, gum printing, collage, and hand coloring.

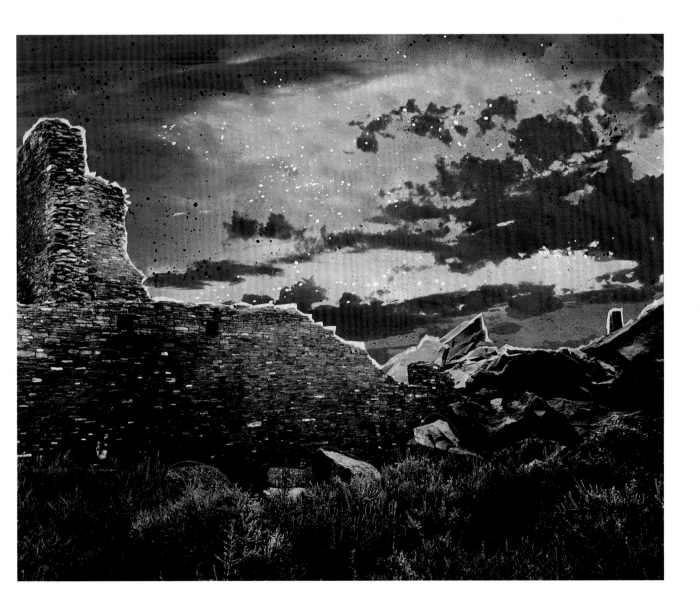

needed for a print with a full range of tonal values in one printing cycle. To build up satisfactory midtone and shadow detail, two or three successive coating/exposure/wash cycles are usually required. Image contrast can be controlled by both exposure and development.

Paper

Gum prints can be made on a spectrum of surfaces, including plastic sheets, glass, and ordinary paper. Though it is costly, you should use only the best papers, even when preliminary tests are being carried out. Results that obtain with one type of paper seldom hold true for another brand.

Papers used for gum printing must have high wet strength and be able to withstand prolonged soaking in water. Artist's intaglio paper, which is used to print etchings, has all the desirable properties needed for gum printing and is the preferred medium for making fine prints.

Either coarse- or smooth-surfaced papers can be used, depending upon the effect you wish to achieve. Smooth-surfaced papers produce sharper prints with greater contrast.

Heavier papers (for example, 140-pound and higher) survive repeated soaking and handling better than lightweight papers do. Heavy papers that have been well sized are especially desirable when multiple printing is practiced. Both Arches Aquarelle and Rives BFK have been used for decades and are elegant and effective supports for gum prints.

Sizing

The importance of using a well-sized paper for gum printing cannot be overemphasized. Virtually all commercial papers intended for use with gum printing require additional sizing. In evaluating a size, consider both the ease of application and its influence on the surface characteristics of the paper. Many of the techniques for rapid sizing mask the surface of the paper and destroy its innate beauty. Quick sizes that can be sprayed or painted on the surface of the paper are most useful when learning the technique of gum printing, and time is best spent on experimenting with other aspects of the gum printing process. When you have progressed beyond the initial stages of gum printing you will find it best to work with gelatin-sized papers. Gelatin preserves the inherent features of a paper while lending it qualities that are ideally suited for gum printing.

The best sizing for gum printing is gelatin hardened with formaldehyde (see page 144). However, because of environmental and safety issues, *formaldehyde should not be used unless (a) you are skilled in handling chemicals that require special care, and (b) you work in a laboratory equipped with an efficient fume hood.* The sized paper should be quite stiff after it dries, and you may need to flatten it in a press before use. An alternative sizing mixture can be made by diluting one part of gesso (a mixture of plaster and glue) with four to six parts of water. The gesso coating can be applied with a brush or by soaking the paper in a solution. The dilution of the gesso should be adjusted so that the deposited coating is not too heavy; otherwise, it will flake off when the

print is being developed. A single, evenly applied coating of gesso is adequate.

Other sizings have been compounded from synthetic glues of various kinds. Hercon 40 is available in art supply stores and can be applied either with a brush or by soaking the paper in a tray of the diluted compound. Soaking a sheet of paper in Elmer's Glue-All, diluted one part to four parts water, serves as an effective size.

Brushes

Two brushes are needed for gum printing, one (the "spreader") to paint the emulsion on the paper, and the other (the "blender") to smooth and absorb the excess coating. While for some printing processes the use of brushes with metal ferrules must be avoided, these brushes do not interfere with the chemistry involved in gum printing and work well. The gum solution used as the emulsion has a slightly oily consistency and can be spread with the same brushes used for cyanotyping or other processes. The blender brush should be larger than the spreader and have moderately stiff brush hairs. A 2-inch brush works well as a blender. The tips of the blender pick up the excess gum arabic and pigment and should be washed thoroughly after each use in warm water containing a little ammonia. If the gum is allowed to set and harden, the usefulness of the brush will be compromised. Use a hair-dryer to dry the bristles of the brush after washing.

Sensitizer and Pigment Stock Solutions

The emulsion used for gum printing is a blend of gum arabic, a watercolor pigment, and a sensitizer solution of ammonium dichromate or potassium dichromate.

Gum Arabic The matrix that binds the pigment to the paper in gum printing is an insoluble polymer of gum arabic. Solutions of gum arabic in a suitable strength for gum printing (12° to 14° Baumé — a measure of the specific gravity of solutions) can be obtained from stores that sell printing and graphic arts supplies. Purchasing the premixed solution is highly preferable to preparing the solution yourself.

If you are unable to locate a supply of gum arabic solution, you can purchase gum arabic chips or powder from an art supply store. To prepare a solution suitable for gum printing, add a liter of cold water and 15 ml. of 37-percent formaldehyde to 300 grams of powdered gum arabic. *Note:* The water must be cold; hot water unfavorably alters the properties of the gum arabic.

Allow the mixture to stand in a cool, dark place, and stir it occasionally. Several days may be required to dissolve most of the gum. When it has dissolved, a residue of impurities contained in the gum will be suspended in solution. Remove these by pouring the solution through a filter made of a wad of cotton or cheesecloth, and store the filtered solution in a cool, dark place.

As an alternative to formaldehyde as a preservative, 2.5 grams of mercuric chloride can be used. *Caution! Both formaldehyde and mercuric chloride are toxic and must be handled with care.*

From the
Mexican Series,
1994

Early photography was generally taught as a craft, not an art form. Today, education in photography differs, as shown by the programs of universities and colleges throughout the world. If historians were asked what great contributions photography has made, many would say, "The snapshot!" — ordinary pictures, of ordinary people, in ordinary places. If we wanted to know the most popular processes in the history of photography, several would be certain to answer, "The gum dichromate process!" And for good reason.

Early photography was primarily directed toward portrait and documentary usage. The discovery of gum dichromate printing gave the photographer an ability to challenge preconceived notions and to intensify its development as a fine art. Far from being captives of the past glories of the medium, modern gum dichromate printers relish and elect the freedom the process offers in contrast to the limitations imposed by commercially available photographic materials.

The most celebrated practitioners of gum printing were Robert Demachy and Alfred Maskell. As gum printers — and photographic amateurs — they redirected the popular conventions of photography into a new genre and elevated the art of photography to one of great refinement. (It is noteworthy that they called the method the "photo-aquatint process" — undeniably a more poetic name.)

Stuart Koop, Director of the Center for Contemporary Photography in Melbourne, Australia, has remarked,

> *Gum bichromate prints are palpable; they appear as objects. And this is the striking difference to me between conventional prints and gum bichromate prints. In the former the image is embedded in the paper; it appears completely flat, seamless and ethereal, as if it has nothing to do with human endeavor but actually is the mechanical product of automatic procedures. However, gum bichromate printing leaves behind a physical residue that comprises the image; a kind of bas relief. The gum bichromate photograph is avowedly a material object, an object that can be caressed and gouged, smothered and scratched; it becomes the substrate for physical and motivated actions, for a particular kind of expression . . .*

On a personal level, I seldom title photographs and most commonly give them a literal description or location. The photograph "two girls on a teeter-totter near Patzcuaro" was one of fifteen images I printed in the spring of 1994 (twenty years after I first began gum dichromate printing). My mood was one of great defiance, challenged by my involvement in an upcoming symposium on gum printing. Could I achieve greater accolades for this revered medium? To do

so, I would use the complete dictionary of historical and contemporary processes, determined to push the medium to new limits.

All the color images that I chose to explore were made from black-and-white negatives. I prefer this as a starting record since it's abstract and dictates no pre-conceived color formula. I use a variety of cameras but prefer the 35mm format. This photograph was taken with a 35mm stereo camera, which produces (almost) a half-frame image. I use Tri-X film, expose on the threshold (without underexposing), and process to a minimum time in D-76. This produces negatives with excellent resolution and fine grain and permits a skilled printer to make quality enlargements at high degrees of magnification.

My plan was to create gum prints printed from color-separation negatives that conveyed my perceptions of color in Mexico. I had to colorize each image before creating the separation films, and I considered a variety of techniques:

- backlit optical coloring
- simpler processes, such as hand coloring a print and photographing it to get a color transparency that could be color separated with an enlarger
- photo-mechanical methods using a traditional process camera
- digital processes

For anyone with access to a good digital system, several software programs provide an easy approach for photographers wishing to color or otherwise modify images (see chapter 12). With digital methods, the most economical input comes from a scan made at a service bureau on Photo CD, but my experience shows this kind of scan does not compare in quality with a custom scan made at a specialized service bureau.

Once a photograph has been converted into a digital format, a variety of routes to new or modified film records are available. For beginners, a 35mm color transparency, from which color separations can be made by using an enlarger (see page 115), is the most economical output. Another option is to ask a digital service bureau to produce color separations directly from the digital file. Once a method is selected and the color separation films are made, the gum dichromate printing process can be started.

The details of dichromate printing have a strong impact on the nature of the image produced. For example, the choice of printing paper, a particular watercolor, or even the brand of gum arabic can dramatically change results. Experimenting with a number of products is essential, and careful records must be kept.

I like the printed results of a three-color gum dichromate separation. For each print, I prefer to make only one exposure with each separation negative (a total of three exposures per print), but for this image I required a modified and stronger cyan printer, because no black separation is used. (On rare occasions I give the cyan printer a second exposure to create extra contrast or density.) A fourth (black) separation negative can be used to build up print density values, but it changes the inherent quality of the image. Gray balance is important when printing color separation negatives, and for that reason I use still-water development with no brushwork or hand manipulation.

Watercolor is pleasant to work with, and with printing films that represent good color separations, excellent brilliance is possible. For a final touch, to increase the intensity of the image, I apply artists' wax to the image area of the finished print. This also gives the print a little more luster, deepens the tones, and improves the appearance.

Gum dichromate printing offers a number of advantages over making traditional silver prints:

- Gum prints are not made in a "darkroom." With the exception of producing film negatives for printing, gum printing can safely be carried out in a room lit with incandescent bulbs of low wattage. Once the prints have entered the developing water, they are no longer light sensitive and can be manipulated under normal room illumination.

- Gum prints have a tactile surface and a three-dimensional quality. The printed emulsion builds greater deposits of pigment in the shadow densities. You can readily observe this by viewing a print from an angle — the image appears as if the pigment is layered in the darker sections, rather than the result of a smooth overall application.

- Working with watercolors and color fundamentals is truly satisfying. All the flexibilities inherent in traditional watercolor painting are possible in gum printing. This includes the ability to define specific pigments as primary and secondary colors, color mixing, brush-stroke innovation, and so forth.

- The cost per gum print for the necessary chemistry is low, and the chemistry is stable, which reduces waste.

- The viewer's response to a gum print is excellent. The prints have a unique quality and are immediately recognized as different from other color print media. This distinct identity, coupled with the history of the process, has created an enormous mystique about the procedure.

- Photographers enjoy paper and will particularly enjoy the exploration of good paper when making gum prints. The quality of a fine-art paper provides a special experience for the viewer, especially when the print edges are visible.

- Commercial printers, especially fine-art and -book printers, are more knowledgeable about color separation and the behavior of color pigments on paper than most photographers are. You can draw on their expertise — from paper selection to pigment stain — if help is needed with the gum process. I have found that most printing houses are intrigued with gum printing, and are pleased to offer comments and suggestions on problem solving.

— DAVID SCOPICK

Sensitizer The sensitizer is prepared as a 13-percent solution of potassium dichromate (13 grams of crystals dissolved in 75 ml. of distilled water, then diluted to make 100 ml.) or a 27-percent solution of ammonium dichromate (27 grams of ammonium dichromate dissolved in 75 ml. of distilled water, then diluted to make 100 ml. of solution).

Pigments Pigment suspensions are prepared by mixing a watercolor with the gum arabic solution. Watercolor pigments are available either as powders or as pastes that have been premixed with a carrier solution. Premixed pigments are sold as a paste by the tube, and these are far easier to work with than powders. Tubed pigments are highly recommended when you begin to work in gum printing.

Powders must be finely ground with a mortar and pestle and converted to a paste before they can be used for gum printing. To convert the powder to a paste, a carrier solution consisting of 40 grams of white sugar, 150 ml. of gum arabic solution, 30 ml. of glycerol, and 10 drops of Kodak Photo-Flo should be prepared. Add sufficient drops of carrier solution to the powdered pigment to wet the powder, then proceed to knead the mass with a spatula or glass stirring rod until the entire mass turns into a uniform paste.

An additional factor that should be considered when purchasing watercolors, whether powdered or premixed, is the long-term stability of the pigments after they have been incorporated into the photograph. Most organic dyes fade on prolonged exposure to light, while inorganic pigments tend to be very stable. Color permanence is usually rated by the manufacturer; the rating will indicate if a particular pigment is stable or fugitive on prolonged exposure to light.

A basic array of pigments that are light stable and ideally suited for gum printing follows:

Lampblack. This dispersion of powdered carbon is available in subtle shades of black. It is difficult to mix from the powdered form, since carbon shows extreme resistance to wetting.

Umbers and Siennas. These are various forms of iron oxide and come in shades that include yellow-brown, brick red, and dark brown.

Alizarin Crimson. This organic pigment is close to magenta in color. It is used as a pigment for tricolor printing.

Monastral Blue. This deep blue pigment is also known as Thalo Blue. It is used for tricolor printing (see page 240).

Cadmium Yellow. Available in several shades in the range of pale yellow to orange, this pigment is used for tricolor printing.

Other colors that have been used extensively for gum printing are sepia, Indian Red, Thalo Green, and Hansa Yellow.

Figure 10.7: John P. Schaefer, *Agave, 1993.* Green was chosen as the color for a gum print of this pinhole photograph. A single coating and exposure was sufficient to produce the contrast and color saturation desired. (See figure 8.13 for a salt print of this image.)

A reasonable way to approach gum printing is to select a single color — a sienna or umber pigment, for example — that has visual appeal and is in harmony with the aesthetic of your photography. Work with that pigment exclusively until you learn what the best ratio of pigment to gum arabic is, what approximate exposure times are needed, how the print responds to development, and which routine manipulations are possible. Then continue your explorations with other colors that are consistent with the prints you create.

Pigment Concentration

> *As the longest scale of gradation is secured when the coating mixture contains the largest possible amount of pigment and as a long scale is usually desired, it follows that the coating mixture should hold as much of the pigment as can satisfactorily be used. But for every paper, every pigment, and every gum solution there is a maximum relation of pigment to gum which can be used without staining the paper — or rather, to be precise, there are two such maxima, one for automatic development, the other for brush development.* — PAUL L. ANDERSON

Each pigment has an optimal concentration for use in gum printing. If the concentration is too low, the print will lack contrast and overall density. Conversely, too high a concentration may cause the pigment to flake off during development of the image or stain the paper in the image highlights. If the coating is too dense, light will not penetrate the emulsion through to the paper surface, and the image will fail to attach itself to the paper fibers. While it may

be necessary to print a negative two or more times on the same sheet of paper to achieve the desired print density and contrast, it is worth experimenting with formulations and different brands of pigments so that you can come as close as possible to the envisioned print in a single exposure.

In an effort to achieve a finished print in one printing cycle, French photographers, notably Demachy and Puyo, preferred pigments that were highly opaque and intensely colored. The pigment solutions they prepared contained higher-than-normal concentrations of watercolor powders, which are considerably more difficult to coat and blend on a sheet of paper. Both workers were able to achieve extraordinary prints using this technique. The German, or Vienna, school of gum printers preferred to work with much weaker gum solutions that required two or more coatings to produce a print with a full tonal scale. Multiple coatings and exposures of weakly pigmented gum solutions produce prints with a very delicate separation of tonal values; this cannot be achieved with a single application of a concentrated pigment solution. Either method can lead to fine prints, and the strategy you choose is a matter of personal preference best determined by your personal experimentation of the medium's characteristics.

The pigment concentrations listed in table 10.1 have been worked out by Crawford and are an excellent starting point when you begin to print. However, the optimal gum arabic/pigment ratio is highly dependent upon the printing paper being used and the degree of sizing of the paper, so the values best suited for your printing tasks may differ significantly from these. A few trial prints will indicate whether the concentration of pigment should be increased or decreased from the suggested values.

Table 10.1

Pigment Concentrations for Gum Printing

Pigment	Paste	Powder
Lampblack	1 gram	0.2 gram
Alizarin Crimson	1.4 grams	0.5 gram
Monastral Blue	1 gram	0.3 gram
Cadmium Yellow (Pale)	1.6 grams	1.2 grams
Hansa Yellow	1.6 grams	0.3 gram
Burnt Sienna	1.6 grams	0.8 gram
Burnt Umber	1.6 grams	0.8 gram

Note: The quantities tabulated should be dissolved in 20 ml. of gum arabic solution. When powders are being used, they should first be made into a paste, then diluted with 20 ml. of gum arabic solution.

It is possible to work with higher percentages of pigment by using a more concentrated stock solution of gum arabic. (The easiest way to do this is to add chips or powder of gum arabic to the stock solution.) Gum/pigment solutions prepared in this way are useful at higher pigment concentrations and produce prints with greater overall density and a longer tonal scale. Printers who depend upon a single coating to make a print use this technique. As the strength of the gum arabic solution is increased, however, it becomes more difficult to spread and blend on the paper's surface, which is a limitation.

Gum solutions that are too weak are equally undesirable. The resulting prints are pale and disappointing. Furthermore, the emulsion may be so thin that, rather than remaining on the paper's surface, it soaks into the body as it is applied and stains both the paper and sizing. The outcome of all tests designed to determine the optimal pigment concentration (see below) is highly dependent on the degree to which the paper has been sized. A poorly sized paper will encourage a degree of staining that cannot be overcome by altering the composition of the gum/pigment solution.

Determining Pigment Concentrations In determining pigment concentrations, two parameters need to be considered: (1) the pigment concentration that survives an undisturbed 30-minute soaking in a tray of water, and (2) the pigment concentration that persists after brushing the stained area of a wet print. Pigment concentrations greater than the value of (2) will stain highlights and lend an overall color cast to the print that may be unacceptable.

The tests to determine these parameters are extremely simple to do and eliminate much of the guesswork involved in formulating emulsions. Use the following procedure.

1. Make up a small batch of gum/pigment solution in the strongest concentration you are likely to use. A good starting point would be 1 gram of tube pigment in 3 ml. of gum solution (or 1 gram of pigment powder in 6 ml. of gum solution). *Note: Do not* add any dichromate solution to the gum/pigment mixture. The dilution of the gum/pigment solution caused by the water in the sensitizer does not seem to alter the results of these tests appreciably.

2. To determine the maximum level of pigment concentration that leaches out of the paper in 30 minutes, measure twenty drops of pigment solution into a small cup or glass. Dip a small (#0 or #00) watercolor brush into the pigment solution and brush a dot of it onto the surface of a test strip of paper. Use a pencil and write "1" next to the dot. Next, add two drops of gum arabic stock solution to the pigment solution in the cup, stir the mixture thoroughly, and apply a dot of the diluted solution to the same test strip about 1 inch away from the first; label it "2." Add two more drops of gum arabic stock solution to the cup and repeat the procedure. By the time you have added twenty drops of gum arabic solution to the original gum/pigment solution, you will have a series of dots that shows a gradation from the starting concentration to half that value.

3. "Develop" the strip by floating it facedown in a tray of water. Lift the strip from the water at 5-minute intervals, allow it to drain for a moment, then return it to the tray. The object is to find the pigment concentration that dissolves in 30 minutes. At the end of a half hour, note which of the dilutions remain on the paper. If all of them are still visible, dilute the original gum/pigment stock solution and repeat the experiment. The pigment concentration that dissolves completely is the one that you should use for automatic development (see page 250).

4. For the dots of pigment that remain on the paper, brush the *wet* test strip lightly with a fine watercolor brush to see if the residual stain of pigment can be removed. The last dot that can be removed in this way represents the

maximum pigment concentration that can be used with brush development (see page 251). If the staining cannot be removed, the gum/pigment stock should be further diluted.

These procedures take very little time and effort, and a number of pigments can be tested at the same time on one sheet of paper. Because the coating, exposure, and development of a gum print require at least a half hour, a few preliminary tests are ultimately preferable to wasting a lot of time and paper making prints that have to be thrown away because of unwanted staining.

Sensitizing Paper for Gum Printing

Gum dichromate papers are moderately susceptible to exposure by ambient ultraviolet rays, and all coating and handling should be done under incandescent lighting.

The standard sensitized coating for gum printing is an equal mixture of one of the dichromate solutions (see page 237) and a gum arabic/pigment formulation, but you may choose to vary this ratio as you gain experience. Keep in mind the following:

1. Increasing the ratio of pigment to sensitizer enhances the tonal range of the image, but the highlights may show signs of staining.

2. A high ratio of pigment to sensitizer results in a viscous solution that may be difficult to spread evenly on the paper. While this ratio increases image contrast, flakes of the image may tend to chip off the surface of the paper during development.

3. Lowering the ratio of pigment to sensitizer reduces the density of print values and favors the development of highlight details at the expense of the shadow areas.

4. An excess of sensitizer increases the printing speed of the emulsion at the price of print contrast.

5. If the emulsion is too watery, it may penetrate too deeply into the paper and leave stains that cannot be removed during development.

The proper ratio of gum/pigment to sensitizer is a variable determined by the pigment being used. Excellent color saturation can be obtained with a low ratio of lampblack to dichromate, for example, while much higher ratios are required for pigments such as the sepias, umbers, or Van Dyck brown. A few trial runs at various ratios will reveal the ratio that produces the best overall image density and contrast for a given pigment. Experiments of this nature should be carefully recorded and described in a notebook so that the database of experience you acquire can be used to simplify future printings.

Making a Gum Dichromate Print

One reason that so many beginners in gum work get into trouble is that they expect the first printing from a negative to look like a print and try to make it so. It should not; it should look like a very sick imitation of a print — pale, washed out, very likely no more than a flat tone in the shadows, and in general thoroughly unsatisfactory. It is astonishing to an inexperienced worker to see how the print assumes vigor and character with the addition of subsequent printings. — PAUL L. ANDERSON

In contrast to other photographic printing processes, a single gum print usually needs to be worked on again and again, over a period of hours or days. Gum printing places a premium on craft and requires patience and a willingness to forgo instant gratification for a more distant goal. Two or more printings per image is the rule, not the exception. Because of the time involved in making a finished print, it is feasible (and desirable) to work on several prints simultaneously once the basic manipulative techniques are learned.

The procedure for making a gum print involves the following steps:
1. Sensitizing the pigment solution
2. Coating the paper
3. Exposing the print
4. Developing the print
5. Drying the print
6. Developing the print further (if necessary)
7. Clearing the print

Sensitizing the Pigment Solution

Stir the gum arabic solution with a glass or plastic rod until the pigment is uniformly dispersed. Avoid vigorous shaking of the bottle of pigment just before use, because finely dispersed bubbles of air in the gum arabic can influence the properties of the emulsion. For a first printing, measure ample and equal volumes of the dichromate sensitizer and pigment solution into a small medicine cup or glass. Mix the two by using a small glass or plastic stirring rod or by swirling the container. The yellow-orange color of the dichromate solution temporarily alters the color of the pigment solution, but this will wash out during development. Because the mixed solution begins to harden soon after it is formulated, it should be used as soon as possible. Any unused solution should be discarded.

Coating the Paper

Paper can be coated when it is dry or wet. Paper coated in the dry state may show signs of brush marks that are either subtle or distinct, depending on your preference and technique. With wet paper a perfectly smooth and uniform coating is easy to achieve. Soak the paper in water just prior to coating, blot off the excess moisture with a paper towel, and then apply the emulsion as described below.

Trim a sheet of the paper that is to be used for printing so that there will be at least a 2-inch margin around the print area. Use a few strips of drafting tape to affix the paper to a sheet of plate glass. Dip a damp brush into the mixed solution to thoroughly charge the bristles, wipe off the excess solution on the edge of the container, and begin coating by sweeping the brush back and forth across the surface of the paper, first right and left, then up and down. Do not flood the paper with sensitizer but use enough to create a visibly wet surface. Make the coating as even as possible and minimize streaks by going over any obvious faults with the wet brush.

When the coating looks reasonably uniform, put the brush aside and pick up the dry blending brush. Hold it so that the bristles are perpendicular to the paper and use a series of light strokes along the length and width of the coating so that the tips of the bristles just skim across the surface of the emulsion. The brush strokes quickly blend the coating into a uniform whole, and no more than a few minor differences in density should be visible. The coating begins to dry rapidly as the blending brush does its work. Stop brushing as soon as the coating appears smooth and loses its wet surface sheen. Excessive brushing may degrade the surface of the paper and disturb the sizing, thereby marring the print. The entire coating procedure for an 8 x 10-inch print should take less than 1 minute.

Proper blending is critical to the outcome in gum printing. A good gum print with a long tonal scale and appropriate print contrast depends upon achieving a thin coating of emulsion, rich in pigment. Thick coatings retard the penetration of light through to the paper surface, causing the highlights and lighter tones of the print to wash away during development.

If the emulsion sets too rapidly as it is being brushed on, either add more gum arabic solution to the stock solution of pigment or increase the percentage of sensitizer in the coating formulation.

The sensitized paper can be air-dried in the dark with the aid of a fan. A better alternative is to dry it quickly using a blow-dryer set on moderate. Gum dichromate coatings become insoluble over time, even in the absence of light, and the rate of degradation is increased by heat and humidity. It is best to expose and process paper immediately, but if this cannot be done, seal the paper in a plastic bag and store it in a refrigerator. Under these conditions it will keep for a few days.

Store any brush that you use in a jar of water as soon as you are finished with it. Then wash it thoroughly with soap and water containing a small amount of ammonia. If the emulsion is allowed to remain on the brush very long after use it may harden and dry, ruining the brush. You can dry brushes quickly after washing with a blow-dryer.

Exposing the Print

Gum printing is a contact printing process, and as such, it requires a strong actinic light source. The materials are considerably faster than those used for other alternative processes and require much less exposure. Furthermore, papers sensitized with ammonium dichromate are more active than those made with

the potassium salt. A visible latent image develops out as the print is exposed, and, as experience is gained, this can be used as a measure of exposure.

Not all pigments and coatings print at the same speed. It is best to use a test strip to determine an approximate exposure time and then use that as a guide for printing the entire negative. Considerable control of print density is possible by monitoring the development process, and this enables you to achieve a considerable degree of fine-tuning for the print.

Developing the Print

Once a gum print has been exposed, it should be developed immediately because the dichromate coating will continue to harden, even without additional exposure to light. The simplest and classic way to develop a gum print is by *automatic development*. Fill a tray with tap water and slide the print face-up under the surface of the water. When it is thoroughly wet pull the print from the water and return it to the tray, facedown, so that it floats on the surface. Make certain that no bubbles are trapped between the print surface and the water. Allow the print to rest without agitation in the water bath. In a few moments pigment will begin to leach out of the paper and cloud the water. After approximately 5 minutes, lift the print by a corner out of the water, let the excess water drain off the print surface, and transfer the print to a tray of fresh water.

Excess pigment and dichromate will continue to leach away from the gum print, but with the passage of time, the development rate will slow dramatically. Change the water bath at 5- to 10-minute intervals and lift the print out of the water occasionally to check its progress. Development should be continued as long as the water draining off the print's surface is colored by pigment. Usually a correctly exposed print will be fully developed in 30 minutes.

A more efficient way to develop a gum print is to fit a tray with a Kodak Tank and Tray Siphon and adjust the flow rate of water to a steady dribble. Under these conditions the normal siphon action of fill/drain will not be operative, and the water level in the tray will remain constant as the tray drains slowly and continuously. When a print is placed facedown in the tray, the barely perceptible stream of water carries away the pigment without disturbing the print surface. You can check the development progress by lifting the print out of the water at 5-minute intervals.

Development Controls It will quickly become apparent during development if a print is either seriously overexposed or underexposed. Historically, one of the advantages of gum printing was the opportunity it afforded for intervention at various stages of the printing process to correct under- or overexposure. In addition to the obvious changes that can be effected in any photographic process by altering the negative, dramatic transformations in the character of a gum print can be accomplished during development.

Overexposure or coating a print with too high a concentration of pigment results in slow development. In the case of an underexposed print, the pigment washes off very rapidly, leaving behind an image in which the high-

lights and lighter tonal values are faint, while the regions of greater density are weak and lack contrast and definition.

To increase the rate of development for an overexposed print, either raise the temperature of the wash water or add a few drops or milliliters of ammonia to the tray of water and continue development by tilting the tray. Both of these actions soften the polymerized gum and increase the rate at which pigment diffuses from the print surface. When the overexposed print has been reduced to the correct overall density, rinse it briefly in plain water and let it dry (see below).

To decrease the rate of development in the case of an underexposed print, wash the print until the pigment diffusing into the wash water is minimal. Then dry the print and recoat and reexpose the paper. Develop the image as before. It should be noted that underexposure of a gum print is *not* a failing; the most traditional way of making gum prints involves the successive building up of pigment layers on the paper surface. It is the exception rather than the rule when a single exposure and development cycle produces a satisfactory gum dichromate print.

Two basic techniques used to modify a developing gum print involve selective removal of pigment either through brushwork or by washing. Keep in mind, however, that careless forced development by either of these methods can result not only in the complete removal of pigment from the image but also the destruction of the paper surface and coating of sizing. Caution and experimentation are in order when using these techniques.

Brush Development. To lighten a selected area using brush development, place the print in a tray and add just enough water to cover the surface with a thin layer. Use a sable or other soft-bristled brush and barely touch the surface of the emulsion as if you were spotting the print. Pigment is released from the print surface wherever the brush makes contact. With a fine brush (#00), highlights can be cleared and emphasized, and very precise modifications of the image can be accomplished. Avoid the temptation to stroke the surface of the print with the brush unless you envision an image that features brush marks as part of the composition. Wide brushes can be used to clear broad areas of the print quickly. This technique is useful if you wish to create a collage of images of differing colors.

Water Development. An alternative to using a brush is to direct a *stream of water* directly onto the surface of the print. Use either a length of tubing fitted with an eyedropper to serve as a nozzle or a plastic squeeze bottle filled with water. By controlling the flow rate and intensity of the water striking the print surface, you can generate distinctive patterns as the image structure is altered. Another alternative is to add very *fine sawdust to the wash water* and gently slosh this suspension back and forth across the print surface; this removes pigment rapidly and uniformly. (The use of sawdust to develop a print is a key step in making Fresson prints, a custom color-printing process based on gum dichromate chemistry. The Fresson process produces color prints with many of the same characteristics as a fine watercolor painting.)

Drying the Print

To dry a gum print, first drain off the surface water by holding it by one or two of the corners and allow the water to drip into the sink. If the water being drained contains a large amount of pigment, additional washing is usually in order.

Lay the drained print *with the emulsion side up* on a sheet of blotting paper and allow the print to dry. Drying toughens the emulsion and prevents the pigment from diffusing or bleeding into adjacent areas. The print should be allowed to dry under conditions that enable the paper to return to its natural state. A gentle stream of warm air can be used to hasten drying, but excessive heat will damage the emulsion and distort the dimensions of the paper.

Developing the Print Further (if necessary)

If the highlights have the correct density values, but the midtones and darker areas need further development, you can dry the highlights of the print selectively with a blow-dryer. Then return the print to the water bath. The portions of the print that have been dried will undergo little further development, while those that remained wet will continue to develop normally.

Clearing the Print

After the finished print is thoroughly dry and has the characteristics you envisioned, soak it thoroughly in water and then transfer it to a tray containing a 2- to 5-percent solution of sodium bisulfite for 1 to 2 minutes. The bisulfite solution reduces any dichromate remaining in the paper, which would cause a yellow stain and degrade the paper over time. Rinse the print in a stream of running water for 10 to 15 minutes and dry the print.

Prints can be spotted in the traditional way by using the appropriate watercolor pigment. Gum prints should not be dry-mounted. Affix the print to a mounting board with corner sleeves and then overlay a sheet of mat board with an appropriate window cut out to prevent abrasion of the print surface.

Full-Color Gum Printing

Full-color gum prints or color abstractions can be made by applying successive coatings of various colors and reexposing the same sheet several times with the same or different negatives. To make a color print that is a reasonably faithful representation of a color transparency or of the original subject, a set of separation negatives must be generated.* These negatives can then be printed in sequence with precise registration of the images and the appropriate dyes to generate a color print.

Making multiple printings on a single sheet of paper carries with it special registration problems. If a fresh sheet of paper is wet, then dried, its size in-

* For an introduction to or general review of the theory of color photography, see John P. Schaefer, *Basic Techniques of Photography, Book 1* (Boston: Little, Brown, 1992), chapters 10 and 11. See page 278 of this book for details on how to prepare, register, and use separation negatives.

Figure 10.9: Diana Parrish Cull, *Man in Backyard Pool, Flamingo Set, c. 1988.* Hand-colored gum dichromate print. A 35mm negative was enlarged to produce two negatives with different densities. Eight colors were used to print the negatives using eighteen to twenty successive exposure/development cycles. Hand coloring was used on the flamingoes. Each gum print is unique.

creases significantly; furthermore, the sheet expands in one direction more than the other. Fortunately, once a sheet of paper has been thoroughly soaked and saturated with water, it tends to dry to the same size and shape thereafter. To minimize the problem caused by expansion and shrinkage, any sheet of paper that will be subjected to multiple printings must be soaked thoroughly in hot water for 30 minutes, then dried, *prior to receiving its first coating*. If you size the paper yourself, the sizing process will accomplish what soaking does. It is important to dry the sheet of paper in exactly the same way during multiple printings. For example, if the sheet is air-dried by hanging it from a clothespin, always hang the sheet from the same corner.

It is impossible to reproduce precisely a range of colors by any photographic process. Thus, an aesthetic judgment of gum prints should not rest on a literal comparison to the subject but on the merits of the print as an original, free-standing work of art. If fidelity to the color of the source of an image is the motivating force in printmaking, other photographic color processes are better suited to the purpose.

The basic method for making a full-color image with the gum dichromate process involves a coating-exposure-development sequence for each color. The order in which colors are applied and exposed can be important: the preferred order is yellow, magenta, cyan, and black. If yellow is used last, the image may have a mottled appearance after development.

Summing Up

The gum dichromate process can be used to make permanent black-and-white or color prints. Contrast and colors can be controlled at will, and prints can be made on a broad spectrum of surfaces that vary from metal to paper or glass. It offers the most opportunities of all photographic printing methods for the creative interpretation of negatives and leads to prints that have excellent light fastness and are otherwise permanent. A gum print can be made by relatively straightforward techniques or represent a tour de force of skills and procedures that lead to highly complex imagery. Extensive manipulation is possible at all

Figure 10.10: Bernard Plossu, *Big Sur, 1970.* Fresson prints are handmade from color transparencies at the family factory in France. They have the visual presence of an exquisite watercolor.

Figure 10.11: Wallace Edwin Dancy, *Retreat from Care, 1938.* Gum dichromate print.

stages of printmaking. The low cost of making a print is offset by the time commitment needed.

To create an image with a broad tonal range, multiple coating, exposure, and development is necessary. Papers must be well sized to withstand prolonged soaking and to ensure a return to the original dimensions in order to avoid faulty registration of the image. While full-color images are relatively easy to create, realistic image color is virtually impossible to achieve. Furthermore, fine details tend to be obscured in the printing process.

Within these limitations, gum printing offers an invitation to free expression and creativity that cannot be matched by any other photographic process.

We should know what we desire in our print before we expose the negative. Then we expose and develop the negative to achieve the required sequence of opacities that is the foundation of the visualized print. . . . But we must remember that the print need not be a literal transcription of the negative any more than the negative is a literal transcription of the values in the subject photographed. And the print, of course, cannot be a literal transcription of the subject.

Chapter Eleven

Approaches to Color Photography

The photographic rendition of color may be approached three ways: literal or accurate simulation, aesthetic simulation, and abstract, or nonrealistic, interpretations. For literal simulation it is necessary to match carefully the color temperature of the light source(s) to the film's color balance and to use filters as required to correct for color temperature variations, length of exposure, and other factors affecting color.

Aesthetic simulation replaces the objective judgment of color rendering with subjective evaluation. We can visualize a great variety of interpretations in which the impression of light, substance, and color may not be based on the "realistic." Colors have varying emotional effect, alone and in relation to other colors, depending partly on their depth (saturation). . . .

In interpreting color in an abstract manner we can literally "paint" with a color, creating departures-from-reality in great variety. We can use strong filters, direct light of varying colors on the subject, and use optical "distortions," double-exposure and processing alterations to lead us away from the obvious. No matter how far we go in such efforts, we are bound by the characteristics of the medium, and we should make every effort to understand them thoroughly. — ANSEL ADAMS

The quest for color in photography dates back to the earliest days of the art form. A close look at many early daguerreotype portraits reveals that the images usually show the stern-faced sitter flush with rosy cheeks, perhaps with an arm resting on a colorful tablecloth or holding a gilt-edged family Bible. Because the technical problems relating to the photochemical generation of color were decades away from being solved, colors were applied to the delicate surface with the age-old skills that had been used to hand color lithographs and printed works of art on paper. As albumen prints and stereo view cards made their way into the marketplace, these, too, were often hand colored by assistants trained and skilled in the art of retouching. The tints of added color were an attempt to move the photograph, an optically faithful black-and-white abstraction, a step closer to reality.

Figure 11.1: Gail Skoff, *Flaming Sarcophagus,* from the Images of Bali series, 1977.

Significant technical advances over the past few decades have improved both the materials and processes that are the basis of modern color photography. From being a chore that could be handled only in a sophisticated professional laboratory or by a very skilled and dedicated amateur, making a color print has become a relatively routine procedure that is often simpler than making a black-and-white photograph. Reasonably priced enlargers equipped with color heads, and affordable machines for processing simplify printing and provide the controls necessary to ensure repeatable results.* Printing papers and the chemistry needed for processing offer a variety of pleasing color palettes and result in photographs that have acceptable light stability. The major decisions that a photographer needs to make are which color palette is most pleasing and which processing chemistry and system are most convenient to use.

However, the ability to interpret a color negative or transparency with the same degree of freedom enjoyed by printers of black-and-white photographs requires skills and procedures that are far more complex. For example, the traditional approach to enhancing a particular color such as red in a scene without changing the color balance of yellows, greens, and blues calls for the preparation and use of black-and-white masks (see page 276) that are registered with the color negative or transparency during exposure. The analogous problem in black-and-white printing, namely, altering specific tonal values, is usually solved easily by appropriate dodging or burning-in during exposure. The creative possibilities for printing color negatives and transparencies are substantially enhanced if the range of controls used with traditional color assembly techniques are applied to modern materials and processes.

The
Hand-Colored
Print

With the development of direct methods for making full-color photographs, hand coloring became little more than a footnote in the history of photography. The revival of interest in alternative printing processes and the continuing exploration of photography's potential has led to a renewal of interest in the creative possibilities of hand coloring. Depending upon the objective, the effect of hand coloring can be either realistic or abstract.

Superb work by artists in the past decade using hand coloring has elevated it to a fine art form, with a distinctive, powerful aesthetic that cannot be achieved by either a traditional black-and-white print or a color photograph. Hand coloring offers a palette that is unavailable on color printing papers and enables a photographer to pursue interpretations that vary from subtle, barely perceptible color, to selective coloring, natural color, or a bold, fantasy world.

The starting point for a fine hand-colored print is a fine black-and-white print with a range of tonal values that are appropriate to the image. A poorly conceived and poorly executed black-and-white photograph will not be improved in the slightest by the addition of color. Photographic details should be visible through the applied color. If a print lacks visible structure in the shadow areas and highlights because of excessive contrast, the colored image will only magnify the deficiencies of the photograph. Color applied to black

* See John P. Schaefer, *Basic Techniques of Photography, Book 1* (Boston: Little, Brown, 1992), chapter 10.

Figure 11.2: Karen Truax, Untitled, from the Painted Women series, c. 1977. Hand-colored gelatin silver print.

areas is barely visible, while featureless highlights are transformed into colored featureless highlights, generally not an aesthetic improvement. Similarly, a flat print leads to a low-contrast colored image. The tonal scale of the black-and-white photograph, not the applied colors, determines image contrast. Prints can be toned prior to coloring to define the basic background color of the photograph. For example, sepia toning changes the reference background from neutral black to a warm brown, a shift that may be desirable when working with a portrait or with certain landscapes.

Hand coloring a print may require several hours, so set aside a block of time to work on a project to completion in one sitting if possible. If prints sit overnight, the oils begin to set and are difficult to rework. Completed prints

Figure 11.3: *Coloring supplies.* Marshall photo oils, oil paints, colored pencils, marking pens, and brushes are available from art supply stores and are suitable for hand coloring photographs.

Figure 11.4: *Preparation for hand coloring.* Carefully tape the photograph to a sheet of cardboard or Masonite. Prepare the surface of the photograph by wiping it with Marlene or a high grade of turpentine. Work in a well-lit, dust-free area.

often require several days to dry before you can handle them without smudging or damaging the surface.

Paper

While any photographic paper can be used for hand coloring, surface characteristics of the papers vary widely and influence the results. Most resin-coated papers do not absorb colors as readily as fiber-based papers do, and consequently, the applied colors are less intense. Three resin-coated papers that do work well for coloring are Luminos RCR, Ilford Multigrade III RC Rapid, and Kodak P-Max Art RC. If the advantages of working with RC papers are otherwise compelling, these are excellent choices, though their archival properties are still questionable.

Fiber-based papers have been used for more than a century and are available in glossy, matte, or textured surfaces. The gelatin surface of fiber-based papers is highly absorbent, and it readily accepts photo oils and dyes. In certain cases the receptivity of the emulsion can be improved by wiping it thoroughly with a conditioning compound, such as Marshall's Prepared Medium Solution, or Marlene. These compounds should be thoroughly rubbed into the surface with a cotton wad, and, after application, any excess solution should be removed with dry cotton. While the use of a conditioning compound is optional if you're using oils or dyes, it is essential if coloring is to be done with photo pencils; the compound softens the pencils' pigment as it is applied and allows it to be absorbed into the emulsion rather than remaining as a powdery residue on the surface of the print.

Supplies

Hand coloring requires a basic set of supplies that can be obtained from Light Impressions (see page 376), the dealer for Marshall's photo-coloring products. It can provide sets of oils ranging from an introductory kit containing five basic oil-color tubes to a Master Oil Set, which includes forty-six colors, extender, drier, Marlene color-removing solution, Prepared Medium Solution,

Duolac varnish, a mixing palette, cotton, and detailed instructions for their use. While the Master Oil Set is expensive, the spectrum of colors available minimizes the need to create intermediate colors by blending those that come with the basic kit. Photo pencil sets are also available at a modest price and include fourteen basic colors and ancillary supplies.

Hand coloring of images is not restricted, however, to the use of photo oils. Many workers use watercolor paints or food dyes and apply them with brushes. Another alternative is to use felt-tipped pens. Each of these alternatives requires a different level of skills and leads to distinctive and innovative outcomes. The instructions given below refer to photo oils, but the procedures are applicable to many other materials and can be modified accordingly.

In addition to the basic supplies, you will need a well-lit desk and comfortable chair, a hard surface (such as a sheet of Masonite) to which the print can be taped, drafting tape, and a handy wastebasket to dispose of oil-soaked cotton swabs. Wear clothing that you don't mind staining, because contact with wet oil paint can leave a permanent mark.

Making a Hand-Colored Print

Getting Started

Any print that is to be hand colored should be made with a generous border (1 inch or more). Choose an 8 x 10-inch print of a simple subject to practice on, and develop the techniques and feel for the materials that are necessary to handle more complex images with lots of fine detail.

Wipe the surface of the mounting board clean (smooth Masonite or plate glass is ideal) and use strips of drafting tape to attach the print flat to the smooth side of the surface. Take time to line up the edge of the drafting tape with the print's border; this saves a considerable amount of effort when you have finished coloring the image because you will not need to clean unwanted colors off the white border of the print. Make certain that the mounting surface is free of scratches and grit — these inevitably show up on the surface of the print as unwanted lines or bumps that ruin the image.

Study the image and envision the effect that you want to achieve. Decide if the image calls for the subtle addition of tints or the bold application of color. The addition of color is very similar to the procedure for making a watercolor painting. The first step is to apply broad washes of background to establish the basic color patterns for the print. The second step focuses on image details, removing overlapping colors from the first wash, flushing out shadows and highlights, and building up tonalities and saturation until the feel of the image approaches that of the visualized print. The third step is to make the subtle adjustments in the details of the photograph and bring it into perfect harmony with the visualized image. The last step involves finishing and mounting the print.

Making a Wash

The purpose of the wash is to spread a uniform layer of color over the area you are covering.

Tubes of Marshall's photo oils are sealed with a thin metallic diaphragm that needs to be punctured. To avoid squirting oil paint, be careful not to squeeze the tube as you puncture it. Grasp the tube gently near the neck and punch a small hole into the center of the threaded opening using the pointed pricking device provided.

Take a cotton swab (Q-tips work very well) and squeeze a very small drop of photo oil onto the tip. Using the swab as if it were an eraser, gently rub the surface of the print to apply the color. For very large areas, such as an expanse of sky, it is more convenient to use a ball of cotton to apply the oil, but it is obviously more difficult to stay within confined areas with a larger applicator.

During the wash step, *do not* try to avoid straying over color boundaries. In fact, you should intentionally rub a thin layer of the oil over into the adjacent color zone. If you try to work just to the edge of a boundary line, a bead of oil will form that will be darker than the rest of the area, and when the adjacent area is swabbed, the colors will run together wherever there are excess oils, creating new, unwanted colors and undesirable outcomes.

Once the basic wash has been applied, take a fresh cotton ball or swab and rub it over the area that has been colored to smooth out and wipe up all the excess photo oil. Strive for a light, uniform application of color, stopping short of the color intensity you envision for the final print. You can build up color saturation later by selectively adding additional photo oil.

Apply the second color wash to a new area in the same way. As you come to an area where colors have overlapped, the second color will actually remove and completely replace the first color. Again, it is important to have a slight amount of overlap to avoid building up excess oil at a color boundary. After the second area has been covered, use a fresh cotton swab to remove all of the excess oil. Keep repeating the process until the entire print has been covered with all of the basic colors you plan to use. Resist the temptation at this stage to deal with details (for example, coloring the eyes or lips in a portrait). Instead, strive to give the face the desired overall flesh tones; blue eyes and red lips can be added during subsequent phases. (*Note:* There are a few instances where overlapping colors need a little extra encouragement to lift off. If a very strong color, such as Extra-Strong Cadmium Yellow or Viridian Green, is applied first, it may mix with the second color, producing an obviously unwanted blend. If that happens, take a new swab, charge it with a little of the correct color, and go back over the flawed area. This usually lifts off the unwanted mixed color and replaces it with the correct one. As always, any excess oil must be rubbed off with a clean swab. Small flaws at overlaps can easily be dealt with during the detailing stage.)

When the wash step is complete, hold the print so that light glances across the surface. Light will reflect from areas where photo oils have been applied, and the intensity of the light should be uniform. If parts of the print are brighter than others, especially in color boundary areas, excess oils are probably present and should be removed. Rub these surfaces with a fresh cotton ball or swab, taking care to wipe down both sides of any borders. When the print has a uniform sheen, the wash step is complete. At this stage, all of the basic colors of the image should be present, but their intensity will look quite muted, and the print will look flat. This deficiency will be corrected in the next step.

Figure 11.5: Patricia White, *Abstraction: Overlapping Sheer Fabric, 1979–1982.* Hand-colored gelatin silver print.

As with any new technique, practice leads to a feel for the materials and processes and enables you to make uniform, effective washes. The primary skill to develop is the ability to work at the borders between colors so that overlap is minimal but sufficient to ensure the correct boundary transitions.

Detailing the Print

The second stage of hand coloring corresponds to the "dodging and burning-in" phases of printing and builds upon the basic characteristics of the image that are defined by the washes. The objectives are to make sure that colors blend seamlessly and to add strength and intensity to key areas of the photograph, moving it closer to the envisioned image.

The first step is to remove overlapping colors. Do this by charging a new cotton swab with a small amount of photo oil of the desired color, and rework the color border by wiping on the color and lifting off the offending overlap. If the basic colors are particularly intense, several lifts may be needed. Work to blend the new photo oil into the existing wash so that the lift is uniform and does not give rise to a new blemish.

Detailing requires finesse, patience, and considerable care. Use only small amounts of photo oil on the tip of the swab to avoid applying a heavy layer of color that stands in jarring contrast to the earlier wash. The objective is to

eliminate all signs of overlap while blending the new application of color into the background of the earlier wash. Apply the color with one end of a cotton swab, and use the other end to wipe off excess color. Clean cotton has a high capacity for absorbing photo oils, so take care to rub the new application gently enough to avoid leaving a spot that is lighter than the original wash. The process is similar to spotting a print, in which the dyes are stippled and blended into an area by many light touches of the brush. With a little practice you will develop a feel for how much photo oil to use and for how it is best applied and rubbed into the surface. Work on cleaning up all of the border areas before continuing to the next step.

When all of the border areas have been cleaned up, it is time to work on adding depth and dimension to individual elements in the photograph. Start with the shadow areas by taking a swab charged with a small amount of Neutral Tint photo oil and apply it to the darkest regions of the shadows, working outward toward lighter regions. The Neutral Tint (which looks gray as it comes out of the tube) takes on the tone of the underlying color. For example, if the underlying photo oil is earth colored, adding Neutral Tint does not lift the basic color, but deepens and enriches its tone substantially. In the lighter shadow areas, the gray cast of the Neutral Tint may begin to overwhelm the base color. If this happens, mix in a small amount of base color with the Neutral Tint and rework the area until the color and tonal values are satisfactory.

When the shadows have been built up to a satisfactory tonality, address the highlights of the image. The major task is to clean up any tints that compromise the features of the photograph that introduce the elements of brilliance to the print. There should be an absence of hues in the extreme highlights, and any color can be removed by swabbing over it with Neutral Tint, diluted with extender oil (used to dilute a color) if necessary. To avoid an abrupt tonal change, work outward from the center of a highlight feature into the surrounding areas.

The last phase of detailing is to enhance or reduce color saturation selectively in the print. For example, the sky may have a uniform blue tonality after the initial wash, but a more realistic rendering would show a gradual transition from light to dark blue as you move from the horizon line to the top margin of the print. To accomplish this effect, take the same cotton ball that was used to apply and rub down the basic wash and begin to rub it over the areas where you want to intensify the color. If you need to use a fresh bit of cotton, charge the surface with a dab of fresh photo oil and rub it over a smooth surface to distribute the oil over the entire surface of the cotton before you apply it to the print; otherwise, the clean cotton will actually absorb and lift color from the print instead of applying color to it. To minimize the possibility of streaking, use the largest applicator you can comfortably work with when applying colors.

At the end of the detailing stage, the print will still have an unfinished look (color saturation is not what it should be, the image looks a bit flat, and so forth), but the borders should be clean and free of obvious imperfections, and the shadows and highlights should be close to the expected values. The print is now ready for fine-tuning.

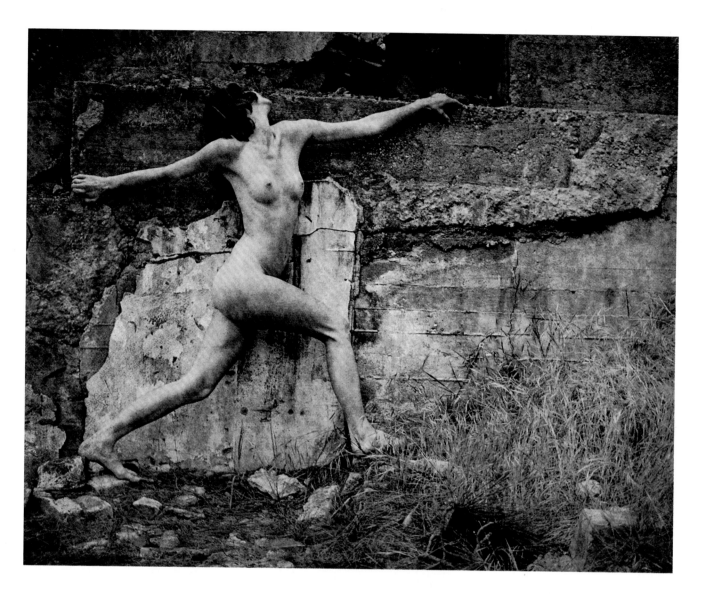

Figure 11.6: Joan Myers, *Los Angeles Frieze, 1977*. **Hand-colored gelatin silver print.**

(*Note:* Some photographers prefer to use photo pencils at the detail stage of coloring an image. This is largely a matter of personal preference. Photo pencils do not "lift" colors as effectively as photo oils, and a little more skill is needed to achieve the desired effect.)

Fine-Tuning the Print

In any photograph the distinction between an image that is a nice record of what the camera saw and a fine print lies in the details. In hand coloring, fine-tuning involves revisiting key areas of the print and giving them the visual impact that raises the image from a paint-by-number exercise to a compelling, powerful photographic statement, a well-conceived and well-executed fine print.

After you complete the detailing, key areas of the print need adjustment. For example, the eyes in a portrait may be tinted by a bit of the surrounding flesh tones, or small details may be too subdued to merit the visual attention needed. Make a tiny swab by twisting a small amount of a cotton ball onto a

Figure 11.7: Luis Ortiz Lara, *Nervadura, 1984.* Hand-colored and painted gelatin silver print.

toothpick and use this to add or remove colors selectively. A Magic Rub vinyl eraser is a useful device for brightening highlights and removing inadvertent smears of photo oil. Sharpened photo pencils are convenient for putting finishing touches on fine details that are too difficult to attack with a cotton-tipped toothpick.

Make color adjustments as your evaluation of the emerging image dictates. When a yellow tone is too passive, think about adding a stronger tint, such as Cadmium Yellow, to increase its brilliance and color saturation. If the bark of a tree is too uniform, mix in different shades of brown and earth tones to add visual variety, depth, and shape. Experiment and liberate your creative instincts — if you are not pleased with a result, it is easy to undo. Lastly, be

prepared to "let go" of an image when it has a feeling of completeness. Avoid getting trapped by the compulsion to work on every leaf on the tree and learn to recognize the point of diminishing returns.

Finishing and Mounting the Print

A hand-colored print requires a few days to a few weeks of drying time, depending upon the temperature, air movement, and thickness of the layer of oil. Place the drying print in a dust-free area and hang it vertically, if possible. This minimizes the possibility of dust's settling on the wet surface, which will become part of the print as the oil dries. Use a blast of compressed air to blow away any obvious specks of foreign matter.

To remove the wet print from its easel or mounting surface, start at one corner and carefully peel back a small section of the tape used to form the border and hold the print in place. Hold the exposed edge of the print down with your fingers and strip off the row of tape, taking care to avoid tears. Repeat this on all four sides of the print. Use fresh strips of drafting tape on the corners of the print to tack it to a sheet of cardboard to prevent it from curling while it dries.

There will usually be a line that runs around the edge of the print where oils have accumulated against the drafting tape. If you intend to overmat the print (generally a preferable strategy), the line can be ignored; otherwise, it needs to be carefully removed. Take a clean swab and rub it along the line, taking care not to move your swab into the picture. When all of the excess oil has been mopped up, use a vinyl eraser for the final cleanup. This requires slow and patient effort, because an inadvertent slip of the hand can necessitate a lot of repair work. Be sure to blow away all erasure residue with a blast of compressed air before setting the print aside to dry.

Once dry, the print's surface is tough and durable. For protection of the image surface the print should be overmatted and taped to a mounting board. Do not try to dry-mount a hand-colored print.

Image Transfer Printing

Legend has it that sometime in the mid-1960s one of Polaroid's research photographers inadvertently left a Polacolor negative face down on a countertop, later picked it up, and found an image had transferred to the counter. He and several of his colleagues began to play with the process until Polaroid founder Dr. Edwin Land found out about it and sternly discouraged this deviant activity. And so Pandora's box was closed . . . for the time being. — POLAROID MANUAL

Polacolor and similar films are part of a growing family of photographic materials that produce "instant" prints, available moments after exposure and processing. These films are generally used as a primary photographic medium by exposing the film directly in the camera and processing it immediately thereafter. However, Polacolor film can also be used as a color printing process by projecting a transparency housed in an enlarger directly onto the film's unexposed surface in total darkness. Processing the Polacolor film in its normal

processor leads to a print of the transparency. This technique has the advantage of allowing you to crop, dodge, burn-in, and alter the color balance of the image while maintaining a permanent reference and record of the scene in the form of the original transparency.

The color palettes of instant films are vibrant and distinctive, and they meet all of the criteria of a fine print, with the possible exception of permanence. Tests suggest that the display life of Polacolor 2 prints is four to six years, depending upon ambient lighting conditions; dark stability (that is, storing the print in an album or drawer), is far greater.* If a color transparency is used as the source of the image, and the Polacolor image is exposed using an enlarger, any of the standard dodging and burning-in techniques can be used during projection printing. The cost of materials for making an 8 x 10-inch Polacolor print compares favorably with Ilfochrome printing, and the simplicity of the process makes it especially advantageous and economical when only a few prints are needed.

The following steps are involved in producing an instant print: (1) removing a dark slide to ready the negative for exposure; (2) exposing the film; (3) moving a sheet of paper or another support surface into contact with the negative; (4) spreading the developer chemistry over the surface of the negative; (5) developing the image; and (6) diffusing the image onto the supporting surface of paper. By interrupting the process at step 6 and changing the support to which the image is being transferred, you can achieve interesting creative interpretations of the original image that completely alter the aesthetic of the color print. For example, when a watercolor paper is substituted for the normal receiving surface for the image, colors are muted and details are softened. Images take on many of the characteristics of a finely made full-color gum print. You can further alter the photograph with watercolors or colored pencils if you choose. A superb summary and portfolio of Polaroid image transfers is available from the Polaroid Corporation by calling 800-225-1618.

Polacolor Films

Any of the peel-apart Polaroid Polacolor films can be used to make image transfers. Films can be exposed through a camera or by projection printing of a color transparency through an enlarger directly onto the film's surface. Projection printing enables you to crop the image if necessary, dodge and burn-in, use filters to make color corrections, and produce multiple copies from a single transparency.

The chemistry needed to process Polacolor films is integrated with each sheet of film that is exposed, and processing is started by pulling or otherwise moving a sheet of film through a special holder. This action breaks a pod containing the processing chemistry, spreads the chemicals over the film, and begins film development. As developing proceeds, the image diffuses from the negative onto a paper or plastic support that has been rolled into contact with the film surface. In the transfer process, you must quickly peel apart the

* Henry Wilhelm, *The Permanence and Care of Color Photographs* (Grinnell, Iowa: Preservation Publishing Co., 1993).

Figure 11.8: Kelly Madden-Burgoyne,
Untitled, 1993. Polaroid transfer print.

negative-positive sandwich in the midst of the normal development transfer process and replace the photographic base supplied by Polaroid with one of your own choosing.

The chemicals that are used to process Polaroid Polacolor films are incorporated into a caustic paste, and contact with the skin should be avoided. Wash off any chemicals that you contact immediately with cold, running water. If you develop a pronounced sensitivity to the Polacolor chemistry, wear protective gloves during the processing steps.

Equipment

In addition to the film holders and processors that are normally used to process and develop Polaroid films, you will need a roller, a hard surface to work on (such as a sheet of plate glass), and a supply of fine paper or fabric to serve as a receptor for the transfer image. A bottle of water fitted with a nozzle that emits a misting spray is useful for making "wet" transfers.

Paper and Other Supports

The first decision is the support to be used for the print. Fine papers (for example, those used to make platinum prints) work best and can add considerable elegance to the image, but they need to be tested because their suitability varies. The intricate structural patterns of rice papers create an entirely different visual effect from that achieved on wove papers, as do fabrics such as silk. Vellum used by draftsmen is translucent, and while it can be difficult to get an image to adhere to the smooth surface, the semitransparent nature of the image contributes to its uniqueness.

Transfers can be made onto either wet or dry paper. With damp paper the image has the diffuse feel of a watercolor, while dry transfers favor sharper prints. To make a wet transfer, soak the paper (or fabric) in warm water (90°F–100°F) until it is wet thoroughly. Then drain the sheet, place it on a hard surface such as a sheet of plate glass, and use a roller or squeegee to remove the excess water. Be careful not to abrade the surface of the paper. Rice paper and other thin papers may fall apart when they are soaked in water. These are best laid out on a sheet of glass and moistened by using a bottle of water with a misting spray nozzle attachment. (A spray bottle of window cleaner rinsed thoroughly and refilled with pure water works well.)

Figure 11.9: *Polaroid transfer printing.*
Any of the available Polaroid film holders can be used to make transfer prints. Print rollers can be obtained from an art supply store.

Figure 11.10: *Polaroid 8 x 10 processor.*
An automated processor is made by Polaroid to process their 8 x 10 instant films.

Making a Polaroid Transfer Print

The film holders that are used to house Polaroid sheet films or film packs can be propped in place directly on the base of an enlarger, and the image can be composed and focused on a sheet of paper cut to the size of the opening shielded by the holder's dark slide. If a print is to be made by direct exposure of the subject, follow the directions supplied with your particular film and holder.

If you intend to make a wet transfer, prepare the paper as described above. For a dry transfer, place a sheet of the paper that is to receive the image on a sheet of plate glass.

Expose the print in the camera or through the enlarger as you normally would and begin processing by pulling the print through the Polaroid holder.

Approximately 10 to 15 seconds after processing has started, peel apart the paper-and-negative packet and immediately place the negative facedown on the wet or dry transfer sheet. If the negative is peeled apart too early, dye migration will be quickly arrested and the negative will retain almost all of the cyan dye, half of the magenta, and very little yellow. The result will be a positive that is strongly biased toward cyan. To correct this, 10 to 20cc of red filtration should be given at the time of the exposure to correct the color balance. If you wait too long to peel apart the negative and Polaroid film base, the concentration of dyes available for transfer will be reduced, and a lighter image will result.

Figure 11.11: *Polaroid sheet film.* After processing the Polaroid film, begin development and, after 10 to 15 seconds, peel apart the paper-and-negative packet.

Figure 11.12: *Transferring the Polaroid image.* Immediately after the negative has been separated from the packet lay it facedown on the transfer paper and with firm pressure push the roller over the negative to bond it to the surface of the paper.

Figure 11.13: *Separating the Polaroid negative and paper.* After the transfer is complete (1$\frac{1}{2}$ to 2 minutes), gently peel the negative away from the surface of the paper.

A

B

Figure 11.14: *Polaroid print and transfer image.* (A) A 4 x 5 Polaroid print. (B) A Polaroid transfer image of the same subject. Note that the colors in B are muted compared to those in the Polaroid print. Small defects are easily corrected by spotting with color pencils.

Using a roller or gentle pressure from your hand, rub the entire back surface of the negative to ensure that intimate contact is made between the negative and transfer surface. Then allow the print to sit undisturbed. A brayer (a hand roller used by printers for applying ink and available at art supply stores) or squeegee works well for applying even pressure on the negative as it is brought into contact with the receiving surface. However, darker areas often require more pressure than lighter colors, and local pressure can be applied by using the back of the bowl of a plastic spoon.

After waiting 1½ to 2 minutes, gently peel the negative away from the surface of the paper. The image will have been transferred directly from the negative to the paper. As you peel apart the negative and positive, the darker areas may tend to lift up as a gummy mass. If this occurs, stop the peeling process and reroll the negative onto the surface or use the back of the bowl of a spoon to apply a little additional local pressure to the back of the negative in critical dark areas. If gummy deposits around the edge of the photograph start to pull the image itself away from the transfer surface, use the point of a sharp knife to separate the image from the negative edge.

The colors on the wet surface of the print are easy to manipulate, and the dyes can be brushed and altered as if the image were a wet painting. Polaroid transfer images should be air-dried to minimize the possibility of cracking of the surface layer of pigments. Any retouching of the photograph can be done when it is either wet or dry.

Two variables that strongly influence results are the temperature at which the transfer is taking place and the transfer time allowed. Working on a thick sheet of plate glass that has been soaked in warm water is an effective way to control the temperature of the paper and negative during the transfer stage. The glass will remain warm for several minutes even in a cold room if it is placed on a newspaper, blotted dry, and used as the transfer surface support.

If too much dark sludge is being transferred to the image, try reducing the transfer time substantially. After the print dries, color saturation can be increased by the hand application of dyes or the use of photo pencils.

Figure 11.15: Kelly Madden-Burgoyne, Untitled, 1993. Polaroid transfer print and montage.

Color Assembly Printing Processes

While color photography demands precise exposure and processing, the basic approach does not differ greatly from other forms of photography. Our visualizations must take into account various factors of light and film color balance, exposure-scale limitations, and so on, and we must refine our reactions to color hue and saturation. Much color photography of an inferior creative and aesthetic value has been done, and much emphasis has been given to superficial functions, delaying its recognition as an art form. However, in recent years color images have dominated in many fields. Knowing the potentials as well as the limitations of the process, we have no reason not to learn to see the world and visualize the image in terms of color with impact equal to or greater than in black-and-white.

All color photography is based on the theory that any color in the visible spectrum can be generated by assembling an appropriate combination of either the three primary colors or complementary colors. In practice this is not quite true, because it has not been possible to find or synthesize dyes that are "pure" red, green, blue, cyan, magenta, or yellow. The spectrum of a cyan dye invariably trails off into magenta, while magenta dyes always spread into the cyan and red portion of the color palette. One consequence of using imperfect dyes is that it is difficult to make a color print that has both vibrant greens and vibrant reds — a gain in the saturation and purity of one color usually results in the sacrifice of another on the opposite side of the color wheel. To a degree it is possible to compensate for some of the deficiencies of dyes by incorporating chemical or physical *masks* into the negatives to alter the effective ratio of dyes in selected regions of a photograph, thereby producing truer color renderings. The superb quality of prints available from color negatives is a tribute to the advances made in photochemistry in recent decades. It is worth noting, however, that *no two prints from color processes that use either different negative materials or different printing papers will look alike.*

Intensive recent and ongoing research and development efforts by all of the major photographic companies have made printing color negatives and transparencies a relatively simple matter. Color transparencies can be printed by using either color reversal chemistry or the Ilfochrome (formerly called Cibachrome) process.* The persistent problems of excessive color print contrast that have plagued printing from color slides have largely been mitigated by the introduction of lower-contrast papers.

Printing color negatives has become as straightforward as black-and-white printing, with the exception that all color print materials must be handled in total darkness. Kodak's RA-4 chemistry delivers reliable and consistent results in processing color-negative papers, which are now available in a variety of different surfaces (matte, semimatte — also called pearl or luster — and glossy) and a limited selection of contrast ranges. Compatible products made

* For descriptions of the procedures, see John P. Schaefer, *Basic Techniques of Photography, Book 1* (Boston: Little, Brown, 1992), chapters 10 and 11.

Figure 11.16: Gail Skoff, *Lizard Mound, 1980.* Hand-colored gelatin silver print.

by independent manufacturers such as Beseler also provide reliable and consistent results, often using simpler processing conditions. The availability of inexpensive tabletop color processors has further simplified color printing for the amateur and professional and lowered the technical barriers that were traditionally associated with color printing.

Despite the ease of making color prints, lingering concerns remain in the minds of many photographers about the characteristics of the prints that are produced and their potential for the expressive and creative work that has been the hallmark of fine black-and-white photography for more than 150 years. All of the commercially available printing materials feature either resin-coated papers or ones with a polyester base, which have a different aesthetic presence than fiber-based prints. Furthermore, the range of controls (dodging and burning-in, contrast controls, developer variations, and so forth) that are readily used to alter the character of a black-and-white print made from a given negative are limited and extremely difficult to apply to color materials.

Separation Negatives

The only way to achieve complete freedom in making color prints — altering contrast, color balance, color density, individual hues, tonal values, and so on — is to return to the basic black-and-white records that form the basis for all color images. This requires the preparation of separation negatives.

Color Transparency Separation Negatives

The usual starting point for making separation negatives is a color transparency. The advantage of using a transparency is that a constant reference to the starting point for comparison is available at any time. Separation negatives can be made by projecting the color transparency image onto a panchromatic black-and-white film through one of three sharp-cutting tricolor filters — usually #29 (red), #61 (green), and #47B (blue) — following the same procedure used in making a black-and-white print. Films are developed in the usual way, and the film development time can be used to control the contrast of each separation negative. The parameters that must be determined by experiment in the darkroom are: (1) accurate filter factors for each of the tricolor filters; (2) exposure times for each separation negative (related to [1]); and (3) development times for each separation negative (they will differ). However, for accurate color reproduction, elaborate masking techniques are needed that require skills and equipment usually found only in professional laboratories.

The easiest and most accurate way to make separation negatives from either color transparencies or negatives (see below) is to create a digital file of the image and use a computer to print out the separations on film (see chapter 13). This can be done either on a personal computer if you have the required hardware and software or by a modern print shop, which can scan the image and produce the separations for you at a nominal cost.

Direct Separation Negatives

If your subject is static (for example, a still-life, statue, building), the best separation negatives can be made by using the camera to generate them as a primary record of the image. The most straightforward way to proceed is to photograph the subject on three separate sheets of film, using #29, #61, and #47B filters — red, green, and blue, respectively. The red filter subtracts its complementary color, cyan, as the negative is exposed, recording the remainder of the visible spectrum on film, and the resulting negative is used as the cyan printer. Likewise, the green filter subtracts magenta, and its negative becomes the magenta printer, while the blue filter subtracts yellow and generates the yellow printer.

Care must be taken that neither the camera nor subject move in the slightest during or between exposures. The advantage of this approach is that the resulting separation negatives can be used directly for printing without the need for elaborate masking techniques. A color slide of the scene can be used as a reference standard when the separation negatives are being used to make a color print.

To produce color prints that are faithful to the original subject, the separation negatives must have the same contrast and be correctly exposed. If separation negatives vary in contrast, the color image will suffer from color "crossover." For example, if the contrast of the negatives used to print cyan and magenta differ, highlight values will show a magenta tint while shadow areas will be biased toward cyan, or vice versa, depending on the relative slopes of the curves. Small overall exposure errors for separation negatives are relatively easy to compensate for by altering the exposure required when the negative is used to make a print.

The key to making a set of matched separation negatives is to determine (1) filter factors that should be applied *for the light source being used* (the factors will vary substantially from those suggested by the manufacturer, which are for use in sunlight), and (2) the correct development time for each negative. This is easily done by determining the characteristic curves for a film using the three basic filters and the procedures detailed in chapter 4.

The factors given by manufacturers are for daylight (5,200°K) and can be used with confidence. In artificial lighting, however, filter factors differ dramatically. For example, under tungsten light the factor for a red filter decreases by a step or more, while that for the blue filter will increase by several steps. In deep shade, which is rich in blue skylight, just the opposite occurs. To compensate for changes in the color temperature of the ambient lighting, the exposure must be altered.

While red and green filters have a similar effect on panchromatic film, *a blue filter reduces overall image contrast.* To compensate for lower contrast, the film exposed with a blue filter should be developed for approximately 50 percent *longer* than the others.

Filter Factors for Making Direct Separation Negatives: Sheet Film
To determine filter factors for sheet films, tape a calibrated density strip across the surface of the film, determine the camera settings needed to achieve a Zone X exposure, and expose the film. Clip off the lower right-hand corner of the film to identify it as the sheet for which no filter was used.

Cover the camera lens with the red filter and make an exposure on a fresh sheet of film, increasing the previous exposure by the recommended filter factor (#29 = +4$^1/_3$ stops).

Repeat the procedure with the green filter (#61 = +3 stops) and clip the upper right-hand corner of the film.

Repeat the procedure with the blue filter (#47B = +2$^2/_3$ stops) and clip both the upper left-hand and upper right-hand corners of the film.

Develop all four sheets of film simultaneously for the recommended time, but continue the development of the blue filter negative (the clipped corners enable you to identify the film in the dark) for an additional 50 percent of the base development time.

Complete the film processing, measure the densities of the image of the calibrated density strip on all four films, and plot the data on a graph. The curves for the three negatives in which a filter was used should be closely grouped around that of the unfiltered negative.

If they differ significantly, estimate what changes in filter factors (that is, the exposure relative to the negative made without a filter attached to the lens) are needed for the curves to be superimposable, and use those values in future tests and to make color separations.

Once you have determined the correct filter factors and development times, simply set up your camera and tripod and photograph the subject using the three filters, correcting each exposure by the determined filter factor. Usually the easiest procedure is to use a gray card to estimate the exposure for the subject, and then increase the setting by applying the appropriate filter factor. *Use the same lens aperture for all three exposures to keep the focus and depth of field constant; adjust the exposures by varying the shutter speed.*

Always expose the films in the same order (red, green, blue) and label the film holders after each exposure so you know which filter was used with a particular sheet of film.

Filter Factors for Making Direct Separation Negatives: Roll Film
The method for determining filter factors using a roll film camera is based upon the same principles described for sheet film, and it uses the procedures detailed in chapter 4 for determining the characteristic curves of roll film. While the shape and slope of the characteristic curves of film exposed through a red or green filter are virtually identical, those features differ slightly when a blue filter is used. When a camera with interchangeable film backs is used, it is feasible to make exposures through the blue filter on a separate roll of film, followed by separate development of that roll so that its characteristic curve will match that of the red and green separations.

However, most photographers are not concerned with achieving an exact color match for the print and the original subject and opt to ignore the slight color crossover that occurs when the blue filter is used and the film receives the same processing as the red and green exposures. Fortunately, color crossover with the yellow printer (from the blue filtered negative) is generally the least bothersome visually and is difficult to detect for average subjects, except by a very practiced eye.

As a first attempt at making direct color separations, the easiest strategy to follow with roll film is to make all of the exposures on the same roll of film in the order of red, green, and blue, using the correct filter factors. Develop the film and use the negatives without further correction. If you subsequently decide to increase the contrast of the blue separation negative, you can do so by increasing the development time for that negative when you are making an enlarged duplicate for printing.

Registration Systems

For successful multiple printings of a negative or negatives on a single sheet it is necessary to devise a way to place a negative in a precise location on the sheet in a repeatable fashion. If two superimposed images are out of registration by as little as a few hundredths of an inch, fringes will be visible wherever sharply defined lines are present. The best way to superimpose images is to use a pin registration system.

Figure 11.17: Alice Steinhardt, *The Swimmer, c. 1978.* Hand-colored gelatin silver print.

To support the use of its now-defunct Dye Transfer Process, Kodak developed an elegant punch registration system that used a specially designed punch, registration pins, and a Kodak Register Printing Frame. The cost of a new punch and frame is substantial, but they work very well, offer accurate and repeatable results, and are easy to use. With the demise of the dye transfer process, it may be possible to find used equipment on the market.

All registration systems require that both the negative and printing sheet be punched with holes that are spaced precisely the same distance apart and that serve as rigid points of connection. Stainless steel pins are inserted through the holes in the negative and sheet, thus effectively preventing any horizontal or vertical displacement of the negative and sheet. With the Kodak Contact Printing Frame, the registration pins are attached to one edge of the frame. To make a print, the punched negative is slipped onto the registration pins and then covered with the punched sheet of paper. The back is locked into place, and the frame is ready to be exposed.

Figure 11.19 illustrates a homemade registration punch system that is versatile and easy to assemble. A simple two-hole paper punch bolted onto a wooden frame and a set of registration pins are the basic items needed to construct a registration system.

Negatives to be used for printing in an assembly process should have a 1- to 2-inch margin along one end. Because the normal margin size on film is seldom more than $1/4$ inch, the simplest way to accomplish this is to tape a scrap

strip of film 1 to 2 inches wide along one edge of the film. A length of masking tape affixed to each side of the join will bond the negative and strip securely and keep them from shifting relative positions as they are used in printing.

Use a paper cutter to cut three 2-inch-wide strips of scrap film (with scissors it is too difficult to produce a clean straight edge).

Lay a negative on a clean sheet of plate glass, hold it in place with a scrap of *drafting tape,* place one of the cut strips along an edge of the film, and use a strip of *masking tape* to attach it to the negative without encroaching on the image itself. (Be sure to use the right kind of tape: drafting tape pulls away from a surface easily; masking tape sticks firmly. Both are available at art supply stores.) Do this for all three negatives.

Place the registration punch and frame on a light box. Take the "red" negative and, with the emulsion side facing toward the plate glass, slip the edge to which the film strip has been attached into the slot housing the punches. Move the film against the back of the punch, then back off about $^1/_8$ inch and tape the negative securely in place on the plate glass by attaching a strip of drafting tape to each corner and along an edge if necessary. Make sure that the negative lies absolutely flat on the glass surface and is not buckled.

Punch holes in the strip by pressing down the lever arm of the punch. *The red negative must remain in place undisturbed while you perform the following operations.*

Take the "green" negative record and lay it over the "red," shifting it until the images are *exactly* superimposed. This is best accomplished by a series of successive approximations. Select a prominent feature in a corner of the negative and bring the two negatives into alignment by shifting the "green" negative. Use a small piece of drafting tape to lightly tack that corner of the "green" negative in place.

Shift your attention to the opposite corner of the image and do the same. The image should now be close to superimposed, but some slight adjustments

Figure 11.18: *Kodak Register Printing Frame.* These register printing frames were originally made for use with Kodak's Dye Transfer process. Registration pins corresponding to those on the Kodak Registration Punch are built into the frame, enabling easy registration of paper and negatives for any processes that require contact printing.

Figure 11.19: *Registration punches.* A Kodak Registration Punch and a simple two-hole punch were mounted on a wooden frame housing a sheet of plate glass. The assembly is placed on a light box to register and punch separation negatives prior to printing.

Figure 11.20: *Film leader.* To use the full negative in a contact printing process that requires registration of multiple negatives, it is necessary to tape a blank sheet of film along one edge of the negative so that it can be punched.

are usually needed. Use a magnifying loupe (6x or 8x is sufficient) and focus on a clearly discernible detail in a corner of the negative. Loosen the drafting tape in that corner, shift the "green" negative as needed by tapping the edges until the magnified images are exactly superimposed, and reaffix the drafting tape.

Repeat this procedure at the opposite corner and when both the "red" and the "green" records match everywhere, tape the "green" record securely in place and punch a set of holes through it. The punch cylinders will pass through the same set of holes previously made in the "red" record.

Carefully peel away the tape from the "green" separation negative *without disturbing the "red" negative,* remove the "green" negative, and follow the same procedure to register and punch the "blue" negative.

Peel the drafting tape from both the "red" and "blue" negatives and insert a set of registration pins through the punched holes of all three negatives. When the assembly is viewed on a light box, the images from three negatives should be exactly superimposed. (Some color separation procedures use a fourth printer for black, made from a negative exposed through a yellow filter. Use the same technique to register it with the other negatives.)

After all of the negatives have been punched, slip a sheet of printing paper into the registration punch and punch holes along one of the edges. When the paper and negatives are mounted on registration pins they will always be in register.

Despite all of these efforts, it is virtually impossible to ensure absolute registration of multiple images when paper is being used as the printing surface. For pictures up to 8 x 10 inches in size, following the procedures described above usually produces visually acceptable results. If it is clear that the negative and image are out of register, try to shift the paper so that sharply defined features of the image are in close register while allowing areas of the print that are more diffuse to be slightly out of register.

For very large prints some photographers stretch and tape the paper to a firm support, such as a sheet of plate glass. The negative is then registered visu-

Figure 11.21: *Punching a negative leader.* After a leader has been securely taped to each negative to be punched, slide the leader into the punch and tape it and the negative to the plate-glass surface of the punching frame so that it will not move during subsequent operations. Punch the leader by lowering the handle.

Figure 11.22: *Register punching.* After the first negative has been punched, slide the second negative in place over the first and carefully register it with the underlying image, taping it in place.

Figure 11.23: *Printing assembly.* This simple setup for multiple printings needs only registration pins that can be purchased from a graphic arts store, a two-hole punch (available from an office supply store), and two sheets of plate glass. The assembly is slipped between two sheets of plate glass and is ready for exposure.

ally with the previously printed image and held in place by drafting tape affixed to the corners of the negative prior to a second printing. A heavy sheet of plate glass is used to cover the negative and achieve close contact between the negative and paper during exposure.

There may be occasions where one of the negatives is slightly out of register. This can be caused by slight differences in the geometry or placement of film holders (Kodak recommends that, if possible, the same film holder be used for all three exposures when direct separation negatives are being made) or by an infinitesimal shift in the plane of the transparency if separation negatives are made by projection. Rather than remake the entire set of negatives, first try to match the individual records as closely as possible, working to align sharply defined edges and settling for a slight mismatch in more diffuse areas where misalignment is not as critical. In certain processes (for example, making tricolor gum dichromate prints, or carbro or dye transfers), slight errors in registration of the separation negatives can often be tolerated and are virtually imperceptible in the final print. For printing with any of the current color negative papers and chemistry (C-prints), exact alignment is usually critical.

Making a Print from Separation Negatives

To make a full-color print from separation negatives the printing paper must also be punched prior to use. For alternative processes such as gum printing it is critical that the paper be well sized and presoaked and dried before punching; otherwise, it will not return to its original size after each coating and processing step, and all of your efforts to register the separation negatives will have gone for naught. While specific details for making color prints by each assembly process will vary, the following is typical of the steps that are required in all of them:

1. Punch the prepared paper using the registration punch.

2. To make an exposure of the cyan image, insert the registration pins through the holes from the back side of the appropriately sensitized paper. Next, press the "red" negative record through the same pins, so that the emulsion side of the negative is in contact with the emulsion coating on the paper.

3. Cover the assembly with a heavy pane of plate glass or use a contact printing frame to hold the negative and paper in place. Expose and process the paper.

4. Recoat the paper over the cyan image with the magenta emulsion, and expose it in the same way, replacing the "red" negative with the "green" negative. Process the exposed paper.

5. Recoat the same sheet of paper with the yellow emulsion and expose and process the image as described above. The product of the third exposure will be a full-color print.

Determining Correct Exposures for Separation Negatives

The exposure given to the sensitized paper for each separation negative during an assembly color printing process controls both overall print density and

color balance. The print of the cyan image is used to determine the basic exposure. This is done by exposing a full sheet of sensitized paper in stepwise intervals (for example, 5, 10, 15, 20, and 25 seconds) from one edge to the other, exactly as you would when making a black-and-white print by enlargement.

Process and dry the print, then view it through a #29 filter — it will look very much like a black-and-white print. Select the best exposure using the definition of highlight details as a basic criterion, just as you would in making a black-and-white print.

If all three separation negatives are perfectly balanced — that is, if their characteristic curves overlap *exactly* — the same exposures should be used to expose the "green" and "blue" negatives. Using the same basic exposure for all three separation negatives should result in a color print in which the color balance and print density are very close to the targeted values.

Color balance can be adjusted by altering the *exposure times* of either or both of the magenta and yellow printers (the "green" and "blue" negatives, respectively). Increasing exposure of either negative will increase the intensity of that color; decreasing exposure does the opposite. With wash-off processes such as gum dichromate printing, an additional measure of control can be exercised during the washing cycle, through which the intensity of a color can be altered by adjusting the duration of the wash.

While most color prints (usually called *C-prints, color couplers, dye couplers,* or *chromogenic prints*) will continue to be made directly from color film negatives, there are some advantages that can be achieved only by using separation negatives as the primary records for printing. If care has been taken in the preparation of the separation negatives, the color print will be perceptibly sharper than one made by enlargement of a color negative. The ability to alter each color record individually or to mix different separation negatives to achieve multiple printings offers a route to departures from reality that are not possible when a color negative is used as the primary record. Finally, separation negatives provide an alternative route to make prints from color transparencies.

The EverColor Process

The photographer "sees" differently from the way the painter does; he must see in terms of his medium of the camera and lens and light-sensitive materials, while the painter may see in terms of his own materials and colors and the structure of aesthetic forms. Similarly, one "sees" differently with color photography than with black-and-white. . . . In short, visualization must be modified by the specific nature of the equipment and materials being used: camera and lens, luminance evaluation, film, filters, exposure, development, and printing. . . .

Visualization can be a rewarding experience even if we do not always carry through with the photograph. Emphasis on looking *at the world about us, seeking shape and value relationships, thinking of space and texture and the ever-present miracle of light, provides a fresh conviction of the beauty of the world and the creative potentials all about us.*

The quest for photographic images that faithfully reproduce desired colors and meet reasonable expectations for permanence has occupied chemists, physicists, and photographers for more than a century. In the 1860s Louis Ducos du Hauron developed a three-color pigment process based on gum dichromate photochemistry. The technique was refined and evolved into the *carbro process,* which was used to make fine prints through the 1930s. Carbro prints are long-lived because they use light-stable pigments to generate the print colors. Unfortunately, the process is costly because of its complexity and the high level of operator skill required to make a fine print. Eastman Kodak's Dye Transfer process replaced carbro printing but was withdrawn from the marketplace in 1993.

Fortunately, the emergence of computer technology and its integration into the printing and publishing industry have resulted in a new approach to color photography, the EverColor process. EverColor integrates many of the traditional strands of color photography into a single system to produce the finest color photographs yet made. The technology developed can be used to create light-stable pigment prints or traditional C-prints from color transparencies, color negatives, or other color prints. Credit for the current state of the process, which continues to evolve, must be given to William Nordstrom, whose forty-year involvement with the graphic arts made him a master of techniques such as scanning images, making Dye Transfer prints, color separations, and carbro prints, and using prepress technology for color printing.

In the EverColor process of printing color photographs, printing begins with the scanning of an image and the reducing of the data to a digital format. A Scitex Smart Scanner is used to scan either a color negative or, preferably, a transparency. The scanner can handle up to 8 x 10 film at high resolution. The workstations used for image processing are capable of handling massive

Figure 11.24: *Iris Printer.* **An Iris printer is a means of producing fine art–quality prints from digital files. The printers come in several sizes, the largest of which can accommodate paper up to 34 x 46 inches.**

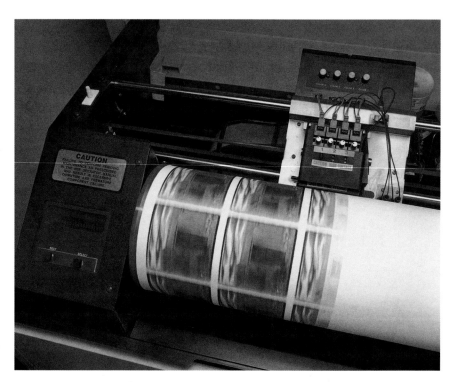

Figure 11.25: Ansel Adams, *Caladium Leaves, Foster Botanical Gardens, Honolulu, Hawaii, 1948.* This print was made from a 4 x 5-inch Ektachrome transparency by the EverColor pigment print process. The original transparency had faded significantly. Colors were restored by scanning the image, correcting the colors using a computer, and making four-color separations directly from the digital data file. Pigment prints are the most stable of all color photographs and have an expected lifetime of hundreds of years.

amounts of data and large numbers of files that routinely generate critically sharp prints, limited only by the grain structure of the original image. Enlargements can routinely be made anywhere in the range of 8 x 10 to 24 x 36, and larger formats can be accommodated as special orders. Typical data files are of the order of 100 megabytes for each image.

After the basic scan is complete, the photograph is displayed on a high-resolution monitor, and the image is fine-tuned. This can involve such operations as adjusting the color balance, image contrast, and tonal range of the photograph, removing scratches and obvious faults, sharpening or softening resolution, and altering the image in ways that only your imagination can dictate. When these steps are completed, the data for the photograph are compressed and transmitted to an Iris printer, which is linked to a workstation. The resulting print is a near-perfect match for one of the two types of images (dye print or pigment print) that can be produced by EverColor. The Iris print is sent to the photographer for evaluation, and any corrections or alterations that are desired are communicated back to the laboratory.

A Theatre of
Silver and Gold, 1996

In the early sixties I was an undergraduate student in art school studying to be a painter when I took my first photography class. So in 1964 it seemed natural to me to take photographic self-portraits and paint half the face with heavy oil paint. Half the face was a black-and-white photograph, and half was flesh-colored impasto. The result was a counterpoint, part cool and photographic and part swirling energetic color.

In graduate school, my professor, Van Deren Coke, showed me daguerreo-types from more than a century before that were also hand painted. In the case of those delicate pictures, the colored pigment had to be carefully brushed on dry. The colorists gently breathed on the images, their warm, moist breath softly dissolving the colors and bonding them to the plate.

I don't breathe on my photographs, but I have continued to paint and mark on them for the last thirty years. I still love going out with my Crown Graphic and printing the straight print in the darkroom, but I often return to the brush or pen to alter and assist the picture. I think of it not so much as destroying the photograph as enhancing it.

For the past few years I have been using gold iridescent acrylic paint. There are several properties of this method that are attractive. Some parts of the photograph are left unaltered by the paint, and from an angle the viewer can see the unpainted shapes floating in the field of iridescence — an interplay of gold and silver to make the photograph perform, to "do something."

Engaging conversations occur between the physical presence of the paint and the illusion of presence of the photograph, the touch of the brush and the neutrality of the photograph. Since the transparencies of the paint have to be built up slowly, layer upon layer, my process represents two kinds of time — that compressed within the photograph and that given physical depth by each layer of transparency.

These conversations are brought to mind when the viewer sifts through the transparencies to "find" layers of photographic information revealed. The act of seeing, often passive, is made active, a physical experience, as the viewer sees into the picture. The surface itself, iridescent and elusive, shifts from open and transparent to opaque and reflective as the viewer changes position. And in turn, this experience heightens the event occurring inside the photograph. The unpainted part of the photograph moves forward as an enlivened presence, an actor in the scene of the photograph.

And so, for many years now, I have used painting on photographs to create pictures where the heart is photographic and the spirit a quiet drama.

— HAROLD JONES

The Iris printer was designed for prepress work in the publishing business to produce a proof print that could be evaluated prior to printing and would serve as a target to be achieved on the printed page. The Iris uses high-resolution ink-jet nozzles that spray microscopic quantities of dyes onto the surface of a paper or polyester support. The dyes blend as they are applied and create a very high quality full-color photograph. Iris prints are indistinguishable from other color photographs unless they are carefully examined through a magnifier, which reveals the fine dot pattern characteristic of a halftone print.

A limitation of the use of the Iris printer in color photography has been the ephemeral nature of the vegetable dyes it uses. Because the printer nozzles have an extremely fine aperture (about 10 microns, one-tenth the diameter of a human hair), soluble dyes that do not clog them are a necessity; vegetable dyes fill that requirement admirably. Unfortunately, these dyes are susceptible to fading when displayed in bright light for a period of time; for dark storage, lifetimes are comparable to that of Dye Transfer prints. The unique visual qualities of an Iris print on artist's paper has encouraged research, and new dyes are being sought and introduced that have greater stability. If the quest for light-stable dyes that can be used with the Iris printer is successful, Iris prints could become an important vehicle for recording and presenting color photographs in the computer age.

EverColor Halftone Negatives

When an Iris print has been deemed satisfactory by the photographer and EverColor personnel, the final digital file is transmitted to an image setter, which produces a set of four halftone separation negatives. Because many color printing processes are not able to achieve dense *black* tones by combining equal amounts of cyan, magenta, and yellow dyes or pigments, a fourth separation negative is made by exposing an image through a light yellow filter. This negative is used to apply a light layer of black pigment or ink to the print. The separation negatives are designated by the letters CMYK, which stand for cyan, magenta, yellow, and black. The separation negatives have a resolution equivalent to a 600-line screen (for comparison, the best fine-art productions in a book are made with a 200-line screen), and the variable-dot-size pattern is distributed in a stochastic, or completely random, pattern that, on viewing, reads as a continuous-tone image. The dots can be seen only when viewed closely with a strong magnifier.

Because halftone screens usually imply mechanical reproduction, some photographers have a philosophical problem with these images, wondering if they should still be considered photographs. I believe that the concern is misplaced and that it diverts attention from the critical aspect of the issue, namely image quality. Both the pigment prints and C-prints are made by contact printing (a purely photographic process), the separation negatives are made by classical photographic processes on the image setter, and the resulting *photographs* produced are without peer. Furthermore, for gum dichromate and many other alternative printing processes, it is often more advantageous to work with halftone negatives (that is, negatives made on litho film consisting of an extremely fine mosaic of dots that mimic a continuous-tone photo-

Figure 11.26: John Wawrzonek, *Blue Ice and Oak Leaves, Walden Pond, Concord, Massachusetts, 1997*. EverColor print. The strong texture in the ice is evident in the original, but it is much more subtle; a strong unsharp mask was used in Photoshop to reveal the texture. A curves adjustment in Photoshop increased the contrast and saturation of the blue. See chapter 13.

graphic negative; usually the dots cannot be seen without the aid of a magnifier) rather than continuous-tone negatives, because exposure times are shorter, and the dot pattern virtually disappears during processing.

Making an EverColor Print

After the separation negatives have been prepared, the process of making an EverColor print begins. The negatives are first registered and punched in a sequence similar to that previously described (see pages 278–282). A blank polyester sheet that serves as the support for the photograph is also punched. The pigments that are to be applied are incorporated into thin sheets of gelatin, which are laminated to the polyester base. Each gelatin sheet is formulated with a silver salt that is sensitive to exposure by ultraviolet light. The pigments used by EverColor were selected after a joint research effort between Nordstrom and Agfa and were chosen on the basis of maximum permanence and color fidelity.

The polyester base is covered with a sheet of gelatin containing the yellow pigment, and the two are joined under pressure by rolling the pair through a laminator. The resulting joined sheets are then moved to an exposure cabinet, attached to a vacuum easel by registration pins, and covered by the appropriate separation negative, which is also held in place by the registration pins. The resulting sandwich is covered with glass, and a vacuum is applied to ensure intimate contact between the negative and gelatin surface. The print is then exposed using a carefully calibrated high-intensity UV light source. The exposed print is then put through a machine containing a tanning developer that hardens (and makes insoluble) the gelatin in direct proportion to the degree of exposure received. The print emerging from the processor has been fixed, washed, and dried. The cycle is repeated for the black, magenta, and

cyan printers. After a final washing, the print is trimmed and ready for display. Because of the labor-intensive aspect of printing, the average number of pigment prints is two prints per hour, though for smaller sizes, a number of prints can be made on a single sheet and later trimmed to size.

Fujicolor Prints by EverColor

An alternative to the pigment print offered by EverColor is a Dyeprint™, currently being made on Fujicolor paper, which uses a balanced set of separation negatives. To make a Dyeprint™ a single sheet of Fujicolor paper is sequentially exposed in a darkroom to all four separation negatives. A vacuum easel fitted with a pin registration system ensures that each negative is held securely in contact with the printing paper and that all four are exactly superimposed on the sheet. The four exposures are done in a few minutes, and the print is machine processed using ordinary color-negative chemistry (RA-4). Because the color printing process used by EverColor avoids the use of an enlarger and the inevitable problems of lens aberrations and flare, the Fujicolor prints produced by EverColor are *distinctly* sharper than those produced by traditional darkroom methods.

After closely examining and evaluating a large number of EverColor pigment and dye prints, it is clear that the processes and prints that are being made now define the state of the art for color printing and reflect the direction that should be pursued in color photography in the future.

EverColor keeps separation negatives and digital records on file so that additional prints can be made at any future time without incurring new setup charges.

One of the attractive aspects of the printing program that has been developed by EverColor is that it is also possible to send them a digital file of your own creation from which they can make an Iris ink-jet proof and fine prints. This is an attractive alternative for photographers who either create original works of art on their own computers or prefer to do image editing personally (and save considerable money in the process) but lack the facilities for making fine prints themselves. EverColor sells a monitor-calibration kit for use with Adobe Photoshop that provides simple, detailed instructions and reference images to enable you to adjust your own monitor to match the EverColor system and their output.

Alternatively, high-resolution scans can be made and stored on a Photo CD (see page 316) through a local camera store. This enables you to begin the process at your own computer workstation. After fine-tuning the digital image, you can write the data on a removable SyQuest hard disk and mail it to EverColor for further processing. EverColor's computers routinely handle files in excess of 100 megabytes, and the staff is available to answer any questions you may have about formats and procedures (call 508-798-6612; fax 508-757-2216; e-mail Light@EverColor.com).

The cost of an EverColor pigment print places it out of the price range for printing ordinary color photographs, but for fine work that warrants reproductions of the highest quality and for permanence in a color print that probably exceeds that which is achievable in an archivally processed black-and-white photograph, the price is reasonable.

Summing Up

The major technical problems that have confronted color photography since its inception have yielded in the last few decades to the intensive research efforts carried out by the manufacturers of photographic paper and chemistry. A primary continuing concern in need of further resolution is the longevity of color prints. The palette of the ubiquitous C-print has evolved in quality, and printing on color negative paper is a simple procedure that can be carried out satisfactorily in the simplest of amateur darkrooms. Print stability has been improved markedly, but the organic dyes produced by most color photography processes are susceptible to degradation by light and air oxidation. *No* C-print can withstand the viewing conditions that are needed for full appreciation of the image for more than a few years, a sharp contrast to the stability that is routinely achieved by careful processing of a black-and-white print. It is unlikely that significant additional advances can be made on this problem.

Ilfochrome prints feature dyes that are inherently more stable than those generated through color coupling reactions. The high contrast and intense colors that are characteristic of an Ilfochrome print (a blessing or a curse, depending upon your aesthetic preferences and the image in hand) have been tamed to a degree with the introduction of new products that have made the creation of a fine print from a color transparency a goal that is reasonably easy to achieve.

Alternative color reversal processes that are available for printing transparencies generate dyes that are generally less stable than those found in C-prints. If the aesthetics of an Ilfochrome print are in harmony with what you envision in terms of color, the archival properties of the print make the Ilfochrome process an attractive choice. Adaptation of features of the Ilfochrome system to printing color negatives would constitute an important advance in color photography.

It seems to be inescapable that the greatest potential for advances in color photography resides in the marriage of the color image with computer technology. The computer workstation opens a pathway to creative interpretation of transparencies and color negatives that was previously possible only through the application of complex masking procedures and collage techniques. It provides the photographer-artist with the tools and ability to break out of the "reality trap" that is the dual-edged sword with which those who work in color have had to cope. At the same time, the controls that are available through the computer allow for the most literal interpretation of color images in printed form that has ever been possible.

The formation of organizations such as EverColor represents an opportunity for photographers to utilize the leading-edge advances in technology, though the costs are considerable. However, the technical advantages, aesthetic characteristics, and permanence of the process are such apparent benefits that the integration of color photography and computer technology is destined to play an important, perhaps dominant, role in defining the direction of the future of color photography.

Chapter Twelve

Photography and Electronic Imaging

Certainly photography does not grow simpler, neither its theory nor its practice. Technologies become more sophisticated and remote, intertwined with others hardly invented thirty years ago; instruments are more fragile and expensive, some — the electron microscope, for example, nearly inaccessible; others — film and television, for instance — require collaboration and thus special management skills. The older processes, helping the individual artist to recapture his sense of craftsmanship, are accessible mainly through personal effort and ingenuity.

One ought not leave a man or woman who has completed the work for an advanced degree at the mercy of esthetic decisions made primarily by technologist, manufacturer or mass marketer. Instead, one should foster what used to be known as Yankee ingenuity and encourage the student to combine sound traditional esthetic values with a sharp eye for possibilities for innovation. Then whatever happens, happens.
— HENRY HOLMES SMITH

One defining characteristic of our age is the ascendancy of the image over the written word as the dominant language for secondary communication, conversation being the primary mode. Television, by combining words and images and transmitting them universally, has become the vehicle through which a vast segment of the population receives most of its news and information and is entertained and, in a real sense, educated. Two or more generations of the population have now grown up in a world in which television has been a primary influence.

Paralleling television's evolution in communication has been the invention and development of the modern computer. In its current form, a computer is a conceptually simple device that can be used to store and manipulate information. Through the use of *programs* (semiautomatic operating instructions and commands that guide the computer's operation), letters, words, numbers, colors, light intensity, sound, and music — in short, information of any kind — can be captured, created, and transformed. In the realm of communication, the usefulness of a computer lies in its ability to interact with a variety of instruments, so that the information it contains or produces can be

Figure 12.1: Olivia Parker, *Action Toy, Toys and Games,* from the History of the Real series, 1994.

Figure 12.2: *Computer workstation.* An "electronic darkroom" fits on a desktop and consists of a computer, a monitor, a keyboard and mouse, and peripheral devices such as a color printer and one or more image scanners.

displayed on a screen, reduced to the printed word or a photographic image, or listened to as words or music.

To appreciate the power of the computer to influence the creation of a photographic image, it is important to understand how the image you see on a *monitor* (the video display unit) differs from a photograph (a print, transparency, or negative). A photograph is an assembly of grains of metal or dye that forms a visual image. In the computerized version of that photograph, the image is recorded and presented as a mosaic, similar to a sheet of graph paper made up of microscopic squares. Each square has an *address* that defines the image's location on the grid, a *luminance value* that defines its brightness on a gray scale (usually a 256-step gray scale that spans the range of black to white), and *numerical values* that define its colors on a red-green-blue (RGB) or cyan-magenta-yellow-black (CMYK) scale. (The rainbow of colors that can be generated can be subdivided into 16.8 million segments, far outstripping the eye's ability to distinguish them.) What the computer enables you to do is to change any and every one of those values (location, brightness, and color) as you choose.

The implications of this technology have far-reaching consequences for photography. Simply put, anything you can imagine as a photograph can be created with a computer if you make the required effort. Combining images to make a photographic collage is simpler than cutting up photographs and pasting them together in a new arrangement — and undetectable as well. Adding color to a black-and-white image is easier and more realistic than hand coloring; photographs can be made without the use of film; color separations are available at the push of a button; color slides or negatives can be made into prints in a matter of minutes without your setting foot in the darkroom; images can be sharpened or diffused; perspective can be changed; unwanted

elements can be deleted from a scene; colors can be changed arbitrarily — the list of possibilities is virtually unlimited. Creating images using a computer enables the user to circumvent the restrictions imposed on photographers by the laws of optics and the physics and chemistry of film.

The awesome power of electronic imaging has led to expressions of concern similar to those uttered in the 1840s about the future of art and speculation that the camera would forever replace the paintbrush. Although the invention of the daguerreotype and calotype did bring about the virtual demise of the miniature hand-painted portrait, ultimately the photograph was accepted as another vehicle for artistic expression, and it took its place alongside painting, engraving, and the other plastic arts. While it is possible that the filmless camera and computer could replace traditional photographic equipment, it is far more likely that it will emerge as another tool that photographers and artists will use in the expanding universe of opportunities for making and creating images. The era of electronic imaging has become an affordable reality for the serious amateur, and a skill and necessity that will assume increasing importance in the life of professional photographers.

The Great Hardware Dilemma

Artists in the 1840s had to make a fundamental decision about which photographic process to use. The daguerreotype was sharp and detailed, albeit reversed from left to right, but each image was one — and only one — of a kind. The calotype was somewhat diffuse, and it required considerable skill to avoid murky shadows and featureless highlights; once mastered, however, it allowed for the production of multiple copies. Over time the technical problems associated with the creation of images on paper were resolved, and the daguerreotype became a momentary, though brilliant, chapter in the history of photography.

At the time of this writing, two basic operating systems are available to those who are on a limited budget and are interested in pursuing electronic imaging. Asking for advice to help you make an informed decision about which system to use is not unlike asking a diverse group of people which religion or political party is best: you will receive passionate answers, ringing with conviction, defending choices and maligning all of the alternatives. Decisions are further complicated by the rapid evolution and monthly introduction of new products. Financial and operational consequences of the selection you make are significant, and careful research before you leap into the fray will pay significant dividends. A bit of history may help you make a choice.

The operating system for Apple computers' Macintosh ("Mac") was developed around a strong graphical component and features *icons* (small graphical pictures or symbols that stand for computer commands or programs) that are easy to interpret. These icons greatly simplify learning to use and run the machine. To operate the computer, the user activates a given program simply by pointing to the proper icon and clicking a button. The graphical environment chosen by Apple created a user-friendly image, and its computers became a favorite for use in school and at home. Apple's early orientation toward graphics enabled it to establish a virtual monopoly in the graphics-based desktop computer market during the 1980s.

However, a corporate decision to keep the family of Apple computers proprietary products that no one else could manufacture or clone (that is, to employ a *closed architectural system*) created a formidable barrier that discouraged others from developing useful programs (software) to serve the much larger and growing needs of business and industry. Traditionally, these segments of the computer market were the domain of IBM, which initially used a character-based disk operating system, or DOS (pronounced "doss") for its personal computers, or PCs, called PC-DOS; that system was later replaced by Microsoft's MS-DOS as the disk operating system for its desktop computers. The multitude of computer manufacturers that produced IBM clones did the same.

Because the PC and its operating system, MS-DOS, could be made and used by any manufacturer willing to obtain a license, competition and market forces drove down the price of the PC drastically, giving it a strong edge over Apple's Mac in the marketplace. The concurrent development of a vast array of superior software quickly made the PC the more rational choice for tasks such as writing (word processing) and handling financial data (spread sheets), and for high-powered computing (for example, number crunching). Excellent software, coupled with the low-priced hardware, has made the PC the dominant computer in the marketplace. PCs now outsell Macs by a ratio of more than ten to one, and their share of the market is increasing.

Apple's early focus and emphasis on graphics made it the machine of choice — indeed the only choice — for those working in the graphic arts in the early 1980s. It is still the most commonly used platform for workers in the graphic arts and in print shops. However, as the size and potential of the graphic arts market became apparent to PC hardware and software manufacturers, and as the superiority of using a graphical interface (rather than typed commands) to communicate with the computer was established, a platform that offered a graphical environment to the PC user became available. With the introduction of Microsoft's Windows and its successors, the user-friendly gap between the Mac and PC diminished; indeed, with the introduction of Windows 95, the distinction disappeared. Simultaneously, all of the image-processing programs that were once the exclusive domain of the Mac were reconfigured and made available to the PC user.

The *open architecture* of the PC encourages innovation, and its capabilities continue to expand the horizon for desktop computers by the development and addition of powerful peripheral devices (fax, printers, CD-ROM, sound and music, movies, and so forth). Competition and cooperation have led to more rapid development and lower costs for the basic PC and its peripherals. However, progress has come at a price. The incompatibility of peripheral devices, software, and the like, that inevitably occurs when independent manufacturers introduce new products or upgrade older ones can lead to major frustration for the user until the problems are "debugged."

Apple has not remained idle, and each succeeding generation of its computers features innovations that enhance its performance and expand its general usefulness. It, too, suffers problems when new features are introduced, but Apple's approach of coordinating the design of the computer and its periph-

Figure 12.3: John Paul Caponigro, *Small Green Island, Waterways,* from the Elemental series, 1996.

eral devices generally makes problems easier to solve than with a PC, unless you have access to good technical support.

Is there then a clear preference in computer hardware for photographers who want to enter the world of electronic imaging? Because of the rapid evolution of the computer industry, the answer depends upon the year the question is asked, how much money you are willing to spend, and, most important, *the level of technical support you can count on when the system is being set up or if something goes wrong.* In the current and probable future domain of software there is no notable difference in the performance or complexity of image-processing programs of a Mac or a PC. New chips that drive the computer system may give one or the other machine a temporary advantage, but in the economic environment of the computer world those differences are rapidly minimized by the competition.

Because of its open architecture and the enormous number of PCs that are being sold and used, the PC environment will almost certainly continue to lead in the introduction of innovations in hardware and software and be lower priced than the Mac, but the PC user may be more vulnerable to short-term problems arising from incompatibility of the new with the old. If you are comfortable handling hardware (most photographers are) and have access to knowledgeable technical help, the PC is an excellent and economical choice, destined to accommodate evolution and change. Otherwise, a Mac may be a safer bet.

What a Computer Does

Working with a computer is far easier and faster than tackling a task with a pencil, paper, and books. Many adults are hesitant to begin using a computer, but the discovery that the operating rules are simple and that it is impossible to make a mistake that cannot be undone breaks down whatever reticence may be present. What beginners soon learn is that the computer technology quickly becomes invisible as they begin working with it, just as the camera becomes an extension of their eye.

What follows is a simplified description of what a computer is, how it functions, and how it can be used for image processing. It will not make you an instant expert but should provide sufficient background information to demystify the machine and introduce the vocabulary that is basic to the computer world. A thorough understanding of these concepts before you begin is no more necessary than being able to diagram and explain the inner workings of a modern electronic camera before you attempt to take a photograph. But as in photography, knowledge of basic concepts enables you to make better choices and enhances creativity.

A computer is basically a device that stores information — letters, words, numbers, colors, sound, and so forth — much the same way a book encodes information through the symbolic languages of the alphabet, numbers, and pictures for the reader to interpret.

The fundamental unit used by a computer to encode information is called a *bit*. A bit can be any object or particle that can exist in one of two states — in essence, a switch that can be either on or off. In the modern computer, these switches can either be particles that are magnetized (on) or demagnetized (off), or electric circuits that are open (on) or closed (off). A computer's electronic network enables it to go to a specific location and recognize its state (that is, as on or off). To simplify notation, let 0 stand for off and 1 stand for on. Bits can now be combined to create a new language. If two bits are used, four possible states can be identified: 00, 01, 11, 10 (off, off; off, on; on, on; on, off). Since there are twenty-six letters in the alphabet and ten numeric digits, using two bits is obviously an inadequate basis for building much of a language. However, if six more bits are added to create an expanded basic unit (8 bits, or 1 *byte*), the number of possible combinations increases to $2^8 = 256$, which is more than sufficient to create the characters (termed *alphanumeric symbols*) needed for letters (upper and lower case), numbers, and the other symbols (,?';:@.#!$%^&* -()<>`~, and so on) that are part of our communication system. The agreed-upon standard for encoding symbols is the American Standard Code for Information Exchange, *ASCII* (pronounced "a-skee"), and its use enables computers of different kinds to communicate.

To record information associated with images (colors and intensity, for example), more complex codes using 16-, 24-, or 32-bit strings are more practical and are used in most modern operating systems. Computerized images are a mosaic of small squares, called *pixels* (derived from *picture elements*). Each pixel has a color value assigned to it in digital code. A 1-bit image (in which "off" or "on" corresponds to black or white) is sufficient to define a simple black-and-white image, though it has a speckled appearance and does not reproduce a gray scale that would satisfy a photographer. A 2-bit image can

define four colors, but the image is only marginally acceptable for viewing. A 4-bit image can generate sixteen colors per pixel and results in an image pattern that is better, but far from satisfactory for photography. An 8-bit code defines 256 separate colors, which generates quite a good image for viewing on the average color monitor but is still marginal for a color print. Using 16 bits per pixel increases the number of possible colors to approximately 65,500 (2^{16}), while going to 24 bits raises the number of possibilities to 16.8 million, greater than the eye is able to distinguish. The possible number of colors that a computer system is able to handle and display depends upon the hardware and software that the system uses.

A color image on a computer monitor consists of hundreds of thousands of pixels, and the information storage space required to display a photograph requires enormous amounts of computer memory — millions of bytes. Because of the size of the numbers involved, memory blocks are described in kilobytes (KB) (thousands), megabytes (MB) (millions), and gigabytes (GB) (thousands of megabytes).

Computer Memory

Digital information for computers is stored either electronically or magnetically. Data in electronic memory is incorporated into chips that are plugged into the body of the computer. These operate only when the computer is turned on and the memory chip is electrically charged. As soon as the power to the computer is switched off, all of the information contained in electronic memory is lost. Information stored in electronic memory is easy to access, thereby increasing the speed and efficiency of a computer enormously when large graphics data files are being manipulated. Electronic memory chips that can be written on again and again are called *random-access memory (RAM)*.

Magnetic memory relies on the magnetization of a metallic particle to store data and does not depend upon the computer's being on or off. Magnetic storage is how data is saved and preserved on disks — either floppy or hard — which are coated with finely divided magnetic particles on which information can be encoded, stored, retrieved, and erased or overwritten if desired. A floppy disk typically stores up to 1.4 megabytes of data (or 1,400,000 bytes) and is inserted into a slot in the computer housing.

Hard disks are rigid platters manufactured to close tolerances and are usually built into the housing of the computer. A hard disk is capable of holding thousands of megabytes of data in magnetic storage. If a computer is to be used for image processing, a hard disk that has at least 200 megabytes of storage is desirable. Disks featuring gigabytes of memory are now commonplace for use with PCs and are an excellent investment.

Removable hard disks for computers are also available. These typically hold at least 40 megabytes of data and are useful for transporting data to a print shop or for storing large image files on something other than a permanently installed hard disk.

Tape drives are also magnetic memory devices, but these are useful only for archival or backup storage of data. They cannot be used for normal computer operations, since their data can be read or written only sequentially —

Figure 12.4: Joyce Neimanas, *Licks, 1996.*

the way you would listen to an audiotape — unlike floppy or hard disks, which allow random access to data so that the computer can direct its read/write sensor to move to any position on the disk in an instant.

How Information Is Stored

Information generated and used by computers is stored as a tightly organized *file* in an electronic or magnetic filing cabinet. The information in a file might be a program that guides the computer through a sequence of operations or simply a compilation of data. Each byte in a file has an address in memory, the same way a word in a dictionary has its location defined by a page number and line. If a computer needs to read or record a piece of information, it looks up the appropriate address for a byte and either reads or writes the information as instructed.

A special section of electronic memory is reserved for *display,* or *video, memory,* and the computer constantly displays its contents on the monitor. As data flows in and out of video memory, the changes are reflected on the computer's video display unit (monitor).

For image processing it is desirable to have a large amount of RAM. Most of the software needed to work with photographs requires at least 8 megabytes of RAM, but operating at this minimal level is not really practical. With a large file and a small amount of RAM, the computer is forced to transfer data back and forth between RAM and the hard disk. In this mode many of the simplest image-processing operations or calculations take an inordinate amount of time to perform, and they may exceed the capability of the computer system. Additional RAM can be purchased in 1-megabyte increments, and experience suggests that 32 megabytes represents a practical lower limit of electronic memory to have and use with photographic images. Increasing the amount of

RAM to 64 or 128 megabytes greatly enhances the speed at which operations can be performed. Be aware, however, that with some computer systems, too much RAM may begin to impair the computer's efficiency.

The Central Processing Unit (CPU)

A computer can perform only three operations: add, subtract, and compare two numbers to see which is greater. Every task a computer accomplishes — from word processing to displaying an image or playing music — results from the clever combination of these simple maneuvers by a programmer. A computer's usefulness and power stem from its ability to perform thousands of operations in a fraction of a second.

These activities are carried out by a single chip called the *central processing unit,* or *CPU,* which directs and performs all of the computer's fundamental operations. The CPU is located on a card in the computer called a *motherboard,* which houses the processor chip, memory chips, and the like. In addition to processing all of the data, the CPU oversees all of the computer's basic operations, including interacting with input and output devices such as the keyboard, the video display unit, or monitor, printers, scanners, and all memory units.

To communicate with the CPU, an electronic signal needs to be sent. For example, when you depress a key on the keyboard, a message travels to the CPU, where it is interpreted. A message is then sent to video memory, and the result of the action triggered by your depressing a key is displayed on the monitor. This may be as simple as having a letter appear on the screen or as complex as displaying a colored image.

Performance and much of the cost of a computer is determined by the CPU. At the time of this writing, the two leading CPUs feature the Pentium chip or its equivalent in the PC, and the Power PC in the Mac; both of these deliver superb performance. An earlier generation of the Intel chip, the 486, performs image-processing functions efficiently, but for computers with older versions of this chip (for example, the 286 or 386), an upgrade should be considered a priority. If the past is any predictor, chip technology will continue to evolve rapidly. When you purchase a computer, look for one that can be upgraded in the future and has a ZIF (zero insertion force) slot on the computer's motherboard to enable you to incorporate the fastest state-of-the-art chip you can afford.

More advanced chips and CPUs incorporate a *cache* and a *cache controller,* which speed up the operation of a computer by anticipating instructions, storing them in memory, and retrieving them rapidly on an as-needed basis.

The Computer Bus

The panel within a computer to which the various cards that operate it and any peripheral devices are connected is called a bus. Cards are plugged into the bus, which serves as a pathway to transmit data. The *bandwidth* is the rate that data can be transferred; the amount of data that can be sent from one component to another increases with the bandwidth. The bus should have a band-

Sabattier Prints, 1969 (original image) and 1997

In years past the techniques I used to print photographic images with ink were based on a complex photographic separation (literally, photographic digitization) of the information in a negative. I would print a negative on litho film, and by controlling the exposure, I was able to create from six to fourteen litho positives that corresponded to different density values in the starting negative. These positives were contact printed onto litho film to generate a set of litho negatives. This procedure captured in tonally separated negative form the entire content of the original negative. By accurately registering and progressively exposing in sequence a sheet of photographic paper to these negatives, I could emphasize any tonal region I chose and utilize the full tonal range of the original negative far more expressively than by using traditional printing techniques.

Unfortunately, I not only used an exorbitant pile of film and time in this process, but I often lost all interest in the image I was trying to print along the way! In contact printing the images, there were always fourteen layers of dust to contend with as well as the relatively small print size. To survive as a commercial photographer I was forced to relegate the results of most of these ridiculous activities to the trash bin.

Years later I became interested in the reasons my beautiful color transparencies always looked so ugly by the time they were reproduced (even though they sold a lot of Chevys!), so I bought myself a small offset printing press. The piles of film once again built up as I learned that it wasn't necessary to make traditional color-separation negatives to make expressive color pictures.

I began by separating a black-and-white negative into several tonal values as described earlier, then aligning a negative step with an unlike positive to generate still another separation. I used these to print a color value I chose and by registering and printing other negatives with different color values to assemble a color print. This is the basic procedure for posterization, but by using as many as fourteen to eighteen printings for a single print I was carrying the process to a ridiculous extreme. I first did this making gum dichromate prints but later used the silkscreen process and the printing press. The possibilities for images created in this way are endless.

The overall process involved printing one color at a time on the paper, assessing the result, and mixing and printing the next color until I arrived at the final image. For each step, a day was required for drying time and to achieve paper expansion/shrinkage stabilization. Each print made this way required up to three weeks to think through and process before the final image was visible. Reprinting an image was out of the question. I learned how each color influences another color placed adjacent to it, and each color-value selection I made during a printing sequence became an irreversible commitment. If I made a regrettable choice, I didn't throw the paper away and start again with the same image!

When a computer became available I thought about using the procedures I had worked out photographically with this new tool. I first used an Apple II, which

1969

offered very low-image resolution and only white/black, orange/blue, and magenta/green colors. I learned a lot using this computer, but I now have a far more powerful PC, capable of working with highly resolved images and a broad spectrum of color values. Decisions and procedures that once took weeks of work in the darkroom can now be done in hours on a computer.

The results I attained using the methods outlined above can now be achieved relatively simply by using a computer, a scanner, and appropriate software. On the computer I can separate my black-and-white negatives into 256 separate tones of the gray scale, whereas with photographic methods I was limited to 14 or fewer. With these separations I can do everything that I have been able to imagine. Most of my ideas probably would never have occurred to me without all of my previous experience as a photographer and my understanding of how perception is altered by changing the marks made on the surface of a print. With the computer, each pixel is a mark I can make, just as a pen, pencil, or brush can make an expressive mark for the artist.

The information carried by each ray of light collected by the lens of my camera is a potential mark on my print. That mark can be altered to any value or color I imagine. In the computer, as pixels, marks can be used to define an imagined object in an imagined space. By adjusting those pixels I can make the object thick or thin, rough or smooth. I can adjust and apply tones to that object, and define the camera that sees this object, the lights that make it visible, and the entire scene in which it will appear. Then I can save it as a file and make a print of the image.

Working in my darkroom, I agonized over burning-in or holding back a value in a print, making slight variations again and again until I made a print that I liked. The creation of the final image file on the computer is a similar process and takes as much time. Variations can be saved, reevaluated, and altered until the hoped-for qualities are reached. For these decisions the computer is not a timesaver because the possible variations are even more numerous and subtle.

The computer allows me to revisit the world I photographed in, using old negatives to construct and reinvent the entire scene. Working with a computer is like making a photograph in a perfect studio that has available at your fingertips every option you can imagine.

For an exhibition of my recent work, I wrote this statement:

"In a fleeting expression or a passing gesture we may reveal an aspect of ourselves that others might never see nor understand. Upon closer reexamination of the photographs I have made over the years, I see a few that reveal moments when my camera saw far more clearly than I did. I work now to enhance these images and make such moments more visible to myself and perhaps to others."

— TODD WALKER

1997

width great enough to respond to the demands of the various cards. If you have a 32-bit machine attempting to communicate with a 32-bit video card, a 16-bit bus will create a serious bottleneck. The PCI bus seems to be gaining dominance, and a board with PCI and ISA (industry standard architecture) features meets the needs of most computer applications.

The Monitor

The most basic output device for a computer is the video display terminal, or monitor, which enables you to see and follow what the computer is doing. A computer monitor is similar to a television screen, but it has a much higher resolution, and the characters that appear are more sharply defined. A good monitor is easy to adjust for color balance, brightness, clarity, and contrast. It also affords flicker-free viewing, which is extremely important since you will be sitting close to the screen for extended periods of time, and a poorly performing monitor is a guaranteed source of headaches and eyestrain.

The principle behind the operation of a color monitor is similar to that involved in color photography. The screen is coated with phosphors that emit red, green, or blue light when struck by a stream of electrons. Three different electron guns are used to activate the primary colors, and the color that you see is an appropriate blend of the primary colors. The two important characteristics of a good color monitor are its *video bandwidth* — a measure of the highest input frequency the monitor can handle — and its *dot pitch.* Dot pitch is roughly analogous to the grain in film in that it is a measure of how far apart the dots are that make up the phosphor screen; the smaller the dot pitch, the finer the resolution. The actual resolution of a monitor is determined by a combination of video bandwidth and the dot pitch of the screen.

An image is generated on the monitor screen by a horizontal sweeping pattern of the electron guns as line after line of electronic impulses is sent by the computer to the screen. The *vertical refresh rate* is the measure of the cycle time needed to completely repaint the monitor screen, the unit of measure being frequency, which is expressed as hertz (Hz). The slower the vertical refresh rate, the greater the flicker. Noninterlaced scanning (a scanning mode available on better monitors) at high refresh rates (60–72 Hz) ensures flicker-free operation of the monitor.

Video Cards

To enable the computer to communicate with a monitor, a video card is needed. A high-end monitor capable of delivering a rainbow of colors and crisply defined details requires an expensive ($150–$500, 1998 list price) graphics display card. These are seldom sold as a package with a monitor and must be purchased separately. Don't purchase a card unless you have an opportunity to test it with your favorite applications and software and have a money-back guarantee that it can be returned if it does not perform as expected.

Video cards control the resolution, the number of available colors that can be displayed, and the speed at which Windows and other graphics programs perform. Some boards contain a *graphics coprocessor,* which takes over

some of the functions usually carried out in the CPU. These units enhance the computer's performance with graphics programs but do increase the price of a board significantly. Available cards come under the headings of VGA (video graphics array), Super VGA, and XGA cards. Cards needed for image processing have 1 to 4 megabytes of memory chips integrated into the graphics accelerator package, called *DRAM* (dynamic random-access memory) or *VRAM* (video random-access memory). The latter is faster and more expensive but preferable when working with photographs.

The evolution of video cards has been so rapid that the average lifetime for a particular version is about six months. It is wise to review the independent ratings of cards (and other computer accessories) in current computer publications such as *PC Magazine* or *Mac World* before you shop.

The Keyboard

A keyboard is usually included in the purchase price of the computer. Computer keyboards have the same general layout as typewriter keyboards, but they have several additional keys called *function keys,* which are labeled F1 to F10, F12, or F15. These keys have been or can be programmed to carry out specific commands, such as to search for a word, check spelling, create columns, introduce graphics symbols, and so forth. Most keyboards also have a *numeric keypad,* which is arranged like a calculator and can be used to input numeric data.

Keyboards are connected to the computer by a long flexible cord and can be changed if you do not like the feel or the layout of a particular model. Look for a model that is designed for comfort.

Mice, Trackballs, and the Stylus

A mouse is an add-on device that serves many of the same functions as a keyboard. It features a ball on its bottom that moves an arrow around the screen as you slide the mouse over the desktop. A mouse will have either two or three buttons that enable you to activate a program. In a typical action you might use the mouse to guide the pointer and create an outline around a certain area of a photograph. A click of one of the keys on the mouse might then instruct the computer to tint the selected area with a specific color. The same maneuvers can be accomplished using the keyboard, but the tasks would be unspeakably tedious. A trackball is basically a mouse that has been turned upside down and attached to the keyboard.

A stylus looks and feels like a pencil that you use with a special electronic drawing pad, or digitizing pad. These pads range in size from 5 x 5 inches to 12 x 18 inches or larger. Points on the pad correspond to locations on the monitor, and any shapes drawn by touching the stylus to the pad immediately appear on the computer screen. Because it is similar to working with a pencil and a pad of paper, a stylus is one of the most useful devices for creating and manipulating images. The larger the pad, the easier it is to create accurate drawings or interact with the details of an existing image. A higher-end stylus has touch sensitivity — the harder you press, the broader the line.

Figure 12.5: Stephen Golding, Untitled, from the Road to Necropolis series, 1994.

Computer Programs

The operating instructions that guide every action of the CPU are called programs. Most programs that are purchased come on floppy or CD-ROM (see below) disks that are inserted into the computer on an as-needed basis. Commonly used programs are usually rewritten onto the computer's hard disk to facilitate access. A small number of programs are engraved onto memory chips and made a permanent part of the computer's memory. These chips can be read only and not written upon. This kind of memory is called *read-only memory* or *ROM* (not to be confused with random-access memory, or RAM). ROM is used to store many of the routine operating programs used by the computer on a regular basis, such as how the CPU communicates with devices such as the disk drives or video monitor. Programs are stored on disks in exactly the same way as data files are stored. When a program is activated it is first transferred from a disk to electronic memory, from which location it performs its functions.

A CD-ROM is a compact disk that looks like a CD used to play music but holds computer data instead. The CD-ROM has expanded the domain of the computer dramatically, delivering sound, images, computer programs, movies, and interactive capabilities to the workstation. A CD-ROM player should be an integral part of every personal computer system. With a prodi-

gious storage capacity in excess of 650 megabytes (newer versions will have far greater storage capacity), a single disk can accommodate as much information as 400 to 450 floppy disks.

Technology introduced by Eastman Kodak has led to the introduction of the Photo CD as part of a package in which slides or negatives can be scanned at various resolutions. The data obtained from the scan of the image is recorded on the CD, and the images can then be viewed on a PC or Mac or accessed for image processing (see page 316).

The key to mastering any set of operations or programs on the computer is to *learn by doing.* All of the sophisticated software packages that are useful for image processing come with extensive manuals, floppy disks, and/or CD-ROMs, and most feature uniformly superb tutorials that will get you

Figure 12.6: Olivia Parker, *Still Life with Soap Bubble, 1996.*

started. Most of the commonly used software packages for image processing also provide the purchaser with a telephone number to call to help sort out any unexpected difficulties that may be encountered.

Begin by doing the lessons in the tutorial in a step-by-step fashion and resist the temptation to skip over the "simple stuff"; repetition of the obvious helps to imprint in your memory maneuvers that are used frequently. Next, apply the lessons learned to an image of your own. After you've spent a few hours using a program, it becomes part of a straightforward routine — no different from burning-in and dodging a print in the darkroom.

Do not be intimidated by the size of the instruction manual that is included in the software package, which often runs to 500 pages or more. Think of the manual as and use it as an encyclopedia to turn to when you need guidance, not as a book that must be memorized before you can start working with images.

Not all software packages are created equal. Some are a pleasure to use, while others are poorly written and documented, and do not live up to expectations. Talk to friends and experts and read the reviews on software packages that appear in monthly computer magazines or a buyer's guide prior to making a purchase.

What to Buy

For photographers who want to explore the emerging world of image processing, the immediate questions are: what do I need to purchase in a basic package? and how much will it cost? In the quickly changing computer world any specific recommendations that appear in a book will be out-of-date by the time of publication. However, in the absence of an unlikely and radical change in direction, the following should remain valid for several years.

Macs

Macintosh systems are proven performers, easy to learn and use, and have defined the state of the art in image processing for many years. The Power Macintosh system is an excellent, user-friendly basic computer, easily expanded into a sophisticated image-processing station. If you have never used a computer before, a Mac is an excellent choice.

PCs

A PC offers a computer architecture that is flexible, easily expanded, and certain to be around for years to come, simply by virtue of the fact that more than one hundred million machines are currently in use and the marketplace continues to grow rapidly. A PC offers significantly more computer power than a Mac for the same amount of money. However, to obtain the best performance and price from a PC you need to be able to deal with a reliable vendor who will provide appropriate guarantees on parts and labor and technical support at all times. Microsoft's Windows 95 should be used as the basic platform for graphics programs.

Options The following is a checklist of options to consider when purchasing a PC.*

Processor (CPU). Mid-range PCs are packaged with Intel's DX4/100, Pentium/60, or Pentium/66 chip, while higher-performance systems utilize faster Pentium processors. Compatible CPUs are available from other manufacturers (for example, AMD, Cyrix, IBM). Purchase the fastest processor you can afford. The preferred size of the processor cache is 256K.

Memory. The minimum amount of memory that should be purchased is 16MB, and larger amounts greatly enhance the performance of the computer for image processing. Computer memory has become a commodity item, and recent prices have ranged from $5 to $50 per megabyte.

Disk Drives. The cost of hard disk capacity is 50¢ to 75¢ per megabyte. Buy a drive with a minimum of 340 megabytes and consider a 520-megabyte or higher drive if the price difference is reasonable. Purchase a CD-ROM drive that delivers at least double-speed performance. Consider adding a 16-bit sound card with *wavetable* (not just FM) features and speakers to exploit the developing uses for CD-ROM.

Graphics. For image processing, an accelerated, 64-bit graphics card with 2 to 4 megabytes of VRAM is highly desirable. While a 15-inch monitor is satisfactory, a 17-inch monitor capable of 1,024 x 768 pixel resolution is more useful and easier to view.

Suppliers. PCs are available from many sources, and a *critical* factor in your selection should be the level of support that you may need to get started. If you're inexperienced, having a local consultant who can assemble and test a system, including the software you will use, is invaluable and worth whatever premium you may need to pay.

Direct vendors and large mail-order houses offer a broad spectrum of lower-priced, custom-configured PCs that are capable of handling image-processing tasks. Many (Compaq, Dell, Gateway, Micron, Zeos, to name a few) have long track records as reputable companies that will customize, stand behind an assembly designed to meet your specific needs, and carefully test their products prior to shipping.

Prices. A high-performance PC with the following features and capable of performing image-processing tasks can be purchased for approximately $2,500 (1998 price): Intel 233MHz Pentium II processor with 512K cache, 32MB DRAM; 17-inch color monitor; 3.2GB hard drive; 3.5-inch 1.44MB floppy disk drive; 12X CD-ROM drive; graphic accelerator card with 2MB VRAM; MS Windows 95; Microsoft Mouse.

There are literally thousands of possible combinations of components that can be assembled to create powerful, custom-designed image-processing workstations (a distinct advantage if you can navigate your way through the options), but unless you have access to technical support it is best to purchase a packaged unit that is configured to meet your needs.

* See *PC Magazine,* December 6, 1994, for a comparison of features and ratings.

Peripheral Devices for Image Processing

The most difficult aspect of image processing does not involve purchasing a computer system or mastering the software that transforms images into flights of fancy or magazine covers. It is the not-so-simple challenge of getting an image into and out of the computer at a level of quality that will withstand critical observation and judgment. In every instance quality is limited by the performance of key peripheral devices whose prices, by comparison, usually make the cost of the most expensive personal computer seem trivial. The real challenge for the segment of the computer industry concerned with image processing is to increase the quality of performance of peripheral devices and reduce prices so that they fall within the reach of the ordinary professional and serious amateur photographer. If the progress that has been made during the past decade is a valid predictor, these goals will be achieved.

Input devices enable you to acquire an image and convert it to a digital format. The tools described below vary in importance, but some are as necessary to electronic image processing as an enlarger is to the darkroom. A by-product of the high cost of some of these instruments is that businesses involved with digital imaging (that is, service bureaus) working with or as part of modern camera stores and print shops have become commonplace, and they provide ultra-high-quality image scans, photographic-quality prints, and other services at very reasonable prices. For the occasional user, a service bureau is a sensible alternative to purchasing an expensive tool that may soon be outdated.

The most important consideration when you purchase or lease an input or output device is the ultimate use of the images created. The requirements of an image intended for display as a work of art are vastly different, for example, from that of a photograph needed to illustrate a magazine cover or for publication in a newspaper. It would be foolish to spend a small fortune on an expensive film scanner if the only use of an image is to illustrate a newsletter. And it would be equally wasteful to purchase an inexpensive slide scanner if the goal is to generate large photographic-quality images that are intended for the walls of an art gallery.

Input Devices

The ideal input device for image processing would be a camera that records the primary information in a scene in digital form and at very high resolution. Filmless cameras fitted with digital recording backs are now in production and are beginning to find a small niche, but their performance, measured by image resolution, flexibility, and sensitivity, pales beside that of film's. However, as quality improves and costs decline, digital cameras will offer an alternative to traditional techniques that many photographers will wish to consider. For the present, anyone interested in electronic imaging needs to evaluate numerous alternatives and balance the inevitable trade-offs between quality, convenience, and cost.

While remarkable progress has been made in the development of digital cameras and still video cameras, issues of image quality remain. *There is simply*

Figure 12.7: Joyce Neimanas, *Baby Tale,* from the Too Late series, 1995.

no electronic or digital substitute for film and the resolution, tonal quality, light sensitivity, and contrast that photographers expect. Furthermore, it is improbable that the current technology and approach to direct digital imaging through a modified camera can be sufficiently refined to rival film performance. In the absence of compelling time pressures, the arguments for using the current generation of digital cameras to capture images are not convincing, and other routes to digitized images are less expensive and produce results that are far superior.

Video Cameras The critical component of a video camera, a digital camera, or camera back is a *charge-coupled device (CCD),* a special type of chip that converts light rays into electrical impulses. Each CCD has thousands of small detectors on its surface that translate an exposure into an array of pixels that can be viewed as an image on a monitor. The cost of a video camera or a digital camera or camera back is largely determined by the degree of resolution that the CCD is capable of producing.

In a typical video camera or camcorder the image is captured by a scanning device that sweeps back and forth across a scene in a pattern and divides the image into a stack of horizontal rows. The scanner is usually a small mirror that sequentially projects each segment of a scene onto a thin line of very small sensors on the CCD. The measured value of the light intensity is stored on an output device and can be displayed on a monitor to create an image. Colors are recorded by passing the light through filters and recording the values for the three primaries — red, blue, and green. Resolution is a function of the size of the segment projected onto the CCD sensor and the number of sensors per inch of the detector.

Video cameras store data on tapes or floppy disks in analog fashion, much the same way as magnetic tape records sound. If the picture is to be used for image processing, a computer program translates the recorded data into a digital format, where the scene is defined by a mosaic of pixels.

Still video cameras. In a still video camera, specially configured CCDs function much like film and record the entire scene in a single exposure. Light is sensed by a rectangular CCD chip that is a composite of a vast array of sensors. Each sensor registers the intensity of light striking it and stores the value on a floppy disk that can be read into the computer and digitized. The advantage of the still video camera over a camcorder or other video camera is that the image is much clearer and sharper. The definition of any video camera image is limited by the size and resolution of the sensor field on the CCD.

Several models of still video cameras are available. The Canon RC-570 contains a ½-inch CCD that records an image at a resolution of approximately 410,000 pixels (910 pixels x 450 lines). The camera can store up to twenty-five images at this level of resolution when used in a single-frame exposure mode. Single images can be added or deleted from the storage disk at will and the camera has a built-in flash unit. Software is available that enables you to transfer the floppy-disk data directly into the computer, where it is converted into a digital format. An optional film adapter enables you to copy slides or negatives directly onto the floppy disk, thereby converting film-based

images to a digital format. The price (1998) of the camera is approximately $3,500.

A more flexible (and more costly — about $7,000) still video camera is the Sony MVC-7000. The camera generates very high-quality video output and has many of the features of any fine medium-format camera, such as interchangeable lenses, electronic flash, remote control capability, and so forth.

Film Video Processors A relatively inexpensive instrument that translates negatives or transparencies into a video image that can be stored on videotape and converted into a digital format is the Tamron Fotovix film video processor. The slide or negative is placed on an illuminated stage, and a fixed lens reproduces the image on a monitor. The zoom lens enables you to capture only a portion of the scene. Up to 1,500 slides can be stored on a 2-hour videotape by connecting the Fotovix to a VCR. Individual images can be converted into a digitized format, which represents the photograph in approximately 410,000 pixels. Prices for the unit range from $900 to $1,900, depending upon the features selected.

A valuable adjunct to video cameras is a *frame grabber,* which isolates a single image from the moving sequence that you capture on videotape. This combination of hardware and software captures either composite or still video input and writes it in a digital format. Digital Vision ComputerEyes Pro provides 24-bit color at a resolution of 640 pixels x 480 lines (307,200 pixels), while the ComputerEyes/RT allows frame grabs at $1/30$ second at a resolution of 512 pixels x 512 lines (262,144 pixels). None of these resolutions are adequate for making large prints intended for display, but they are satisfactory for viewing images on a video monitor or for applications such as newsletters, where image quality is not a primary concern.

Digital Cameras The least expensive digital camera that produces color images is the Kodak DC-20 (about $200, 1998). It produces images of only moderate photographic quality, and even at modest enlargements (4 x 6), prints lack detail and have a pointillistic character, reminiscent of an extremely grainy photograph. At best the photographs may be useful for newsletters or low-end desktop publishing efforts. The camera operates in either standard resolution (16 images at 320 x 240 pixels) or high resolution (8 images at 493 x 373 pixels). Its closest focus point is four feet, and the camera is equipped with a fixed lens. Images are easily transferred to a Mac or PC for processing, but the usefulness of the camera for the serious photographer is limited.

A far more sophisticated digital camera, the Kodak DCS-460, features a Nikon N-90 camera body fitted with a Kodak camera back. The camera captures images in 36-bit color, and the CCD sensor provides an impressive resolution of 3060 pixels x 2036 lines (more than 6 million megapixels). It operates as a typical 35mm camera, but the battery pack and attached storage unit make the outfit quite heavy (about 4 pounds). Sound can be recorded and an exposure can be made every 12 seconds. Kodak also provides for removable image storage in the form of a hard disk or flash memory cards. These are plugged directly into the camera body and can be removed after data have been

Figure 12.8: *Digital cameras.* Digital cameras record and store images internally on a disk or computer memory chip in a digital format. Data can be transferred directly to a computer, displayed on a monitor, and used for all image-processing applications.

Figure 12.9: *Digital camera with pop-up image.* Many digital cameras are equipped with a small screen that displays the image after exposure.

recorded. A card reader enables the information on the cards to be downloaded directly into a computer. Removable storage allows exposure of hundreds of frames without having to transfer the data to a computer. At a price in the neighborhood of approximately $25,000, the camera is clearly beyond the range of most amateurs, but its performance and flexibility does make it an option for professionals who face tight publishing deadlines and who use electronic imaging as the route to print. Photographic prints made from digital data acquired by the Kodak DCS-420 are quite good but still fall far short of the quality obtainable from film.

High-resolution digital camera backs are made for medium and large formats by Leaf and can be attached to a Hasselblad 553 ELX, a Sinar P2, or a Mamiya RZ camera. These are becoming increasingly popular for the production of catalogs and magazines, since an image can be directly dropped electronically into a page makeup an instant after the click of the shutter. A base cost of $35,000 currently limits use of the Leaf Digital Camera Back to the professional marketplace, but if the history of the computer industry is a valid guide, these prices will fall rapidly within a few years.

Photo CD The simplest and most economical way to translate a camera image into digital data that can be accessed by the computer is through a *Kodak Photo CD.* Kodak and independent processing laboratories scan and convert photographic images into a digital format that can be displayed on a monitor and accessed by a computer for image processing. The photo CD provides five levels of resolution for each 35mm image: Base/16, 128 x 192 (thumbnail resolution, 24,576 pixels); Base/4, 256 x 384 (low resolution, 98,304 pixels); Base, 512 x 768 (standard TV resolution, 393,216 pixels); Base x 4, 1024 x 1536 (HDTV resolution, 1,572,864 pixels); Base x 16, 2048 x 3072 (35mm film resolution, 6,291,456 pixels). A single CD can accommodate approximately one hundred 35mm images. While having an entire roll of film transferred to a photo CD is less expensive than scanning individual images, you may not wish to have each frame reduced to digitized form on the

CD — once there, they cannot be replaced. Though more costly, a preferable strategy is to select photographs of interest and pay the additional cost for scanning and recording them separately (approximately $1 per 35mm image).

The *PRO Photo CD* has a sixth level of scanning, Base x 64, 4096 x 6144 (25,165,824 pixels), a resolution capable of producing high-quality photographic prints. These ultra-high scans create large files, and a single image requires 72 megabytes of memory. To work with images of this magnitude, a large amount of RAM is needed. The cost for a PRO Photo CD is slightly higher than for a Kodak Photo CD, but images up to 4 x 5 inches can be scanned at ultra-high resolutions for less than $20 an image.

Most camera stores now offer scanning/photo CD services and deliver a CD and a set of prints within a few days. Special software (for example, Kodak Photo CD Access Plus) is needed to access the data, but this is inexpensive ($40) and easy to use (image-processing programs often incorporate image-

Figure 12.10: Martin Paul, *Measure, 1997.* Original components were captured with a digital camera and then manipulated and combined on Adobe Photoshop.

accessing software in the basic package). Kodak PhotoEdge software enables you to adjust image contrast, sharpness, and color tone and to print the photo on a compatible Macintosh or PC printer. Kodak claims that a photo CD has a lifetime of more than a century, and is therefore a viable means of storing color images that might otherwise fade as prints. A major advantage of the photo CD is that you have both film and very high-quality digital data to work with at a reasonable cost.

Scanners The speed and convenience of converting a photograph to a digitized image on the desktop is a compelling reason to consider the purchase of one or more scanning devices as peripherals for an image-processing workstation. Very high-resolution film scanners are extremely expensive specialty items whose cost ($40,000 and up) can be justified only by large commercial shops. Several affordable 35mm film scanners that produce digitized images of good quality are now available for $750 to $1,200.

Characteristics to look for in a scanner are the optical resolution that the scanner can deliver, the ability to handle image contrast, and the color fidelity of the scanned image. Scanner performance is frequently reviewed by computer magazines and these reviews are worth consulting prior to making a purchase. Most scanners provide resolutions in the range of 400 to 800 dots per inch (dpi), and some include interpolation software that doubles those values. However, interpolation software varies widely in "intelligence" and the results of the process may be disappointing.

The degree of resolution selected depends on the final use of the image being created. If the digitized photo will ultimately be printed on a 300-dpi laser printer, it makes little sense to begin with an image with a far higher resolution. Furthermore, the size of files increases exponentially with resolution, and large images require enormous amounts of file space.

Figure 12.11: *Nikon LS-10 Coolscan.* Desktop scanners convert either 35mm transparencies or negatives directly into digital data.

The Nikon LS-10 Coolscan is a 35mm slide or negative scanner that can either be installed into the computer housing or connected externally to the system. The film — black-and-white or color — is slipped into a slot and positioned for scanning. A preliminary scan is then made and the image is displayed on the monitor. After making any necessary fine-focus adjustments and cropping the image, a scan is made. Before the image is saved in a permanent file, it should be examined for contrast, shadow and highlight detail, and color balance. It is worth spending a bit of time fine-tuning the controls so that the digitized image is as faithful a copy of the original slide or negative as possible. Further corrections of contrast and color balance are easily achieved by using image-processing software, but the quality of the end product is inevitably limited by the input.

The user can specify the desired resolution for the scan, the highest value being 2,700 dpi. This level of resolution is capable of delivering photographic prints of good quality at modest degrees of enlargement. It is excellent for virtually all desktop publishing applications.

The Nikon LS-3510AF is a desktop scanner that delivers higher optical resolution (3,185 dpi) and a broader color spectrum than the Coolscan, but it is considerably more expensive. In the absence of a compelling need for quick, very

Figure 12.12: *Microtek ScanMaker.* Flatbed scanners convert documents and photographs into digital data.

high-quality scans, an investment in a photo CD may be a better alternative.

The Microtek ScanMaker 35t is an economical scanner that performs well, providing optical resolution up to 1,828 dpi. The effective resolution can be increased to 7,300 dpi through the use of an interpolation program that is part of the software package. Interpolated data is not "real," because it represents a computer-generated color value that is an average of nearest neighbor pixels. Despite the artificial nature of these synthesized pixels, the interpolated values considerably improve the quality of the displayed or printed image.

The Polaroid SprintScan 35 is a quick, efficient tool for digitizing 35mm images. The SprintScan 35 scans images at 10 bits per color and processes and transmits data as 24-bit information, capable of generating a spectrum of sixteen million colors. The SprintScan produces images that are free of artifacts, such as unwanted random bands of arbitrary color, which occasionally plague scanning instruments. The scanner's high-resolution capability and features such as image-cropping capabilities, automatic image sharpening, color balance controls, gray scale, and contrast controls, make the Polaroid SprintScan 35 one of the most versatile and effective small-format scanners available.

Flatbed scanners. Resembling small copying machines, flatbed scanners "read" printed images and record color and tonal values as digital data directly into computer memory. Excellent flatbed scanners capable of capturing subtle color and tonal values are available for less than $1,000, and their versatility makes them a very useful input device for image processing.

Typical input for a flatbed scanner would be a photograph. To scan an image, the picture is placed facedown on the glass face of the scanner and covered by a lid. The scanner is controlled from the computer by the keyboard and mouse. At the start a quick scan is initiated to bring up a low-resolution version of the image on the monitor. Most scanners enable the user to crop the area to be scanned so that unwanted portions of the print can be excluded. It is usually necessary to calibrate the scanner so that the color balance of the image seen on the monitor corresponds to the original artwork.

The software bundled with the scanner allows the user to specify resolution, adjust the color balance, and change the image contrast. When a satisfactory scan is completed, the digitized image can be saved to a hard or floppy disk. Because images on paper have a lower contrast range than on transparencies, it is often easier to capture shadow and highlight details with a flatbed scanner than with a low-priced film scanner. However, a print is one generation removed from the originating slide or negative, and valuable details are sometimes lost in that translation.

Handheld scanners. These relatively inexpensive devices look similar to a mouse. They have a roller on the bottom and a window through which the scanner reads the image. Both black-and-white and color scanners are available. After the desired resolution has been set, the scanner is slowly rolled across the surface of a picture or text. Light from the scanner is reflected onto a CCD and then recorded and processed by software that is integral to the scanner. The scanner window is usually 4 to 5 inches wide, and the data are collected and displayed as a column. If you make a series of overlapping par-

allel scans down a page and use an *autostitching* feature of the scanner software, columns can be combined to generate larger images.

Handheld scanners require some skill to use. The quality of the scan depends upon using a steady, consistent, straight-line motion during the scanning process. Varying the speed compresses or stretches the image, while deviations from a straight line skew or twist the image. Some scanners provide adjustable frames to serve as guidance devices. Handheld scanners are useful when portability is important and high-quality output is not a primary consideration.

Output Devices

For most photographers the starting point and desired end product of image processing will be a photograph, whether the computer is used for a simple "clean-up" of a scene with flaws or a complex synthesis of something completely new, stitched together from multiple fragments captured at random or deliberately accumulated. Peripheral devices that produce film or prints would be an ideal addition to a desktop workstation, but the basic cost of high-quality printers that turn out prints or film in a variety of useful sizes and for-

Figure 12.13: Roswell Angier and Susan Hawley, *Versions of Ariadne,* from the Phantom Doll series, 1996.

Figure 12.14: *Epson Color Stylus ink-jet printer.* Ink-jet printers are inexpensive output devices that produce full-color prints of good quality.

mats has been prohibitive. Remarkable strides are being made, and it appears likely that printers capable of delivering photographic-quality images will soon be available at prices comparable to that of a fine enlarger. For the foreseeable future the most viable option for outputting images may be a service bureau that converts digital data stored on a portable hard disk or drive to a print, slide, negative, or halftone that meets your needs.

Printers are peripheral devices that convert digital information into words and images. Countless high-quality laser printers deliver superb print quality at modest cost, but for photographic images, the current options are more limited — and expensive. In addition, consumable supplies — special paper, color cartridges, and the like — are a continuing significant expense.

Currently there are several basic technologies for printing color images from a computer database: ink-jet printers, dye sublimation, and thermal-wax transfer. For photorealistic images the only printers that currently produce photographic quality prints use either dye sublimation or thermal-wax-transfer technology, but the print quality produced by a few ink-jet printers (the Epson Color Stylus and the Hewlett Packard printers are exceptionally good) make them low-priced alternatives that produce impressive results for the money.

Current prices for a quality dye-sublimation desktop printer fall in the range of $8,000 to $10,000, with the exception of the Fargo printer, which sells for less than $1,500. Dye-sublimation printers require several minutes to produce a print, because three or four passes over the paper are needed to produce a full-color image. Inexpensive printers require a much longer printing time to output an image than more costly models do.

Dye sublimation relies on pinpoints of heated wires that sublimate dyes from a transfer sheet onto the printing paper. Primary colors are superimposed to generate different colors in a seamless fashion that is virtually grain-free. Because special paper is needed to receive the dyes, the average cost of a print will exceed $3.

Thermal-wax-transfer printers are less expensive than dye-sublimation printers and produce full-color images of photographic quality that fall just short of the quality of a dye-sublimation print. The per-page cost of a print is in the range of 50¢ to 80¢.

Numerous photographic-quality printers are available (the Kodak ColorEase PS and the Tektronix Phaser IISDX are two printers that perform well), and prices are falling into a range that makes them a plausible accessory for a computer workstation. If you are considering a purchase, be sure to take with you to the dealer a disk loaded with an image file and have it printed out on several different brands of paper. Compare the images closely to be certain that the print quality lives up to your expectations before you buy.

Two important determinants of print quality are color fidelity and image resolution. The dyes chosen by manufacturers to generate full-color images are imperfect matches for the primary colors. For example, the Kodak ColorEase PS printer generates vivid, highly saturated colors, but images have blue overtones and high contrast, while the Tektronix Phaser IISDX produces prints with a slightly greenish cast and lower contrast. Some of these characteristics can be mediated by altering the color balance of the image on the computer

Figure 12.15: *SyQuest external hard drive.* External drives let you store and transport large data files at a very low unit cost.

Figure 12.16: *CD-ROM writer.* A CD-ROM is a convenient way to store large data files. A recording device can be connected to any computer as a peripheral accessory.

before sending it to the printer, but as with printing color photographs from slides or negatives, each brand produces a spectrum of colors that is unique.

The image resolution of a computer printout is determined by the number of dots per inch that a scanner can record *and* that the printer is capable of delivering. With dye-sublimation printers, dye diffusion often makes dot patterns virtually invisible even at resolutions below 200 dpi, but at low resolutions an image may suffer from the jaggies, a stair-step pattern that manifests itself in the printing (or viewing on a computer monitor) of diagonal lines and curves. The source of the jaggies may be inherent limitations of the scanner or the printer, and the qualities of both need to be considered and evaluated. As always, increased quality has a price tag associated with it, and the higher the quality and resolution of a printer, the more substantial is its cost.

A further word of caution is in order. Dye-sublimation prints and thermal-wax-transfer prints are not light stable, and color balance shifts after a few months of exposure to bright light. Color stability for images stored in a cool, dark setting is fine, but none of these color prints have archival characteristics.

A convenient, high-performance digital color printer is the Sony UP-D7000. It prints either color or black-and-white images on 8½ x 11-inch paper or transparent plastic sheets. Prints are sized and oriented by the computer prior to being sent to the printer. Resolution is 163 dpi and the photographic quality of an image is actually enhanced by a slight amount of dye diffusion that occurs on the surface of the paper. Each of the colors used to print an image can be displayed in 256 different gradations of tone, which generates a palette of more than sixteen million colors. Prints are remarkably vibrant and rich, and a full-color print requires about 140 seconds to make; black-and-white images are printed in 60 seconds. The number of copies printed is controlled by a setting on the printer control panel, and up to twenty copies at a time can be made. The printer also has controls for adjusting color balance and intensity (saturation) that modify settings on the computer and can be used to fine-tune images so that what you see on the computer screen is the same as what appears in the print. The Sony UP-D7000 and later models are easy, reliable printers to use.

Low-cost color printers are beginning to appear on the market; one example, the Fargo Primera, delivers good-quality dye-sublimation or thermal-wax-transfer images (depending on how the printer is configured) at reasonable cost. The street price of the printer is approximately $1,300, and the near-photographic quality of the images produced makes the Primera a useful tool for evaluating or proofing work in progress. The Fargo Primera relies on the computer to drive the printer, which accounts for its low cost, but 9 to 12 minutes may be needed to print a full image. As with all dye-sublimation printers, special paper is required, which makes the per-print cost high (about $3 per copy).

An alternative to owning a printer is to send the digital data that you have generated from image processing to a service bureau to convert it either to film or a print. Data can be written on a removable SyQuest hard disk or a Zip™ or Jaz™ or SyQuest external hard drive or compressed onto floppy disks. The service bureau transfers the data to a film writer, a peripheral printing device that produces a 35mm transparency or negative that, in turn, can be used to make a print electronically or in the traditional manner.

Output of digital data to film has an obvious appeal because the digitally altered image can easily be translated into a traditional photographic print. However, the prices for high-quality film recorders range from $20,000 to $50,000, which means that a service bureau will charge a lot ($50–$100) to produce a photographic-quality transparency. Images for applications in which lower resolution is acceptable (for example, lecture presentations or multimedia displays) cost far less and can be obtained for about $5 per slide. As the usage of service bureaus increases, the cost of services will continue to fall substantially.

Polaroid makes an economical film recorder that produces up to 4 x 5-inch images. The software is programmed for use with Polaroid film, but it is straightforward to program exposures for all films. The recorder comes with a Polaroid back, but it also accepts ordinary sheet film holders. Current list prices are approximately $3,900.

Summing Up

The dawn of the digital age has presented us with an immensely powerful new tool for making and shaping photographic images, and the creative potential of this medium is just beginning to be explored. The capital investment required to practice the art is substantial and constitutes a barrier to entry, but costs are falling rapidly while new developments increase the power and scope of digital imaging. Consider attending one of the many excellent workshops on electronic imaging that are available — these are an efficient way to learn the basics and to gain an insight into the nature and limitations of various pieces of equipment.

A reasonable strategy to follow is to acquire a basic computer system (which has many other uses) with as much RAM as you can afford and expand the system as your resources allow. Instead of purchasing a spectrum of high-priced peripherals, consider using service bureaus to take care of input and output needs during the exploratory phase of the learning process and add other items such as printers and scanners as the need arises.

Chapter Thirteen

Digital Imaging

Photography Is a Language. The concept underlying this phrase is a very important one indeed. It leads to a better understanding of the scope and power of photography as a varied medium of expression and communication. Just as in the media of the written word we have poems, essays, scientific and journalistic reports, novels, dramas and catalogues — so with photography we touch the domains of science, illustration, documentation and expressive art. — ANSEL ADAMS

A photographic negative or transparency is simply information collected through the lens of a camera and recorded on film. Making a contact print, enlarging a negative, or viewing a projected image is an act of interpretation, equivalent to reading the written word or hearing it recited. Digital imaging, a process that enables you to work with photographic data on a computer, is unquestionably the most powerful technique yet devised for interpreting and transforming photographs, and its creative potential appears to be limited only by the imagination of the photographer.

It is unfortunate that the word *manipulation* rather than *creation* is often used to describe the genesis of a photograph by digital imaging, since *manipulation* often has a pejorative connotation, signaling dishonest, impure intentions.

In point of fact, it is difficult to find a computer technique for which there is no classical photographic precedent. The techniques of coloring, collaging, using multiple images to make a single print, creating optical distortion, masking, dodging, burning-in, altering contrast, blurring, overpainting, texturing, and so forth, have all been used by photographers and artists since the nineteenth century. The computer and its accessories are just twentieth-century tools that allow the same ends to be achieved.

A digitized image is simply a photographic data file that contains as much of the information incorporated into a negative, print, or transparency as computer memory permits. For the vast majority of digitized images, the computer is only a sophisticated enlarger that can carry out operations identical to those that can be accomplished in the darkroom — but with superior results and much less effort.

By any standard, a photographic print made from a digital file of a carefully scanned negative or transparency is visibly sharper and truer in color, with vastly better resolution of fine detail, than *any* print that can be made by traditional enlargement with the finest available enlarging lenses. By going directly from digital photographic information to the print, all of the image degradation due to flare is eliminated. Unfortunately, the prices of high-qual-

Figure 13.1: Judy L. Miller, *Agave #2, 1995.*

ity digitally generated prints are also currently significantly higher than you would pay for a simple enlargement; this will undoubtedly change as the cost of computer equipment declines and demand for quality printing increases.

Beyond question, the integration of photographic and computer technologies will come to be recognized as one of the pivotal events in the history of photography. For those who struggle with or rebel against the intrusion of a new technology into "traditional" photography (if, indeed, there is such a concept), keep in mind that a work of art will always be judged on its own merit, not by how it was created. The marriage of the computer with the camera presents new opportunities for creative image making and will expand our vision in new directions. And because computer technology will unquestionably dictate the future of color photography, those who want to explore this field fully will need to be familiar with, if not proficient in, the various opportunities this new technology has to offer.

Camera shops and bookstores abound with hundreds of books and manuals on electronic image processing, while monthly magazines feature articles describing the latest advances in the field. The abundance of written material now available can ease entry into the realm of electronic imaging, but the sheer volume is equally likely to intimidate the potential user into questioning whether or not these techniques are destined to be an integral part of photography or just a passing fad that can safely be ignored. I believe that digital imaging will dominate the future of photography and make its presence felt everywhere from simple snapshots processed at the corner drugstore to fine prints that are exhibited in the leading art galleries and museums. For the foreseeable future, film will remain the preferred primary recording medium for cameras, but much of the traditional activity carried out in the photographer's darkroom, particularly in the field of color photography, will move into the domain of the computer. Superior technology inevitably becomes dominant.

What kinds of traditional darkroom activities are easily performed at a computer workstation? Dodging and burning-in can be accomplished over a broad area of a photograph or on a microscopic portion of it. Scratches, pinholes, and other negative defects are easily fixed; image contrast can be altered at will (on either the entire photograph or a small fraction of it); images can be combined to create a montage; colors can be changed to any one of millions of distinct possibilities; four-color-separation negatives are available at the touch of a button; negatives can be enlarged or copied without loss or change of contrast, highlight, or shadow details; faded images can be restored to their original densities and tonal values, and so forth. With access to the appropriate equipment and software, any and all of these transformations can be accomplished with results equal to or better than those that can be achieved in the best photographic laboratories and darkrooms by highly skilled professionals. Beyond these traditional and straightforward "darkroom" processes, digital imaging offers creative possibilities well beyond the capabilities of the experienced photographer and the most sophisticated darkroom facility.

While most, if not all, of these electronic transformations can be accomplished on reasonably affordable personal computers, the cost of acquiring high-performance output devices that generate photographic-quality prints or

Figure 13.2: Alan Ross, *Ansel Adams, San Juan Bautista, California, c. 1975.* Polaroid SX-70 print. (A) The original print was underexposed and low in contrast. (B) Scanning the print on a flatbed scanner created a digital file that was read by Adobe Photoshop 4.0. The program was used to restore colors and image contrast, remove scratches, and enlarge the image. The restored image was printed as an enlarged dye-sublimation print.

A

B

transparencies places them in the domain of the professional studio. If current price trends continue, however, this barrier may soon disappear. Photographers who intend to use electronic imaging as a tool should establish a relationship with a firm that specializes in the field and can deliver transparencies and prints that color-match the images you create on your computer monitor.

Before You Start

Hardware Requirements

Electronic imaging requires a basic computer system that has the ability to input and output image files. If you are considering the purchase of a computer look for one equipped with at least the following features:

1. a 120-megahertz Pentium processor or its equivalent
2. a 2-gigabyte hard drive
3. an 8X CD-ROM drive
4. a 17-inch color monitor
5. 40 megabytes of RAM

In addition to these features, useful accessories are an ink-jet printer, a flatbed scanner, and a film scanner (see chapter 12, pages 312–323, for a detailed discussion of equipment). The current (1998) cost of a system that includes items 1 to 5, above, is in the range of $2,000 to $2,500.

A growing number of photo dealers are developing well-equipped image-processing centers that photographers can use on an hourly rental basis. These are an excellent way to learn about digital imaging and explore the capabilities of various systems before you make a significant capital investment in equipment.

Choosing Software

Numerous software packages are available to photographers who work with digital images, and though they share a common thread of basic capabilities, each has features that may be useful, unnecessary, or limiting, depending upon your objectives. Software prices range from under $100 for basic programs to over $1,000 for comprehensive packages that enable the user to carry out sophisticated desktop publishing operations. By far the most widely used software package for photographic images is Adobe Photoshop, which is available for both Macs and PCs.

The instruction manuals that accompany the most commonly used software packages are uniformly well illustrated, clearly written, user friendly, and easy to understand. For all of the examples cited in this chapter Adobe Photoshop (version 2.5, 3.0, or 4.0) was used. Its features can handle essentially all of the tasks likely to be encountered by a photographer, and it interfaces seamlessly with peripheral devices such as scanners and printers, making the importing and exporting of image data a simple operation.

Icons that symbolize transformations are fairly standardized, and once you learn how to use one software program, it is easy to understand the characteristics of another. Numerous programs (Corel Draw, Paintshop, and so forth) are capable of carrying out most common operations of interest to pho-

Figure 13.3: *Electronic imaging programs.* A variety of programs suitable for image processing are now available. Programs range from those intended to enhance and print snapshots to others that are incorporated into sophisticated publishing software.

tographers, and it is worthwhile to compare their features (and prices) prior to making a purchase. Publications such as *Computer Artist* feature reviews of software and offer a diverse gallery of images, most of which use photographs as a starting point. These publications and their images are worth studying to gain an appreciation of the range and power of electronic imaging techniques.

Calibrating Your System

To be certain that the image on your monitor reflects the appearance of the original image as obtained from a scanner or photo CD and that a print or transparency made from the digital image has the same color and contrast you see on the monitor (allowing for the differences in media), the monitor and each peripheral device that you use should be calibrated. This means that the controls on each device should be set by you so that *what you see is what you get* (abbreviated WYSIWYG and pronounced "wizziwig" in computer circles). Most software packages contain a test image that you can use as a reference in the calibration procedures.

Calibration is a simple procedure and takes only a few minutes for each device that you use. If you do not calibrate your computer equipment you will waste time and money at each stage of image processing and find that the final image bears little resemblance to what you imagined you were creating. Not calibrating image-processing equipment is analogous to taking a photograph without any idea of what film speed or development time should be used.

Skyline, Clouds, Guilin, China, 1980 and 1997

At the time this photograph was taken, China had terrible problems with air pollution. In addition to unchecked industrial pollution, a huge percentage of the population had only charcoal to serve as a cooking fuel. As a consequence, every morning and evening, vistas in heavily populated areas could become almost completely obscured. Such was the case on the evening this image was made from the rooftop of my hotel. The 4 x 5 negative was given ample exposure, but, alas, I gave the film only normal development, though it could have profited by plus 2. The image has always been terribly difficult to print in the darkroom. I used to have to print it on Seagull Grade 4 (very contrasty) paper and have an assistant in the darkroom with me to help with the dodging (I needed more than two hands!). I figured this would be a likely candidate for testing current digital technology.

To create the image using digital technology (Adobe Photoshop 4.0), I scanned the original negative as a transparency and then inverted it (A). The result revealed a scene that was very flat and pale, so I expanded the tonal range of the image and saved it as the background layer of a new file. I then created three different adjustment layers to dodge and burn-in selected areas of the image, just as I had done in the darkroom using traditional techniques. The digital image at this point lacked vitality, especially in the foreground structures, so I duplicated the background image as a separate layer and increased the contrast of the new image to build up the contrast of the total image. I then created a layer mask to limit the effect to the lower half of the image. I wanted to make an Iris print that was not something I could do in the darkroom, so I decided to create a sepia-style duotone (B). After choosing a color for the duotone, I set a curve, so that the second color would be applied primarily to the midtones with little color in the whites and blacks.

While this current affair with a computer is not likely to cause me to fall out of love with traditional photographic techniques, it is a relationship I am happy to embrace and expect to continue. While the Iris print shown here does not have the tonal nuances or clarity of detail evident in a selenium-toned gelatin silver print, it does have a warmth and tactile richness that make it wonderful in its own right. The computer merely offers the artist another powerful means of expression.

— ALAN ROSS

A

B

Calibrating Your Monitor While manufacturers try to adjust and ship their products to agreed-upon standards, variations in performance are inevitable. The best strategy to follow is to begin by calibrating your computer monitor relative to the printing device that you intend to use. Some companies offer printing services to photographers working with digital images and supply kits with detailed instructions on how to adjust the monitor so that its image corresponds to the print they will produce from your digital file. For example, the EverColor Corporation sells the EverColor Calibration Kit for $29.95, which contains a test print, a digital file of the image, and an instruction booklet that provides details on how to use Adobe Photoshop to carry out the simple steps involved in calibration.

The object of the calibration is to adjust the monitor image so that it matches the provided print as closely as possible. If you use the EverColor Calibration Kit, proceed in the following way. Insert the disk containing the file titled "EverColor Test Image" into the computer and open the file in your imaging software.

Turn on the computer and allow the monitor to warm up for about 30 minutes to ensure its stability. Adjust the room lights to the level of illumination you intend to use while working with computer images and adjust the brightness and contrast controls on the front of the monitor so that the image intensity and contrast are visually comfortable. *Tape down* the control dials so that they will not inadvertently be moved once they have been set. Change the background color on the monitor to light gray.

The steps in calibration are listed below. Details on each step are on the pages that follow.

1. Adjust the white color on the monitor to match the white tone of your printing paper.

2. Adjust the contrast of the monitor by making the changes needed to reproduce a complete gray scale.

3. Adjust the color balance of the monitor to eliminate any visible color tints from the gray scale image.

4. Save the above settings by following the instructions in the dialog boxes that appear on the computer monitor screen.

5. If you know the specific characteristics of the printing inks used by your printer, enter the data in the table that is incorporated in the software program. Otherwise, use the default settings incorporated into the program.

Calibrating Your Printer If you have a printer connected directly to your computer, the printer will likely offer a range of independent adjustments that can be made to control color balance, print density, and print contrast. Most image-processing packages (including Adobe Photoshop) contain a digitized image consisting of a range of color patches, a gray scale, and a multicolored photograph that is intended to help you to calibrate your computer system.

After you have calibrated the monitor, make a print of the digitized image and compare it to the image on the monitor. Use the controls on the printer to adjust color balance, print density, and print contrast. Work to achieve as close a match as you can *but be prepared to accept substantial compromises.*

Figure 13.4: *EverColor Calibration Kit.*

A modestly priced ink-jet or dye-sublimation printer may not be able to reproduce the color and gradation of tonal values that you can achieve in a color photograph or through a high-quality printing process that relies on four-color-separation negative processes to achieve realistic reproductions. When you have come as close as you can to matching the printed image to the monitor, note and save the printer settings for all future applications.

Some ink-jet printers such as the Epson Color Stylus enable you to print at resolutions of 180 dots per inch (dpi) (draft print mode), 360 dpi, or 720 dpi (high-resolution mode). This feature allows you to examine and analyze a quickly made draft print of an image you are working on and not take the extended time needed to print images in the high-resolution mode. At the higher resolution (720 dpi) — and significantly longer printing time — much more ink is transferred to the paper, and the printed image will have more saturated colors than one printed in either the 180 dpi or 360 dpi modes. A set of comparison prints of a standard image will enable you to visualize how the final print will differ from the draft version.

Figure 13.5: *Comparison prints.* A set of comparison prints lets you see how the final print will differ from the draft version. (A) is printed in the CMYK mode, (D) is printed in the RGB mode, and (B) and (C) are printed with different dpi settings, which influences their color saturation — the greater the dpi, the more saturated the colors.

A B

C D

The Epson Color Stylus also enables you to print in the RGB (three-color) (see figure 13.5D) or CMYK (four-color) (see figure 13.5A) mode. The differences in color rendition are readily noticeable in the prints, and vastly superior color reproduction is achieved when the CMYK mode is used. Always use the CMYK option on a printer if you have a choice.

Calibrating Your Scanner(s) Both transparency and flatbed scanners have adjustments that allow you to exert a degree of control over image contrast, brightness, and color balance prior to making a high-quality scan. This is usually accomplished by doing a prescan of the image, examining the result on the monitor, and making a few adjustments to achieve a closer match between the original and the scanned image. Unless the scanned image differs radically from the original, most workers find that it is easier to make small changes on the digitized image after scanning by using the capabilities of the image-processing program.

Figure 13.6: *Calibrating your scanner.* Scan a print that has a wide range of colors and a gray scale without making any adjustments to the factory setting on the scanner. Compare the image that appears on your monitor (A) to the print and, following the directions included in the scanner manual, make whatever adjustments are necessary in the shape of the line (B) to achieve as close a match as possible. Unless there is a great disparity between the scanned image and original print, it is usually best to leave the scanner settings alone and make changes in color and contrast using an image-processing program.

A

B

Working with Digitized Images

Photographers are, in a sense, composers and the negatives are their scores. They first perform their own works, but I see no reason why they should not be available for others to perform. In the electronic age, I am sure that scanning techniques will be developed to achieve prints of extraordinary subtlety from the original negative scores. If I could return in twenty years or so I would hope to see astounding interpretations of my most expressive

images. It is true no one could print my negatives as I did, but they might well get more out of them by electronic means. Image quality is not the product of a machine, but of the person who directs the machine, and there are no limits to imagination and expression.

The best and ultimately the *only* way to learn image-processing techniques is to sit down at a workstation and, using the tutorials and manuals that accompany the software, go through each of the steps described. Within a few hours you can learn most of the basic maneuvers and you will have enough background information to proceed on your own. After that it is simply a matter of adding to your understanding of the processes and increasing your skill level. As you repeat operations they are quickly ingrained in your memory and become as automatic as focusing a camera lens before you take a picture.

The manuals and tutorials that accompany every package of image-processing software are generally straightforward, fun to do, and easy to follow. Approach the reference manuals as you would a dictionary or encyclopedia — when you want to try something different, look up and review the general procedure, then apply it to your own application.

The descriptions and examples that follow illustrate the approach to digital imaging used by Adobe Photoshop, software that I use with both a PC and Macintosh. (In my experience there is no functional difference in performance between the two systems, although different software packages must be purchased for each computer system.) The examples are intended to serve as an introduction to the concepts and routine procedures used in electronic imaging. While specifics will vary with individual programs, the core of the illustrated procedures are common to virtually all of the useful software packages currently available. Attending an imaging workshop is an excellent strategy for speeding up the learning process.

Figure 13.7: *The Adobe group of programs.*

Using the Menu Bar

All programs and subroutines are activated on the computer by moving the cursor to the appropriate icon or heading and clicking the left-hand button on the mouse *or*, on a PC, by striking the ALT key plus the underlined letter in the heading. Begin by activating the Adobe group of programs. This creates an expanded box containing the Photoshop symbol, which is activated by a double click. (Note that the contents of the box labeled **Adobe** will vary and depend upon how the program was installed, whether past versions have been retained, and so forth.) After Photoshop's title page disappears, you will be left with a working screen. This blank screen has a menu bar across the top of the screen, and a toolbox bar down the left-hand side. Each heading on the menu bar (**File, Edit, Image,** and so on) activates its own drop-down submenu, and each entry on the submenu initiates programs and routines needed for image processing.

Because a review of each program contained within Adobe Photoshop or any other image-processing program would duplicate the better-detailed coverage in your software manual and tutorials, I will review only the highlights and some of the more important and useful image controls and features. (*Note:* All illustrations shown in this chapter were created on a PC by using Windows 3.0 as the operating system. Once the Adobe Photoshop program is running, the screens and operations on a PC and a Mac are virtually the same.)

File Activating **File** reveals a submenu that has entries in either black or gray typeface. For every entry on the menu bar, only those submenus in black type can be used at that stage of image processing. The **Preferences** heading opens the programs you need to calibrate the computer monitor and enter data on printing ink characteristics and so forth. **New, Open, Open As,** and **Acquire** are used to call up an image on the screen. **New** creates a blank screen whose size and resolution you can specify and on which you can subsequently enter or draw an image.

Figure 13.8: *The File submenu.*

Open displays a panel that lists images that can be accessed on various drives or disks. **Drives** displays all of the active drives on your computer, and when you specify a drive, **Directories** lists the programs stored at that address. **File Name** simultaneously lists all of the images that are stored under a program heading. Clicking on a file name brings the image to the screen or, in the case of a photo CD, displays a new dialog box that shows a thumbnail sketch of the image and enables you to specify the desired resolution of the file. After specifying the requested parameters, click **OK** and the image will appear on the monitor.

Figure 13.9: *The Open screen.* This screen shows the names of the various files contained in the program.

Figure 13.10: *A new dialog box in Photo CD.* This screen shows a thumbnail sketch of the image and allows you to specify various parameters.

Figure 13.11: *The image.* An image appears, based on the parameters you specified.

If a digitized form of the image is not available, you can use the **Acquire** feature to activate a film or flatbed scanner if you have these peripherals. My flatbed scanner is connected as a **Twain** device, and choosing that option displays the control panel available for my scanner. After specifying options, **Scan** imports the image directly to the monitor screen.

The last four images that you worked on are listed at the bottom of the **File** menu, just above **Exit.** Clicking on any of these entries will retrieve that file and display the image on the screen.

Once a file has been opened, the gray headings in the **File** menu change to black, signifying that these options are now available. For example, **Place** allows you to insert a file from another image-processing program, Adobe Illustrator, into an existing Adobe Photoshop document. This is often used in desktop publishing tasks. **Close, Save, Save As,** and **Save a Copy** do what the headings imply. **Revert** is a useful command that restores a file to its original state. If you carry out several transformations on an image and decide that the result is not what you wanted, **Revert** will return the original document to the screen. Revert can be activated only after a transformation has occurred.

Export is used to save documents in other file formats or to send the document to an alternative printer or other peripheral device.

Figure 13.12: *Available options.* Once a file has been opened, the options under **File** change from gray to black, indicating that they are available.

Edit The **Undo** command displays the last operation carried out by the computer. Using this option undoes the previous step *only* and restores the image to its earlier state. The **Revert** command (under **File**) undoes *all* of the transformations made to an image and redisplays the original image file.

Cut, Copy, Paste, Paste Into, Paste Layer, and **Clear** are all commands that enable you to work with *selected* portions (see page 350) of an image and move them into a new document or around the existing document. The **Fill** command applies the foreground color (see page 357) to a selected area of the image. The **Stroke** command is used to fill the border around a selection. The **Crop** command is a device for cropping a segment of the image that has been outlined using one of the marquee tools from the toolbox (see page 353). I created a poster by using these simple commands to create a compound image (see pages 357–367).

Instead of using a color to fill in the image background, Adobe Photoshop has a large number of patterns built into the software that can be

used to create interesting fills. The **Define Pattern** option is used to specify the desired pattern, along with parameters such as the scale and resolution of the pattern.

The **Take Snapshot** option stores image data for the current selection in a buffer created by Adobe Photoshop each time you work with a file. You can alter an image and choose **Take Snapshot** to save the changes applied (not the image itself). If you subsequently decide to undo some of the alterations, you can go back to the original image and use the **From Snapshot** command along with one of the copying tools to selectively apply the previous changes to a portion of the image.

Mode　The **Mode** command defines how the data of the digital image file are organized, presented on the screen, and transmitted to a printer or other device. **Bitmap**ped images consist of 1 bit of color (black or white) for each pixel and constitute the smallest possible files for an image — consequently, there are few editing options available for bitmapped files. **Grayscale** images have 8 bits of data per pixel and use a 256-step gray scale to characterize the image. **Duotone** allows you to use two inks to print a black-and-white image — a single black ink can reproduce a gray scale only with approximately fifty steps, but by using a second ink such as brown or cyan, you can expand the printed tonal range significantly. With four inks the quality of reproduction can be further improved.

Indexed Color reduces the image data to a palette limited to 256 colors that are contained in a "look-up" table that the computer references. **RGB Color** uses the three primary colors (red, green, and blue) to reproduce up to 16.7 million colors on the monitor. It is the mode used by most color scanners and by image-editing programs. **CMYK** files represent color data in terms of

Fig 13.13: *The Mode menu.* The options in the **Mode** menu define how the data of the digital image file are organized.

Figure 13.14: *The Grayscale option.*
Grayscale is checked off, indicating the image will be characterized by a 256-step gray scale.

cyan, magenta, yellow, and black components. High-quality color printing presses operate in the CMYK mode. **Lab Color** uses three components to generate full-color images and offers you a simple way to alter the luminance of a pixel independent of the color values. The **Multichannel** option opens an additional data channel when you are working with grayscale images and enables you to enhance the printing quality of these images. As you gain experience with image processing and learn more about the reproduction of images in printing processes, you will learn how to select the best mode for a particular application.

Image The options activated under **Image** primarily deal with parameters that control image appearance and format. **Map** contains several features that are useful to photographers: the **Invert** command change a positive image into a negative or vice versa. **Posterize** enables you to convert a normal image directly into "posterized" renditions. The degree of posterization is controlled by specifying the number of gray levels or brightness scale to be used by the computer in assigning color values and then applying those commands. **Equalize** and **Threshold** are tools for adjusting the luminosity of the image and for setting limits on the intensity of pixels that are displayed.

Figure 13.15: *The Image menu.* The options available under **Map** appear here.

Figure 13.16: *The Invert option.* **Invert** changes a positive image to a negative one.

Figure 13.17: *A normal image.*

Figure 13.18: *A posterized rendition of figure 13.17.*

Figure 13.19: *Another posterized rendition of figure 13.17.*

Activating **Adjust** exhibits a submenu with ten further options. These enable you to display and alter histograms (see below) or characteristic curves, to change image brightness and/or contrast, alter colors and their saturation levels, and change the color balance in any way you choose.

Figure 13.20: *The **Posterize** option.* Using **Posterize,** you can specify the number of gray levels or brightness scale.

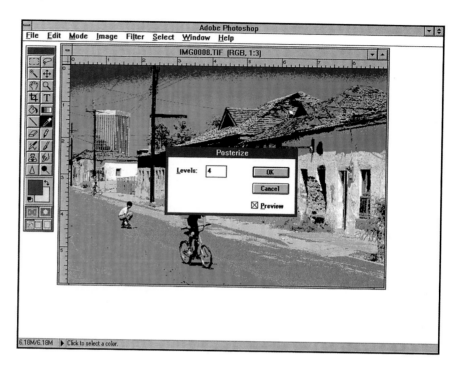

Figure 13.21: *The **Adjust** option in the **Image** menu.*

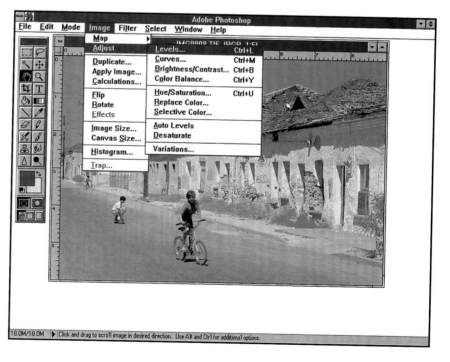

One of the most useful options under **Adjust** is **Variations.** Activating it displays a "ring-around" — that is, thumbnail resolutions of the image arranged as a color wheel, along with a panel of images at three different brightness levels. The original image is displayed in the upper left-hand corner and serves as a reference. To its right is the latest variation you have selected. The degree of change that takes place in any one step is controlled by a sliding scale that varies from "fine" to "coarse" incremental changes. Adjustments can be made selectively to the shadow areas, midtones, and highlights and in the color saturation.

Figure 13.22: *The **Variations** option in the **Adjust** menu*. **Variations** displays thumbnail resolutions of the image arranged as a color wheel, plus a panel showing the image with three different brightness levels.

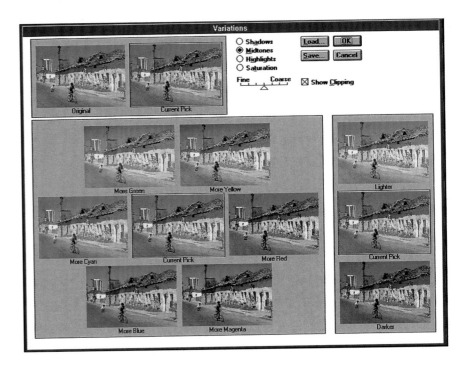

Once the panel of image options is displayed, simply move the pointer to a selection (for example, "More Yellow") and click the button on the mouse. The chosen variation moves over to the "Current Pick" box and a new set of variations immediately appears in the color wheel and other boxes. Using this technique you can achieve an appropriate color balance in just a few moments. When you have an image that meets your criteria, click on **OK;** the screen will now display the new version of the image and the digital file will be altered accordingly.

Duplicate creates a second copy of the original image. It is often useful to have a copy of the original or of your latest modification on display as a reference while you make changes.

Flip enables you to reverse an image in either a horizontal or vertical direction. **Rotate** turns an image in either a clockwise or counterclockwise direction 90 degrees, 180 degrees, or at any specified angle.

Effects is activated only after a portion of an image has been *selected* (see below). It enables you to change the shape or scale of areas of an image such as by skewing it, changing it from a rectangular shape to an irregular geometry, or altering the perception of perspective.

Figure 13.23: *The **Flip** option in the **Image** menu.* Using **Flip** you can reverse an image either horizontally or vertically.

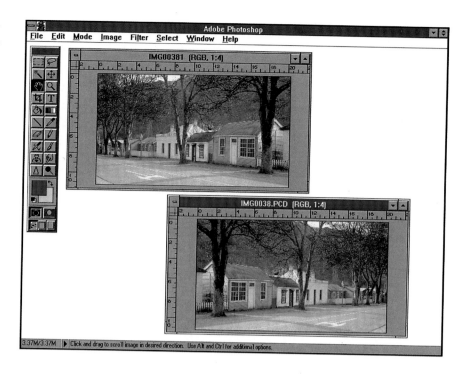

Figure 13.24: *The **Effects** option.* The **Effects** option in the **Image** menu lets you change the shape of selected areas of an image.

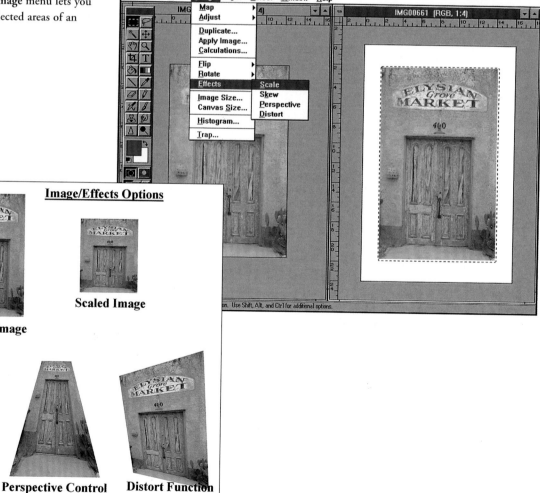

The **Image Size** option specifies the size of the image output as data is sent to a printer or other output device. The program offers the option of changing the width, height, or resolution of the output image.

Canvas Size defines the dimensions of the working area on which the image appears. This is similar to changing paper size at the enlarger without changing the image magnification.

Histogram produces a bar-graph profile of how pixels are distributed along the characteristic curves of an image. The display box contains a mathematical summary, a bar graph, and a color bar that displays the color scale along the horizontal axis of the histogram.

Trap is a printing term that refers to the intentional overlap of color separations created so that small mechanical misalignments of printing plates will not generate color gaps or affect the final appearance of the printed image.

Filter The **Filter** menu contains several options that carry out frequently employed image transformations. For example, most digital images will benefit from a degree of sharpening, and activating the **Sharpen** filter results in a visible increase in image crispness, both on the screen and in printed output. Figures 13.26 to 13.30 illustrate only a small fraction of the various filters' effects that can be achieved.

Figure 13.25: *The Filter menu options.* The various options in the **Filter** menu let you transform the image further.

Figure 13.26: *The **Pointillize** option in the* ***Filter** menu.*

Figure 13.27: *The **Mosaic** option in the* ***Filter** menu.*

Figure 13.28: *The **Posterize** option in the* ***Filter** menu.*

Figure 13.29: *The **Polar Coordinates** option in the **Filter** menu.*

Figure 13.30: *The **Polar Coordinates** option in the **Filter** menu.*

Select The **Select** menu contains options for maneuvering and altering the characteristics of portions of the image that have been isolated by one of the selection tools. Selected areas can be moved to other documents, modified as you choose, or saved as individual documents. If you choose **Float,** the selection can be moved to another location within the image while the original remains in place. If the **Float** option is not chosen before the move is made, the section that is moved will be replaced by the background color.

Figure 13.31: *The Select menu.* The **Select** menu contains options for changing portions of the image that have been isolated by one of the selection tools.

Figure 13.32: *Selecting a section to be moved.* Dotted lines indicate an area that has been selected to be moved to another location. The **Float** option in the **Select** menu moves a selection to another location.*

* While not recommended for a photojournalist, moving a pyramid is a graphic example of the capabilities of Photoshop. If a scene is being presented as part of a photojournalistic presentation, a photographer has an obligation to point out changes that were made. Distortions for the sake of "art" are probably all right (unless the intention is to deliberately mislead the viewer) but should be noted.

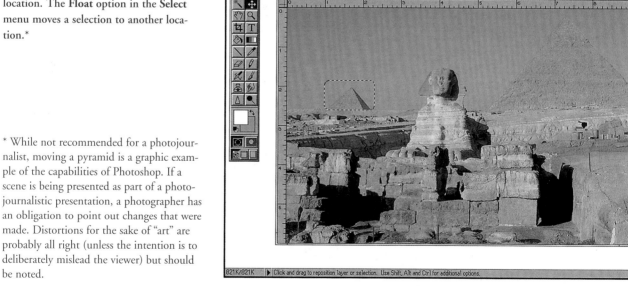

Figure 13.33: *Moving a section.* **Float** moves a selection in the original image (A) to another location within the image while the original remains in place (B).

A

B

Figure 13.34: *Moving a section before choosing Float.* If **Float** is not chosen before the selection is moved, the location where the selection was will be filled in with background color.

Window The **Window** menu controls what you see on the screen and allows you to arrange and work with multiple images or divide an image into channels that contain the individual color records (RGB or CMYK) and grayscale data. The **Palettes** option displays various controls that are used to select foreground and background colors and specify brush sizes and other variables that may need to be defined while you work on an image. **Tile** enables you to display two or more images side-by-side, which is useful when you are combining all or a portion of several images or simply want to keep a copy of the original image visible as you make changes.

Figure 13.35: *The Palettes option*. **Palettes** on the **Window** menu lets you select colors and specify different variables.

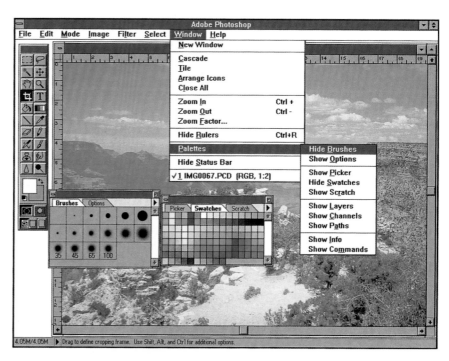

Figure 13.36: *The Tile option*. **Tile** lets you compare two or more images.

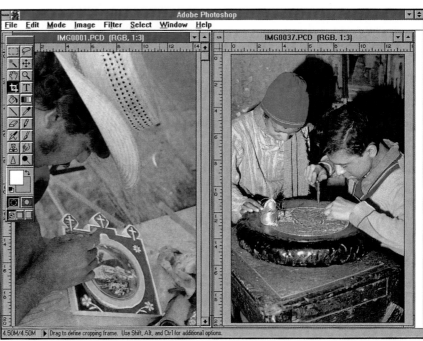

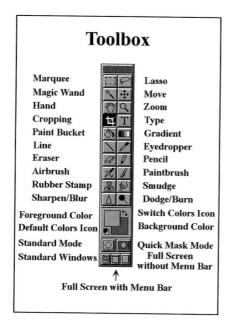

Toolbox

Marquee	Lasso
Magic Wand	Move
Hand	Zoom
Cropping	Type
Paint Bucket	Gradient
Line	Eyedropper
Eraser	Pencil
Airbrush	Paintbrush
Rubber Stamp	Smudge
Sharpen/Blur	Dodge/Burn
Foreground Color	Switch Colors Icon
Default Colors Icon	Background Color
Standard Mode	Quick Mask Mode
Standard Windows	Full Screen without Menu Bar

Full Screen with Menu Bar

Figure 13.37: *The Toolbox.*

Using the Toolbox

The toolbox is a common feature of all image-processing programs, and the icons displayed are reasonably standardized. Each icon resembles a button and is activated by moving the pointer to the desired symbol. Upon clicking the icon, the arrow changes into the symbol seen on the icon button and the program for that icon is activated. For Adobe Photoshop there are twenty icons that initiate frequently used operations, plus other controls and displays that are often needed. Specific uses of most of the individual features of the toolbox are given in the example on pages 357–367.

The **Marquee** tool is used to select or isolate segments of the image that you want to change. Clicking on the icon twice causes an options palette to appear on the screen from which you can choose either an elliptical or rectangular shape for the marquee or limit the selection to a column or row one pixel wide. The area selected by the Marquee tool will be outlined by a fence of moving dots, reminiscent of an army of marching ants. Any subsequent operations that you perform (for example, changing colors, erasing, dodging, or burning-in) will only affect the portion of the image that is outlined within the defined area of the marquee. "Feathering" is a feature that enables you to define the sharpness of the boundary (in units of pixels) that is created by the marquee. The larger the feathering, the softer the boundary.

The **Lasso** tool allows you to make a selection of any shape by drawing a freehand outline around an area. While this can be done by using the mouse as a drawing tool, it is far easier to use an electronic pen and tablet instead. Straight lines can be drawn with the Lasso tool by holding down the ALT key and using the mouse or pen to define the end points of each line.

The **Magic Wand** tool isolates portions of an image based on colors or some other defining feature. Clicking on the wand displays an options palette into which you can enter tolerance values that range from 0 to 255. Low tolerance numbers mean that only closely similar shades will be selected, while higher values increase the range that is selected when the wand is activated. The Magic Wand is a useful way of selecting and isolating objects with complex shapes but uniform colors (for example, a pink rose in a bouquet), so that they can be worked with in isolation from a complex background. The Marquee, Lasso, and Magic Wand tools effectively act as intelligent computer-controlled scissors and simplify the task of selecting and isolating portions of an image.

The **Move** tool allows you to move selections to another location. The **Hand** tool enables you to scroll to other parts of the image when the entire image is too big to be displayed on the screen. The **Zoom** tool acts like a magnifying glass. When the magnifier is moved to a location on the screen and the mouse button (or pen) is clicked, the entire screen is replaced with a magnified version of a small segment of the image, centered around the magnifier symbol. To move to adjacent areas near the point of magnification use the Hand tool. Magnification can also be achieved by striking the CTRL and + keys on the computer keyboard simultaneously (conversely, you can zoom away from an image segment by using the CTRL and – keys). If you are trying to select an area of an image using the Lasso tool, the simplest and most accurate way is to mag-

nify the section of the image you want to work on, use the Lasso tool to select the specific area, then zoom out until the image is restored to its original size.

The **Cropping** tool functions as a pair of cropping Ls, enabling you to crop off part of an image. The borders of an image are defined by moving the symbol to the point that will represent the upper left-hand corner. Hold the mouse button (or pen) down and drag the cropping icon down toward the lower right-hand corner of the image; as you do this, a dotted rectangle will appear on the screen that outlines the cropped image you select. After the temporary new borders of an image have been selected, moving the Cropping icon inside the cropped area will change the symbol to a tiny pair of scissors. If you are satisfied with the new cropping, click the mouse button to "clip" the image to the crop size. The screen then displays a new version of the picture in its cropped format. If you decide you do not like the temporary selection, move the scissors outside the rectangle and click the mouse button. The temporary rectangle will disappear and you'll be free to consider alternative croppings.

The **Type** tool enables you to enter text anywhere on the image. Activating the tool replaces the pointer symbol with an *I*, which should be moved to the place where you want the text to begin. Clicking the mouse button at that point activates a menu from which you can choose a type style and specify type features (for example, spacing between letters, italics, bold, underline, strikeout, outline). The bottom of the menu contains a box into which a message can be typed. When you have completed your choices, click **OK;** the menu box disappears and after a moment the message appears on the screen as a floating message in the Foreground Color (see page 357). If you are satisfied with the appearance of the text, click the mouse and your selections will become a permanent part of the image. If you decide to make a change, move the pointer to **Edit** and click **Undo Type Tool,** or, alternatively, strike the CTRL and **Z** on the keyboard and the floating text will disappear.

The **Paint Bucket** tool is used to color an area of the image that has been selected by the Magic Wand with the tint of the Foreground Color. An important control for the Paint Bucket is the *opacity scale,* which enables you to specify a value between 0 and 100 percent. A low value for the opacity helps retain the impression of color transparency and preserves the underlying features and textures of the painted section. You can experiment and observe the effect of the opacity control by choosing different values for the opacity, filling in the selected area, and using the **Undo** command under the **Edit** heading to return to the original image.

The **Gradient** control is a variant of the Paint Bucket option. It enables you to apply a gradation of colors in a gradual transition from the foreground to the background color or from the foreground to transparent. By choosing black-and-white for the foreground and background colors, the Gradient tool offers one possible route to achieving the effects of burning-in an image as you would by printing a negative in the darkroom.

The **Line** tool paints in straight-line segments on the image. A submenu asks you to specify the line thickness and other characteristics, such as color opacity. An option is also available for starting and/or ending the line with an arrowhead and for shaping its geometry.

The **Eyedropper** tool is used to select the foreground or background color by sampling colors present in the image. To do this, activate the Eyedropper feature and move the tip of the dropper to a color within the image that you want to make the foreground color. Click the mouse button, and the foreground color changes to that color. The Eyedropper is a useful feature when you are trying to achieve a precise color match within or between images.

The **Pencil** tool is used to paint a hard-edged freehand or straight line using the foreground color. The **Eraser** tool erases pixels from the image; the result you obtain depends upon the mode in which you are working. For example, if the **Erase to Saved** option is selected, as the overlay is erased, the original image will appear in that section of the image. As with the Pencil tool and other applications, you can specify the width of the Eraser path and various other controls.

The **Airbrush** tool enables you to apply a diffuse spray of foreground colored paint on the image. Spraying is accomplished either in a freehand mode or to a confined region by circumscribing a portion of the image with the Marquee tool, the Lasso, or the Magic Wand. The transparency of the applied paint is adjusted by a control option on the submenu.

The **Paintbrush** option is similar to the Pencil tool except that soft-edge strokes of the foreground-color paint are applied as the brush is moved about. The width of the brush, paint opacity, and the rate of fading of color intensity from the center of the brush stroke are all controlled by making appropriate choices from submenus. A **Wet Edge** option is also available and gives a visual impression of paint that has dried with an accumulation of pigment at the edge of the brush stroke.

The **Rubber Stamp** tool takes a portion of an image and makes an exact copy of it elsewhere in the same or another image. This is often referred to as

Figure 13.38: *The Gradient tool.* **Gradient** lets you apply a gradation of colors.

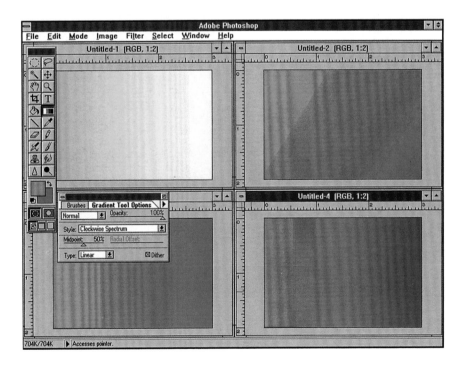

cloning. To activate the tool, double-click on the Rubber Stamp icon. A sub-menu appears from which you can select a variety of options. To clone a feature, move the icon onto the item to be copied, hold down the ALT key and click the mouse button. Then move the Rubber Stamp to the place you want to begin making a copy and hold down the mouse button. Crosshairs will appear on the item selected, and as you move the Rubber Stamp, the pixels in the center of the crosshairs will be reproduced at the site selected.

The **Smudge** tool creates the effect of moving a finger around a freshly painted surface. It is effective for adding texture or altering the features of a smooth area of an image. The **Sharpen/Blur** tool allows you to sharpen or blur selected portions of an image.

Some of the most useful tools are the **Dodge/Burn** tools. These tools can be used to increase or decrease color saturation and work selectively on highlights, shadows, or midtones.

Figure 13.39: *The **Rubber Stamp** tool.* **Rubber Stamp** lets you copy a portion of an image to another location. In (B), several of the leaves from the original (A) were copied and moved to new locations.

A

B

The **Foreground Color** tool controls the color applied with all of the painting and drawing tools. To change the foreground color either double-click on the Foreground Color button to bring up a palette ("Color Picker") featuring a color spectrum from which a new color can be selected or use the Eyedropper tool to pick a color from the image on which you are working. The **Background Color** control is used likewise to alter the background color. This is the color that replaces existing features when the Eraser tool is used or when the gradient tool is employed. The **Switch Colors** tool acts as a toggle switch that interchanges the foreground and background colors. Clicking on the **Default Colors** icon restores the foreground and background colors to black and white, respectively.

The **Standard Mode** and **Quick Mask Mode** buttons are useful in painting and editing operations.

Lastly, the three window display controls at the bottom of the toolbox enable you to control the format of what appears on the screen. When the first button is activated, the screen shows the menu bar at the top and scroll bars (which can be used to scroll quickly up and down or sideways through your document) on the right side and bottom. This first option is the default state of the screen. The second button displays the image in full-screen mode, with only the menu bar showing. The last button displays the image only, omitting both the scroll and menu bars. The TAB key serves as a toggle switch to display or hide any open palettes.

Putting the Toolbox and Menu Bar to Work: Creating a Poster

The example that follows is meant to illustrate how the menu bar and toolbox are used to create and modify images. Most objectives in image processing can be achieved by several routes, and different workers may favor alternative approaches that are equally valid. Here are the steps I took to create the poster I wanted:

1. I opened Adobe Photoshop and activated the **File** menu. I chose **New** from the options to create a blank canvas for the poster.

2. In the box titled **New,** the requested variables **Name, Width, Height, Resolution, Mode,** and **Contents** (canvas color) were specified. (I matched Resolution settings to the characteristics of the printing device that I was using. To specify the **Background Color** in the toolbox, I clicked the pointer on that icon and chose a color from the palette that appeared on the screen.) To signal that the settings for **New** were satisfactory, I moved the pointer to **OK** and clicked the mouse button.

3. A new screen appeared that showed the basic poster "canvas."

4. I specified an image by choosing **File, Open,** and drive **g** (my CD-ROM-drive address) and selected a photograph of the sphinx and pyramids (coded img0018.pcd on the photo CD disk).

5. After specifying the desired resolution, I opened the image file by clicking **OK.**

6. Two images appeared on the screen. (Only one image is active — that is, can be worked on at a given time. The blue title bar indicates the active image.)

7. Because I wanted to use only a portion of IMG0018.PCD in the planned poster, I activated the **Cropping** tool and selected the desired area by dragging the pointer from the upper left-hand to the lower right-hand corner of the dotted rectangle while holding down the mouse button. (If you do not like the initial cropping, click the mouse with the pointer outside the dotted rectangle and begin again.)

8. I moved the pointer within the rectangle and clicked the mouse to crop the image and generate a new screen.

9. To alter the color balance and image brightness, I chose and activated **Image, Adjust,** and **Variations.**

10. I made appropriate selections from the options given to lighten the image and improve the color.

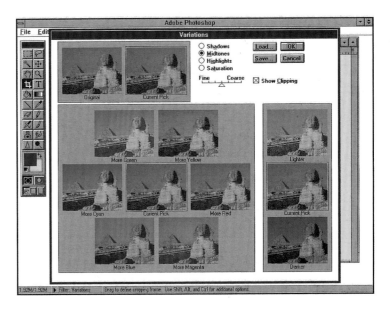

11. I reduced the corrected image to the same scale as the poster background by using the CTRL and – keys to change the image scale from 1:3 to 1:4.

12. I created separate screens for the image and canvas by activating the **Window** option and choosing **New Window.**

13. I clicked the **Tile** option, and the image and canvas screens appeared in adjacent windows.

14. I double-clicked the **Magic Wand** icon in the toolbox to activate its options palette. The tolerance was set to a level of 250 so that all parts of the image would be selected. (I could have used the **Marquee** tool to carefully define the same rectangle.)

15. I activated the **Move** tool (crossed double-headed arrows) in the toolbox by shifting the pointer to this position and clicking the mouse.

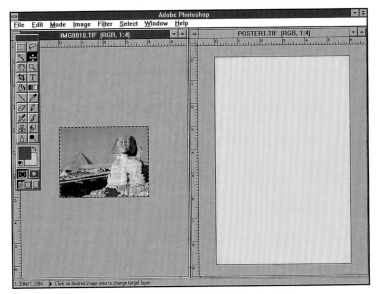

16. I moved the entire selection to the canvas by (1) placing the pointer within the image, and (2) holding down the mouse button and sliding the image across the screen into position on the poster. (Note that as the image was moved from the left tile to the right tile, POSTER1.TIF became the active file.) After completing the move, I chose the **Edit** function.

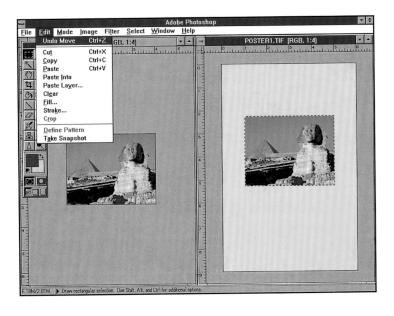

17. I selected **Stroke** from the **Edit** menu to create a frame around the image on the poster. (Determining settings such as the pixel width of the stroke is best done by trial and error. If you do not like a result, activate **Edit, Undo Move, Stroke,** and choose a new value.)

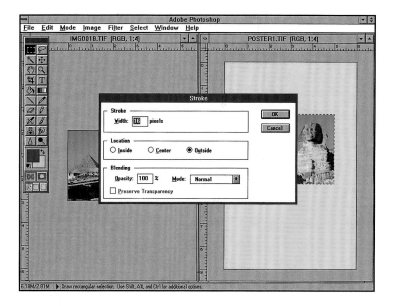

18. The color of the stroke corresponds to the foreground color in the toolbox. I deselected the image by activating the **Marquee** tool and clicking the mouse somewhere on the active image. I saved the modified poster image with a new name (POSTER2.TIF), so that I could keep both images on file rather than replacing the first one with the second.

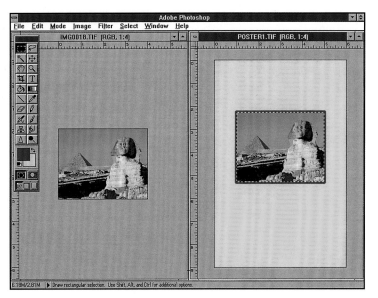

19. A new image of boats on the Nile (IMG0028.PCD) was activated from the CD-ROM file as previously described (see steps 4 and 7).

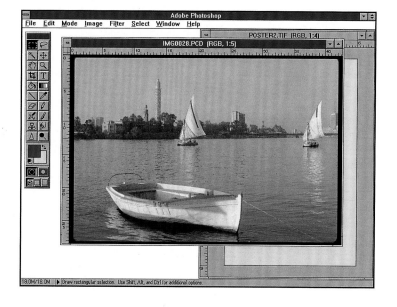

20. The new image was **Tile**d and the **Marquee** tool was used to select a segment of the image (outlined by a fence of moving dots) that I wanted to use in the poster. (The rulers along the top and down the left-hand side of the screen enable you to judge sizes of objects. Objects can be scaled by adjusting the overall image size file or by using the **Scale** option from the **Image** menu.) Next I chose **Copy.** I activated the other screen by moving the pointer to it and clicking the mouse. I opened **Edit** and chose **Paste.**

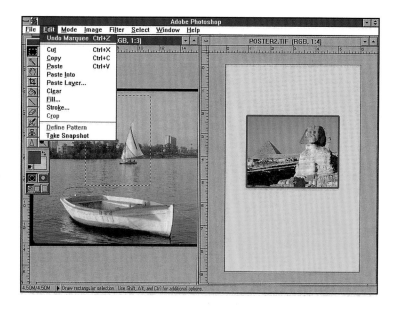

21. By choosing **Paste,** I removed the selected image from the temporary file in which it was stored by Adobe Photoshop and floated the selection in the middle of the specified file.

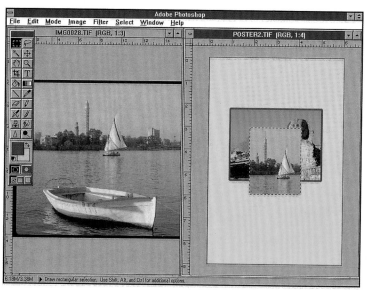

22. I used the **Move** tool to slide the floating section to its new position and then changed the foreground color to black. I chose **Stroke** from the **Edit** file, then deselected the object by reactivating the **Marquee** tool and clicking the mouse.

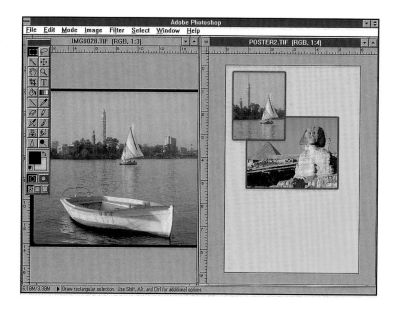

23. I used the **Hand** tool to shift the IMG0028.TIF image on the screen so that the right-hand sailboat became visible.

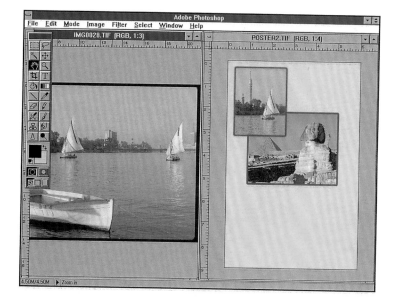

24. Double-clicking the **Marquee** tool displayed the **Marquee Options** palette. I chose the elliptical shape.

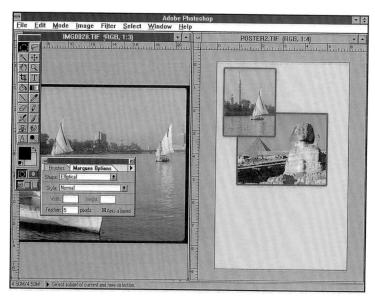

25. Using the pointer, I created an elliptical frame around a new selection.

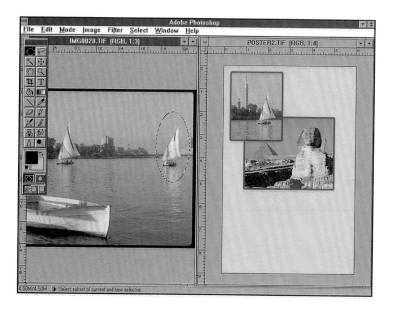

26. Using the previously described procedures (see steps 16, 17, 18), I placed the selection in the POSTER2.TIF file.

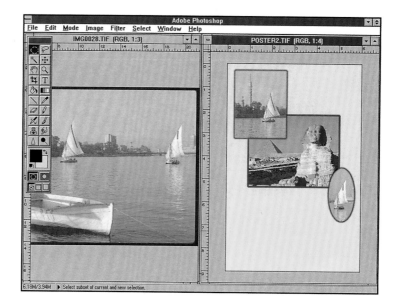

27. I closed the IMG0028.TIF file and saved the poster file as POSTER3.TIF.

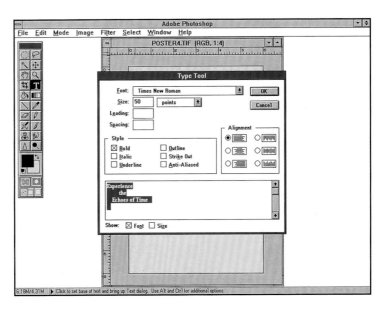

28. I activated the **Type** tool and entered words and phrases in the dialog box, where the format, type size, and fonts were specified.

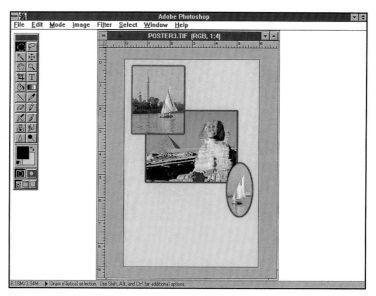

29. My poster was complete. (Note that the background color differs from that displayed in the individual illustrated steps due to artifacts introduced by the screen-capture program used to display each of the steps.)

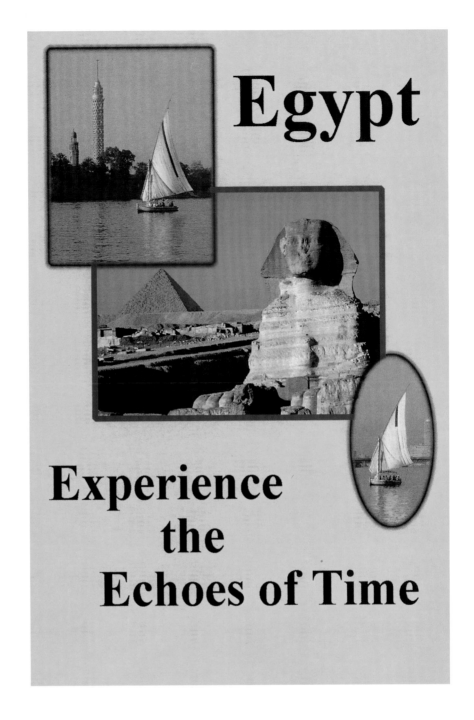

The Burnley Graveyard,
Burnley, England, 1985 and 1995

(A) The black curve.

(B) The midtone curve.

(C) The light gray curve.

Burnley is the small town in northern England where my father spent his childhood. This 35mm Kodachrome 64 transparency taken with a 28mm FD lens on my Canon F1 sat idle for many years until I worked on it in my digital darkroom. Sometimes when I take a photograph, the feelings that I have about the scene are not wholly captured on the film. When I print the photograph, I try to put that evocative quality back — in this case, the dampness in the air, the impending storm, and the feeling of being surrounded by cold stark beauty.

The color Photo-CD scan was flat, and the upper-left sky detail was blown out. After using Photoshop Levels to increase image contrast and correct color, I increased saturation with Hue/Saturation. Looking at this image in color, I decided that black-and-white might better convey the mood I wanted. Using Photoshop, I converted the image to black-and-white. I then used Levels, which allows you to move the tonal values of the image from one zone to another, to create Layer 1 of the image, giving it much darker clouds and sky with more contrast. In terms of the Zone System, this adjustment moved the Zone V midtone values down to about Zone III and similarly moved other zones across the image. In Layer 2, I moved the Zone V values up to Zone VII to add contrast to the midtones, the Zone VII values up to Zone IX or X to enhance the reflections of the gravestones and the intense light of the church windows, and some of the Zone 1 values to Zone 0 to create some dark shadows. I then created a Layer Mask to combine the two Layers, using the clouds and sky from Layer 1 and the gravestones and church from Layer 2. I used a third Layer and another mask to put cloud detail back into the upper-left sky. To finish my evolving visualization of this image, I used Duotone Mode for greater tonal range.

*Duotones (or tritones) are used to print black-and-white reproductions, using two (or three) inks. A different part of the tonal range is carried by each ink. Duotones also let you add subtle color to your black-and-white images. Photoshop's Duotone feature allows you to specify a curve that modifies how the tonal ranges of the image are printed for each color. I used black ink for the dark shadows, with a curve that removed some black from the midtones while adding black in the dark shadows (A). For the second ink I used Pantone Warm Gray 10 CV and adjusted the curve to drastically reduce the ink in the darker shadows and to a lesser extent in the brighter midtones (B). The third ink was a light gray Pantone 422 CV. I adjusted its curve to use a small portion of this ink in the pure white areas (Zone 0), as well as in the highlight areas, to add density to the brightest areas (C). The resulting print finally conveyed the emotions I feel about this scene.**

— BARRY HAYNES

**Adapted from* Photoshop 4 Artistry *by Barry Haynes and Wendy Crumpler (New Riders, 1997).*

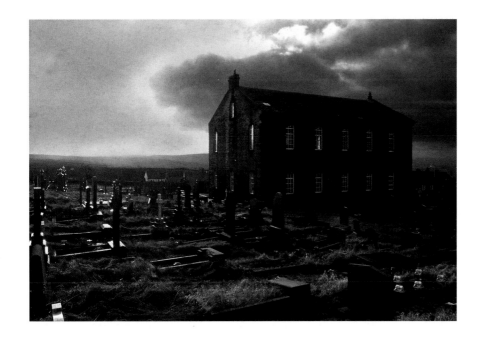

Image printed as a black-and-white halftone (one ink).

Image as created in Photoshop's Duotone mode as a tritone. (For printing in this book the image was converted in Photoshop to CMYK [four-color].)

Creating a Complex Photographic Image Using Adobe Photoshop

**An Essay by
Judy L. Miller**

The image titled *Sunflowers* is a digital image created using Adobe Photoshop 3.0 software. Four photographic elements were used to create the final photographic composite: a sunflower still-life, a canvas texture, a paintbrush, and a picture frame. The sunflower was photographed using a 4 x 5 camera and color transparency film. The canvas texture, paintbrush, and picture frame were photographed using a flatbed scanner.

A flatbed scanner is an efficient camera for photographing both objects and textures. Using the scanner as a camera enables you to skip the film-recording and -processing stages of traditional photography. In some instances a flatbed scanner records a sharper image of a texture or an object than you can achieve with an ordinary camera. Factors that determine the effectiveness of the scanner as a camera are the reflectance of the object being scanned and the object's size, weight, and width. Other considerations influencing the quality of the recorded image are the actual (not interpolated) resolution of the scanner, the depth of field capability of the instrument, and your skill at manipulating the scanner controls.

A flatbed scanner is obviously not designed to scan three-dimensional objects. However, surprisingly good results can often be achieved. Try using additional directional light sources to emphasize textures and depth of field. Alternatively, to eliminate ambient light sources, cover the object with a black cloth. To avoid soiling or scratching the glass surface of the scanner, cover the glass with a sheet of clear acetate film before placing the objects.

Two intermediate images (figures 13.42A and 13.42B) were created and combined to form figure 13.43, which became a component for the final composition. Figure 13.43 began with the original sunflower photograph (figure 13.41A). The digitized image was stretched horizontally using the perspective-control features of Photoshop and then cropped. The image resolution was decreased from the original 350 pixels per inch (ppi) scan to 250 ppi in order to soften the feel of the image. Since I was trying to achieve the diffuse quality of a watercolor in the final image, I used the following Photoshop filters: **Noise, Facet, Gaussian Blur, Motion Blur,** and **Trace Contour.** The **Angled Strokes** filter and **Palette** filter from Gallery Effects (a program now distributed by Adobe) were also applied to the image. Photoshop's **Trace Contour** was the last filter to be used, and it reduced the image to a contour line drawing.

Prior to applying the **Trace Contour** filter, I increased the resolution of the "image in progress" to 350 ppi (to make it consistent with all of the other components that would be used to build the final sunflower composition), and the image was saved. Normally, increasing the resolution of an image is not

Judy Miller is an accomplished photographer and designer who uses Adobe Photoshop to create unique photographically based images. Early in her career as a professional, she hand colored images and created collages to meet the goals of her clients. With the advent of the computer and its remarkable capabilities, she discovered that she could create similar, yet far more complex, imagery much more easily using standard image-processing programs. This essay is her description of how *Sunflowers* was created. While the mechanics of how to implement a specific transition will not be entirely clear without a detailed knowledge of Adobe Photoshop, the strategies that she uses to build a complex image from simple components should be apparent.

Figure 13.40: Judy L. Miller, *Sunflowers,
1995.* This digital image was created using
Adobe Photoshop 3.0 software and com-
bines segments of four photographic
images to simulate the mood of a painting
in progress.

A

B

C

D

A

B

Figure 13.41: (A) Sunflowers were arranged against a background of silk and photographed with 4 x 5 transparency film, which was subsequently scanned to produce a digital record of the image. The three remaining elements that make up the composite image were "photographed" directly at a resolution of 350 pixels per inch (ppi) using a flatbed scanner as a camera. These are (B) a sheet of canvas cloth, (C) a paintbrush, and (D) a section of a picture frame.

Figure 13.42: (A) An intermediate similar to this image was created by cropping figure 13.41A and applying various filters to achieve a watercolor look for the original photograph. The **Trace Contour** filter was applied to the image, saved as a separate document, then combined with the intermediate to produce the image illustrated. (B) The **Trace Contour** image file was composited with the canvas texture image (figure 13.41B), and the **Line** tool was used to draw a grid pattern over the resulting image.

recommended because image sharpness is lost as pixels are interpolated by the computer; however, sharpness was not a primary concern for this component of the image. After the **Trace Contour** filter was applied, the resulting image was saved as a separate document. The softened and highly filtered image was then composited with the **Trace Contour** document using the **Multiply** mode feature built into Photoshop, and figure 13.43 resulted. This image was saved as a new document.

Next, the canvas texture (figure 13.41B) was combined with the **Trace Contour** document using the **Darken** mode feature of Photoshop. A grid pattern was then drawn on the combined images using the **Line** tool. To simplify registration problems for the printer, 70 percent opacity of 100 percent cyan was chosen as the color for the grid.

The goal was to create an image that resembled a painting in progress. To do that, figures 13.41A–D and 13.43 were then used to create figure 13.40 in the following way. Figure 13.41A was opened, and the entire image was connected to the clipboard. That document was closed, and figure 13.41B was opened. Areas of the canvas were outlined and the outlines were "feathered" by a few pixels using the **Lasso** tool. Next, the **Paste** command was used to "paint" the canvas. This step was repeated until the desired result was achieved.

Six layers were used to create the final composition. Layers can be thought of as transparent sheets of acetate that can be stacked and maneuvered to create a composite image. The background layer (layer 1) was filled with 100 percent white. Creating a white background is not necessary, but it gives you the added luxury of being able to move all of the compositional elements. A cropped version of the original 4 x 5 transparency was used to create layer 2. The photograph was cropped using the **Path** tool, so that one of the leaves could be extended beyond the traditional rectangular crop. This cropped version was then copied to the clipboard and pasted into layer 2.

Next, the image was rotated slightly (the rotation control can be found in the **Image** menu). A layer mask was added to layer 2 to create the illusion of the right edge of the photograph blending into the white background. This was achieved by creating a black-to-white blend in the mask layer (the **Blend** tool was used in the **Normal** mode).

The "painting" document (figure 13.43) was opened and copied to the clipboard. The painting was then pasted into layer 3 of the final composition document, overlapping a portion of layer 2. After placement and scale adjustments were made to the painting, the perspective of the "painting" layer was altered (the **Perspective** control can be found in the **Image** menu, **Effects** submenu).

The gold frame component was placed into layer 4. The gold frame (figure 13.41D) was outlined using the **Path** tool. This outline was selected, feathered by one pixel, and copied to the clipboard. The gold frame was then pasted into layer 4 of the final composition. The frame was scaled and rotated, and the perspective of the frame was adjusted. A layer mask was added to layer 4 to allow the frame to blend with the other layers.

The paintbrush document was opened and outlined with the **Path** tool, and the path was selected. This selection was feathered by 1 pixel and the selection was then copied to the clipboard. The paintbrush (figure 13.41C) was

pasted into layer 5 of the final composition. Once placement and the desired scale were achieved, a layer mask was added. The layer mask was used to create a blend with the bottom edge of the paintbrush and the white background.

Layer 5 was duplicated using the **Layers Palette** option selection to create layer 6. The purpose of layer 6 was to create a shadow for the paintbrush. The **Preserve Transparency** box was selected in the **Layers Palette** to protect the background of the image layer from any applied effects. Layer 6 was then filled with 100 percent black. The **Preserve Transparency** box was deselected, and the **Gaussian Blur** filter was applied to layer 6 to soften the shadow edge. The **Gaussian Blur** filter was set for 8 pixels. Edge softness is influenced not only by the number of pixels selected but also by the image resolution. High-resolution images require more pixels to be softened than low-resolution images.

The order of layers 5 and 6 was then switched so that the shadow layer would fall behind the paintbrush layer. The shadow layer was then rotated, and the shadow opacity was adjusted to 30 percent using the opacity guide found in the **Layers Palette** box. The **Multiply** mode was selected for the shadow layer so that the shadow would merge with the underlying areas.

Figure 13.43: This image is the result of combining the previous two intermediates (figures 13.42A and 13.42B).

Figure 13.44: The final composition for *Sunflowers* was achieved by treating each of the component sections as individual layers. These were brought together, modified as desired, and arranged on the screen to create the final image. Layers are equivalent to electronic versions of images on transparent acetate film that can be manipulated freely to create a collage.

The techniques used to create the composition titled *Sunflowers* would probably vary if another digital artist created the same image. Through a process of exploration and experimentation, an image maker develops techniques and a personal approach to composing and assembling imagery. In the "digital darkroom," the image maker has the advantage of being able to revert to the last saved image version, making it possible to recover from any misstep and encouraging exploration. The computer provides limitless possibilities for creative image making. — JUDY L. MILLER

Summing Up

Evolution is nature's way of maintaining the vitality of a species — beneficial traits are propagated, useless modifications quickly disappear. A similar pattern is evident in the history of the arts. Music, painting, literature, and sculpture are dynamic and continue to find new audiences because of the imagination and insights artists bring to their subject. Photography is no different.

Photography is a language of the imagination. In the hands of an artist, the integration of the camera and computer will expand the power and potential of photography, just as impressionism, cubism, and abstract expressionism opened new avenues for painters. The question asked about electronic imaging — "But is it photography?" — should really be "But is it art?" The answer is quite simple: *Art is what an artist does.*

Suppliers of Materials

Artcraft Chemicals, Inc.
P.O. Box 583
Schenectady, NY 12301
phone: 800-682-1730 or
518-355-8700

Supplier of chemicals and supplies for many alternative processes.

Bostick & Sullivan
Box 16639
Santa Fe, NM 87506
phone: 505-474-0890
fax: 505-474-2857
e-mail: richsul@roadrunner.com

Supplier of chemicals, supplies, papers, and literature on alternative processing, especially platinum/palladium printing.

Chicago Albumen Works
P.O. Box 805
Front Street
Housatonic, MA 01236
phone: 413-274-6901
e-mail: albuwrks@bcn.net

Supplier of printing-out paper, supplies, and a copy negative service.

Daniel Smith
4130 First Avenue S.
Seattle, WA 98134-2302
phone: 800-426-6740 or
206-223-9599

Supplier of fine printing papers, brushes, and pigments.

Edmund Scientific Corporation
101 E. Gloucester Pike
Barrington, NJ 08007-1380
phone: 609-573-6250
fax: 609-573-6295

Supplier of supplies generally useful for photography.

Freestyle Sales Co.
5124 Sunset Boulevard
Los Angeles, CA 90027
phone: 800-292-6137 or
213-660-3460
fax: 800-616-3686
e-mail: foto@freestylesalesco.com
website: http://www.freestylesales-co.com

Supplier of specialized photographic materials and equipment.

Light Impressions
439 Monroe Avenue
P.O. Box 940
Rochester, NY 14603-0940
phone: 800-828-6216
fax: 800-828-5539

Supplier of selected photographic equipment, conservation supplies, books, and alternative process kits.

Maine Photographic Workshops
2 Central Street
Rockport, ME 04856
phone: 800-227-1541 or
207-236-8581
fax: 207-236-2558
e-mail: MEWorkshops@aol.com or
mpw@midcoast.com
website: http://www.MEWorkshops.com

The Palladio Company, Inc.
200 Boston Avenue, #2400
Medford, MA 02155
phone: 800-628-9618

Supplier of precoated palladium/platinum papers, chemicals, and supplies; also sells an ultraviolet light exposure cabinet and will make enlarged duplicate negatives through digital scanning.

Photo Eye
376 Garcia Street
Santa Fe, NM 87501
phone: 505-988-5152

A superb collection of photography books and publications related to all aspects of alternative photographic processes.

Photographer's Formulary
P.O. Box 950
Condon, MT 59826
phone: 800-922-5255 or
406-754-2891
fax: 406-754-2896
e-mail: formulary@montana.com

Supplier of photographic chemicals, books, equipment, and kits for alternative and traditional photographic processes.

Photo-Graphic Systems
412 Central S.E.
Albuquerque, NM 87102
phone: 505-247-9780
fax: 505-243-4407

Supplier of an excellent inventory of new and used equipment, including printing frames, light sources, registration equipment, and general photographic supplies.

Silverprint Ltd.
12 Valentine Place
London SE1 8QH
United Kingdom
phone: 0171-620-0844
fax: 0171-620-0129

Supplier of equipment, chemicals, and supplies for alternative processes.

Zone V
Stage Road
P.O. Box 218
South Strafford, VT 14051
phone: 802-765-4508

Supplier of general purpose photographic chemicals.

Contact Printing Frames

The following is a list of camera stores or custom builders that sell suitable contact printing frames.

Conduit Manufacturing Company, Inc.
29 Philo Curtis Road
Sandy Hook, CT 06482
phone: 203-426-4119

Contact printing frame sizes from 5 x 7 to 16 x 20 inches; also available with pin-registration features.

Darkroom Innovations, Inc.
P.O. Box 3620
Carefree, AZ 85377
phone: 602-488-8012
fax: 602-488-9782

Excellent hardwood contact printing frames and other photographic equipment.

Doran Enterprises, Inc.
2779 South 34th Street
Milwaukee, WI 53215
phone: 414-645-0109

Doran has inexpensive 8 x 10- to 16 x 20-inch aluminum frames suitable for students. Frames *do not* have a hinged back, so exposure monitoring is more difficult. Doran makes a useful tray print washer and other useful darkroom accessories.

Douglas Kennedy
918 Louisiana Street
Vallejo, CA 94590
phone: 707-647-1447
e-mail: dbkennedy@juno.com

Superb-quality hardwood frames from 11 x 14 to 20 x 24.

Great Basin Photographic
HCR 33
Box 2
Las Vegas, NV 89124
phone: 702-363-1900

Contact frames made of walnut or cherry and available in sizes from 4 x 5 to 20 x 24 inches.

Mottweiler Photographic
P.O. Box 871
Rancho de Taos, NM 87557
phone: 505-751-3255

A high-quality hardwood frame, 10 x 12 inches for printing up to 8 x 10-inch negatives.

Ultraviolet Light Sources

Aristo Grid Lamp Products
35 Lumber Road
Roslyn, NY 11576
phone: 516-484-6992

nuArc Company
6200 W. Howard Street
Niles, IL 60714
phone: 708-967-4400

Sources for Quotations

Sources for the writings excerpted in the present volume (indicated in the text by italics) are listed below by chapter. For the purposes of this book, some of the excerpts have been abridged or edited. The reader will find the complete reference for each quotation in the work cited.

Chapter One:
The Expressive Photographic Print

"Photography is the most potent . . .": Ansel Adams, manuscript of a letter to Mr. Lester, August 9, 1937.

"What is photography? . . .": Ansel Adams, "Danger Signals," *PSA Journal* 14 (1948): 575.

" 'Enlargement' in most people's minds . . .": Ansel Adams, "A Design for Printing," in *Graphic Graflex Photography: The Master Book for the Larger Camera* (New York: Morgan and Lester, 1940), p. 77.

"A good photographer is like a good cook. . . .": Ansel Adams, "An Approach to a Practical Technique," *U.S. Camera* 9 (1940): 80.

"The first truly great photographer . . .": Ansel Adams, from a manuscript for *Zeiss* magazine (1936).

"The camera, properly used . . .": "A Design for Printing," p. 75.

"The essential element of creative vision . . .": Ansel Adams, "Some Definitions," *Image* 1 (March 1959): 19.

"The Pictorial Period . . .": *Zeiss.*

"The aspect of the world . . .": Ansel Adams, "Natural Light," *Photography Annual* (1957): 247.

"My approach to photography . . .": *Zeiss.*

Chapter Two:
The Quest for the Perfect Negative

"My approach to photography . . .": Ansel Adams, *Camera and Lens,* Book 1 of the Ansel Adams Basic Photo Series (Dobbs Ferry, N.Y.: Morgan and Morgan, 1970), p. 22.

"This particular photograph . . .": Ansel Adams, "Mountain Photography," *The Complete Photographer* 41 (1942): 2635.

"The Zone System . . .": Ansel Adams, "An Approach to Exposure," *U.S. Camera* (Aug. 1961): 64.

"Recent clarifications of the terminology . . .": *Camera and Lens,* pp. 22–23.

"The concept of the 'perfect negative' . . .": Ansel Adams, *The Negative,* Book 2 of the New Ansel Adams Photography Series (Boston: New York Graphic Society Books/Little, Brown and Co., 1981), p. 29.

"We explored a distance southward . . .": Ansel Adams, *Examples: The Making of 40 Photographs* (Boston: New York Graphic Society Books/Little, Brown and Co., 1983), pp. 87–89.

"The most serious error in exposure . . .": *The Negative* (1981), p. 61.

"It is not the luminance . . .": "An Approach to Exposure," p. 66.

Chapter Three:
Film Testing Procedures

"Photography, in the final analysis . . .": Ansel Adams, *Natural-Light Photography,* Book 4 of the Ansel Adams Basic Photo Series (Hastings-on-Hudson, N.Y.: Morgan and Morgan, 1952; rpt. 1971), p. v.

"My intention in describing . . .": *The Negative* (1981), p. 239.

"One cloudy spring day . . .": *Examples,* pp. 79–81.

"All chemical processes . . .": *The Negative* (1981), p. 201.

"For uniform development . . .": *The Negative* (1981), p. 215.

"I went to Arles . . .": *Examples,* pp. 117–119.

"The purpose of this approach . . .": *Natural-Light Photography* (1952), p. vi.

Chapter Four:
Using Characteristic Curves to Evaluate Films and Developers

"A single characteristic curve . . .": *The Negative* (1981), p. 89.

"Light, to the accomplished photographer . . .": *Natural-Light Photography,* p. v.

"Once the optimum film speed . . .": *The Negative* (1981), p. 242.

"We must first establish . . .": *The Negative* (1981), p. 220.

"Weather, however spectacular . . .": *Examples,* pp. 103–105.

"The chief problem . . .": *Natural-Light Photography,* p. 14.

"Texture is both . . .": *Natural-Light Photography,* p. 31.

"The much abused term . . .": *The Negative: Exposure and Development,* Book 2 of the Ansel Adams Basic Photo Series (Hastings-on-Hudson, N.Y.: Morgan and Morgan, 1968; rpt. 1971), p. 107.

"Divided, or two-solution, methods . . .": *The Negative* (1971), p. 107.

"We were in the shadow . . .": *Examples,* pp. 60–62.

"As no two subjects . . .": "An Approach to Exposure," p. 66.

Chapter Five:
Specialty Black-and-White Films

"Most photographers work *backwards* . . .":
Zeiss magazine (April 1937).

"The nature of the characteristic curve . . .":
Artificial-Light Photography, Book 5 of the
Ansel Adams Basic Photo Series (Hastings-
on-Hudson, N.Y.: Morgan and Morgan,
1968; rpt. 1971), p. 101.

*"Important! . . .": Artificial-Light
Photography,* p. 114.

"A word about lenses . . .": *Artificial-Light
Photography,* p. 114.

"[Infrared photography] is a large field . . .":
Natural-Light Photography, pp. 115–116.

Chapter Six:
**Alternative Photographic Printing
Processes: General Considerations**

"The making of a print . . .": Ansel Adams,
The Print, Book 3 of the New Ansel Adams
Photography Series (Boston: New York
Graphic Society Books/Little, Brown and
Co., 1983), p. 1.

"There are different schools . . .": *The Print,*
pp. 3–5.

"In many ways . . .": *The Print,* pp. 6–7.

Chapter Seven: The Cyanotype

"The greatest achievements . . .": Ansel
Adams, from an unpublished manuscript.

Chapter Eight:
Alternative Silver Printing Processes

"All progress in art . . .": Letter to Mr.
Lester, August 9, 1937.

Chapter Nine:
Platinum/Palladium Prints

"Nature is full of pictures . . .": P. H.
Emerson, *Naturalistic Photography for
Students of the Art* (London: Sampson Low,
Marston, Searle and Rivington, 1889).

"A layer of glycerin . . .": Paul L. Anderson,
"Special Printing Processes," in *Handbook of
Photography,* edited by Keith Henney and
Beverly Dudley (New York: McGraw-Hill,
1939), p. 484.

Chapter Ten:
Gum Dichromate Printing Processes

"The discovery of photography . . .": Aaron
Scharf, *Art and Photography* (Harmonds-
worth: Penguin Books, 1975), p. 13.

"Gum bichromate prints are palpable . . .":
Stuart Koop, Director of the Center for
Contemporary Photography, Melbourne,
Australia. From opening remarks at a sym-
posium at the Royal Institute of Technology,
Melbourne, Australia, May 1995.

"As the longest scale . . .": "Special Printing
Processes," p. 489.

"One reason that so many beginners . . .":
"Special Printing Processes," p. 492.

"We should know . . .": Ansel Adams,
The Print, Book 3 of the Ansel Adams Basic
Photo Series (Boston: New York Graphic
Society Books/Little, Brown and Co.,
1950), p. 1.

Chapter Eleven:
Approaches to Color Photography

"The photographic rendition . . .": Ansel
Adams, *Polaroid Land Photography* (Boston:
New York Graphic Society Books/Little,
Brown and Co., 1978), pp. 58–59.

"Legend has it . . .": John Reuter,
"Introduction: Image Transfer Opens
Pandora's Box," in *Polaroid Guide to Instant
Imaging: Advanced Image Transferring*
(Cambridge, Mass.: Polaroid Corporation,
1994), p. 2.

"While color photography demands . . .":
Polaroid Land Photography, p. 62.

"The photographer 'sees' . . .": *Polaroid
Land Photography,* pp. 75–76.

Chapter Twelve:
Photography and Electronic Imaging

"Certainly photography does not grow
simpler . . .": Henry Holmes Smith, "The
Academic Camera Club (or Possibly the
World's Youngest Profession)," *Exposure* 12
([2] May 1977): 21.

Chapter Thirteen: Digital Imaging

"Photography Is a Language. . . .": Ansel
Adams, *Camera and Lens,* from the fore-
word.

"Photographers are, in a sense . . .": Ansel
Adams, *Ansel Adams: An Autobiography*
(Boston: Little, Brown and Co., 1985),
p. 360.

Illustration Credits

Illustrations other than the copyrighted photographs by Ansel Adams, John P. Schaefer, and Alan Ross or those commissioned by the Trustees of the Ansel Adams Publishing Rights Trust for use in this book are used with the kind permission of the following:

Figure 1.5: © Linda Connor

Figure 1.8: Mortensen Estate Collection © 1980

Figure 1.13: Edward S. Curtis image courtesy of Center for Creative Photography, University of Arizona, Tucson, Arizona

Figure 1.15: Peter Henry Emerson image courtesy of Center for Creative Photography, University of Arizona, Tucson, Arizona

Figures 1.16 and on p. 151: © Charles Palmer

Figure 1.17: © 1997, Aperture Foundation Inc., Paul Strand Archive

Figures 1.18, 6.5, 10.1, 10.5, and on p. 239: © David Scopick

Figures 1.19, 12.1, and 12.6: © Olivia Parker 1995, 1994, and 1996, Nash Ink Jet prints

Figure 5.1: © Kevin Smith

Figures on pp. 120–123: © M. Halberstadt

Figure 6.13: © Bobbe Besold

Figure 7.1: © Diane Farris 1979

Figure 7.4: © Laurie Snyder

Figure 7.5: © Bonnie Gordon

Figure 8.1: © Betty Hahn

Figures on p. 183: William Robert Baker images courtesy of Michael Gray

Figure 8.9: © Linda Fry Poverman

Figure on p. 197: © Zoe Zimmerman

Figure 9.1: Laura Gilpin, *Narcissus, 1928*. Platinum print, P1979.95.84 © 1981, Laura Gilpin Collection, Amon Carter Museum, Fort Worth, Texas

Figure 9.2: Anne Brigman image courtesy of Center for Creative Photography, University of Arizona, Tucson, Arizona

Figures 9.3 and 9.9: © Douglas Frank 1982 and 1984

Figure 9.4: William E. MacNaughton image courtesy of Center for Creative Photography, University of Arizona, Tucson, Arizona

Figure 9.6: © Jed Devine, courtesy of Bonni Benrubi Gallery, New York City

Figure on p. 219: © Dick Arentz

Figure 9.7: © Meridel Rubenstein, Palladium print, 16 x 20 inches

Figure 9.8: © Barbara Crane

Figure 10.4: © 1998 Die Photographische Sammlung/SK Stiftung Kultur—August Sander Archiv, Cologne; ARS, New York, 1977

Figure 10.6: © Brian Taylor

Figure 10.8: Charles Macnamara image courtesy of The Art Gallery of Ontario, Toronto, Canada

Figure 10.9: © Diana Parrish

Figure 10.10: © Bernard Plossu, *Big Sur, 1970*, Fresson print courtesy of Eaton Fine Art, West Palm Beach, Florida

Figure 10.11: Wallace Edwin Dancy image courtesy of Center for Creative Photography, University of Arizona, Tucson, Arizona

Figures 11.1 and 11.16: © Gail Skoff 1977 and 1980

Figure 11.2: © Karen Truax

Figure 11.5: © Patricia White

Figure 11.6: © Joan Myers 1977

Figure 11.7: *Nervadura, 1984* © Luis Ortiz Lara (Sevilla, Spain)

Figures 11.8 and 11.15: © Kelly Madden-Burgoyne

Figure 11.17: © Alice Steinhardt

Figure on p. 287: © Harold Jones

Figure 11.26: © John Wawrzonek 1997

Figure 12.3: *Small Green Island, Waterways, The Elemental Series*, copyright ©1996 by John Paul Caponigro

Figures 12.4 and 12.7: © Joyce Neimanas 1996 and 1995, Nash Ink Jet prints, 44 ½ x 23 ³/₄ inches and 19 x 13 inches

Figures on pp. 303 and 305: © Todd Walker

Figure 12.5: © Stephen Golding 1994

Figure 12.10: © Martin Paul

Figure 12.13: © Roswell Angier and Susan Hawley

Figures 13.1, 13.40, 13.41A, 13.41B, 13.41C, 13.41D, 13.42A, 13.42B, 13.43, and 13.44: © Judy L. Miller

Figures on pp. 368–369: © Barry Haynes 1995, all rights reserved. Adapted from *Photoshop 4 Artistry: A Master Class for Photographers, Artists, and Production Artists* by Barry Haynes and Wendy Crumpler (Indianapolis: New Riders Publishing)

Figures 13.3, 13.6, 13.7, 13.8, 13.9, 13.10, 13.11, 13.12, 13.13, 13.14, 13.15, 13.16, 13.20, 13.21, 13.22, 13.23, 13.24, 13.25, 13.31, 13.32, 13.35, 13.36, 13.38, and on pp. 357–366 courtesy of Adobe Systems Incorporated. Adobe® and Photoshop® are trademarks of Adobe Systems Incorporated.

Alan Ross is responsible for most of the technical photographs in this book.

Index

GOSHEN COLLEGE - GOOD LIBRARY

3 9310 01012456 6